SO-AZK-702

GANYMEDE IN THE RENAISSANCE

GANYMEDE

IN THE

RENAISSANCE

Homosexuality in Art and Society

James M. Saslow

YALE UNIVERSITY PRESS · NEW HAVEN AND LONDON

OCLC # 11866964

NX
650
·H6
S27
1986

Copyright © 1986 by James M. Saslow.
All rights reserved.
This book may not be reproduced, in whole
or in part, in any form (beyond that
copying permitted by Sections 107 and 108
of the U.S. Copyright Law and except by
reviewers for the public press), without
written permission from the publishers.

Designed by Sally Harris
and set in Zapf International type
by Graphic Composition Inc.
Printed in the United States of America by
Murray Printing Company, Westford, Massachusetts.

Library of Congress Cataloging in Publication Data

Saslow, James M.
Ganymede in the Renaissance.

Revision of thesis (Ph.D.)—Columbia University.
Bibliography: p.
Includes index.
1. Homosexuality in art. 2. Arts, Renaissance—Italy.
3. Arts, Italian. 4. Arts, European. 5. Homosexuality—
Social aspects—Italy. 6. Homosexuality—Social aspects—
Europe. I. Title.
NX650.H6S27 1986 700'.94 85-2357
ISBNs 0–300–04199–3 (pbk.) 0–300–03423–7 (cloth)

The paper in this book meets the guidelines for
permanence and durability of the Committee on
Production Guidelines for Book Longevity
of the Council on Library Resources.

3 5 7 9 10 8 6 4 2

To the memory of
Paul S. Ronder
1940–1977

I'll have no worse a name than Jove's own page;
And therefore look you call me Ganymede.

—*William Shakespeare,* As You Like It

HOLY SPIRIT LIBRARY

92 2465

CABRINI COLLEGE, RADNOR, PA.

CONTENTS

LIST OF ILLUSTRATIONS

Chapter 1

Chapter 3

Chapter 5

ACKNOWLEDGMENTS

\mathcal{T}his book is a revised version of my doctoral dissertation, which was supported by a generous fellowship from the Mrs. Giles Whiting Foundation. I also wish to thank the Department of Art History and Archaeology of Columbia University for their continuous financial assistance, including a travel grant that enabled me to examine works of art in Italy, France, and England.

My study would not have come into being without the active support and continual guidance of Professor David Rosand of Columbia University, who first suggested the subject and whose intellectual and practical criticisms were invaluable. I am also deeply appreciative of the enthusiasm and constructive comments of the late Howard Hibbard and of Robert S. Liebert, who participated in the shaping of this work from the beginning. My debt to these three advisors is analogous, in its somewhat less lofty realm, to the words Dr. Liebert has written regarding Michelangelo: "The artist's capacity to create was enormously dependent on the palpable encouragement of the idealized and devoted patron."

That creative capacity also benefited from many friends and family members who provided unstinting emotional and practical support. I especially wish to thank Louis Rispoli and Ellen Datloff for reading and commenting on the manuscript at various stages. The staff of *The Advocate*, Los Angeles, California, particularly Robert I. McQueen and Mark Thompson, have contributed equally to my development as a writer and to the indispensable faith that there is a sympathetic audience for one's thoughts and feelings.

In developing the interests and understanding that led to this area of study I was inspired by the scholarly example and encouragement of William Koelsch, Clark University; Richard Plant, City University of New York,

retired; and Martin Greif of Main Street Press, as well as several other individuals cited in the notes. The opportunity to present my preliminary findings at the annual conference of the Gay Academic Union at the University of Southern California in 1978 led to useful contributions from several scholars.

Among the numerous institutions and individuals who graciously assisted in my research I especially thank Jennifer Montagu of the Warburg Institute and Homan Potterton, Assistant Keeper at the National Gallery, London, whose early enthusiasm for this project spurred my own. The staffs of the Cabinet des Dessins, Musée du Louvre, and of the Gabinetto Disegni e Stampe of the Galleria degli Uffizi were also helpful and encouraging. Excerpts from Greek and Latin authors quoted in the Loeb Classical Library translations are reprinted by permission of Harvard University Press; the translations of Cellini's *Autobiography* and Castiglione's *Book of the Courtier* are reprinted by permission of Penguin Books Ltd.; John Boswell's translation of *Post aquile raptus* and the version of Euripides' *Medea* are copyright, University of Chicago Press.

Gladys Topkis offered many stimulating suggestions along with tea and sympathy. Nancy R. Woodington's patient and thorough editing of the final manuscript prodded me to resolve numerous problems of form and style; any infelicities that remain are my own.

Finally, though he is still too young to read these pages, I wish to thank Jake Rockwood Saslow. For those who, in Plato's words, are "better equipped for offspring of the soul than for those of the body," the birth of a nephew is perhaps the most immediate experience of the continuity of life and the value of working for future generations. Jake arrived when my own creative gestation most needed that assurance.

INTRODUCTION

\mathcal{T}he classical myth of Ganymede, the beautiful Trojan boy who became cupbearer to the gods, figures as a subject in approximately two hundred works of visual art surviving or recorded from the Renaissance and early Baroque periods. His abduction by Jupiter and subsequent service to the king of the gods as wine-pourer and, in many accounts, beloved, are also mentioned or described in numerous literary works of the time, from theological or philosophical texts to plays and autobiographies. These appearances in a variety of media and contexts attest to the widespread popularity of the theme in Italy from the mid-fifteenth through the mid-seventeenth centuries. Although Ganymede did not figure so prominently in the arts of other western European cultures, the diffusion—and frequent alteration—of Italian artistic and philosophical influences can be traced in a number of illustrations of the myth in France, England, Germany, and the Low Countries.

Artists and authors of the Renaissance drew their visual and iconographic inspiration for Ganymede from a long and complex tradition in the cultures of Greece and Rome and, to a lesser extent, of the Middle Ages. The resurgence of interest in the antique Ganymede, prefigured by the fourteenth-century literary researches of Petrarch and Boccaccio, was but one aspect of the revival of classical art and thought, which popularized the characters and language of Olympian mythology. The frequency and importance of Ganymede's depictions in art closely paralleled this general trend, which may be broadly characterized as a bell curve. His trajectory, rising from the enthusiastic recovery and adaptation of antique models in the Quattrocento and early Cinquecento, reached its apogee between 1530 and 1550. This brief period, during and just after the zenith of the High Renaissance, produced the greatest number of Ganymede images and most

of the significant ones by major Italian artists. At that point a sweeping reevaluation of classical influences was prompted by the spiritual and intellectual crises of the Reformation and Counter-Reformation. The decline of Ganymede, both in frequency of portrayal and in the level of idealization and dignity accorded him, began just as the Council of Trent (1545–63) curtailed the use of pagan themes and codified a program of artistic and social reform that stressed moral didacticism and condemned nudity and lasciviousness.[1]

The change in attitude toward Ganymede and what he represented is neatly illustrated by two examples that bracket the period covered in this study. In 1435 Alberti, the first Renaissance theoretician to discuss suitable visualizations of the myth, implied that Ganymede should be idealized, with a smooth brow and soft, beautiful thighs.[2] Exactly two centuries later, Rembrandt's painting of the *Rape of Ganymede* (fig. 5.9, 1635) reduced the exquisite ephebe of classical tradition to a crying, incontinent baby who appears vigorously to protest his abduction.

In iconographic terms, the abduction and heavenly service of the beautiful mortal youth represented the epitome of four interlinked emotions: the rapture of the pure human soul or intellect in the presence of divinity, the uplifting power of chaste earthly love, and both the delight and the disapproval associated with sexual passion, particularly in its homosexual form. Most previous studies of Ganymede have emphasized his more abstract spiritual connotations, which developed in the Neoplatonic philosophy of Marsilio Ficino, Andrea Alciati, and other authors. However, a persistent substratum of erotic associations adhered to the myth from classical times; the very word *ganymede* was used from medieval times well into the seventeenth century to mean an object of homosexual desire. This level of meaning has often been overlooked in various discussions of the subject. In addition to the discomfort of some scholars with sexual, especially homosexual, subject matter, this neglect is due to a tendency to view Renaissance art and society as more uniformly serious than was probably true and to the fact that many references to homosexuality are vague or occur in satirical or moralizing contexts, where it is tempting to dismiss them as mere exaggerations.[3]

This book supplements earlier interpretations of Ganymede as a spiritual metaphor with a more detailed investigation of the sexual, emotional, and social issues he also symbolized, from pederasty to misogyny to conventions of marriage and gender roles. Ganymede served more than has been previously understood as an artistic vehicle for explicitly erotic or sexual concerns; and changes in his popularity, form, and iconography can be

closely correlated with shifting attitudes toward eroticism, specifically homoeroticism.

Imagery and Classical Sources

Ganymede appeared in art from the fifteenth to the seventeenth centuries in several different roles drawn primarily from classical myth and literature, in part as extended (and altered) by medieval commentators. These sometimes conflicting accounts vary in emphasis and detail, but taken together they outline three successive principal episodes in the myth. These gave rise to three corresponding artistic personae of the Phrygian youth along with several minor ones and a few iconographically unique treatments. At first a mortal boy abducted by Jupiter, he next became the honored and desired attendant of the Olympian ruler, who after Ganymede's death granted him immortality and transformed him into the constellation Aquarius.

The first and most important of these three narrative episodes is the rape of the youth, sometimes illustrated as an isolated event, at other times as one in a series recounting loves of the gods or loves of Jupiter. In this personification, reaching back to Homer, Ganymede is the archetype of ideal, youthful male beauty: a handsome shepherd or hunter, son of the king and queen of Troy, whom Jupiter, captivated by his appearance, elevated from earthly life to the heavenly realm.[4]

The account of the rape and its aftermath that was most familiar and influential during the Renaissance is Ovid's (_Metamorphoses_ 10:155–61): "The king of the gods once burned with love for Phrygian Ganymede, and something was found which Jove would rather be than what he was. Still he did not deign to take the form of any bird save that which could bear his thunderbolts [the eagle]. Without delay he cleft the air on his lying wings and stole away the Trojan boy, who even now, though against the will of Juno, mingles the nectar and attends the cups of Jove."[5] The rape was described in more detail by Virgil (_Aeneid_ 5:250–57) in an _ekphrasis_ of an embroidered cloak: "Interwoven thereon the royal boy, with javelin and speedy foot, on leafy Ida tires fleet stags, eager, and like to one who pants; him Jove's swift armour-bearer has caught up aloft from Ida in his talons; his aged guardians in vain stretch their hands to the stars, and the savage barking of the dogs rises skyward."[6] This version, rich in such dramatic details as the yelping dogs and dismayed tutors, provided Renaissance artists with a fuller scenario than Ovid's; it was followed closely by

Statius's *Thebaid* (1:548–51), which further described the city of Troy and
the nearby hills dramatically receding from the youth's sight as he was
swept aloft. In contrast to Ovid and other writers who maintained that
Jupiter transformed himself into an eagle in order to carry out the abduc-
tion personally, Virgil implies that the bird was merely an agent of the god.

Next in importance to depictions of the boy's ascent are his appearances
as the attendant of Jupiter, showing the two figures either by themselves or
as principal actors in the eternal banquet of the gods. In some accounts,
such as Homer's, Ganymede is limited to a purely ceremonial function and
represents a secondary attribute of Olympus or of its divine ruler. As early
as Theognis, however, numerous other writers interpreted Ganymede's ser-
vice to Jupiter more broadly, reading some degree of sexual interest into
the god's infatuation with the youth's beauty: "The love of boys [παιδοφι-
λειν] has been a pleasant thing ever since Ganymede was loved by the son
of Kronos who brought him to Olympus."[7] Later depictions of Jupiter and
Ganymede on Greek vases show Ganymede holding a cockerel, a gift com-
monly bestowed by older Greek men on youths whose sexual favors they
were seeking.[8] On occasion this intimately physical aspect of the relation-
ship served Renaissance artists as a pretext for a more personalized and
erotic treatment.

Out of this early ambiguity arose two conflicting interpretations of the
myth. Xenophon (*Symposium* 8:28–30) viewed Ganymede's elevation to
heaven as a spiritual allegory representing the ascent of the pure, questing
soul toward knowledge of the divine. Plato acknowledged the same ele-
vated interpretation (*Phaedrus* 255), but elsewhere he wrote disparagingly
that the myth had been invented by the Cretans to justify their predilection
for pederasty (*Laws* 1:636D). In several plays by Euripides, Ganymede is
frankly identified as the bedfellow or plaything of Jupiter, usually in a rib-
ald or satirical context; such references continued in the often bawdy Latin
epigrams of Martial.[9] Eventually Ganymede became virtually eponymous
with male homosexuality, particularly the love of an older man for a youth:
the Latin term *catamitus* (English *catamite*), meaning a boy kept for sex-
ual pleasure, was a corruption of the name Ganymede.[10]

A subsidiary episode of Ganymede's service as cupbearer, occasionally
illustrated in the Renaissance, is his displacement of the previous holder of
that office, the goddess Hebe, daughter of Juno. As Ovid wrote, this substi-
tution was "against the will of Juno," who had two reasons to resent it: the
slight to her daughter's dignity and the threat to herself of a rival lover.
Jupiter's consort also despised Ganymede's compatriot, Paris, because of
the judgment he had delivered against her beauty; her anger at both Tro-

jans is cited by Virgil in the opening lines of the *Aeneid* (1:28) as a contributing factor to the Trojan War. Jupiter's preference for a male over a female attendant was playfully offered by the late Greek novelist Achilles Tatius as a divine justification for men who preferred boys to women as sexual partners (*Leucippe and Clitophon*, book 2, chapters 35–38). The wider vein of misogyny underlying this interpretation is further suggested by the fact that, although Ganymede is the sole male among Jupiter's myriad paramours, he is the only one of them ever to be honored by an invitation to the heavens. Moreover, the god's disregard for Juno's extreme displeasure provided an apt metaphor for the discord that homosexual desires could provoke between an earthly husband and wife.

In the third and final episode of the myth, Ganymede was spared old age and death as a reward for his years of Olympian service. Jupiter transformed him fittingly into the constellation Aquarius, the water-carrier, and set him among the eternal stars. This aspect dates from the late Hellenistic and Roman periods and was consolidated by late antique and early medieval mythographers. By the fourth century A.D. he was illustrated in this guise in the *Calendar of 354*, an astrological text that was frequently copied into Carolingian times.[11] Ganymede-Aquarius continued to figure throughout the Renaissance in astrological art and the related occult symbolism of the alchemists. Less frequently he appeared in other minor art forms such as illustrated printings of the principal classical texts containing his story, notably those of Ovid and Virgil. Also, because the eagle of Jupiter had heraldic connotations in imperial and regal symbolism, Ganymede appeared sporadically in the personal and dynastic iconography of the ruling houses of Medici, Este, Gonzaga, and Habsburg.

Medieval Literary and Visual Sources

In addition to the surviving Greco-Roman sources for Ganymede's mythography, he was known to Renaissance artists from texts and images created during the Middle Ages. Although the myth was a less popular subject in medieval art than it had been earlier, it was by no means unknown: illustrations range from architectural sculptures to manuscript illuminations of several different works, both sacred and secular, that treat Ganymede. As was generally the fate of figures from classical literature, Ganymede's new incarnations preserved his antique form but overlaid it with new content.[12] The spiritual and erotic interpretations present in classical culture persisted, but the spiritual dimension was presented in spe-

cifically Christian terms, and the erotic dimension was more often subject to censure in those same terms.

Early Christian mythographers began to record and codify much of the classical lore about the gods; such compilations, either mythographic or astrological, had a long history. In the treatise *De deorum imaginibus libellus*, probably written by Albricus about 1300, Ganymede is named among the attributes of Jupiter in a catalogue of prescriptions for representing antique deities, and his rape is precisely described. In an extension of his use in classical funerary symbolism, medieval exegetes often interpreted the rape of Ganymede as a religious allegory. Dante's use of the episode in his *Purgatorio* (9:19–24) remained influential during the Renaissance, particularly in the fifteenth-century commentary of Cristoforo Landino, who saw the abduction as a symbol of the human soul uplifted by the rapture of divine love. The *Ovidius moralizatus*, a fourteenth-century Latin treatise in prose by the monk Petrus Berchorius, provided Christian glosses for the characters of the *Metamorphoses*. Berchorius compared Ganymede to St. John the Evangelist, who was also visited by a heavenly eagle, symbol of his divine inspiration; he interpreted Jupiter as an antetype of the Christian God and Ganymede as the pure childlike soul seeking after God.[13]

The *Ovide moralisé*, a fourteenth-century French narrative poem, recounts the same Ovidian episodes. But whereas the Latin version simply ignores any erotic implications of the original source, the French text acknowledges them in order to condemn them as "against law and against nature." This negative attitude, too, had a long history: the second-century divine Justin the Martyr, in his *First Apology*, wrote disparagingly of the amours of Jupiter, including Ganymede, in order to discredit the pagan conception of divinity.[14] In contrast, numerous literary references with clear and positive erotic overtones survive from the eleventh and twelfth centuries. These were presented by John Boswell as evidence of a self-conscious homosexual subculture that flourished in western Europe, especially France, in the century and a half before St. Thomas Aquinas (1225–74) began an intensified ecclesiastical drive to suppress homosexuality.[15]

Toward the close of the Middle Ages, Italian authors of the Trecento laid the groundwork for the Renaissance interest in Ganymede. Both Petrarch and Boccaccio, who together were largely responsible for the revival of classical literature, described him in an essentially antiquarian and encyclopedic spirit, with no moralizing gloss on the original texts. Boccaccio's compilation of literary references to the classical divinities, *Genealogy of the Pagan Gods* (1375), "remained for two centuries the storehouse from which educated men drew their knowledge of the gods." His typically thor-

ough account of Ganymede, "the most beautiful boy," reviews the antique sources, recounts the myth's three major episodes, and ends by quoting Virgil's lines from the *Aeneid*.[16]

Structure and Scope

The following chapters examine Renaissance artistic developments of this classical and medieval tradition of Ganymede, particularly in the light of contemporary sources that reveal social behavior and attitudes about issues of sexuality and gender. These include legal records pertaining to the sex lives of such artists as Leonardo, Botticelli, and Cellini as well as of the general population; social history and commentary, including the chronicles of the Anonimo Gaddiano and the theoretical writings of Castiglione; and the poetry, drama, and correspondence of Poliziano, Michelangelo, Aretino, and Cellini. The surviving data suggest that the popularity of the Ganymede myth was in part due to the topicality of its theme. Homosexual sex, often called sodomy, was widespread among various classes; although a matter of great official concern, in practice it was often tolerated and at times almost expected. Since a number of artists and aristocratic patrons were homosexual in varying degrees, for several major depictions of Ganymede some precise conclusions can be drawn about the expression of the general cultural patterns in individual lives and works of art.[17]

Not all the extant representations of Ganymede are discussed below; nor, even if they were, would this study constitute a complete survey of homosexuality in the Renaissance (though such a work is greatly needed). Many minor treatments of the theme, such as in tapestry borders and astrological cycles, or pictures where the myth is primarily a pretext for landscape painting, are omitted or mentioned only in the notes. Focusing on one myth prevents more than passing investigation of several homosexual or bisexual artists who never illustrated this subject, notably Leonardo, Sodoma, and Caravaggio. Social settings where homosexuality was prevalent but not expressed artistically, such as sixteenth-century Venice and France under Louis XIII (r. 1610–43), are also excluded.[18] In addition, Ganymede could symbolize only one form of homosexuality, that between an older and a younger partner (pederasty). It could thus be argued that the subtitle of this book should speak of "homosexualities" rather than of "homosexuality" in the singular; but in fact almost all references to homosexual behavior in this period concern relations between men and adolescent boys. This pattern suggests that Ganymede was the single most appropriate, if not

the exclusive, symbol of male-male love as it was then understood. Having stated these limitations, it should also be noted that concentrating on one myth has compensating advantages. Besides offering a set of constant narrative sources against which to measure progressive changes in interpretation, this focus allows us to penetrate beyond statistics and anecdotes to a more profound level of personal and psychological symbolism, as revealed in those artists particularly drawn to the myth.

The following study consists of five chapters. Each of the first four examines a group of works united by their formal and/or iconographic affinity with depictions by a major artist (in one case, two artists) in whose oeuvre Ganymede holds some special importance by virtue of frequent representation, outstanding artistic quality or influence, or identifiable personal interest in the theme on the part of either artist or patron. The focal images by these artists cluster within the period from about 1525 to 1545, and the treatment of them is not, strictly speaking, chronological. In each chapter a few major iconographic themes and compositional types are investigated for their antecedents and parallels in classical, medieval, and Renaissance art and thought. At the same time, however, the overall sequence of discussion is roughly chronological in terms of the birthdates and lifespans of the principal artists. This arrangement permits us to observe the broader diachronic pattern of Ganymede's changing popularity and expressive complexity within Renaissance culture. The fifth chapter examines the subsequent influence of the Cinquecento syntheses by tracing their development into the mid-seventeenth century.

Michelangelo, born in 1475, is the oldest of the artists considered. His intellectual and artistic roots lay in the Florentine Quattrocento and, even farther back, in his admiration for Dante, and in the excitement that attended the fifteenth century's rediscovery of ancient society, thought, and visual models. But he survived all the younger artists treated in this study except Cellini and lived well into the period of crisis occasioned by the religious upheavals of the Reformation and the Counter-Reformation. Hence his drawing of Ganymede and the events surrounding it also set the stage for the end of our study by displaying the psychological roots of the eventual breakdown of the lyrical, poetic, and paganized culture that had developed during his youth at the "court" of Lorenzo the Magnificent.

Medicean Florence, home of both Ficino and Savonarola, was keenly aware of the contradictions between Christian ideas of love, sexuality, and spirituality and those sanctioned by the revered example of the classical past. Michelangelo's *Ganymede* is a prime example of the synthesis of these two traditions that was achieved by Ficino's elevated Neoplatonic philoso-

phy. But that uneasy equilibrium could be maintained only at the cost of suppressing physical passion. Michelangelo appears to have been exclusively homosexual in his orientation, but he clearly had strong inhibitions about acting on his impulses. The polarity between the spiritual and erotic Ganymedes, foreshadowed in Xenophon and Plato and present in Michelangelo, proved to be a continuing source of tension in society over the next century, much as it was in Michelangelo himself. Most of Western art and culture resolved this tension by the same means that Michelangelo chose: rejection or modification of Ganymede's erotic connotations.

Chapters 2 and 3 examine a trio of artists in the generation following Michelangelo who were closely linked in time and place. Correggio (b. 1489 or 1494), Parmigianino (b. 1503), and Giulio Romano (b. 1499) were principally active in Parma, Mantua, and neighboring northern Italian areas. None of these artists' personalities is well known, as they did not leave the revealing letters, poems, or memoirs that we possess so abundantly from Michelangelo. None is documented as having been homosexual. On the other hand, they all knew each other and worked for many of the same clients, sometimes simultaneously. Hence, rather than dealing with questions of individual psychological expression, the discussion of these artists addresses issues of artistic context: the interests of their patrons and of subsequent buyers of their works and the influence of social attitudes about sexuality, gender, and the nature of homosexuality. The cluster of important writers from northern Italy in the first half of the Cinquecento, including Ariosto, Aretino, and Castiglione—acquainted with one another and with the artists active in the same milieu—provides detailed material for understanding the associations and values underlying these artists' depictions of Ganymede.

Generally, northern Italian artists used Ganymede more overtly than had Michelangelo to celebrate physical beauty and erotic stimulation. In part this earlier, less conflict-ridden approach to the myth reflected the hedonistic atmosphere of Mantua exemplified by Correggio's and Giulio's libertine patron, Federigo II Gonzaga, and shown particularly in the writings of Aretino. Visual sources and aspects of Ganymede's iconography were selected that tended to emphasize his erotic appeal: his affinities with Apollo and Cupid and his replacement of Hebe. These patterns embodied contemporary ideas about the physical delights of boys and, more broadly, the superiority of men over women. Finally, the interest of both Parmigianino and the emperor Rudolf II in alchemical pursuits introduces Ganymede's role within the iconography of Renaissance occult lore.

The fourth chapter returns to Florence and to another artist whose

psychic makeup included a significant homosexual component. But the sculptor Benvenuto Cellini (1500–71), though a fervent admirer of his older compatriot, was otherwise radically different from Michelangelo: bisexual rather than exclusively homosexual and, at least in his early years, a flamboyant and boastful libertine. His actions, images, and writings point to a pattern in which Ganymede symbolized the current social pattern of close and often erotic relationships between masters and their servants or apprentices. The only artist in our study to outlive Michelangelo, Cellini had to adapt to the more austere moral and artistic atmosphere of the second half of the Cinquecento; in later life, he seems to have abandoned both homoerotic behavior and subject matter. His poems and celebrated autobiography, along with judicial records, clearly set forth the external impetus for this transformation, attesting to the public embarrassment, denunciations, and eventual imprisonment that attended his erotic exploits.

Chapter 5 briefly examines the transformations and dwindling frequency of Ganymede imagery in the century following Cellini's marble sculpture and the Council of Trent, particularly as the subject spread north of the Alps. Although Ganymede's erotic associations were never entirely forgotten, later artists in France, England, and the Low Countries were more interested in adapting the myth to very different social purposes and moral attitudes. In the hands of Rubens, Rembrandt, and others, the attractive adolescent of tradition was often reduced to a child, adapted to a more heterosexual version of his myth, or expressly banished from civilized society. Tracing this process for a specific myth illuminates changing attitudes toward sexuality; at the same time, the fate of this single subject adds to our understanding of the general decline and atrophy of classical mythology in art during the seventeenth and eighteenth centuries.

Traditional Interpretations and New Methodologies

The myth of Ganymede has not lacked for art-historical treatments using established iconographic methods. Antique interpretations of the myth are surveyed in Hellmut Sichtermann's *Ganymed: Mythos und Gestalt in der antiken Kunst*, the basic work in its field and useful for classical images known in the Renaissance. More specific information about erotic associations of the myth in art is contained in K. J. Dover's *Greek Homosexuality*. No comprehensive survey of Ganymede in medieval art exists, though his principal occurrences in art and literature have been outlined by Panofsky and, most recently, Boswell.[19] The fundamental study of Gany-

mede in Renaissance art and thought is Panofsky's, whose title, "The Neo-
platonic Movement and Michelangelo" (in his *Studies in Iconology*), de-
notes its principal emphasis. The only other studies specifically devoted to
Ganymede are two doctoral dissertations, the first one now outdated.

Penelope Mayo's survey of Ganymede from classical times to the nine-
teenth century, "*Amor spiritualis et carnalis*: Aspects of the Ganymede
Myth in Art," contains thorough and informative overviews of antique and
medieval imagery. However, she devotes only one chapter to the Renais-
sance and Baroque periods, discusses only a small portion of known works,
and overlooks many significant literary parallels. A published dissertation,
Gerda Kempter's *Ganymed: Studien zur Typologie, Ikonographie und Ikon-
ologie*, incorporates much of the relevant research since Mayo's study. Like
Mayo, however, Kempter surveys images from antiquity through the Vic-
torian period, and her discussion of selected pictures is summary and epi-
sodic, making little attempt at a continuous narrative or at relation to
broader social issues. The most useful feature of her book is its detailed
catalogue of some 250 known works with basic bibliography for each. Al-
though the present study identifies a number of works not included in
Kempter's list, her compilation has obviated the need for another cata-
logue, allowing the present book to concentrate on a thematic and detailed
treatment of the most important images.

In attempting to interpret many of these images as embodiments of
social attitudes and practices, this study necessarily branches out from
traditional art-historical approaches into sociological and psychological
methods for analyzing the history and dynamics of sexuality and gender.
Three such areas are fundamental to this inquiry: feminist studies, the
psychological interpretation of art, and gay studies. Each of these fields,
while remaining controversial or, at best, incompletely established, has
much to contribute to a more comprehensive understanding of Ganymede
in the Renaissance.

By addressing such issues as the status of women in history, the changing
nature of masculine and feminine gender roles, and the importance of
sexuality as a determinant of culture, the field of women's studies has
paved the way for this investigation, which seeks in part to examine the
connections between Renaissance notions of sexuality and homosexuality,
gender, and misogyny. Recent studies of the functions and status of women
in antiquity, the late Middle Ages, and the Renaissance offer both the data
necessary for understanding attitudes toward male and female sexuality
and a conceptual model for reading such concepts in works of art.[20]

The second discipline often utilized here is psychology. The debate

among art historians over the validity of intrapsychic factors as clues to the meaning of an individual artist's work is long-standing. Freud's pioneering attempt to explain Leonardo's life and work as the product of early child-hood deprivation and trauma provided a methodology for psychoanalytic interpretation that has been greatly refined both by traditional Freudians and in such variant forms as the more poetic and speculative analysis of Adrian Stokes. Meyer Schapiro, in a long and detailed attempt to refute Freud, not only questioned details of his argument but, more profoundly, suggested that the traditional, external sources of iconographic explanation were adequate in themselves to account for Leonardo's (or any artist's) imagery. Other art historians still hold this view. Most recently, Robert Liebert's *Michelangelo: A Psychoanalytic Study of His Life and Images* has made observations about the significance to Michelangelo of numerous sacred and mythological subjects (Ganymede prominent among them) that evoked both praise and territorial defensiveness.[21]

While far from denying the relevance of transpersonal social and literary influences—indeed, such evidence is central to the material presented here—this book accepts that psychological interpretation can add an important dimension to our understanding of the meanings Ganymede embodied. Such investigation is particularly suitable for two major artists. Both Michelangelo and Cellini left poems, an autobiography, and other personal documents that permit historians to relate their work to their internal lives. Furthermore, the explication of mystical archetypal structures by Carl Jung and his school has been useful in examining Ganymede's role in alchemical symbolism.

Our knowledge of the homoerotic aspects of Ganymede imagery gains breadth and depth from the development during the past decade of a third field of research, which has become known as gay studies: the cross-disciplinary investigation of social, psychological, legal, and artistic aspects of the history of homosexual men and lesbians.[22] Major studies have treated the classical Greeks (Dover) and the early Middle Ages (Boswell); others have assembled useful sociological and legal data on specific cultures, most recently for Renaissance England. As yet no similar studies exist for Renaissance Italy or classical Rome, two cultures whose relevance to the present study is central, although Amy Richlin's *The Garden of Priapus: Sexuality and Aggression in Roman Humor* (New Haven and London: Yale University Press, 1983) has much to say about homosexuality. A number of secondary studies have gathered some of the literary and social references from the period under consideration here, though their usefulness varies considerably.[23]

INTRODUCTION

The history of research into such familiar Renaissance subjects for het-
erosexual erotic art as the figure of Venus or the contrast of sacred and
profane love is long and illustrious, but the corresponding study of homo-
erotic images and themes is still in its infancy. Some information can be
gleaned from general surveys of erotic art; in particular, the volume *Studies
in Erotic Art*, sponsored by the Kinsey Institute for Sex Research, contains
information germane to this study about Greco-Roman art and Michelan-
gelo.[24] Although Dover makes extensive use of visual material, his interest
in art is primarily as evidence for social history. Only two published studies
of an expressly art-historical nature have addressed homoerotic subject
matter of some relevance to the present inquiry. Thomas Pelzel's study of
a forged Ganymede from the circle of J. J. Winckelmann and Donald Pos-
ner's examination of "Caravaggio's Homo-erotic Early Works" opened the
way for consideration of how patrons' erotic preferences influenced artists.
In addition, a session of the College Art Association conference at Los An-
geles in 1977 featured several papers on aspects of homosexuality in West-
ern art; one of these, Wayne Dynes's "Orpheus after Eurydice," deals with
a mythological theme whose affinities to Ganymede are treated below in
chapters 1 and 3.

Gay Studies: History and Critical Issues

Three fundamental problems face any scholar attempting to deal with
the historical manifestations of homoerotic personality and imagery: the
limitations of the surviving evidence, the inadequacies of some of the pio-
neering work in this field, and resistance on the part of other historians to
acknowledge or address directly what they consider deviant or distasteful
behavior.

The paucity of direct evidence for homosexuality is due to two factors.
First is the nearly universal official condemnation of homosexual activity
by Renaissance authorities, both civil and ecclesiastical, and the resulting
tendency of artists and others to downplay, conceal, or deny such behavior.
When Aretino, for example, insinuated that Michelangelo's infatuation
with Cavalieri was improper, Michelangelo retaliated through Condivi,
who expressly noted his master's chastity. In the following generation
Michelangelo's great-nephew changed the genders in numerous poems by
his uncle from male to female before publishing them. Consequently,
much of the evidence for sexual interests and behavior is secondhand—
such as anecdotes about Donatello recorded after his death—or inconclu-

13

sive, like Leonardo's sodomy trial, which reached no verdict. Even where the evidence is incontrovertible, as in the record of Cellini's sodomy convictions, the artist's own account of his life omitted most of his homosexual episodes and bitterly declared his innocence in others, even while he wrote with casual pride of his numerous illicit affairs with women and his illegitimate children.[25] Contributing further to this problem is the fact that the fundamental sources for art-historical information about the Renaissance were not concerned with questions of sexual identity. Vasari, for example, is generally not much interested in his subjects' private lives. He mentions homosexuality only once, in relation to Sodoma (ed. Milanesi, 6:379–86), and makes an issue of it principally because it had become public knowledge at the artist's own initiative and because the chronicler related the flamboyant iconoclasm of this incident to a pattern of bizarre behavior that, in Vasari's view, affected the artist's work.

The first generation of scholars actively concerned to resurrect and analyze homosexuality as a historical phenomenon worked in the last quarter of the nineteenth century. This group, conceptual pioneers of what is now termed gay studies, thoughtfully reexamined history, literature, and the visual arts in the light of anthropological, medical, and psychological data. The debt of present-day gay researchers to John Addington Symonds (1840–93) is particularly deserving of credit: his *Life of Michelangelo*, *Life of Benvenuto Cellini*, and *The Renaissance in Italy* were the first to redress the bowdlerizations and oversights of earlier writers and (with Walter Pater) attempt to connect the psychosexual lives of artists with their work. Useful biographical accounts of Michelangelo begin with Symonds, who had access to materials in the Buonarroti archives unavailable to earlier scholars or willfully misinterpreted by them. His eloquent denunciation of editors who changed the genders in the poetry or asserted that Michelangelo's obvious addresses to a male love object were merely allegorized references to a female pointed out the hidden motivation of these commentators: to purify a great artist from any taint of homosexuality, in deference to the moral ideals of later eras.

Unfortunately, while performing the essential task of raising such questions, Symonds and others of his generation were not entirely able to transcend the limitations of their own period, both methodological and philosophical. They sometimes attributed homosexuality to historical figures on what would today be considered slim evidence or conjecture or used criteria for homosexual identity, such as effeminacy or emotional dependence, that betray now outdated notions of the psychology and value of homosexuality. Even—or perhaps especially—Symonds, acutely aware of his own

homosexual orientation, felt it necessary to refer to Cellini's similar desires as "the darker lusts which deformed Florentine society in that epoch."[26]

The sometimes excessive zeal of these early scholars was directed against the more common tendency, present even today, to minimize historical evidence of homosexuality by ignoring it, suppressing it, explaining it away, or dismissing it as irrelevant to academic discourse. Arno Karlen, for example, took Vasari's single reference to Sodoma as evidence that no other artists were homosexual, assuming that Vasari would have mentioned that same fact about them if they were; but a glance at Vasari's usual interests makes any argument from silence untenable.[27] The urge to establish, on little or no evidence, that an artist's passions were heterosexual and thus orthodox has been particularly strong in regard to Leonardo, Freud's frankness notwithstanding.[28]

When homosexuality is acknowledged or alluded to, it is often in terms that betray discomfort and hostility. At times this judgment is merely implied by discreet evasiveness: Cellini was publicly accused of being a "dirty sodomite," a charge that his biographer Plon described only as "the most cutting insult one man can address to another." More often the condemnation is explicit and brusque: Mayo speaks of various Ganymede images in such terms as "a blatant example of pederasty" and an "abnormal relationship." The most recent and extreme statement of this position is by Martin Kemp, in regard to Leonardo's painting *St. John the Baptist* (fig. 2.7): "No one has ever denied that the *St. John* conveys a remarkable impression of emotional involvement, but the nature of that involvement has been variously interpreted—and often not to Leonardo's credit. At worst it has been characterized as the effusion of an aging homosexual. Perhaps in one sense it is, but if this is all it is, it would have no more value than an obscene graffito."[29]

Not content with deriding Leonardo's innermost feelings, Kemp goes on to deny the applicability of any personal factors to art-historical analysis: "The 'psychological' interpretation is, to my mind, a supreme irrelevance." Other scholars, though less intemperate, take much the same view. Andrée Hayum, in her study of the notorious Sodoma, dismisses any interest in "speculations about his private personality" or the source of his nickname, noting in exasperation that such discussion in the past has been "essentially fruitless" and that "the moral defense of or accusation against the artist and his works that it initiated is for us an extraneous issue." Her resistance to the moralizing tone of much previous work on homosexual artists is appropriate, but the proper antidote is to pay better attention rather than less. Shorn of judgmental intrusions, acknowledgment of an artist's per-

sonal life and examination of his relation to his social context can reveal much of value about the meaning of works of art and the values and beliefs of the surrounding culture. As Theodore Bowie asserts, "the broader the frame of reference, the more clearly one can perceive how deeply sexual problems inform a whole civilization." Leo Steinberg makes a similarly telling observation in regard to the first artist considered here: "Much of Michelangelo's idiom is unintelligible so long as its indwelling sexuality remains unexplored."[30]

Because a legacy of ill-conceived scholarship on both sides has led to a chronic suspicion that any assertion of a historical figure's homosexuality constitutes "special pleading," it must be emphasized that the present book does not seek to extend the catalogue of homosexuality in art merely for the sake of an illusory validation through numbers. When viewed without bias, the evidence of such behavior and its artistic expression is abundant enough. Nor am I concerned to present homosexual men of the Renaissance as more self-affirming or "well adjusted" than they actually were; indeed, the external forces that caused Michelangelo, Leonardo, and others so much internal anxiety are an integral part of the historical context within which we must examine their attempts to mold a coherent sense of identity. What I hope to add to our knowledge of the Renaissance is ultimately less quantitative than qualitative: a profile of the wide range of psychological and esthetic sensibilities that arose from or were directed to homosexual experience.

This book assumes that the history of homoerotic expression is worthy of study as an identifiable historical phenomenon. For those who object to homosexual feelings and practices and wish not to acknowledge their existence, it may be of some consolation that the information presented documents negative attitudes and strictures at least as often as it notes opportunities for positive self-expression. I myself find it more significant that three of the five principal artists discussed were not, so far as we know, homosexual; in their work it becomes clear that knowledge and appreciation of the long tradition of homoerotic art and literature were not confined to those with "special interests." If anyone has been guilty of special pleading, it is those who persist in using their own standards of morality to justify a selective presentation of the cultural variety of another time and place—a practice unacceptable to good scholarship.

·1·

MICHELANGELO:
Myth as Personal Imagery

*T*he Florentine artist Michelangelo Buonarroti (1475–1564) first met the handsome and cultivated Roman nobleman Tommaso de' Cavalieri in the spring or summer of 1532, during a visit to Rome.[1] Michelangelo, then aged fifty-seven, formed an immediate and excited attachment to the twenty-three-year-old Tommaso, apparently attracted by the young man's intelligence, exceptional physical beauty, and deep love of art and acquisitive admiration for antique sculpture. Michelangelo's bond with Cavalieri, though not unlike the artist's emotionally charged relationships with other younger men such as Gherardo Perini and Febo di Poggio, was the most profound and long-lasting of his life. The chronicler Giorgio Vasari records that Michelangelo even consented to draw a portrait of Cavalieri, a concession he refused on principle to accord to any but persons of "infinite beauty." Cavalieri was later appointed to complete Michelangelo's projects for the Roman *Campidoglio* and the Vatican basilica of St. Peter's, and was one of the intimate group at the artist's deathbed.[2]

In what is probably the first of three surviving letters from Cavalieri to Michelangelo, the young man thanks the artist for the gift of "two of your drawings which Pier Antonio has brought me," going on to say, "the more I look at them, the more they please me, and I shall greatly appease my illness by thinking of the hope that the said Pier Antonio has given me of letting me see other things of yours." Cavalieri eventually did receive numerous "other things": Vasari records among Michelangelo's gifts a series of four drawings on mythological subjects—*Ganymede*, *Tityos*, the *Fall of Phaethon*, and a *Children's Bacchanal*—as well as *molte teste divine*, "many divine heads." Of these, it is generally assumed that the first made, the two referred to in Cavalieri's letter, are the related subjects of Ganymede and Tityos.[3]

The entire series enjoyed wide renown soon after Cavalieri received them. His third letter to Michelangelo, dated September 6, 1533, tells us that after the *Fall of Phaethon* reached him in Rome, Cardinal Ippolito de' Medici "wanted to see all of your drawings, and he liked them so much that he wanted to have the *Tityos* and *Ganymede* made in crystal." The resulting carvings by Giovanni Bernardi, which survive in several versions, are the first of some two dozen copies or adaptations of the *Ganymede* drawing that have come down to us, establishing Michelangelo's prototype as the single most influential illustration of this myth in Renaissance art.[4]

The practical function of Michelangelo's gifts of the *Ganymede* and its companions, according to Vasari, was to serve as models for the drawing instruction of Cavalieri, who was a cultivated amateur of the arts.[5] But the initial impulses behind the gifts were more private and intensely personal. It seems clear from both the circumstances of the gifts and the symbolic content of their subjects that Michelangelo also intended them as eloquent expressions of his deep love for the young man. The drawings, using the established allegorical vocabulary of Neoplatonic humanism, simultaneously communicate the artist's intense individual emotions and locate these feelings within a broader system of values that interlinks love, passion, beauty, ecstasy, and experience of the divine.

An examination of the form and iconography of the *Ganymede* will explore the manifold meanings that this well-known myth held for Michelangelo as a paradigm of love between an older man and a youth. In addition to more strictly art-historical sources for his image and its content, our inquiry will consider two broader functions of the Ganymede myth: the social and the psychological.

On the largest scale, during the Renaissance (and indeed since antiquity) Ganymede served frequently as a literary and artistic vehicle for expressing general cultural attitudes toward homosexuality. At the opposite extreme, the myth resonated with certain fundamental dynamics within Michelangelo's intense and distinctly individual psychology, particularly his passionate feelings toward other men and his profound ambivalence about that attraction. Michelangelo's contradictory responses to homosexual friendship and passion reflect in miniature a similar dichotomy running throughout Italian society of the late Quattrocento and early Cinquecento, itself an unstable confluence of pagan, humanist, and Christian attitudes toward love and sexuality.

The debate among art historians over the validity of psychological interpretation is long standing. If such a methodology is at all applicable, however, it is particularly so for Michelangelo, about whose outer and inner

lives we are far better informed than about those of any earlier artist. He has left us an unusually complete personal record, from several hundred poems and letters to the thinly disguised autobiography transcribed by his admiring disciple Ascanio Condivi. Vasari, whose _Lives of the Artists_ is a fundamental source for this period, knew Michelangelo and verified parts of his biographical account with him; other prominent writers such as Benedetto Varchi and Donato Giannotti recorded their conversations with Michelangelo and publicly discussed his life and work.[6]

About the _Ganymede_ drawing we are not quite so fortunate. The other Cavalieri drawings have survived intact, but the _Ganymede_ is presumed lost and is now known only through contemporary copies and one drawing that appears to be a preliminary version by Michelangelo himself. Two versions of the _Ganymede_, however—those now in the Fogg Art Museum (fig. 1.1) and the Royal Collection, Windsor (fig. 1.2)—are considered close enough to the original presentation piece to permit a composite reconstruction of its imagery.

The larger of the two drawings (the one in the Fogg) is the more detailed and complete.[7] In the upper half of the vertical sheet the young, heavily muscled, light-haired Ganymede swoons as he is carried aloft by Jupiter in the form of an eagle. The enormous bird grasps the shepherd boy's legs in his talons and cranes his neck around the youth's chest in a gesture at once touchingly protective and aggressively thrusting. On the ground below, in much lighter underdrawing, the young shepherd's dog sits beside the bag and staff left behind by his master. His body alert but unmoving, he turns his head skyward, as if in awed contemplation of an incident so miraculous that it stills his expected canine response of agitated barking and jumping. In the right background are faint suggestions of the flock of sheep over which dog and master had been watching. The horizontal Windsor version is identical to the Fogg sheet in the principal motif of eagle and boy, but the lower half of the composition is missing.[8]

Stylistic and other evidence points to the conclusion that the Fogg sheet is by Michelangelo but is not the drawing given to Cavalieri, as that one was probably reduced to a simplified horizontal format, perhaps to harmonize it with the proportions of the _Tityos_ (fig. 1.7). The Windsor drawing, whether copied from the Fogg sheet or from the lost presentation drawing, suggests by its dimensions and its fidelity to small details of the Fogg sheet that it was intended as a direct transcription of Michelangelo's version. We can conclude that Michelangelo at first considered a more extensive composition than the final one on which the majority of later copies are based. But because at least some later adaptations utilize elements of

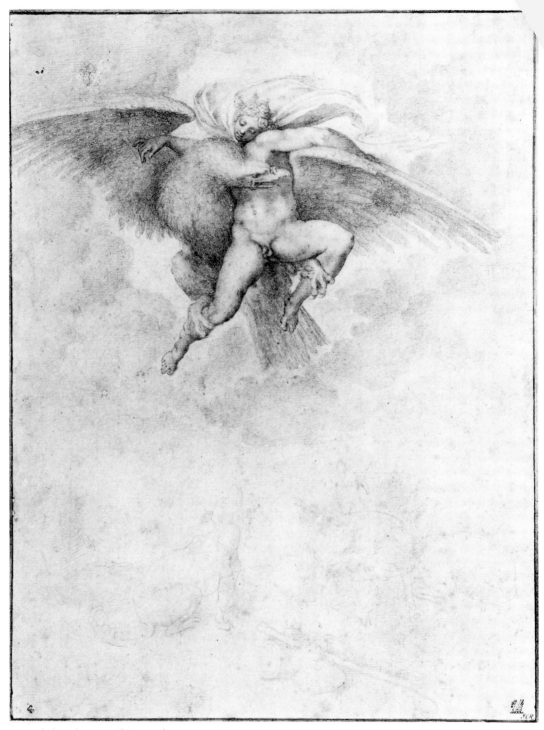

1.1 Michelangelo, *Rape of Ganymede*.

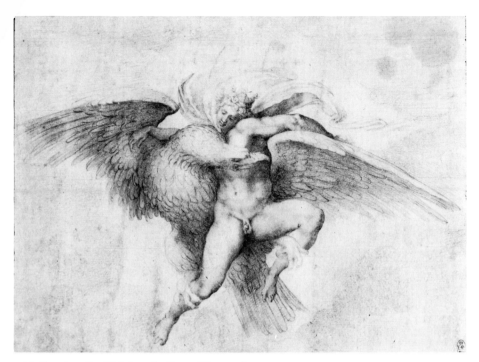

1.2 Drawing after Michelangelo, *Rape of Ganymede.*

his lower scene, the Fogg drawing, although an unfinished draft, must have shared in the prestige and public dissemination attached to so many of the master's drawings. In any case, the size, arrangement on the page, and details of anatomy are so similar in both sheets that for purposes of iconographic analysis we can be confident that at least the principal motif in both is a reasonable approximation of the presentation version.[9]

Neoplatonism and Christianity: Twin Sources of Michelangelo's Iconography

The iconographic meanings that Michelangelo and his contemporaries would have read into the image of Ganymede's abduction derived from two complementary sources: medieval Christian glosses on classical myth, and antique concepts as resurrected and reinterpreted by Renaissance humanists. Michelangelo, who was both a devout Christian and educated in the Neoplatonic circle of Medicean Florence, would have been well aware of both sets of meanings. The artist applied these precedents to three somewhat overlapping functions: the public, the personal, and the intrapsychic. Publicly Michelangelo was offering Cavalieri an illustration of the kind of

learned classical conceit both men appreciated, but he was also offering this particular myth as symbol of his personal feelings for Cavalieri. And finally, the broad cultural associations of the Ganymede myth had specific personal resonances for Michelangelo, best understood within the framework of his individual psychology.

In his thorough study "The Neoplatonic Movement and Michelangelo," which remains the fundamental summary of this aspect of the Renaissance iconography of Ganymede, Erwin Panofsky divided the medieval and Renaissance interpretations of Ganymede into two categories, each based on precedents in Greek and Latin authors:

> In the fourth century B.C. we find two already opposite conceptions: while Plato believed the myth of Ganymede to have been invented by the Cretans in order to justify amorous relations between men and boys or adolescents, Xenophon explained it as a moral allegory denoting the superiority of the mind in comparison with the body; according to him the very name of Ganymede, supposedly derived from Greek ΓΑΝΕΣΘΑΙ (to enjoy) and ΜΕΔΕΣΙ (intelligence), would bear witness to the fact that intellectual, not physical advantages win the affection of the gods and assure immortality.[10]

These two interpretations—the erotic and the spiritual/intellectual—prefigure the later division of love into *amor spiritualis et carnalis* made by Christian theologians and humanist philosophers alike. The same dichotomy is essential to the philosophy of love developed by Marsilio Ficino (1433–97), protégé of Lorenzo de' Medici and the Quattrocento's preeminent Neoplatonist, who declared, "Let there be two Venuses in the soul, the one heavenly, the other earthly."[11] But the Christian and Neoplatonic categorizations differ in the value they place on these two aspects.

Renaissance Neoplatonic thought used Ganymede as one of the prime embodiments of its theories about divine love, a concept that occupied a central place in its values: "the idea of love is, in fact, the very axis of Ficino's philosophical system."[12] However, this axis had two poles, which interpreted Ganymede in very different ways. In his exegesis of the classical myths concerning Venus, goddess of love, Ficino held that the two contrasting accounts of her birth symbolize the dual nature of the emotion over which she presides. She is both the heavenly Aphrodite Urania, born without mother from the foam of the sea fertilized by the castrated seed of Uranus, and the earthly Aphrodite Pandemos, begotten of the lust of Zeus for the nymph Dione.[13]

The first of these two incarnations, whom Ficino also calls Venus Hu-

manitas, personifies the same virtues as the Ganymede etymologized by Xenophon. As patroness of the liberal arts, she represents the sphere of human intelligence and creativity whose greatest goal is the apprehension of the divine. This kind of love is anagogic in function: insofar as contemplation of physical perfection inspires the observer to meditate on and more deeply appreciate the perfection of the creator, then the enjoyment of nature, works of art, or one's fellow mortals offers the most powerful opportunity to apprehend, as Symonds succinctly describes it, "deity made manifest in one of its main attributes, beauty."[14]

Extending this metaphor to the emotional quality of spiritual experience, Neoplatonism identified the sense of rapture, of intense physical delight in the presence of one's beloved, as the closest earthly analogue to the exaltation of experiencing divine love. Already in late antiquity the abduction of Ganymede had appeared on sarcophagi as a symbol of mystical reunion with God after death—a logical extension of the meaning of the myth as "the joys of the innocent soul enraptured by God."[15] Beginning with Andrea Alciati's _Emblemata_, published at Augsburg in 1531 and often reprinted with varying illustrations, the widely influential emblem books through which Neoplatonism propagated its symbolism employed Ganymede to represent _desiderio verso Iddio_ (yearning toward God).

Michelangelo's _Ganymede_ owes much to the emblem books, which codified the philosophy developed by Ficino and his school in the Medicean Florence of Michelangelo's youth. The relationship of the artist to this literary and visual tradition was reciprocal: Michelangelo's image, conceived in a matrix of Neoplatonic ideas, succeeded so well in visualizing the Neoplatonic interpretation of Ganymede that several emblem books published subsequently saw fit to replace the earlier, cruder illustration with reproductions or adaptations of Michelangelo's drawing.

The emblem book most immediately predating Michelangelo's drawing is the _editio princeps_ of Alciati's _Emblemata_ (fig. 1.3), printed with anonymous woodcut illustrations in 1531. This work is regarded as the prototype for a characteristic genre of Renaissance philosophy, the blending of text and image to produce a series of "speaking pictures."[16] The edition of 1531 places a crude woodcut of a child Ganymede riding atop the back of a rather cock-like eagle, under the heading _in Deo laetandum_, "rejoicing in God." An edition of Alciati printed between 1548 and 1551 with more complex woodcuts shows in its illustration to the same heading (fig. 1.4)[17] several points in common with Michelangelo's drawing, suggesting that the value and relevance of his image were already appreciated by Neoplatonists. The scene now includes some of the elements in Michelangelo's Fogg

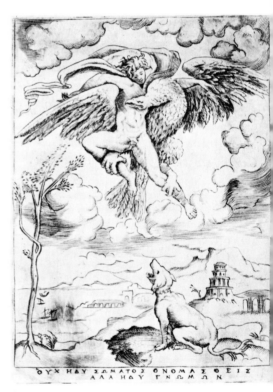

IN DEO LAETANDVM

Aspice ut egregium puerum Iouis alite pictor
Fecerit iliacum summa per astra uehi.

1.3 Woodcut, *Rape of Ganymede*.
Andrea Alciati, *Emblemata*, 1531.

1.4 Woodcut, *Rape of Ganymede*.
Andrea Alciati, *Emblemata*, 1551.

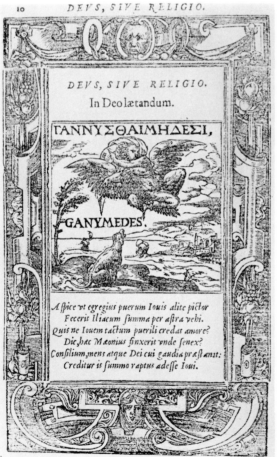

10 DEVS, SIVE RELIGIO.

DEVS, SIVE RELIGIO.
In Deo lætandum.

ΓΑΝΝΥΣΘΑΙΜΗΔΕΣΙ,

GANYMEDES.

Aspice vt egregius puerum Iouis alite pictor
Fecerit iliacum summa per astra vehi.
Quis ne Iouem tactum puerili credat amore?
Dic, hæc Mæonius finxerit vnde senex?
Consilium, mens atque Dei cui gaudia præstant:
Creditur is summo raptus adesse Ioui.

ΟΥΧ ΗΔΥ ΣΩΜΑΤΟΣ ΟΝΟΜΑ ΣΘΕΙΣ
ΑΛΛ ΗΟΥ ΓΝΩΜΩΝ

1.5 Achille Bocchi, *Symbolicarum quaestionum*,
Emblem LXXVIII.

drawing: the motif of boy and bird in a full landscape and the plaintive dog on a hill in the left foreground. Although the illustrator substitutes for Michelangelo's sheep a panoramic prospect of city, bay, and mountains, the dog is identical with that in the Fogg drawing. As in Michelangelo's depiction, the eagle spreads his wings horizontally in carrying the boy upward, and boy and bird interlock in a similar complex, twisting manner, though only the thrust of the eagle's long neck across the boy's torso is directly reminiscent of Michelangelo's drawing. The caption adds to the Latin epigram of 1531 Xenophon's Greek phrase deriving Ganymede's name from the words "intellectual delight."

The relation of these images to the ideas expressed in the accompanying Latin sestet and in Alciati's further commentary has been outlined by Panofsky and Seznec. The central metaphor is the double meaning of *transport*: both a physical movement and an emotional state. (The same ambiguity inheres in the English expression "carried away," which equates the physical experience of abduction to the ecstasy of succumbing to one's emotional enthusiasms.) In his discussion of the uplifting power of earthly beauty, Ficino explains that, upon beholding especial beauty, "the Soul is enflamed by a divine splendor, glowing in the beautiful person as in a mirror, and secretly lifted up by it as by a hook in order to become God."[18] Although Alciati does not make explicit this important corollary to his theme—the Ficinian notion that earthly love is anagogic to divine love— his poem beneath the Ganymede illustration does compare the boy's joyous heavenward journey to the rapturous flight of the human mind toward knowledge of God.

Michelangelo contributed more directly to the emblematic tradition through two engravings by Giulio Bonasone for Achille Bocchi's Neoplatonic treatise *Symbolicarum quaestionum de universo genere*, printed in Bologna in 1555 and again in 1574. In both emblems, Bonasone reproduces the essentials of Michelangelo's motif; the two versions are quite similar, but Emblem LXXVIII (fig. 1.5) shows the youth nude, and Emblem LXXIX (fig. 2.3) clothes him in a long, flowing tunic and buskins, or leg straps. Whereas Emblem LXXVIII dutifully includes Michelangelo's one canonical dog, Emblem LXXIX adds another dog of the engraver's own invention, whose more actively coiled pose and alert stance recall the yelping canine in Correggio's *Rape of Ganymede* (fig. 2.1). As Bocchi's accompanying Latin caption makes clear, the dog stands for the base earthly desires left behind in the ascent toward divine love.[19]

Although Michelangelo never wrote of Ganymede by name, the metaphoric language of his letters and poems shows his feelings for Cavalieri in

terms consonant with the meaning Alciati attaches to the "transport" of Ganymede. The principal metaphors through which Michelangelo understood his own attraction to Tommaso—metaphors strongly influenced by Neoplatonism—appear repeatedly in his sonnets. We know from Benedetto Varchi's _Lezzioni_ that a number of these were addressed to Cavalieri; in one case Michelangelo puns on Tommaso's name, declaring himself _prigion d'un cavalier armato_ (prisoner of an armed knight).[20] Within these very personal texts Michelangelo made frequent use of several interrelated images of love: ascent and winged flight, light and heat, and death. All of these metaphors apply to Ganymede, making him an ideal vehicle for Michelangelo's passionate feelings.

The metaphor most overtly related to the iconography of the Ganymede drawing is Michelangelo's description of himself drawn upward in the ecstasy of love by a lover characterized as a bird. In Sonnet 89, which Varchi says was "written, perhaps, for the same person" (Cavalieri), Michelangelo writes:

> I with your beautiful eyes see gentle light,
> While mine are so blind I never can;
> With your feet, on my back can bear a burden,
> While mine are crippled, and have no such habit;
> Having no feathers, on your wings my flight,
> By your keen wits forever drawn toward Heaven.[21]

In another poetic conceit Michelangelo compares his sense of loving bliss both to an eagle and to a wingless mortal yearning to rise like an angel:

> I thought, on the first day I admired
> So many beauties, matchless and alone,
> I'd pin my eyes, like eagles in the sun,
> On the smallest of many I desired
>
>
>
> To have no wings, yet after an angel run.
>
> (G. 80; Gilbert 78)[22]

This identification of love with winged flight naturally enough leads Michelangelo to compare his beloved to the winged Cupid, personification of Eros (on the conflation of Cupid and Ganymede see below, chapter 3):

> From the hard blow and from the biting arrow
> My heart would be repaired, if cut clean through,
> But this is what my lord alone can do,

> Adding to life with added injury.
> And though the first blow that he gave was deadly,
> A messenger from love came with him too,
> To say, "Love, rather burn, for those who die
> Have no wings else on earth for a heavenly journey."
>
> (G. 39; Gilbert 37)

There is a further, more subtle parallel between Michelangelo's conception of love and the Ganymede myth. He frequently describes his swooning, passive absorption into his beloved as a kind of death or as a joining of two mortal souls in a bliss that seems to transcend the limitations of mortality. Such language recalls the antique association of Ganymede with the ascent of dead souls. Death, like Ganymede's abduction, leads upward to heavenly bliss; moreover, Ganymede himself was a mortal whom Jupiter compensated for his death by placing him among the stars as the immortal constellation Aquarius. Thus Michelangelo's illustration of the youth's ascent can be interpreted as a visual equivalent of such lines as:

> And if two bodies have one soul, grown deathless,
> That, with like wings, lifts both of them to heaven,
> If love's one stroke and golden dart can burn
> And separate the vitals of two breasts.
>
>
> . . . such sympathy
> That both would wish to have a single end.
>
> (G. 59; Gilbert 57).[23]

The love of which Michelangelo speaks so dramatically is as much emotional and esthetic as it is erotic or sexual. When Michelangelo said (as reported in Donato Giannotti's *Dialogue*), "You must know that I am, of all men who were ever born, the most inclined to love persons," he immediately clarified the basis of such attraction: "Whenever I behold someone who possesses any talent or displays any dexterity of mind, who can do or say something more appropriately than the rest of the world, I am compelled to fall in love with him."[24] This sentiment accords with the Neoplatonic tenet that earthly perfection is a reflection of and witness to the perfection of God. Thus, enjoyment of the beloved is most valued for the higher awareness it fosters:

> Love wakens, rouses, puts the wings in feather,
> As a first step, so that the soul will soar

27

And rise to find its maker. . . .

<div style="text-align: right">(G. 260; Gilbert 258)</div>

God, in His grace, shows himself nowhere more
To me, than through some veil, mortal and lovely,
Which I will only love for being His mirror.

<div style="text-align: right">(G. 106; Gilbert 104)</div>

In the light of such elevated motivations, Michelangelo's willingness to draw a portrait of Cavalieri takes on unique significance. Vasari took pains to point out how exceptional the incident was, since Michelangelo hated making portraits from life, unless the sitter possessed infinite beauty. The Ganymede drawing, then, can be seen as Michelangelo's most direct attempt to record the uplifting feeling he experienced in the presence of an extremely rare beauty. Carried away by this love, he finds the ecstatic fulfilment of a lifelong desire. Hence he could write (in the voice of Cupid):

I am the one who in your earliest years
Made your powerless eyes turn to that beauty
That leads up from the earth to heaven alive.

<div style="text-align: right">(G. 39; Gilbert 37)</div>

The letters, sonnets, and drawings for Cavalieri constitute a single, multilayered homage to the ideals of Platonic love exemplified for Michelangelo by this singularly handsome and intelligent young man. The swooning ecstasy of the *Ganymede* and the fevered, often tortuous language of his writings are the outpourings of a passionate man who feels he has at last satisfied a deep longing for an earthly love that foreshadows the divine.

The Earthly Venus: Ganymede as a Symbol of Overt Sexuality

Michelangelo's elevated Neoplatonic infatuation with Cavalieri provided an immediate and powerful impetus for the *Ganymede*, but a full consideration of the drawing's iconography must also take into account numerous other contemporary appearances of the myth that emphasize the physical rather than the spiritual aspect of Jupiter's love for the fair youth. By Michelangelo's time a long tradition existed that utilized Ganymede (along with related figures from classical literature) as a symbol for sodomy, or, more precisely, pederasty. If the Neoplatonists took their spiritualized interpretation of Ganymede from Xenophon, they were equally aware of the eroticized gloss on the myth provided by Plato himself, who wrote: "We all

accuse the Cretans of having concocted the story about Ganymede. Because it was the belief that they derived their laws from Zeus, they added on this story about Zeus in order that they might be following his example in enjoying this pleasure as well."[25] Late classical and medieval writers from Hyginus (first century A.D.) to the fourteenth-century author of the *Ovide moralisé* also described Ganymede's abduction by Jupiter as an archetype of the sexual attraction of a mature man to a youth.[26] Indeed, the myth played a particularly important role throughout the Middle Ages and the Renaissance as an embodiment of homosexuality. The recurring Latin term *catamitus* is supposed to have resulted from a corruption of his name, and to medieval writers the word *ganymede* meant the same thing: a boy used for sexual pleasure. Although occurrences of the term declined in the Quattrocento, its sexual meaning was never lost; *ganymede* reappeared in the sixteenth and seventeenth centuries as a synonym for male concubine.[27]

It has been said that the humanist culture in which Michelangelo developed "made a religion of love."[28] If Neoplatonism provided the spiritual and theological underpinnings for this religion, the outward and visible sign of its creed was, at least in some cases, celebrated in the flesh. It is difficult to determine the exact degree to which the enraptured language and antiquarian play-acting of the Villa Careggi circle moved from poetic conceit to carnal actuality. There is little concrete evidence to suggest that Ficino's deep love for Giovanni Cavalcanti—whom he enthroned as the hero of his annual symposium commemorating the death of Plato on November 7—was anything other than chaste. Any physical component of the intense devotion of Pico della Mirandola and Girolamo Benivieni—who wrote passionate sonnets to each other and were buried in the same tomb in San Marco, like husband and wife—must eventually have given way to more spiritual memory, since Benivieni outlived Pico by forty years.[29]

In the life and work of Angelo Poliziano, however, we find a clear example of a Florentine Neoplatonist who overtly translated homosexual feelings into erotic expression. A central figure in the Medici circle and a close friend and mentor of Michelangelo's youth, Poliziano (1454–94) wrote frequently of Ganymede and other homoerotic classical figures, in language quite as lyrically physical as it was romantically spiritual.

Poliziano, who was ugly but brilliant, served for a time as tutor to the children of Lorenzo de' Medici. He was renowned for his mastery of Greek and Latin, especially his pioneering translations from the Greek, and taught some five hundred young men from all corners of Europe, who expressed their admiration by accompanying him daily to and from his lectures at the University of Florence. He never married and was consid-

ered homosexual by his contemporaries.[30] After Poliziano's death, Paolo Giovio published a tale alleging that the poet had died of a fever brought on by an insatiable passion for a youth. Although Giovio often libelously inflated his anecdotes, the story was accepted as accurate in essence, if not in detail. We can only speculate on the degree to which Michelangelo's own emerging homoerotic feelings might have led him to feel a personal sympathy with Poliziano, but in artistic terms the poet forcefully shaped the younger man's iconographic interests and knowledge. Condivi tells us of Poliziano: "Recognizing in Michelangelo a superior spirit, he loved him very much and, although there was no need, he continually urged him on in his studies, always explaining things to him and providing him with subjects. Among these, one day he proposed to him the Rape of Deianira and the Battle of the Centaurs, telling the whole story one part at a time."[31]

It is highly likely, then, that Michelangelo was familiar with the several occasions where Poliziano's writings speak of Ganymede in sexual terms. In his _Greek Epigrams_, a series of erotically charged epistles to various named and unnamed _fanciulli_, Poliziano frankly describes his amorous desires toward them, once specifically comparing his feelings to Jupiter's love for Ganymede:

> Look down on me from heaven while I have my youth in my arms, and do not envy me, O Jupiter, and I shall envy no one. Content yourself, O Jupiter, with Ganymede, and leave to me the splendid Chiomadoro ["golden-curls"] who is sweeter than honey. O, I am thrice and four times happy! For truly I have kissed, and truly I kiss again your mouth, O delightful youth! . . . Intertwine your tongue with mine, O youth![32]

The first mention of Ganymede in Poliziano's poetry is in Book I of his _Stanze per la giostra_ (1478), as part of an extended ekphrasis of the imaginary doors to the castle of Venus. The subject matter of the door-panels is the loves of the gods. The juxtaposition of Jupiter's attraction to Ganymede with the well-known females he has seduced and its position between descriptions of Jupiter's rape of Europa and Apollo's pursuit of Daphne implies that the youth, who hangs suspended from the eagle much as Michelangelo later pictured him, excited the same degree and kind of passion:

> Now the form of a swan, then of a shower of gold,
> Now of snake, then of shepherd does Jove wear
> To aid his projects amorous and bold.
> Now changing into an eagle, he takes the air

> Like Cupid, and into the heavenly fold
> Carries, suspended, his Ganymede so fair,
> All nude, his golden locks with cypress bound,
> And with naught else but ivy girded round.[33]

Ganymede reappears in a broader and more complex homoerotic context in Poliziano's verse drama *Orfeo*, first produced at Mantua in 1480.[34] Near the end of the play, which recounts the love of Orpheus for Eurydice and his ill-fated attempt to lead her out of Hades, Orpheus renounces the love of women on the ground that all of them are, like Eurydice, a source of misfortune through their fickleness and lack of trust:

> If you would share in my society,
> Do not discourse on female love to me.
>
> How pitiful the man who changes his mind
> For woman, or for her feels joy or dismay,
> Or who permits her his liberty to bind,
> Or trusts her words or glances that betray.
> For she wavers more than a wind-blown leaf, I find:
> She will, she won't, a thousand times a day;
> Trails him who flees, from him who trails her hides;
> And comes and goes as do, on shore, the tides.
>
> Great Jupiter bears witness to this creed,
> Who, by the knot of sweet love held in thrall,
> Enjoys in heaven his fair boy Ganymede
> As Apollo on earth for Hyacinth does call.
> To this holy love did Hercules concede,
> He who felled giants till Hylas made him fall.
> I urge all husbands: seek divorce, and flee
> Each one away from female company.[35]

Apart from the misogyny that underlies Orpheus' bitter denunciation, what is most noteworthy in this passage is the list of mythological precedents Poliziano adduces as sanction for male homosexuality, which was practiced by Hercules and Apollo as well as by Zeus. Moreover, the imputation of this behavior to Orpheus—who in the play, as in several classical sources, is finally torn apart by angry maenads in revenge for having introduced homosexuality to Thrace—indicates Poliziano's willingness to acknowledge homosexuality even in the figure most respected by the humanists as a principal source of the ancient esoteric philosophy they revered and developed.[36]

31

The myth of Orpheus seems never to have seized Michelangelo's imagination as a subject for illustration. He did, however, make ample use of at least one classical hero besides Ganymede cited in Poliziano's catalogue of homosexual lovers: Hercules. The circumstances of these works suggest that, influenced by Poliziano, Michelangelo understood the ancient hero as a symbol of strong male-male affinity.[37] Although his own depictions of Hercules bespeak friendship rather than sexual passion, both Hercules and Orpheus were illustrated with a more specifically erotic reference by Michelangelo's German contemporary Albrecht Dürer, whose connections to Italy are well documented and whose works were familiar to Michelangelo.[38]

Dürer's *Gallic Hercules*, dated about 1496, and *Death of Orpheus* (fig. 1.6)

1.6 Albrecht Dürer, *Death of Orpheus*.

of about 1494 share the motif of a small boy holding a bird—a device which, from classical times, alluded to the Greek custom of a man's offering a love-gift of a cockerel to his younger beloved.[39] Although neither design makes explicit reference to Ganymede, it is in classical sculptures of Ganymede, some of which were known in the Renaissance (see below, chapter 4), that the bird-gift is often found, both suggesting the erotic nature of Jupiter's attraction and recalling in miniature the god's eagle. Dürer reinforces his meaning by twining a banderole above the scene of Orpheus being attacked by two maenads—virtually an illustration of the final scene of *Orfeo*—on which is inscribed the legend "Orfeus der erst puseran" (Orpheus, the first sodomite).[40]

Whether Dürer intended to elevate or to satirize homoerotic love is open to debate.[41] The one conclusion that can certainly be deduced from these two designs—and the one most useful in the present attempt to set in context Michelangelo's own uses of mythology—is that the elaborate philosophical glosses that humanists from Italy to Germany read into the ancient myths in no way blinded them to the overtly erotic character of their sources. In the following generation the mythographer Gyraldus compiled a comprehensive list of the numerous youths whom Hercules was recorded to have loved. Not long before, the poet Ludovico Ariosto had claimed in his *Satires* that, regarding the sin of Sodom and Gomorrah, "few humanists are free of that vice."[42] This sweeping assertion may be exaggerated, but it is significant that Ariosto singles out humanists to identify with this particular trait. His choice suggests that their concern to document homosexuality among the ancients was motivated in some measure by a desire to understand and dignify their own practices.

Christian Attitudes toward Eroticism: Guilt and Condemnation

Whatever the Neoplatonists' degree of familiarity with classical precedents for homosexuality, their philosophy always ranked Ganymede far more highly as a symbol of chaste intellectual intercourse than of its fleshly counterpart. Moreover, while in practice a degree of tolerance toward overt homosexuality may have resulted from the venerable examples popularized by humanist researches, the official attitude of both ecclesiastical and civil authority strongly condemned any such behavior. Hence Michelangelo's *Ganymede*, interpreted thus far in terms of ecstatic delight, is shadowed as well by the darker emotions of ambivalence, guilt, and fear of punishment. We may well extend a seminal literary insight of Symonds

(2:385) to the artist's visual expressions: "It is not impossible that the tragic accent discernible throughout Michelangelo's love poetry may be due to his sense of discrepancy between his own deepest emotions and the customs of Christian society."

This note of tragic ambivalence has long been observed in the other drawings Michelangelo gave to Cavalieri. Several additional layers of meaning in the *Ganymede* are revealed by relating it to *Tityos*, the *Fall of Phaethon* (in three versions), and the *Children's Bacchanal*.[43] Strictly speaking, only *Tityos* can be considered a pendant to *Ganymede*, and we have no explicit evidence that these two were intended as complementary statements, either to each other or to the other subjects. However, the drawings are linked more than coincidentally by shared visual motifs, iconographic sources, and above all by underlying themes of erotic love, license, and punishment. Moreover, similar themes and concerns inspire at least two other important drawings that Michelangelo executed during this period— *Archers Shooting at a Herm* and *The Dream*—indicating that he continued to meditate on what was an urgent issue even outside his direct communications with Tommaso. Hence the Cavalieri group (and to some extent the contemporary drawings) can be treated as related works shedding light on aspects of a common iconographic focus. Since Panofsky most commentators, although varying in emphasis or detail, have agreed that this focus lay in the conflicting feelings experienced by the presumptuous lover: "Taken together, the drawings constitute a poetic confession of Michelangelo's love for Cavalieri, and of the elation, guilt, ascent and fall which he associated with love."[44]

The drawing most directly related to the *Ganymede* is the *Tityos* (fig. 1.7). Cavalieri's letters speak of them together, and he probably received them at the same time.[45] The *Tityos* is nearly identical in height to the Windsor *Ganymede* (19.0, 19.2 cm), and Michelangelo may have shortened his original vertical conception of *Ganymede* to accord with the horizontal format of *Tityos*. The giant Tityos is shown being punished for attempting to seduce Latona, mother of Apollo and Diana, by being chained to the rock of Tartarus, his liver eternally devoured by a vulture. His fate is a moral mirror image of the tale of Ganymede: active and evil aggressor contrasted with innocent, passive victim. The suffering of Tityos had been interpreted since Lucretius as an allegory of "the agonies of sensual passion enslaving the soul and debasing it,"[46] the antithesis of the yearning toward God associated with Ganymede. As Ganymede's dog represents the rejection of worldly desires, Tityos' suffering embodies the punishment for yielding to them.

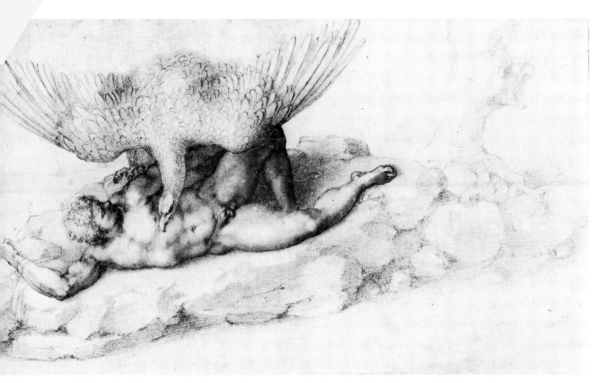

1.7 Michelangelo, *Tityos.*

Michelangelo emphasizes the two stories' thematic connection by alter-
ing Tityos' vulture, also a messenger of Jupiter, into an eagle indistinguish-
able from the one who abducts Ganymede.[47] The pose of Michelangelo's
supine Tityos, who is virtually a twin of the Ganymede figure in body type
and has the same curly light hair, differs significantly from that of the rapt
shepherd; Tityos is horizontal and earthbound, where Ganymede is trans-
ported vertically into the heavens. The two drawings, then, "constitute a
pair symbolizing the dual nature of love."[48]

The autobiographical element is clear, but the duality these drawings
represent can be interpreted in two ways. To Tolnay, the pair exemplifies
the ecstasy and the suffering inherent in any individual experience of love:
"The two drawings show the two aspects of Michelangelo's love for Cava-
lieri: *Tityos* the tortures of love, and *Ganymede* the mystic union and rap-
ture." Panofsky, while concurring that the allegorical content of both works
"was invested with the deeper meaning of a personal confession," sees the
duality rather as a moralizing division between *amor sacro e profano*, and
implies that Michelangelo identified his own passion exclusively with Gany-
mede as the positive pole of Neoplatonic *amor sacro*.[49]

These two interpretations are not mutually exclusive, and evidence can be cited to support both. Michelangelo's poetry contrasts love of women and love of men in terms that could be taken as an exaltation of Ganymede (beloved of the male Jupiter) and condemnation of Tityos (seducer of the female Latona):

> The love for what I speak of reaches higher;
> Woman's too much unlike, no heart by rights
> Ought to grow hot for her, if wise and male.
> One draws to heaven and to earth the other,
> One in the soul, one living in the sense
> Drawing its bow on what is base and vile.
>
> (G. 260; Gilbert 258)

On the other hand, such lines as "love seizes me, and beauty keeps me bound" suggest that Michelangelo also saw Tityos, the slave of passion, as symbolizing his own feelings of subjection to Tommaso. His well-known poetic reference to Tommaso could almost be a caption for his illustration of Tityos:

> If capture and defeat must be my joy,
> It is no wonder that, alone and naked,
> I remain prisoner of a knight-at-arms.
>
> (G. 98; Gilbert 96)

We can conclude from these examples that Michelangelo saw Tityos' suffering as an integral part of the experience of love; at the same time, he was acutely aware that love could be either uplifting or debasing and took pains to assert that his love was spiritual.[50]

The *Fall of Phaethon* (fig. 1.8)[51] speaks further of Michelangelo's fear of passion. In each of the three versions of this theme, Michelangelo conflates several episodes from Ovid's account of the story. Ill-fated Phaethon, who asked his father, Apollo, for permission to drive the chariot of the sun, is depicted in midair tumbling down along with the contorted horses he could not control. Above sits Jupiter, who resolves the chaos in the heavens by destroying Phaethon with a thunderbolt. On the ground below are Phaethon's sisters, transformed into poplars because they grieved for the presumptuous youth; his cousin Cycnus, transformed for the same reason into a swan; and a personification of the river Eridanus, which carried away the amber tears of the metamorphosed nymphs.[52] Secondary formal and iconographic elements link these three compositions to the other drawings in the series. The pose of Jupiter in the British Museum version

1.8 Michelangelo, *Fall of Phaethon*.

is almost the same as the figure of Tityos, but rotated to a vertical position (a pose Michelangelo adapted three years later for the Christ of the Sistine Chapel *Last Judgment*). In the most finished version, at Windsor (fig. 1.8), Eridanus is attended by a water-carrying putto who recalls Ganymede in both his function as cupbearer and his apotheosis into the constellation Aquarius, the water-carrier.

Phaethon's sin was the classical failing of *hubris*—immodest mortal aspiration to the divine. Once again, the reference is autobiographical: as Tolnay writes, "It is evident that Michelangelo intended to symbolize in these drawings the fate of the 'presumptuous' lover, annihilated by the fire of love as Phaethon by the thunderbolt of Jupiter." Michelangelo twice described himself in letters to Cavalieri as *prosuntuoso*, almost ashamed to approach a youth whose beauty and virtue so outstripped his own.[53]

Despite the clear implications in both *Tityos* and *Ganymede* that Michelangelo was haunted by the perils of overt sexuality and by the fear of failure if he acted on desires he felt to be presumptuous, many interpreters of these drawings have maintained that what Michelangelo is rejecting so violently is more an intellectual construct than an emotion he had experienced. According to Panofsky, for whom Michelangelo was "the only genuine Platonic among artists influenced by Neoplatonism," Tityos stood for those base aspects of *amor profano* that could have no place in Michelangelo's feelings for Cavalieri, and the presumption of Phaethon represented nothing more than the insecurities common to all infatuations.[54]

Yet the drawings from this period are replete with images of sexual desire, debauchery, internal conflict, and epic punishment, suggesting that Michelangelo's reaction to Cavalieri encompassed physical as well as spiritual desire. We must, therefore, add a further dimension to our analysis of each emotion portrayed in these drawings: the nature of those feelings as experienced by a homosexual lover, especially in light of contemporaneous social attitudes toward homosexuality. Michelangelo knew that to act on his erotic attraction to the youth was officially proscribed. The drawings' recurrent note of conflict between ideal and actual behavior seems to correspond to his acute sense of discrepancy between his "own deepest emotions and the customs of Christian society" first observed by Symonds. Hence, as Eissler wrote of the torture shown in *Tityos*, "This inexorable fate expressed in the work of art is a reflection of the feeling of doom caused by an indomitable drive that is rejected by conscience."[55]

Three iconographic aspects of *Ganymede* and the related drawings reflect the artist's internal conflict and uncover the sources and meaning of Michelangelo's rejection of sexuality. First, it can be shown that Michelan-

gelo's feelings for Cavalieri were partly sexual. Second, examination of contemporary homosexual behavior in its legal, social, and theological contexts demonstrates that the artist was painfully aware that this passion was at odds with the moral dictates of his own religion and society. Finally, some evidence suggests that Michelangelo and those close to him felt a need to conceal or deny the full nature of those feelings in the face of public suspicion and disapproval. The following investigation of Michelangelo's iconography moves back and forth between external influences, such as legal and religious decrees, and intrapsychic responses to those pressures. The two are not easily separable and indeed can reinforce each other. To the degree that Michelangelo's _Ganymede_ expresses an avowal of physical attraction, our understanding of his inner conflict about that attraction will be strengthened by evidence that his surrounding culture encouraged him to condemn such feelings.

Erotic Imagery

The Ganymede drawing reveals Michelangelo's sexual reading of the myth by depicting the boy as if the eagle were physically penetrating him. In contrast to earlier, less erotic visualizations of Ganymede's abduction, Michelangelo introduces a front-to-back positioning of the boy and eagle and greatly increases the proximity, overlapping, and intertwining of their bodies. In addition, he shows the youth entirely nude, in a full frontal pose that for the first time exposes Ganymede's genitals.[56]

Unlike this tightly unified central motif, most Quattrocento illustrations might best be described as "boy dangling below bird." This formal type clearly derives from the _De deorum imaginibus libellus_, a treatise by the thirteenth-century author Albricus, whose prescriptions for representation of the classical gods continued to influence artists well into the sixteenth century. In these works, the boy, often clothed, hangs loosely, usually separated by a clear space from the eagle, who grasps him gingerly, in Albricus' phrase, "in his talons" (inter pedes suos).[57] The distance between the two figures implied by Albricus effectively limits the sense of physical contact between them, and the general awkwardness of the figures—partly due to the fact that most examples from this period are minor decorative panels or manuscript illuminations rather than monumental paintings—further reduces these abductions to schematic, toy-like illustrations.

The earliest example of this type in Quattrocento art is the tiny relief in the elaborate border panels framing the bronze doors of St. Peter's in

1.9 Filarete, *Rape of Ganymede*.
Rome, St. Peter's.

1.10 Circle of Apollonio di Giovanni, *Rape of Ganymede*.

Rome, sculptured by Filarete (Antonio Averlino) about 1439–45 (fig. 1.9). Filarete represents Ganymede's abduction among a profusion of profile heads, acanthus scrolls, and dozens of narrative scenes drawn from Ovid, Aesop, and other classical sources. While the boy is shown hanging vertically below the grasping eagle, his embrace of the eagle's neck does show some awareness of the erotic quality of the event.[58] Although much later historians expressed shock at the use of pagan scenes in such a sacred setting, "it is likely that to Filarete and his contemporaries these scenes conveyed moral allegories" consonant with the tradition of the fourteenth-century *Ovide moralisé*.[59] Two Florentine *cassone* panels from the third quarter of the Quattrocento also exemplify this rather schematic, inexpressive typology. In one of these, an end-panel from a cassone tentatively associated with the circle of Apollonio di Giovanni, the youth is fully clothed and his two Virgilian companions are thin figures who gesticulate at Ganymede's sudden ascent (fig. 1.10).[60]

Compared to these precedents, the novel pose of Michelangelo's eagle, who enfolds Ganymede tightly from the rear, greatly intensifies the sense of a passionately sexual embrace; as Panofsky noted (216, n. 145), no previous representation of this theme had shown the youth so firmly in the eagle's grip. Some psychologically oriented commentators go so far as to interpret Ganymede's ambiguously drawn genitalia as female labia from which protrudes the eagle's penis piercing him from the rear. It seems highly improbable that the predominantly homosexual Michelangelo would have wished to endow himself or his male beloved with female attributes; the positions of boy and eagle do, however, admit the possibility of "Ganymede's ecstatically passive yielding to anal eroticism."[61]

The literary tradition to which the essentially late medieval works preceding Michelangelo's drawing belong is typified by two fourteenth-century texts, the *Ovidius moralizatus* and *Ovide moralisé*. Both of these attempts to "moralize" the *Metamorphoses* are part of a medieval exegetical process which overlaid Ganymede and the entire repertory of classical legends with Christianized interpretations that preserved the legends' antique form but filled it with contrasting content.[62] Where Neoplatonism idealized and spiritualized the love between god and youth, this tradition either assimilated the myth into an allegorical system where sexuality had no place or acknowledged the sexual implications of the tale in order to condemn them explicitly. Such references are a likely source for Michelangelo's understanding of Ganymede as a symbol both of overt homoeroticism and of his religion's strong avoidance and disapproval of homosexual practices.

Michelangelo probably knew at first hand the illustrations on themes from the *Ovide moralisé* cast for the doors of St. Peter's by his Florentine compatriot Filarete. The familiarity of his circle with the *Ovidius moralizatus* tradition is attested by a letter to Michelangelo from his protégé the Venetian painter Sebastiano del Piombo (*Carteggio*, 4:CMX). On July 17, 1533, Sebastiano wrote to the artist, who was then at work on the Medici Chapel in Florence: "Regarding the painting that is to be done in the vault of the lantern. . . . It seems to me that the Ganymede would go well there, and you could give him a halo so that he would look like St. John of the Apocalypse when he was carried up to heaven." Sebastiano's conflation of Michelangelo's recently completed *Ganymede* and St. John the Evangelist echoes an equation made by the author of the *Ovidius moralizatus*, usually identified as the monk Berchorius. After recounting the classical version of the story, Berchorius, assuming that the legend's true import is theological, adds that "Jupiter can stand for God, Prince and Lord of the heavens."[63] Extending this interpretation, he appends among other Biblical glosses (most pertaining to Jupiter's eagle) Matthew 19:14, "Suffer little children to come unto me." As Jupiter symbolizes the Christian godhead, so the eagle who transports Ganymede into heavenly realms prefigures the attribute of John, the pure young disciple especially beloved of Jesus, who received a similar *furor divinus* from the eagle who inspired his apocalyptic visions and writings.[64]

The French *Ovide moralisé*, a long narrative poem also from the early fourteenth century, makes explicit what the Latin *Ovidius* merely overlooks: that the spiritual symbolism applied to Ganymede supplanted an overtly erotic Ovidian reading unacceptable to Christian mores. The *Ovide moralisé* testifies to the continuing awareness of the myth's homoerotic content, even though it now had a negative moral connotation:

> Jupiter saw him, young and fair,
> And abducted him from Tros, his father;
> Carried him off to his realm
> And enjoyed himself with him
> Many times, voluptuously,
> Against law and against nature.[65]

The phrase "against nature" echoes Thomas Aquinas, whose *Summa theologica* of the previous century had attacked homosexuality as *contra naturam*.[66] The *Ovide moralisé* reverses the Neoplatonic view that love is spiritually elevating, emphasizing instead its power to drag down even heavenly beings to the level of earthly lust. In concluding his recitation

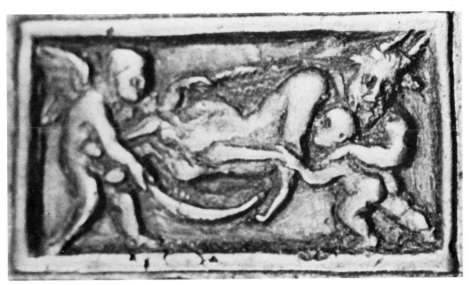

1.11 Filarete, *Satyrs at Play.*

(lines 3408–3423), the author exhorts both gods and mortals to pursue spiritual delights instead.

The moral direction of these passages is clear, but equally important is their manifest association of Ganymede with homosexual eros. Filarete may not have emphasized the erotic interplay of boy and bird, but other motifs on the doors of St. Peter's testify to his awareness of the kind of homoerotic activity alluded to in the *Ovide moralisé*, notably the tiny mock-reliefs of male satyrs at play, one of whom tugs at an older satyr's penis (fig. 1.11).[67] Such images and literary allusions were readily available to Michelangelo, and he could hardly have been ignorant of the actively sexual connotations of the Ovidian subject he chose to represent his passion for Cavalieri.

This reading of explicitly sexual concerns into Michelangelo's drawing is reinforced by more direct allusions in three closely related drawings: the *Bacchanal of Children*, also given to Cavalieri, *The Dream*, and *Archers Shooting at a Herm*. In these we not only encounter the artist's fantasies about sexual desire but also glimpse more obvious expression of his concomitant feelings of disapproval and guilt.

Among the Cavalieri drawings the *Bacchanal* (fig. 1.12) is the clearest depiction of uncontrolled eros.[68] Dancing around a fiery cauldron, the exuberant children, one of whom grips the penis of a horse, descend from a long tradition in which the nude putto, a miniature Cupid (Eros), stood for unconscious passion. The passion of such a virtually all-male debauch

1.12. Michelangelo, *Bacchanal of Children.*

1.13 Florentine marble relief, *Pan Pursuing Olympus.*

is, of course, implicitly homoerotic. The *Bacchanal* is a raucous variation on Michelangelo's earlier *Drunkenness of Noah* in the Sistine Chapel: in place of the virtuous sons who there cover their drunken father's nakedness, here the mischievous putti at lower right are draping the nakedness of a similarly posed man who, perhaps, has fallen into a drunken stupor. The seated female satyr at lower left recalls the many instances in which goat-footed creatures, who symbolized general lasciviousness and debauchery, were specifically viewed as homosexual. The satyrs who cavort on Filarete's doors are followed in the sixteenth century by such works as the Florentine marble relief of the goat-footed *Pan Pursuing Olympus* (fig. 1.13).[69] Michelangelo's *Bacchanal* is usually interpreted as a condemnation of carnality, a negative comparison meant to emphasize the higher value of spiritual love. The scene is admittedly boisterous, and the putto who urinates into a wine vat makes it both scatological and implicitly sacrilegious. At the same time, however, by going out of his way to portray what he rejects, Michelangelo indirectly testified to the strength of its fascination for him. As Stokes expresses it (*Michelangelo*, 141), "His judgment did not preclude his gusto."[70]

The same combination of fascination with and rejection of male sexuality is already evident in *Archers Shooting at a Herm*, where Michelangelo drew a group of nude men shooting arrows (phallic in their own right, but further associated with the weapons of Cupid) at a herm, a familiar Greek priapic monument. This drawing probably dates from before April 1530, indicating that sexuality was an issue in Michelangelo's work and thought in the years just before his infatuation with Tommaso gave the problem renewed urgency.[71]

The *Bacchanal* and the *Archers* display a fascination with sexuality, but *The Dream* (fig. 1.14) makes explicit Michelangelo's awareness of conflict between sexual temptations and the dictates of divine will. *The Dream*, although not recorded as given to Cavalieri, is generally dated on stylistic grounds to the period 1530–35 and is thus within the period under discussion. In it a nude young man, leaning on a globe, sits on a box full of masks (the central, bearded one resembles Michelangelo's self-portrait as St. Bartholomew in the *Last Judgment*). He glances upward, his attention drawn by the trumpet-call of a descending winged figure, while around him, as if in a mist, swirl apparitions of the seven deadly sins. The central figure seems torn between an angelic call to higher concerns and the specters of earthly temptation. Among these desires eroticism is particularly prominent. Along with Sloth, Avarice, and Gluttony, the surrounding groups include three grappling couples at the upper left, alluding to Lust; in addi-

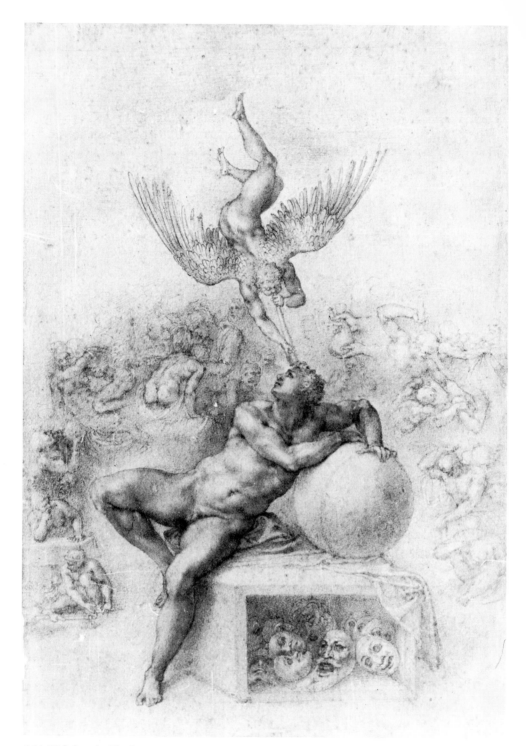

1.14 Michelangelo, *The Dream*.

tion, the vague, bulbous shape between two of the couples, although nearly erased in the original, seems to represent a hand masturbating an erect penis.[72]

Legal and Social Attitudes toward Homosexuality

In the Cavalieri series and other contemporaneous drawings, Michelangelo reveals himself to be deeply concerned with the struggle between earthly and celestial longings, not least with the powerful allure of physical love. Although guilt, ambivalence, and fear of punishment may afflict all lovers, whether homosexual or (like Tityos) heterosexual, Michelangelo's homoerotic feelings were subject to distinctive and harsh forms of condemnation and control. The artist's guilt about sexuality and the implications of the conflict expressed in the drawings can be elucidated by consulting both clerical and secular proscriptions of homosexuality.

Since the time of Dante—who consigned his prominent Florentine predecessor Brunetto Latini to the same circle of the Inferno as the sodomites—Florence had been proverbial for sodomy. The practice was continually attacked by the clergy; Tuscan moralists from St. Bernardino to Savonarola inveighed against its prevalence. Increasingly strong punitive measures to control homosexual sex were enacted by civil authorities in the course of the fifteenth century; most notable was the institution of the _Ufficiali de' notti_, a special tribunal empowered to receive and investigate anonymous accusations of sodomy and other crimes. The ultimate penalty for chronic offenders was death; in practice, these judges were usually more lenient.[73]

Perhaps most directly significant for Michelangelo was the attack on sodomy launched by the fiery monk Girolamo Savonarola, whose influence in Florence lasted from the final days of Lorenzo de' Medici until Savonarola's own death at the stake in 1498. In a sermon on November 1, 1494, Savonarola railed at the priests of Florence: "Abandon your pomp and your banquets and your sumptuous meals. Abandon, I tell you, your concubines and your beardless youths. Abandon, I say, that unspeakable vice, abandon that abominable vice that has brought God's wrath upon you, or else: woe, woe to you!" Neoplatonism's unstable amalgam of antique sensuality and Christian spirituality seems to have been particularly vulnerable to Savonarola's moralizing appeal. Several artists associated with the Medici circle, including Lorenzo di Credi and Fra Bartolommeo, consigned their paintings of nudes and other subjects deemed lascivious to the flames of

the friar's Bonfires of Vanities, held in 1497 and 1498. Both Pico della Mirandola and Girolamo Benivieni, so closely bound in Platonic love that they were buried together like husband and wife, became devout followers of Savonarola; after Pico's death, Benivieni wrote the children's hymns sung at the *brucciamenti*.[74]

Both Vasari and Condivi attest to Michelangelo's passionate admiration for Savonarola and the Christian doctrines he preached: "He has likewise read the Holy Scriptures with great application and study, both the Old Testament and the New, as well as the writings of those who have studied them, such as Savonarola, for whom he has always had great affection and whose voice still lives in his memory."[75] These writers, heavily influenced by Michelangelo, may have been unwitting agents of the aging artist's desire to create a retroactive image of personal piety. But however much the twenty-year-old who heard Savonarola preach was influenced at the time, the attitudes he expressed in his later years suggest that he eventually came to internalize much of the monk's moralizing fervor.

To recapitulate briefly, Michelangelo's drawings imply that his attachment to Cavalieri was partly sexual, and Michelangelo was aware that this aspect of his feelings was at odds with theological and civil morality. He may never have consummated his desire (there is no evidence that he did, and good reason to believe that his own internal resistance would have prevented him; see below). But he probably knew that the particular image chosen to symbolize his love was in part understood by the public to represent sexual attraction, and that such an interpretation of his *Ganymede* could arouse public censure. It appears that he therefore took care, as did both Cavalieri and Sebastiano del Piombo, to avoid having the public see the image or grasp its meaning too clearly.

Pietro Aretino's letter to Michelangelo of November 1545, complaining of the artist's failure to send a drawing of the *Last Judgment* that Aretino had requested, demonstrates the social risks then inherent in any overt expression of affection between males. Although the veiled accusations of this notoriously unscrupulous and bawdy-minded writer can seldom be taken at face value, his snide implications presuppose for their effect a concern for public opinion and the likelihood of that public interpreting one's actions sexually. After expressing his shock at the nudity and licentiousness of the Sistine fresco, Aretino writes: "If you had sent me what you had promised, you would have done only what it was in your best interest to do, since by so doing, you would have silenced all those spiteful tongues, who say that only certain Gherardos and Tommasos can obtain them."[76] Gherardo Perini was an earlier object of Michelangelo's affection;[77]

Tommaso is Tommaso de' Cavalieri. Aretino was apparently not the first to draw such suspicious conclusions, because Michelangelo had earlier insisted in a poem addressed to Cavalieri, as if in response to similar implications, that only chaste and noble motives lay behind his love:

> The evil, foolish and invidious mob
> May point, and charge to others its own taste,
> And yet no less my faith, my honest wish,
> My love and my keen longing leave me glad.
> (G. 83; Gilbert 81)

Twenty years later, Michelangelo again insisted, this time through Condivi, that his love for "la bellezza umana" was essentially esthetic and utterly nonsexual. Here too he alludes to certain accusations made against him, perhaps this time by Aretino:

> He has also loved the beauty of the human body as one who knows it extremely well, and loved it in such a way as to inspire certain carnal men, who are incapable of understanding the love of beauty except as lascivious and indecent, to think and speak ill of him. It is as though Alcibiades, a very beautiful young man, had not been most chastely loved by Socrates, of whom he was wont to say that, when he lay down with him, he arose from his side as from the side of his father.[78]

Michelangelo may have felt further compelled to defend himself repeatedly and at length in part because of a general perception that homosexuality was particularly prevalent among artists. The workshop practices of the time could easily have encouraged such suspicions: older masters kept a number of live-in apprentices, some as young as twelve. Other artists were known or believed to have sexual interest in their students: Vasari ridicules Sodoma's attraction to his foppish *garzoni*, and Leonardo was commonly thought to choose his assistants more for their looks than for their talent.[79] In a letter probably dating from 1518, Michelangelo recounts an incident in which this assumption was made of him. A man had come to him asking that the artist take on his son as an apprentice, adding as an enticement, "if I [Michelangelo] wished, I could have him not only in my house, but also in my bed." Michelangelo's sarcastic reply indicates, with typical Florentine ribaldry, that not only artists might be open to such temptations: "I renounce this consolation, not wanting to deprive him [the father] of it."[80]

In the light of such public assumptions about artists' motives toward students and friends, it is not surprising that Vasari noted a tendency on

Michelangelo's part toward prudent indirection.[81] Michelangelo's first letter to Cavalieri, accompanying the gift of *Tityos* and *Ganymede*, is a particularly suggestive example of this tendency. It strongly implies that the artist was conscious of something in the drawings that was best left unstated. The two rejected drafts of the letter both contain this postscript: "It would be permissible to name to the one receiving them the things that a man gives, but out of nicety it will not be done here." Whether he meant merely the titles of the drawings or some broader acknowledgment of the emotions they symbolized, in his final version of the letter Michelangelo omits not only the names of the things presented, but even his enigmatic apology for that omission. This bowing to social discretion is unexpected in view of the generally accurate assertion by Wittkower and Wittkower (151) that "Michelangelo never showed any reticence in making his feelings and passions known not only to the recipients of his letters and poems but also to many of his other acquaintances."[82]

Both Cavalieri and Sebastiano del Piombo, who knew Cavalieri in Rome and acted as intermediary between him and Michelangelo during the time of this exchange,[83] also made provocative comments about the *Ganymede*. Their remarks are open to varying interpretations. Taken together with Michelangelo's recorded ambivalence, they can be read as indications that three persons familiar with the drawings and their personal meaning were careful not to expose the artist's fascination for his "Ganymede" to public scrutiny.

Cavalieri, in his letter to Michelangelo of September 6, 1533 (*Carteggio*, 4:CMXXXII), thanks the artist for the newly arrived *Phaethon* and reports that both Clement VII and Cardinal Ippolito de' Medici came to see Michelangelo's gifts: "Cardinal de' Medici wanted to see all your drawings, and he liked them so much that he wanted to have the Tityos and the Ganymede made in crystal; I couldn't do enough to keep him from having the Tityos made, and now master Giovanni [Bernardi] is doing it. I tried hard to save the Ganymede." Cavalieri's failure meant that both drawings were widely copied and became familiar within a short time. But his singling out of the *Ganymede* for protection raises the question of motivation. Perhaps it was merely modesty that led Cavalieri to try to keep private its deeply personal message; but the other drawings in the series were no less confessional in intent. What distinguishes the *Ganymede* from *Tityos* and *Phaethon* is its positive eroticism, which, however purified by Neoplatonic reference, was still susceptible to "misunderstanding" by a public equally familiar with the myth's more earthy overtones.

The same note of duplicity or concealment may also underlie Sebasti-

ano's letter to Michelangelo suggesting that the figure of Ganymede be used as a prototype for the St. John in the Medici Chapel. Sebastiano knew the traditional parallel between the two young male figures, and his suggestion was both theologically and formally appropriate. At the same time, his language seems to hint at a deliberate camouflage of the original reference rather than straightforward adaptation: he advises Michelangelo to give Ganymede a halo so that the youth "might look like" (*paresse*) the saint.[84]

Intrapsychic Meanings of Ganymede for Michelangelo

Our examination of Michelangelo's iconography, whether drawn from Neoplatonic or Christian sources, from pagan poetry or contemporary legislation, has thus far focused on external influences on his ideas and symbols. A deeper level of interpretation, the striking suitability of the Ganymede myth to embody certain dynamics of the artist's individual psychology, remains to be considered. Freud, Eissler, Hibbard, Liebert, and others have explored the psychic content of Michelangelo's art at length. Of the fundamental aspects of his psychology that they have identified, the *Ganymede* and its companions resonate most directly with two dynamics: the relation of father and son, and the guilt and fear associated with overt sexuality.

Two examples indicate Michelangelo's lifelong pattern of identification with strong paternal figures, both positive and negative: his deep love and admiration for Lorenzo de' Medici and his vivid memory of Savonarola, who was "doubtless an inner figure that reinforced the severer aspects of the father image" (Stokes, *Michelangelo*, 41, n. 3). Vasari clearly states how Michelangelo saw in his first patron, who was far more supportive of the boy's artistic urges than the disapproving Ludovico, a kind of surrogate father; he records Lorenzo's saying to Ludovico of the young artist that he wanted to keep him as one of his children. Michelangelo's eagerness to please his new "father" is evident from Condivi's account of one of the artist's first sculptures, copied after an antique head of a faun among the Medici sculptures. That Michelangelo should have been attracted to such a smiling, paternal subject—"in appearance very old, with a long beard and a laughing face"—is itself significant, but even more suggestive of the strength of his feelings is his reaction to Lorenzo's criticism of the work. Lorenzo praised it, but when he remarked jokingly that such an old man would not retain all of his teeth, Michelangelo impulsively knocked one of them off.[85] Liebert has elaborated on this central concern with a metaphor

directly relevant to the works we are attempting to interpret. In his psychoanalytic study of the iconography of the *Dying Slave*, Liebert (173) explains that the "autobiographical myth" that Michelangelo dictated to Condivi comprises "a life-long series of variations on the Ganymede myth." According to this interpretation, the relationship of Ganymede to the king of the gods, an archetype operative in the artist's life and works, represents Michelangelo's conflicting need for and fear of an all-powerful male patron, mentor, or love-object: in short, a father-type.

Whether it was directed toward Lorenzo, Savonarola, or—in a final reversal—the much younger Cavalieri, Michelangelo acknowledged that his yearning for mystical union with a powerful and supportive man was the distinctive and dominating passion of his life. But the strength of that desire created deep anxiety whenever Michelangelo came close to realizing it, causing him to find fault with his patrons and admirers and to complain of his bondage to his father, Ludovico, and, inter alios, Pope Julius II. As Liebert summarizes these twin attitudes, "a splitting of paternal internal representation into two actual figures occurs. One is an idealized, powerful public figure who has an uncommonly strong personal, as well as artistic, investment in him. The other is his weak and denigrated *actual* father . . . toward whom an unbreakable and ambivalent tie is rationalized as selfless filial piety." Liebert's thesis relating Michelangelo's psychological strivings to his oeuvre is that "the controlling fantasy and unconscious conflict that determined the artistic resolution, in form and content, of many of his works involved the yearning for eternal union with an idealized, powerful paternal transformation."[86]

As Liebert has noted (p. 178), the death of Michelangelo's father in 1531 affected the artist deeply, and his later passion for Cavalieri (and perhaps as well for Febo di Poggio) "developed in response to the feeling of abandonment and emptiness." This analysis of the impact of Ludovico's death stresses Michelangelo's desire to make of Cavalieri a surrogate parent, a fantasy oblivious to considerations of the two men's actual relative ages. But Michelangelo was by then forty years older than when he had seen himself as the adoring young "Ganymede" of Lorenzo de' Medici, and it seems more plausible that his father's death presented him instead with an opportunity for psychic regeneration by transformation into a new identity, still founded in the Ganymede myth but assigning him a new role more in keeping with his own maturity. Liberated once and for all from his life-long role of unloved son, Michelangelo expressed through Ganymede the new potential of becoming all that his own father never was— loving and supportive of other men and loved by them in return. This

change of role is evident in his correspondence with the beautiful young Febo di Poggio, whom he met shortly after he met Cavalieri. Febo's letter of January 14, 1535, addresses him as "Magnifico Messer Michelangelo da padre honorando" (honored as a father) and is signed "Per vostro, da figliolo" (yours as a son).[87]

The duality of Michelangelo's personal identification with the Ganymede myth—first as son, later as father—suggests a more complex reading of his Cavalieri drawings than that given them previously. Instead of a simple expression of his love for a particular individual, his *Ganymede* can also be seen as a symbolic resolution of the conflict between Michelangelo's yearning toward all male figures and the threats and deprivations he had experienced from numerous powerful men. Ganymede represented for him both unconflicted desire and compensation, both the ecstatic fulfillment of his present passion and reversal of his earlier ill-treatment by others. With his own father gone, Michelangelo the adult was now free to identify with the very role of benevolent, paternal "Jupiter" that he had, as a younger Ganymede, so often sought in others. Beginning life as the unloved son, Michelangelo later found in his love for Cavalieri an opportunity to invert that role, and hence to resolve his frustration and redeem his own misfortune by acting toward another young man as a loving father.[88]

In classical mythology, Jupiter, like Michelangelo, is an unwanted son who matures into a loving father-surrogate for Ganymede. One potentially fruitful legend is occasionally associated with the paternal lover: Jupiter's relationship with his own savagely cannibalistic father, Saturn. A note of caution is necessary in examining the possible relevance of this incident to Michelangelo; existing examples of such a pairing are sporadic, and the artist himself did not speak directly of the myth. But the following examples will demonstrate that a rudimentary iconographic matrix existed uniting Saturn, Jupiter, and Ganymede and suggest that Michelangelo could have understood Jupiter's love for Ganymede as intertwined with the same god's outcast childhood and subsequent vengeance.

Jupiter's relationship with his monstrous father was characterized by the same contempt and fears of destruction Michelangelo felt at the hands of so many paternal figures. When the dying Uranus, whom his son Saturn had castrated with a sickle, prophesied that one of Saturn's children would supplant him, Saturn attempted to eat all his own offspring. His wife, Rhea, managed to save only the infant Jupiter, by spiriting him off to be raised secretly on Crete's Mount Ida (not to be confused with the Trojan Mount Ida from which Jupiter later plucked Ganymede). When grown to manhood, Jupiter avenged himself on his father by killing him and assum-

ing kingship of the gods in his stead. In a striking, if incidental, parallel with Ganymede, Jupiter was able to approach his father by being appointed (incognito) Saturn's cupbearer.[89]

The resulting duality of Jupiter's roles was touched upon by several writers and artists. In the fourteenth century, Petrarch (whom Michelangelo read and admired) included both Ganymede and Saturn in his description of Jupiter in his poem _Africa_, explicitly contrasting their ages as _juvenem_ and _seneca_.[90] The inverse relation connecting Jovian pederasty and Saturnine "pederophagy" (child-eating) or castration was clearly perceived by fifteenth- and sixteenth-century artists, though they were as apt to conflate Uranus, Saturn, and Jupiter as to distinguish them. The Ferrarese poet Antonio Cornazzano (ca. 1431–ca. 1500) alluded in one of his _Proverbii_ (ca. 1470) to "Saturno sodomita," although this epithet properly belongs to Saturn's son, Jupiter:

> Saturn the sodomite sets off on foot
> For a period of thirty years, coming a long way
> To drink from the hand of Ganymede.[91]

Similarly, a stucco relief on the Casino Pio in the Vatican (ca. 1560) shows Venus, who was born of the sea foam impregnated by semen falling from the castrated Uranus, rising from the sea, flanked by two cloudborne male figures. At left, Uranus flees the scene, his wind-blown drapery concealing what he has lost; but he carries the scythe of Father Time, more usually an attribute of his son Cronos/Chronos (Saturn). To the right, the reclining figure holding an outstretched sickle in his hand should be the castrater Saturn, but his accompanying eagle marks him as Jupiter.[92] In this conflated version, Jupiter takes on Saturn's attribute as a symbol for his murder of his father. In denouncing the antique gods, patristic writers had long before connected what to them were Jupiter's related sins. Justin the Martyr declared: "Far be it from every sound mind to entertain such a concept of the deities as that Zeus . . . should have been a parricide and the son of a parricide, and that moved by desire of evil and shameful pleasures he descended on Ganymede and the many women he seduced."[93]

The combination of Jupiter's twin roles—unloved son and loving "father"—is illustrated in a composition by Polidoro da Caravaggio (d. 1543), one of a series of mythological tondos known through engravings by Cherubino Alberti. The print identified by Bartsch as _Jupiter Embracing Ganymede_ (fig. 1.15) joins other loves of the gods, among them _Apollo and Daphne_ and _Jupiter Embracing Cupid_, a subject remarkably similar to Ganymede (see fig. 3.28). Polidoro depicts Jupiter not as an eagle but in

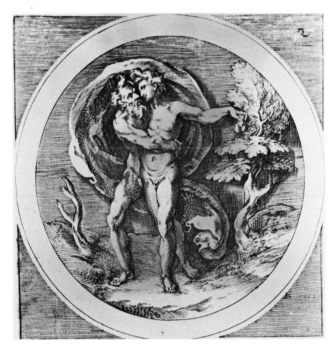

1.15 Cherubino Alberti, engraving after Polidoro da Caravaggio, *Jupiter Embracing Ganymede*.

1.16 Cherubino Alberti, engraving after Polidoro da Caravaggio, *Bacchanal*.

human form, embracing the standing Ganymede, who holds in his out-stretched hand a set of severed male genitalia, presumably those of Ur-anus.[94] Polidoro's rare presentation of Jupiter in human form intensifies the myth's inherent homoeroticism, an aspect of his classical sources that other pictures in the series, for example, the *Bacchanal* (fig. 1.16), show Polidoro clearly understood.[95] As there is no literary source in which Gany-mede holds Uranus's genitals, we may speculate that this allusion asso-ciates Jupiter's manifest love for the youth with its opposite, the paternal hatred that both Saturn and Jupiter earlier experienced, and their resultant acts of revenge.

The same events were also paired—much later and in a context without clear iconographic intent—by the Flemish artist Peter Paul Rubens, in the pendants *The Rape of Ganymede* (fig. 5.14) and *Saturn Devouring His Chil-dren*. These form two of the smaller vertical panels in the mythological suite he painted in the 1630s for the Torre de la Parada in Spain. Jupiter's eagle nips at Ganymede's strap in an echo of the bite Saturn takes from the chest of his helpless child. Although his program was not developed as a consistent allegory, Rubens, like Ovid, was primarily concerned with the variety and force of love.[96]

The myth of Saturn links eros and patricide in yet another symbolic coincidence. Just as the exquisite Venus, goddess of love, is born from Ura-nus' seed, so from the blood of his wound are born the three hideous Fu-ries, female avengers of patricide (Hesiod, *Theogony*, 133–86, 616–23). The finer points of such elaborate and detailed correspondences might not have occurred to any but professional mythographers, but though the underly-ing notion of a combined reversal and resolution in Jupiter's action toward Ganymede is made explicit only occasionally, it nevertheless represents a kind of metaphoric thinking quite familiar in Christian theology.[97] Michel-angelo could thus have understood Jupiter's loving embrace of Ganymede as a reversal of the god's earlier threat from his father, allowing us to see in his drawing of the subject a symbolic presentation of his fatherly love for Cavalieri as a fitting compensation for the artist's own earlier neglect.

Just as Michelangelo saw in Jupiter's love for Ganymede a type of ideal-ized resolution of his frustrated yearning for fatherly love, so his choice of Phaethon (fig. 1.8) provided him with an inverse archetype expressing his concomitant fear of destruction for acting too boldly on forbidden desires. If the contrast of the positions of Ganymede and Tityos—one vertical, the other horizontal—represents, respectively, spiritual and carnal forces within the individual, the contrast between the movements of Ganymede and Phaethon—both vertical, but one ascending and the other falling—

symbolizes success and failure. Ganymede is transported, but Phaethon is demoted, debased, cast down, and figuratively, if not literally, castrated. For both, the prime mover is Jupiter, the all-powerful father in whose hands lie both love and damnation. The powers of the pagan god closely parallel those of the Christian God of the Last Judgment, who simultaneously metes out salvation (rising souls) and damnation (falling souls).

In Neoplatonic interpretations such as Panofsky's, the sin for which Phaethon merits such catastrophic retribution is hubris—presumption to divine status, interpreted in Michelangelo's case as the fear associated with the presumption of approaching a loved one whose perfection and beauty seem divine. As with the other drawings discussed above, however, this abstract allegorical aspect of the myth coexists with aspects of deeper significance to Michelangelo's personal psychic dynamic. The specific content of Phaethon's presumptuousness resonates with two aspects of the artist's "Ganymede myth": his lifelong quest for a loving fatherly figure, and his associated fear that gratification of that desire in sexual union will bring about psychic destruction.

The correspondences between Phaethon and Michelangelo are particularly clear in the light of Ovid's text, which Michelangelo followed closely in preparing his composition. Although Ovid's account treats mainly Phaethon's dealings with Apollo, it was the relationship of Phaethon to Jupiter that concerned Michelangelo. In minor details (e.g., the river god and attendants) Michelangelo demonstrates familiarity with antique representations of Phaethon's fall, but he departs significantly from tradition by adding the father of the gods, linked to his role in both the *Ganymede* and *Tityos* by the presence of the eagle.[98] Attention is thus deflected from Phaethon's actual father, Apollo—who, with misgivings, allows the youth his desire—to the surrogate father-authority, who punishes him for indulging that wish: Ovid's Apollo bitterly describes Jupiter's thunder as "the bolts that are destined to rob fathers of their boys."[99]

The figure of Jupiter in the London and Venice versions, closely allied to the pose that ultimately became the avenging Christ of the Sistine *Last Judgment*,[100] confirms the central theme of Michelangelo's interpretation: divine judgment and punishment by paternal authority for illicit desires. As the motivation for the request that leads to his downfall, Ovid attributes to Phaethon the desire for recognition of his true nature—that is, acceptance by his father and visible proof of his father's love—precisely Michelangelo's own chronic need.

Phaethon begs his mother, Clymene, for proof of his divine birth. Her reply, indicating the rapturous, supernatural quality of the love Phaethon

seeks, recalls the many instances in Michelangelo's poetry where Cavalieri or another man is described as light or the sun (Phoebus Apollo): "Clymene . . . stretched out both arms to heaven, and, turning her eyes on the bright sun, exclaimed: 'By the splendour of that radiant orb which both hears and sees me now, I swear to you, my boy, that you are sprung from the Sun, that being whom you behold, that being who sways the world.'" But this maternal affirmation does not suffice. For Phaethon, as for Michelangelo, the existence of the ideal loving father remained problematic and uncertain; he set off across the world in search of proof, until finally (like Jupiter in the house of Saturn) when he "had come beneath the roof of his sire whose fatherhood had been questioned, straightway he turned him to his father's face, but halted some little space away; for he could not bear the radiance at a nearer view . . . filled with terror at the strange new sights." The meeting with Apollo results in the fulfillment of Phaethon's desire: he embraces his father pleadingly and receives the ultimate prize, the reins of the sun-chariot—though Apollo warns that no mortal can manage his divine steeds, and adds: "Dost thou in sooth seek sure pledges that thou art son of mine? Behold, I give sure pledges by my very fear; I show myself thy father by my fatherly anxiety. See! Look upon my face. And oh, that thou couldst look into my heart as well, and understand a father's cares therein."[101] Apollo begs to no avail, and Phaethon's fall, the central episode of Michelangelo's drawing, results in his annihilation.

Michelangelo may have understood this cautionary tale in sexual terms. The pose of Phaethon in the Windsor version is similar to the pose of the youth in *The Dream*, suggesting some degree of identification between Phaethon's aspirations and the sensuality that besets and torments the dreamer. Iconographically, the myth of Apollo and Phaethon has various erotic overtones. Both Ovid and Poliziano describe how Apollo frequently loved male youths, and Ovid tells us that Phaethon himself loved his cousin Cycnus, to whom he was joined even more closely by affection than by blood; the relationship seems implicitly that of lovers, on the Greek model.[102] The relevance of Phaethon's tale to Michelangelo's homoerotic psychodrama would thus have been clear to the artist.

We have already examined the social pressures that caused Michelangelo's guilt and fear of overt sexual expression. Such external factors do not, however, fully account for the intensity of his anxiety about sexuality, for he seems to have feared not only detection and punishment, but also the internal dangers of any overt realization of sexual impulse.[103] Although his private behavior may well have included activities not known to outsiders, by all accounts he never consummated any of his passionate friendships.[104]

Giannotti, after telling us that Michelangelo called himself "the most in-
clined to love persons," goes on to recount the artist's refusal of a dinner
invitation in terms that betray what Liebert calls his "sense of the fragility
of his ego boundaries" even in far less intimate relationships. Michelangelo
begs off for fear that, given his intense susceptibility to refined companion-
ship, each of the guests "would take from me a portion of myself," with
the result that "for many days to come I should not know in what world I
was moving."[105] In the case of Cavalieri, the beloved as well as the lover
may have resisted this consummation; but here, as with Febo di Poggio,
the artist's avoidance of physical expression "has less to do with moral
constraints on Michelangelo's part than with the potentially disorganizing
impact that open sexuality would have on him. . . . The glorious arena of
his life was imagination, where beauty reigned and anything was possible.
In contrast, orgasm, with its loss of boundaries and immediate reduction
in tension, would have been, for him, a bodily analogue of death."[106]

The death that Phaethon suffers is like this physical release. Michelan-
gelo visualizes Phaethon's longing for paternal love as leading inevitably to
loss of control and to destruction by Jupiter's thunderbolts, which represent
the terrifying negative aspect of the father-image. In Michelangelo's inter-
pretation, the gratification of "unbridled" desire is fraught with the "dread
of bodily disintegration." It must have struck the artist with a particular
shiver to read that Phaethon's grieving mother searched across the globe
to find only his charred and buried bones.

The *Ganymede* drawing and the others that accompany it all deal with
love in the broadest sense: with eros as passionate bliss (*Ganymede*), as
a free sensuality (*Children's Bacchanal*) whose excesses are punished
(*Tityos*), and as a destructive desire for paternal recognition and love
(*Phaethon*). Because these characters are all male and correlate signifi-
cantly with the major male figures in Michelangelo's emotional life, the
series can be further interpreted as the first comprehensive attempt in art
to deal concurrently with a more specific and personally resonant aspect
of love: the fate of the presumptuous homosexual lover.

Conclusion

In illustrating Ganymede, Michelangelo identified simultaneously with
the paternal Jupiter and the beloved boy; the drawing is his expression of
a love that redeems his frustrated desire for a powerful, loving father.
Ganymede was for him the ultimate symbol of unconflicted fulfillment of

desire, and the artist posed him in a relationship to the eagle of Jupiter similar to that of Christ to the heavenly Father who stands behind him in depictions of the Trinity.[107] In Michelangelo's unfinished terza rima on the death of his own father, he had expressed the same yearning for ecstatic fulfillment through the metaphor of the Christian godhead, with its indissoluble union of Son and Father:

> By having died my dying you will teach,
> Dear father, and I see you in my thought
> Where the world hardly ever lets us reach.
>
> Some think that death's the worst, but it is not
> For one whose final day grace will transform
> To his first eternal, near the holy seat,
>
> Where by God's grace I imagine and assume
> And hope to see you are, if reason draws
> My own cold heart out from the earthly slime.
>
> And if the best of love in Heaven increases
> Between father and son, as virtues all grow . . .
>
> (G. 86; Gilbert, 84)

Michelangelo's opposition of heavenly love to "earthly slime" again recalls the condemnation of eroticism, especially homoeroticism, inherent in his Christian ethos. He was caught between his desires and the fear of realizing them, a fear including not only rejection by his beloved but also the rejection of the validity of his love by church, society, and self. We have seen that, though he resentfully attacked those who impugned the purity of his motives, Michelangelo's feelings for Cavalieri were in fact erotically charged. Even if he was partly unconscious of their erotic side, Michelangelo and his friends took pains to conceal his graphic expressions of love, knowing that other people would read a physical component into their language. The drawings as a group embody Michelangelo's fundamental belief that men's love for men contains psychic conflict and the potential for punishment, by authority or by internal disorientation.

The contradictions and obstacles in his fantasies of male love led Michelangelo to imbue Ganymede with a complex of feelings that reflects paradoxes in the culture around him. As Stokes concludes, "The Renaissance was an age of elevated yet earthly and equivocal convictions. . . . We are aware, without any precise knowledge of Neoplatonism, . . . that many of Michelangelo's nudes are bemedalled with the light of an enamoured

philosophy whereby guilt and other unconscious material achieves the air of epic poetry" (*Michelangelo*, 139).

Ganymede's lyrical, effortlessly blissful transport takes on an added glow of poignancy in the light of its companions, which deal more darkly with the attendant dangers of passion and sensuality. The conflict Michelangelo felt even in the midst of ecstatic union with Tommaso is simultaneously internal (between the impulses of earthly physicality and the ideal of heavenly spirituality) and—the same conflict writ large—externalized onto the artist's hostility and fear toward those forces and individuals in the world around him who would restrain his desires.

The dramatic tension of the Cavalieri drawings reflects their historical moment: the waning decades of the High Renaissance, when the sensuality of pagan mythos was still minimally acceptable and the possibility still alive of reconciling it with Christian strictures. The union of sacred and profane philosophies achieved by the Neoplatonic emblem books was short-lived; its inherent tension, already visible during Michelangelo's youth in the dichotomy between the nostalgic antiquarianism of the Medici humanists and the reforming zeal of Savonarola's *brucciamenti*, could no longer be sustained. A decade after Michelangelo's love-gifts, the Council of Trent began its work of proscribing classical references in religious art—in effect banishing all pretext for incorporating non-Christian notions of sensuality, however elevated, within a positive spiritual context.

Nor could Michelangelo himself, already on the threshold of old age when he met Cavalieri, bear this conflict much longer. His feelings for the youth were swept away in the rising tide of the artist's apocalyptic religious intensity, which found its first form in the *Last Judgment* begun in 1536—sketches for which were taking shape concurrently with the Cavalieri drawings, one of them on the same sheets of paper. Although they remained close for the rest of his life, after Cavalieri married and became a father the two men's relationship became more formal and concerned with work. Michelangelo's most intimate later letters and poems were written to Vittoria Colonna, the pious noblewoman with whom he shared his growing religious fervor.[108]

In their emphasis on divine retribution and death, the Cavalieri drawings foreshadow the personal and artistic direction of Michelangelo's old age.[109] In the years after his infatuation with Cavalieri, the increasingly melancholy sculptor seems to have capitulated to the ascetic enthusiasm of the Counter-Reformation. As Colonna replaced Cavalieri, so the eternal forces of heaven and hell predominate in his later works over the earlier concern for personal happiness on earth in human relations. The smoothly

finished drawing of Jupiter and Ganymede's unconflicted, ecstatic love gives way to the _Last Judgment_ and the increasingly fragmentary and frustrating series of late _Pietàs_, versions of that oft-repeated theme in Michelangelo's oeuvre that is, at its core, a scene of mourning for a youthful dead male.

Earthly love, increasingly troubled and out of reach, is at last abandoned; the beloved no longer soars but sinks, inert and cold after his suffering. In the version of the _Pietà_ intended for his own tomb, Michelangelo carved his self-portrait into the mournful figure of Nicodemus, who hovers above Christ like Jupiter above Ganymede, but who is unable to prevent the lifeless form from tumbling into the grave.[110]

For a brief moment, Michelangelo's desire to love and be loved like Ganymede found its climax and resolution in the synthesis of Greek myth and Christian values. But his yearning also had elements of the forbidden desire symbolized by Tityos, the bacchic putti, and Phaethon; and in the angry Jupiter who turns on this last young man there exists already, both formally and psychologically, the all-consuming Christ of final judgment.

Condivi, in defending Michelangelo against charges of overt sexuality, claimed that the artist's words "have the power to extinguish in the young any unseemly and unbridled desire which might spring up" (tr. Wohl, 105). The thunderbolt that devastates falling Phaethon marks, in Michelangelo's life and career, the same end to all desire.[111] Ovid's phrase for the bolt's annihilating effect could as easily be applied to Michelangelo's final escape from the conflicts and pains of love—no longer through submission to that love (now an intolerable thought), but through the violent destruction of the yearning self: "So fire extinguished fire."

·2·

CORREGGIO AT MANTUA:
Libertinism and Gender Ambiguity in Northern Italy

*W*hile Michelangelo was working on his *Ganymede* for Tommaso de' Cavalieri, the Emilian painter Antonio Allegri, known as Correggio (1489/94–1534), was completing a series of paintings on mythological subjects commissioned by Federigo II Gonzaga, marquess (later duke) of Mantua. The four known pictures in the series, whose theme was the loves of Jupiter, illustrate the god's rape or seduction of Ganymede, Io, Danaë, and Leda (figs. 2.1., 2.2, 2.5). The *Ganymede* (fig. 2.1), identical in dimensions to the *Io* (164 × 71 cm), is the first large-scale Renaissance interpretation of this myth in oils. Although conceived in the same spiritualized framework of Neoplatonic allegory as Michelangelo's drawings, Correggio's series displays far less ambivalence toward the ecstatic raptures of love. Moreover, partly because of their larger size and more colorful medium, these paintings far surpass the presentation drawings in evoking and extolling their subjects' physical beauty.

Correggio's carefree treatment of Ganymede's abduction can be traced in part to the lack of any personal investment in the subject. The meager biographical information about the artist offers no suggestion of homosexual interests, and he was married and a father.[1] In contrast to the previous study of Michelangelo, therefore, this examination of Correggio's image does not involve the artist's personality. By way of compensation, however, we are blessed with a richly detailed legacy regarding the broader social and intellectual context of the Mantuan court and the other prominent northern Italian cultural centers, Ferrara, Milan, and Urbino, to which the Gonzaga were tied by dynastic marriages. The evidence for contemporary attitudes toward sexuality in this milieu includes the predilections of the

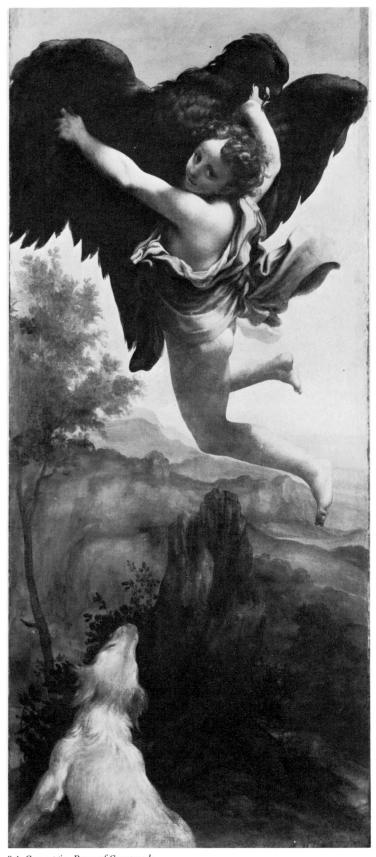

2.1 Correggio, *Rape of Ganymede*.

patron, Federigo; the life and work of his principal court artist, Giulio Romano; and the biographies and writings of several important authors connected with Federigo's circle and with each other, among them Equicola, Aretino, Ariosto, and Castiglione.

The directly sensuous appeal of *Ganymede* and its companions arose from the permissive attitudes of Mantuan society—much altered since the generation of the serious and learned Isabella d'Este, Federigo's mother (d. 1539)—toward eroticism and overt sexuality. The duke and several members of his entourage were of a hedonistic and sometimes irreligious temperament that would have responded more readily to the erotic surface of classical myth than to its spiritual allegorizations, and it may well be that they specified this interest to Correggio. Their recorded comments and actions treat homosexuality as a familiar subject open to frank discussion, albeit often comic or pejorative in tone. As we saw in chapter 1, the physical aspect of Jupiter's love for Ganymede had been acknowledged in Mantua as early as 1480, when Poliziano's *Orfeo* made its premiere in that city, suggesting that Correggio's audience understood and appreciated the erotic appeal of his *Ganymede* as much as that of its three female companions.

On a more profound iconological level, Correggio's *Ganymede* corresponds visually to conceptions prevalent among this audience about the physical and psychological bases of homoerotic attraction. Particularly revealing is the youth's androgynous appearance. The ambiguity of gender draws on a tradition, continuous since classical antiquity, that set forth the androgyne or hermaphrodite as a distinctive ideal of beauty and frequently associated or conflated androgyny with effeminacy, bisexuality, and homosexuality. In this nexus we can glimpse the rudiments of a psychological theory about the nature and dynamics of homosexual passion, which helps to explain why artists of the Cinquecento chose as the preeminent embodiment of that passion a girlish adolescent rather than a grown man.

The *Ganymede* and several other Gonzaga commissions were uniquely suited to Correggio's artistic predilections and abilities. Besides the four rapes, between 1525 and 1534 Correggio also painted for Mantua *The Education of Cupid* (or *School of Love*), *Jupiter and Antiope* (or *Venus, Cupid, and Satyr*), and the paired *Allegory of Virtue* and *Allegory of Vice*. Particularly the first two of these works, like the rapes, gave Correggio free rein to indulge his love of warm, subtly modeled flesh tones and luscious, golden-glazed color, and to evoke repeatedly the same mood of playfully lascivious pastoral that appears even in his treatment of such religious themes as the *Mystic Marriage of Saint Catherine* (Paris, Louvre). The creator of those

exultant throngs of airborne deities who swirl upward across the cupolas of San Giovanni Evangelista and the Duomo in Parma—so often called precursors of the Baroque—found in Ganymede a parallel stimulus to the depiction of an upthrusting aerial delight that fused both angelic and human rapture.[2]

Within the tall, narrow *Ganymede*, Correggio places the observer's viewpoint in mid-air, slightly above the boy. The deep umber eagle, his half-closed wings making him seem to hover unnaturally in the air, is silhouetted against the brilliant graduated blues of the sky and forms a strongly contrasting backdrop for the warm golden-pink tones of the boy's flesh and his rose-colored cloak (which flutters incongruously upward to reveal his buttocks). Rising above a spacious receding landscape of intensely blue-green hills recalling the actual location of the abduction atop Mount Ida, Ganymede is held fast in the eagle's talons, yet seems to dangle precariously below the bird. The panorama revealed in the background by the aerial viewpoint may derive from the description of Ganymede's abduction by Statius (*Thebaid* 1:548–51), an ekphrasis of an embossed gold goblet on which "the Phrygian hunter is borne aloft on tawny wings, Gargara's range sinks downwards as he rises and Troy grows dim beneath him."[3] A single feathery tree at the left and a dark tree stump emphasize the vertical movement of the figure. At the bottom a white dog, more lively and vertical than Michelangelo's (and Correggio's only element of the Virgilian apparatus), looks upward and stretches excitedly toward his disappearing master.

In contrast to Michelangelo's depiction, the boy's body faces the bird, and his arms clutch at the eagle's feathers for support, making the relationship between the two figures more a mutual embrace than a passive abduction. The boy is shown at an oblique angle between profile and rear views, with much of his back and buttocks visible. The gentle, softly lighted modeling of Ganymede's flesh and hair—reminiscent of Correggio's early adoption of Leonardesque sfumato—heightens the sensuality of his appearance; indeed, the eagle licks Ganymede's right wrist as if in recognition of its appeal. In a gesture dramatically different from the heavy-lidded, swooning self-absorption of Michelangelo's Ganymede, this younger figure twists his head around coyly to confront the viewer with suggestively parted lips and direct eye contact—the latter a prerequisite in theories of love from Ficino onward for inflaming the passions of the beholder.

Ganymede's Neoplatonic Associations in Northern Italy

The style and symbolism of this provocative image celebrate both spiritual and carnal love. Although, as we shall see, Mantuan society under Federigo was more at ease with libertinism than with intellectualized piety, Neoplatonism and its associated allegorical systems were well known there and provided the first level of literary and philosophical pretexts for Correggio's cycle.

The mythographic tradition on which Correggio seems to have based the selection of Ganymede and the subjects of the companion paintings grew from Petrarch, an author greatly respected by Cinquecento humanists. While the loves of the gods was a familiar topos in both literature and art (see the series by Polidoro, chapter 1), Correggio's series is limited to the loves of Jupiter, which had never previously served as the theme for a series of paintings. Writers from Ovid to Boccaccio compiled lists of the _amori di Giove_, but all these earlier authors had restricted their lists to mortal women. The most likely source for Correggio's choice of subjects is Bernardo da Siena's commentary on Petrarch's _Trionfi_ published in 1519, the latest enumeration of Jupiter's "uncountable lusts" and the only one to add to the dozen female names the statement that "Jupiter loved, in addition to these, Ganymede." Petrarch's views on love were considered by Neoplatonists as essentially congruent with their own, so Correggio's reading of Bernardo would have made him aware in a general way of the symbolism of earthly striving toward divine love.[4]

Neoplatonic philosophy itself was familiar and respected at the Mantuan court. Federigo's resident Neoplatonist was Mario Equicola (1470–1525), whose eclectic and encyclopedic _Libro di natura d'amore_, begun in 1494, was published in 1525. Equicola does not discuss Ganymede, but his philosophy of love runs closely parallel to Alciatian interpretations of the myth. Holding with Plotinus that love exists in a hierarchy of anagogic levels and that the highest good of the soul is the knowledge of truth and divine wisdom, Equicola writes: "We conclude . . . that love is the desire to have, to use, and to enjoy that which we find beautiful. Let us change that 'beautiful' and say instead 'good'; perhaps this would be a better definition of divine love, since the good and the beautiful can be interchanged."[5]

Although we have no direct evidence that Correggio read Equicola's book, the writer had been the Gonzagas' official historian, and his general influence on the iconography of the Palazzo del Te has been suggested. Equicola's and Alciati's conception of love can be clearly seen in Correggio's

2.2 Correggio, *Rape of Io*.

2.3 Achille Bocchi, *Symbolicarum quaestionum*, Emblem LX

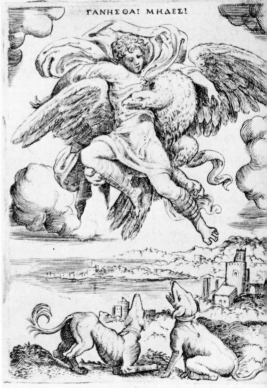

Ganymede and its companion _Io_. The complementary arcs of the two pictures' compositions, bowing respectively outward to the left and to the right, indicate that they were intended to hang together, perhaps flanking a door or window.[6] The vertical format is appropriate to both subjects: the upward flight of Ganymede and the downward movement of Jupiter (in the form of a cloud) from the heavens to the earthbound Io. Both pictures include a disguised Jupiter, an ecstatic mortal, and an accompanying symbolic animal.

The creature drinking from the brook at Io's feet is probably a deer, which since medieval times had stood for the longing for God, by analogy to Psalm 41 (Vg.), "As the hart panteth after the fountains of water, so my soul panteth after thee, O Lord." In Cesare Ripa's _Iconologia_ (1613), an angel and a drinking deer represent _desiderio verso Iddio_.[7] As we saw in Michelangelo's drawing, the dog beneath Ganymede, mentioned by Alciati as a possible addendum to the scene, was considered essential by Achille Bocchi. He took it to represent the base lusts of mortals left behind on rising to divine spheres, and explained Ganymede as symbolizing the victory of the spirit.[8] Correggio's _Ganymede_ seems to have impressed later Neoplatonists as a source for apposite imagery: in Emblem LXXIX of Bocchi's _Symbolicarum quaestionum_ (fig. 2.3) the illustrator incorporated Correggio's distinctive leaping dog into an otherwise purely Michelangelesque conception (cf. fig. 1.4). This adaptation suggests that Neoplatonists considered Correggio's picture, like Michelangelo's drawing, sufficiently spiritual (whatever its original sources) to suit their emblematic conception of the myth.[9]

Erotic Interpretations: Libertinism in Mantua

Neoplatonic allegory offered a familiar and respectable intellectual pretext for the depiction of the loves of Jupiter, but the overtly sensuous surface and mood of Correggio's paintings reflect the hedonism fostered by Federigo Gonzaga, which set the tone for behavior and patronage at his court.

Federigo maintained a relationship of many years with Isabella Boschetti, a married woman who bore him three children and whose preferential treatment at court despite her lack of official position led to conflicts between Federigo and his mother, Isabella d'Este. The vast expansion of the Gonzaga villa on the Isola del Te into what became the Palazzo del Te was begun by Federigo to provide a more sumptuous meeting place for himself and Boschetti, away from the court and her husband. Although a

more public and political aspect was later incorporated into the palazzo's decorative program, the design in its initial phase (from 1527 to about 1535), during which Correggio's pictures were commissioned, envisioned a pleasure retreat. The classically inspired programs for its rooms, designed and decorated under the supervision of Giulio Romano, ranged from the mock-epic humor of the Sala dei Giganti to the frank, light-hearted eroticism of the continuous upper frieze in the Sala di Ovidio.[10] The differences in taste between Federigo and his mother point up the duke's preference for erotic subjects uncomplicated by moral considerations. The serious and learned Isabella had earlier decorated her _studiolo_ in the Palazzo Ducale with such mythological works as Perugino's _Battle between Love and Chastity_, intended to present the classical gods as enemies of chastity; when she commissioned Correggio, it was for a pair of moralizing subjects, _Allegory of Vice_ and _Allegory of Virtue_. In contrast, four of the six known pictures Correggio did in the same period for Federigo show Jupiter seducing a mortal, and the others also deal with erotic play or education.[11]

According to Vasari, at least two of Correggio's loves of Jupiter, _Danaë_ and _Leda_, were commissioned by Federigo as gifts for the emperor Charles V. Although Vasari does not mention _Ganymede_ or _Io_, the subjects of the four paintings are clearly related, and all four were recorded in Spain later in the century; hence there is little reason to doubt that the entire series was presented to Charles. Stylistic and practical considerations suggest that the pictures were painted between the emperor's two visits to Mantua in 1530 and 1532 and given to him on the later occasion or some time afterward.[12]

The eventual presentation of the series to Charles does not, however, preclude the likelihood that Federigo originally commissioned them for himself. The related dimensions of the pictures imply that they were planned to fit a specific architectural setting, possibly a room in the Palazzo del Te; Charles may have seen some or all of the series in 1530 or 1532, and Federigo could then have offered them to their imperial admirer. Even if the _Loves_ never actually hung in the palace, their eroticism and Ovidian themes are close in spirit to the other art and interests of Federigo's circle. The Jovian theme held a continuing appeal for the duke; after Correggio's death in 1534, Federigo wrote to the governor of Parma regarding an unfinished set of cartoons of the loves of Jupiter for which the duke had paid the artist fifty ducats on account.[13]

In the personality and writings of Pietro Aretino (1492–1556) we find an attitude of lighthearted hedonism like that of Federigo and much appre-

ciated by the then Marchese, who wrote to Aretino as early as 1523 inviting him to Mantua. Although Aretino only spent intervals of a few months in Mantua between 1523 and 1527, his relations with Federigo remained close and sympathetic despite occasional misunderstandings. They corresponded and exchanged gifts; Aretino acted as Federigo's agent for procuring pictures; and several of his comedies, among them _La cortigiana_ and _Il marescalco_, were performed at the Mantuan court. We are thus justified in examining Aretino's comments and actions regarding sexuality as indicators of attitudes accepted and admired by Correggio's patron.[14]

In the letters of Aretino, who wrote regularly to Federigo long after his departure for Venice in 1527, we can best glimpse Federigo's attitude that art should incite physical passion—or, more precisely, Aretino's expectation that Federigo would share his own opinion. Concerning one of Federigo's commissions, Aretino wrote on October 6, 1527: "I understand that the most rare Messer Jacopo Sansovino is about to embellish your bedchamber with a statue of Venus so true to life and so living that it will fill with lustful thoughts the mind of anyone who looks at it." In the same letter, Aretino comments on his efforts to secure a painting by Sebastiano del Piombo for Federigo, who apparently had specified that the subject was unimportant as long as "it not be about hypocrisies, stigmata, or nails," that is, not a religious subject.[15]

The most notable aspect of Aretino's erotic interests is their explicit opposition to the idealized love of Neoplatonism. Aretino had numerous affaires and, like Federigo, a long-term mistress, Caterina Sandella, who bore him two daughters; that such liaisons raised little official disapproval is suggested by Aretino's request that Sebastiano del Piombo, who had taken minor orders, act as godfather to one of these children. Aretino satirically contrasts his own lustiness to both the implied prudery of Plato and the feebleness of the Neoplatonists: "I do not deny that there are Platonic steers who in their decrepitude scarce can afford the luxury of one small volley a year, but if I did not draw a bow at this handmaiden or that at least forty times a month, I would hold myself to be all washed out."[16]

Aretino made no secret of his fondness for physical pleasures and was contemptuous of those whose suppression of eroticism seemed to him hypocritical. He became identified with frank erotic expression early in his career, when he wrote a set of _Sonetti lussuriosi_ to accompany Marcantonio Raimondi's engravings after _I modi_, Giulio Romano's designs depicting various positions of intercourse. These provoked a scandal in Rome which led to Raimondi's imprisonment and the destruction of most of the prints. We shall speak of these engravings and poems at greater length in chapter 3,

in connection with Giulio. At present it suffices to cite Aretino's letter defending Raimondi (for whom he claims to have obtained release from prison), which explains that, having seen the prints, "inasmuch as the poets and the sculptors, both ancient and modern, have often written or carved—for their own amusement only—such trifles as the marble satyr in the Chigi Palace who is trying to assault a boy, I scribbled off the sonnets you will find underneath each one."[17]

It is noteworthy that in choosing a classical precedent to justify his artistic pursuit of erotic delight, Aretino cites a homoerotic example. His own amorous desires were not confined to women: he once wrote to Federigo requesting the Marchese's aid in securing the affections of a young boy, "il figliolo del Bianchino," with whom he was infatuated, and when he fell in love with Isabella Sforza he wrote a sonnet declaring that she had altered his earlier homosexual propensities:

> Let it be clearly made known to everyone
> How Isabella Sforza has converted
> Aretino from that which he was born, a sodomite.

But he may not altogether have given up homosexual affaires, since he was forced to flee Venice briefly in the spring of 1538 to escape charges of sodomy; the accusation remains inconclusive, since he was never brought to trial. Whatever the truth of this incident, after his death Aretino's persistent reputation for homosexuality is attested by Luigi Pasqualigo's play *Il fedele* (1576), in which a character mourning Aretino's death addresses him, "Oh, how many young men I would have you enjoy!"[18] Aretino's snide insinuation about Michelangelo's weakness for youthful "Gherardos and Tommasos" (chapter 1) thus seems disingenuous to the point of hypocrisy.

Contemporary homosexuality was acknowledged in a variety of social contexts by other prominent writers, all acquainted with each other, who enjoyed the patronage of Federigo or spent some time in his city. Although often treated with satirical exaggeration and as a subject for ridicule, the practice appears from these references to have been considered current among clergy, nobles, humanists, and commoners. A comment made by the Ferrarese poet Ludovico Ariosto (1474–1533) in the sixth of his *Satires* (1517–25) shows the tenor of these allusions. Ariosto was known to the Gonzaga family through their close family relationship to the Este rulers of Ferrara and was himself present in Mantua in November 1532, on the occasion of Charles V's second visit, when Correggio's *Ganymede* was presumably in progress. In his epic poem *Orlando furioso*, published that year,

he refers to Mario Equicola and bestows on Aretino the title "Scourge of Princes." Ariosto's satire tends to reinforce the observation (chapter 1) that the humanists' awareness of classical sanctions for an idealized form of homoerotic love did not preclude their appreciation of its more appetitive aspects: "Few humanists are without that vice which did not so much persuade, as forced, God to render Gomorrah and her neighbor wretched! . . . The vulgar laugh when they hear of someone who possesses a vein of poetry, and then they say, 'It is a great peril to turn your back if you sleep next to him.'"[19]

The diplomat and author Baldassare Castiglione (1478–1529), in his _Book of the Courtier_ (_Il libro del cortegiano_), similarly alludes to homosexuality in contexts that suggest it was considered prevalent. As with Ariosto and Aretino, we lack direct evidence that Correggio knew Castiglione, who left Mantua in 1524. However, the _Cortegiano_ was published in Venice in 1528, just when Correggio was beginning his major work for Federigo. Besides its enormous popularity throughout Europe in numerous reprints and translations, this book must have had particular influence in Mantua and its neighboring northern Italian states, having drawn its attitudes from experience of that milieu. Castiglione knew the Gonzaga family, to whom he was related, from childhood. Early in life he served Francesco Gonzaga; upon fleeing Urbino in 1516, he resided in Mantua as an intimate friend of Francesco, and after Francesco's death in 1519 Castiglione continued to serve his son Federigo II until departing in 1524 as papal nuncio to Spain, where he remained until his death. In the _Cortegiano_, Castiglione mentions his friendship with Isabella d'Este (Francesco's wife, and mother of Federigo) and with her sister Beatrice d'Este, the late duchess of Milan. Elisabetta Gonzaga, duchess of Urbino during the time in which the book's action is set (ca. 1507), serves as moderator of the characters' discussions, and another Gonzaga, Cesare, is one of the speakers.

Cast as a series of discussions among the aristocratic residents at the court of Urbino about the ideal personal and social qualities of both male and female courtiers, Castiglione's book provides ample scope for expression of conflicting ideas current at the time. In regard to homosexuality, two pertinent remarks are made in the context of a discussion of humor and witticisms. As an example of clever wordplay, Bernardo Dovizi recounts a variation on a line from Ovid's _Ars amatoria_ that reveals a general assumption of widespread homosexuality in Rome. Upon encountering a group of beautiful ladies in the street, a gentleman compliments them in Latin with the original line, "Your Rome has as many girls as the sky has

stars." When a group of young men approaches from the opposite direction, he adds the observation, "Your Rome has as many homosexuals as the meadows have kids."[20]

Slightly later, Bernardo describes another recent incident, also in Rome, that further indicates the characters' familiarity with homosexuality and their amused tolerance. Jacopo Sadoleto asks Filippo Beroaldo why he wants to go to Bologna. Beroaldo replies, "I've got to go there on three counts," to which Sadoleto punningly responds that the three counts "are, first, Count Ludovico da San Bonifacio, next Count Ercole Rangone and third the Count of Pepoli," all identified as "very handsome youths who were then studying at Bologna" (2:63; tr. Bull, 171). Although the comment might refer merely to a teacher's desire to visit former pupils, the stress on their beauty and the ensuing laughter suggest that the audience understands other motives to underlie Beroaldo's eagerness.

One other prominent literary figure at the Mantuan court whose work displays the same jocular appreciation of ribaldry and libertinism is Matteo Bandello (1485–1561). Some time before 1540, this Lombard cleric, who served in Mantua as tutor to Lucrezia Gonzaga, wrote a series of cynical and bawdy *Decameron*-like *novelle* that colorfully evoke the manners and mores of contemporary society. In one of these, "The Tale of Porcellio," the poet of that name (fl. 1450) having fallen seriously ill, his wife, who knows he has often committed sodomy, sends for a confessor. The monk repeatedly asks whether he has "sinned against nature"; Porcellio repeatedly maintains that he has not. When at last the exasperated monk exclaims, "I am assured that thou art a thousand times fainer unto boys than are goats to salt," Porcellio laughingly retorts, "To divert myself with boys is more natural to me than eating and drinking to man, and you asked me if I sinned against nature!"[21]

The joke, of course, turns on Porcellio's use of the term "against nature" in a sense quite different from the friar's Thomist meaning. To Porcellio, nature means instead one's individual nature—a subjective basis for moral judgment—and fidelity to that nature means satisfying desires for food and sex. Although Bandello ends his ironic account with the observation that the brutish protagonist's sexual transgressions incurred public scorn and disgrace, he obviously relishes both Porcellio's witty, frank sensuality and the foolish naiveté of the friar. This example and the others discussed above indicate that the cultural milieu of Correggio's works was both sexually sophisticated and hedonistic, and would have understood and appreciated the erotic significance of his *Ganymede*.

The Hermaphrodite: Androgyny, Effeminacy, and Homosexuality

If Ganymede was understood as the paragon of homosexual eros, we can approach Correggio's picture with a further and more directly visual question. What in the exquisitely detailed appearance of his Ganymede, fairest of all mortal youths, evokes or reflects contemporaneous notions of ideal male beauty? More broadly, how does the visual appeal of this figure correspond to conceptions then current of the physical and psychological bases for homoerotic attraction? The key to these questions lies primarily in Ganymede's androgynous or girlish appearance, which must be viewed in relation to the complex associations in Renaissance and earlier social thought between androgyny, hermaphroditism, effeminacy, and homosexuality.

The ambiguity of Ganymede's gender is shown clearly by comparison with his companion figure, Io. The pair have marked similarities in their physical appearance despite their difference in gender. They share the same delicate facial features, softly modeled pinkish-white skin, and abundant golden curls; the twisting positions of both heads are also related. Ganymede resembles the hermaphrodite, a well-known subject in later Greek art. The hermaphrodite, both as a type and as the demigod Hermaphroditus, combined in one figure a generally soft and female body type, with breasts and a long hairstyle, and male genitalia. The long curly hair and roundly modeled contours of Correggio's Ganymede are much the same as those of numerous examples of the hermaphrodite in various media.[22]

Ganymede's pose resembles even more closely the pose of the well-known Hellenistic sculpture the *Sleeping Hermaphrodite* (fig. 2.4).[23] If this recumbent figure were stood up, its bent left leg would extend backward behind the other limb in a position only slightly less splayed than Ganymede's bent and flailing right leg. The torsos of both figures twist in a similar direction, and their buttocks are equally full and globular (their positions are the same, though of course we can see Ganymede only from the side). Although Correggio's boy must reach out with his left arm to keep from falling, the curve of his right arm behind his head is close to that of the hermaphrodite's supporting arm. The ninety-degree turn of Ganymede's head, which is tucked coyly into his shoulder, also recalls the features of the Borghese sculpture.

A note of caution is necessary in ascribing so much importance to this aspect of Ganymede's appearance, which can be partially accounted for by stylistic and biological factors not directly related to his function as an icon

2.4 Hellenistic marble, *Sleeping Hermaphrodite.*

2.6 Correggio, *Allegory of Vice.*

2.5 Correggio, *Rape of Danaë.*

of homoerotic appeal. To an extent he simply shares in Correggio's prefer-
ence for a youthful, androgynous physical type, evident in many of the
works he painted for the Gonzaga. The attendant Cupid in the related
painting of *Danaë* (fig. 2.5) is identical to Ganymede in body type, hair,
and facial features, as is the slightly younger, grinning urchin in the fore-
ground of the *Allegory of Vice* (fig. 2.6). Moreover, at the literal level of the
narrative, Ganymede is a young boy, and prepubescent boys are, in fact,
still feminine in physical characteristics: beardless, soft-skinned, high-
voiced, and lacking the more pronounced musculature of adult males.

These considerations alone, however, cannot fully account for Gany-
mede's appearance. The similarity to Cupid and the urchin suggests that
Correggio associated this androgynous type with eros in all its forms:
Cupid and the urchin are not specifically homosexual but are more general
symbols of passion and license (for the homoerotic aspect of Cupid see
below, chapter 3). The frequency with which Correggio and other artists
chose the girlish Ganymede to illustrate ideal homoerotic beauty in pref-
erence to an adult male indicates that prevailing contemporary notions of
homosexual attraction were more intimately bound up with adolescent
ambiguity than with the appeal of the more distinctively masculine
adult—at least as far as patrons, themselves adult men, were concerned.

The Hermaphrodite as Sexual Symbol

Literary and visual precedents from classical times to the Renaissance
amply support Correggio's conception of androgyny as the type of male
beauty appropriate in a homoerotic context. The affinities we have noted
between his *Ganymede* and antique visualizations of the god Hermaphro-
ditus recall the importance of that mythical figure in Greek and Roman
sexual symbolism. The child of Hermes and Aphrodite, from whom it got
its name, this compound being shared erotic associations with the other
two children of the love-goddess, its half brothers Eros and Priapus. Her-
maphroditus's parents were the patrons, not of marriage as a social or
romantic institution, but of sexual union and fertility. Their hybrid off-
spring was closely associated with the same primordial forces; in the Hel-
lenistic period, Hermaphroditus was adopted as a symbol of fertility and
the protector of marriage.[24]

Uniquely a part of Hermaphroditus's iconography is its sexual ambiguity,
which underlies such humorous episodes as Pan's attempted seduction of
the sleeping figure, suddenly stopped when he uncovers proof that it is not

the woman he had thought. This duality was also the reason that Hermaphroditus became the patron deity of sexually mixed bathhouses. The *Greek Anthology* records an epigram supposedly inscribed on a statue of the god outside one such establishment: "To men I am Hermes, but to women appear to be Aphrodite, and I bear the tokens of both my parents. Therefore not inappropriately they put me, the Hermaphrodite, the child of doubtful sex, in a bath for both sexes."[25]

The terms *hermaphrodite* and *androgyne* (man-woman) were used interchangeably by Greek and Latin writers. Patristic Greek also used the word ανδϱογυνος to mean "effeminate," leading to early conflation of the concepts of hermaphroditism, effeminacy, and homosexuality. Thus Clement of Alexandria (d. ca. 215), in a condemnation of all nonprocreative intercourse, could symbolize sodomy by the hyena (popularly held to grow alternately male and female genitalia) and identify it with hermaphroditism in humans: "Nor can it be believed that the hyena ever changes its nature, or that the same animal has at the same time both types of genitalia, those of the male and the female, as some have thought, telling of marvelous hermaphrodites and creating a whole new type—a third sex, the androgyne, in between a male and a female."[26]

The word *hermaphroditus* continued to signify homosexual during the Middle Ages. A sixth-century Latin treatise on bizarre creatures describes a man who preferred the passive role in intercourse as being "of both sexes," even though the context clearly refers to homosexual behavior rather than physical hermaphroditism. In *Purgatorio* (26:82), Dante has the sodomites call out, "Nostro peccato fu ermafrodito." Although such texts do not describe Ganymede himself as a hermaphrodite, he is often closely associated with discussions of homosexuality.[27]

The same complex of associations continued to link the hermaphrodite with sexuality, particularly homosexuality, throughout the Renaissance. Antonio Beccadelli's obscene and lascivious homoerotic poem, *L'ermafrodito*, was written between 1419 and 1425 and dedicated to Cosimo de' Medici. Although Beccadelli assured his female lovers that the poem did not preclude his love for them, the book provoked a public debate on sodomy in Florence in 1426.[28] Aretino, in a letter praising the *Venus* by Sebastiano del Piombo, stresses the figure's androgynous combination of physical attributes. In a passage reminiscent of the words ascribed to the hermaphrodite outside the classical bathhouse, Aretino deems the ambiguity suitable for a figure that can incite lust in and toward both genders: "Because this goddess infuses her qualities into the desires of both sexes, the skillful artist has made her with the body of a woman and the muscles of a man. Thus she is stirred by both masculine and feminine feelings."[29]

By implying, as we have noted, that those who commit sodomy are a third sex, Clement of Alexandria was hardly offering a literal description of sodomites. Rather, he appears to have been using genital physiology as a metaphor for the anomalous behavior of sodomites, who seemed to him to exhibit functions or attributes normally belonging to the other sex. When other writers use hermaphrodite to mean homosexual, they may be referring either to behavior—a combination of heterosexual and homosexual acts by one individual—or, more often, to a psychological state presumed to exist within a primarily homosexual individual.

The behavioral sense of the hermaphrodite, graphically representing a male who can alternate between sex with women and with men, would today be categorized not as homosexual but as bisexual. This meaning of the term occurs in a mock epitaph for Paolo Giovio, alleged to have been written by Aretino in retaliation for a priapic medal satirizing Aretino's own lustiness. In an apparent allusion to Giovio's bisexuality, the epitaph declares:

> Here lies Paolo Giovio the hermaphrodite
> Who knew how to act as wife and husband.[30]

A satire of the French court of Henri III (1574–89), treating the bisexuality of the king and his courtiers, was similarly titled *L'Isle des hermaphrodites*.[31]

In practice, during this period the distinction between bisexual and homosexual, like that between hermaphrodite and homosexual, seems not to have been rigidly drawn.[32] The underlying factor that permitted conflation of these categories was another characteristic closely connected to all of them: effeminacy, the presence in men of emotional traits or actions considered appropriate to women. In particular, as we shall see, males were condemned for taking the passive role in anal intercourse with another man, the closest analogue to "acting as a wife" in a heterosexual liaison.

Before moving from this behavioral level of hermaphrodite symbolism to a discussion of the more internal and value-laden concept of effeminacy, it is necessary to draw a distinction between sex and gender. Although these two terms are developments of modern psychology and sociology, they apply very well to Renaissance society. It is precisely the question of establishing norms for male and female behavior, and the related issue of how to treat deviations from these norms, that is implicit in much of the sixteenth-century literature regarding the feminized male.

In modern psychological classification, *sex* refers to an individual's genital and chromosomal identity as either male or female, while *gender*, often used in the compound term *gender-role*, refers to a set of attitudinal and

behavioral expectations considered appropriate to one sex or the other. Sex is innate and basically invariant, but gender is a set of learned behaviors whose content varies from one culture or time period to another, as does the degree to which individuals within a culture accept and internalize those traits. As formulated by psychoanalyst Robert Stoller in his study *Sex and Gender*, "*Gender* is a term that has psychological or cultural rather than biological connotations. If the proper terms for sex are 'male' and 'female,' the corresponding terms for gender are 'masculine' and 'feminine'; these latter may be quite independent of (biological) sex."[33]

Using this terminology, effeminacy is any exhibition on the part of a person whose biological sex is male of gender behavior considered more properly feminine by his culture. This theoretical framework makes it possible to examine statements that disparagingly relate effeminacy and homosexuality and to discover a rudimentary psychological theory about the nature of homosexuality. The Renaissance conflation of effeminacy, hermaphroditism, and homosexuality pivots around the disapproval of passivity in men—specifically, taking a passive or receptive role sexually—this quality being considered more appropriately feminine than masculine.

Effeminacy in men was already linked to male passivity in anal intercourse by the Greeks, who condemned it, at least for adult males. In the common Greek pattern of relations between an older man (*erastes*) and a youth (*eromenos*), it seems to have been understood that the older partner would seek to dominate the younger sexually (though theoretically the eromenos should resist). In his *Nicomachean Ethics* (1148b.15–9a.20) Aristotle debates at length which pleasures are natural and which unnatural; the text is unclear, but the general tenor of his discussion suggests that he viewed the disposition to passive intercourse in males as a kind of disease, and he explicitly contrasts it with women's desire to be mounted, which he views as natural.[34] Aristophanes treats the question in a comic vein, but with the same underlying assumptions. The character of Kleisthenes in several comedies represents a beardless man whose inability to produce this evidence of masculine virility leads variously to suspicions that he is a eunuch; that he weaves rather than fights (that is, performs feminine gender-tasks); and that he desires or at least tolerates sexual penetration. In *Lysistrata* (1092) the representative of the Athenian men, desperate to settle the quarrel that has deprived them of conjugal sexuality, fears that the men will be reduced to mounting Kleisthenes.[35]

The Judeo-Christian tradition proscribed male homosexuality more categorically, and the terms of disapproval also depend on the idea that men should not act like women. We have seen that Clement of Alexandria felt

that sodomites were somehow a third sex, not fully masculine in behavior. Peter Cantor (d. 1192) was one of the few medieval Christian writers to distinguish between the physical condition of hermaphroditism and the tendency to homosexuality, but the point of his discussion is still that sodomy is reprehensible because in becoming the passive receptor of another man, a male is acting like a female. He adduces several biblical texts, among them Leviticus 18:23: "You shall not lie with a male as with a female, for it is an abomination."[36]

In Renaissance Italy, ambiguous gender behavior was subject to ridicule and comic exploitation, often with homosexual overtones. Men whose actions bordered on that considered more suitable for women are derided as effeminate in the writings of Castiglione, Aretino, and other authors close to Correggio's environment. Some representative samples of these writings enable us to understand in more detail the assumptions about gender that lay behind these authors' joining of effeminacy and homosexuality.

Castiglione's _Cortegiano_ devotes a large part of book 3, whose subject is women, to appropriate masculine and feminine behavior. The remarks about effeminacy indicate that transgressions of proper gender behavior are a matter of some concern to all the participants, who are taking such pains to define those norms. As we have seen, the characters display an easy familiarity with homosexuality; they also touch disparagingly on the perceived links between it and effeminacy.

Underlying the otherwise divergent opinions about ideal behavior runs the shared notion of a fundamental polarity between men and women. Men are by nature active, women passive; strong men perform actions, weak women are acted upon. Except to moderate the harshness of his value judgment, no one disputes Gaspare Pallavicino's theory of the sexes as ranked opposites (3:17):

> I don't see . . . how on this point you can deny that man's natural qualities make him more perfect than woman, since women are cold in temperament and men are hot. For warmth is far nobler and more perfect than cold, since it is active and productive; and, as you know, the heavens shed warmth on the earth rather than coldness, which plays no part in the work of Nature. And so I believe that the coldness of women is the reason why they are cowardly and timid.[37]

Parallel to this notion of biological differences runs the assumption that feminine gender behavior is a sign of weakness in men. A male who abdicates his proper role of dynamic, active functions and shows excessive interest in the refinements of dress, toilet, or the arts (considered more

intrinsically feminine) is constantly mocked by various speakers as effeminate, usually with the implication that he is correspondingly deficient in those virile qualities like bravery necessary to the ultimate masculine role of warrior. Gaspare says (1:47): "I think that music, like so many other vanities, is most certainly very suited to women, and perhaps also to some of those who have the appearance of men, but not to real men who should not indulge in pleasures which render their minds effeminate and so cause them to fear death."[38]

By extension, effeminacy becomes closely associated with homosexuality. Any male who seems deficient in masculine power and aggression is liable to the scornful suspicion that he might therefore also act a passive role in sodomy with another man, either from choice or because he lacks sufficient virility to perform appropriately; significantly, the male who plays the active role in sodomy is not subject to ridicule, either explicit or implicit. Echoing Aquinas, Cesare repeats the mocking connection between flagging virility and sexual passivity with specific regard to old men (3:40; tr. Bull. 244): "What is more, these men who so offend God and Nature are already old. . . . But they themselves regret nothing more than their lack of natural vigour to be able to satisfy the abominable desires still lingering in their minds after Nature has denied them to their bodies; and yet they often devise ways for which potency is not required." The snide indirection of this last phrase most probably refers to anal intercourse, passive reception of someone else's "potency." Aretino drew the same parallel more explicitly in one of his boastful sonnets to accompany the lewd illustrations of coitus, the *Modi* of Giulio Romano and Marcantonio Raimondi:

> Let him who hath it small play sodomite.
> But one like mine, both pitiless and proud,
> Should never leave the female nest of joy.[39]

In extreme cases, forcing another man into sexual passivity was regarded as a form of humiliation, as shown by the title "The Tale of the Youth Who Was Caught in the Act of Adultery and Was Sodomized and Flogged by the Husband," written by the Neapolitan jurist Gerolamo Morlino (or Morlini) about 1520.[40]

The behavioral and physical associations between femininity and homosexuality also found expression in the practice of transvestism. The fact that young boys could look like women, and vice versa, occasioned numerous examples of cross-dressing for erotic or humorous effect. A letter from Aretino to a Venetian courtesan implies that frustrated female prostitutes had taken to donning boys' clothing in order to attract customers.[41] The

Florentine sculptor Benvenuto Cellini, whose bisexual interests will be the focus of chapter 4, recounts a typical practical joke revolving around this deliberate sexual ambiguity. Invited to a banquet to which each male guest is to bring a beautiful female companion, Cellini escorts as his entry in this informal beauty contest an adolescent male neighbor—one Diego, known for his beauty—disguised in a dress. When the company declares Cellini's "girl" the winner, he laughingly reveals the deception, to general approval and delight.[42] Cross-dressing was later utilized by Shakespeare with explicit reference to Ganymede. In *As You Like It* (I.3.119–27), Rosalind dresses as a man to protect herself while traveling and chooses a pseudonym for her new identity:

> *Rosalind.* A gallant curtle-axe upon my thigh,
> A boar-spear in my hand; and—in my heart
> Lie there what hidden woman's fear there will—
> We'll have a swashing and a martial outside,
> As many other mannish cowards have
> That do outface it with their semblances.
>
> *Celia.* What shall I call thee when thou art a man?
>
> *Rosalind.* I'll have no worse a name than Jove's own page;
> And therefore look you call me Ganymede.

Her choice of this name for a person who is outwardly male and inwardly female indicates yet another dimension of the sexual and psychological ambiguity read into the youthful paramour of Jupiter.

The implicit associations of Ganymede with girlish male beauty, transvestism, androgyny, and homosexuality are all explicitly brought together in Aretino's bawdy comedy *Il marescalco*, first published in 1533. The play is full of allusions to current events in Mantua, and the characters are described as servants or courtiers of Federigo Gonzaga. The plot revolves around the courtiers' strenuous efforts to get the duke's master of the horse, Marescalco, who is described in the Prologue as "reluctant with women," to comply with the duke's decree that he take a wife. The characters perpetuate an elaborate practical joke by disguising the duke's page, Carlo, as a girl and contriving that Marescalco "be forced to marry a boy who was dressed as a girl." The bridegroom's reaction provides a surprise ending: "Having discovered the ruse, the clever man was as happy to find the youth male as he had been sad to believe he was female."[43]

Marescalco's initial reluctance toward the match can perhaps be attributed almost as much to misogyny as to sexual orientation; but in his pomp-

ously Latinized protestation to the main character about these goings-on, the character of the Pedant makes clear their homoerotic implications. His speech, whose garbling of Latin and Italian is impossible to translate adequately, draws together all the terminology we have examined surrounding Ganymede, effeminacy, androgyny, and homosexuality (*cineduli* derives from *cinaedus*, a Latin term for passive homosexual): "Questi temerari adulescentuli, questi effeminati ganimedi infamano istam urbem clarissimam, a capestri sine rubore, a gli sfacciati cineduli subiaceno gli erarii de le vergiliane littere . . . Me tedet, mi rincresce che l'alma e inclita città di Mantova me genuit, idest Vergilius Maro, sia piena di ermafroditi."[44]

Correggio's *Ganymede*, painted for the very Mantuan court whose sexual foibles and ambiguities were satirized by Aretino, can thus be seen as the preeminent symbol for homosexuality as it was understood there: he is youthful and androgynous in appearance and passive in his behavior. Correggio, like Michelangelo, chose to depict the moment of abduction, when the beautiful and helpless boy is swept aloft by an all-powerful older man (albeit in disguise). In Michelangelo's drawing, there was at least the implication that Ganymede was simultaneously submitting to physical penetration from behind. Correggio makes no such graphic conjunction between boy and bird, but his version accentuates the youth's erotic passivity by other, equally suggestive means. By rotating Ganymede away from the viewer, Correggio both conceals the boy's masculine-active penis and reveals his feminine-receptive buttocks (for the specific erotic associations of this area see below, chapter 3).

As we have seen, although passivity in a homosexual relationship was subject to derision, no disapproval attached to the active enjoyment of such passivity by the more virile adult male; hence the popularity of Ganymede as symbol of homoerotic passion in pictures such as Correggio's, commissioned by a mature man. Michelangelo may have identified personally with the ecstatic youth, but the composition of Correggio's picture, along with Ganymede's outward glance, invites the viewer to identify with Jupiter, to appreciate the younger man as an object of desire. By thus clearly distinguishing two kinds of sexual feelings and behavior and casting themselves exclusively in the role of the fully masculine partner, the men of Mantua were free to delight in the feminized physical appeal of Ganymede's beauty with little of Michelangelo's moral or emotional ambivalence. Those who, like Aretino, were actively bisexual saw no shame in seducing both women and boys, so long as in both cases they consistently played the active part as did the king of the gods in his bisexual affairs depicted in Correggio's series of paintings.

The Androgyne as a Release from Sexuality: Leonardo and Alchemy

The image of the hermaphrodite was sufficiently complex and ambiguous to serve as an allegory for two opposing but closely related concepts. Thus far we have seen how the union of masculine and feminine traits in one individual evoked fantasies of an intensified or extended eroticism, bisexual and at times indiscriminate or licentious. At the same time, an equally long literary and artistic tradition saw this fusion of opposites within one being as an archetype of desexualized self-containment, a fantasy offering release from the ceaseless and conflict-ridden striving of all mortal flesh toward carnal or spiritual union with another mortal.

This alternative ideal of an androgynous being who transcends sexual longing occupied an important place in the intellectual and artistic interests of two artists with significant connections to Correggio. The fascination of Leonardo da Vinci (1452–1519) with androgynous sexuality seems to reflect a highly personal imagery derived from his inner conflicts. Although Leonardo was suspicious, even mildly contemptuous, of alchemy and other occult philosophies still current in the Renaissance, his conception of the androgyne has much in common with the hermaphrodite symbolism central to alchemical art and literature. Though no evidence suggests that Correggio was drawn to alchemy, his compatriot Parmigianino (1503–40) was obsessed with alchemical experiments, and through their esthetic interchange Correggio could easily have been exposed to alchemical ideas and images.

Correggio was apparently aware of the paintings of Leonardo, whose influence on his early works has often been noted. It seems unlikely that he would have known of the more detailed and precise, if at times puzzling, ideas about sexuality recorded in Leonardo's private drawings and notebooks. We cannot, therefore, suppose that Leonardo's distinctive interpretation of the androgyne contributed directly to Correggio's understanding of his own androgynous Ganymede. Nonetheless, Leonardo's conception provides insight into the full range of significance attached to the androgyne ideal in this period and is of particular interest because Leonardo was evidently homosexual.

Leonardo was twice accused of sodomy by anonymous denunciations in the Florentine *tamburo* in 1476, when he was still in the workshop of Verrocchio, though the charges were dismissed without a verdict. This, with his long-suffering toleration of his beautiful but unscrupulous assistant Gian Giacomo de' Caprotti, to whom his notebook references give the

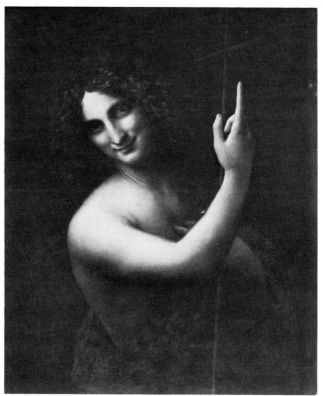

2.7 Leonardo da Vinci, *Saint John the Baptist.*

name of Salai ("little devil"), suggest that Leonardo's emotional and erotic interests were principally directed toward men.[45]

Many of Leonardo's male subjects are sexually ambiguous, notably his *St. John the Baptist* (fig. 2.7). Another painting of St. John, probably executed by assistants, was later overpainted as Bacchus (Paris, Louvre), who was, significantly, called *gynandros* by the Greeks.[46] Leonardo and his followers also made numerous drawings of Salai, whose androgynous beauty infatuated the master and lent itself to personifications of Antinous, Narcissus, and St. Sebastian. Such early works of Correggio's as the *Young Christ* of about 1513 (fig. 2.8) demonstrate familiarity with Leonardo's ideal type: smoothly modeled flesh with delicate sfumato, oval face, long ringlets, mysterious unfocused gaze, and slightly parted lips—features still evident in Correggio's later painting of Ganymede.[47]

We might expect that the androgynous type in Leonardo's oeuvre shows his desire for the kind of hermaphroditic ideal that, as we have seen, was closely associated with homosexual attraction. However, except for the in-

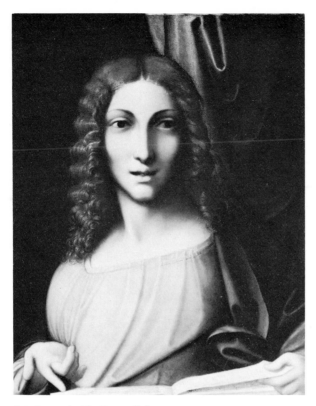

2.8 Correggio, *The Young Christ.*

conclusive *tamburo* episodes, there is no evidence of any overt sexual activity on the part of this lifelong bachelor, nor did he have more than a handful of close personal attachments. Leonardo consistently restrained his emotions and felt a deep antipathy toward sexual passion and the bodily functions related to intercourse. His recorded comments and relevant drawings imply that this predisposition led him to idealize the androgyne not as a symbol of sexual excitation but as a fantasy of escape from sexual desire.

Freud, in his groundbreaking though still controversial attempt to connect Leonardo's scientific projects to his intrapsychic dynamics, drew attention to two related aspects of Leonardo's personality, "his overpowerful instinct for research and the atrophy of his sexual life." From one of the artist's few biographical *ricordi*—a childhood dream in which a great bird (*nibio*) swooped down and beat his mouth—Freud developed a theory of youthful trauma accounting for Leonardo's later fear of sexuality and suggested that the artist sublimated his erotic energies into intellectual pur-

suits. Freud's analysis of this supposedly overwhelming memory helps explain why Leonardo never chose to illustrate the rape of Ganymede. It was too close to the primal experience of which the artist had written: "It seemed to me when I was in the cradle that a kite came and opened my mouth with its tail, and struck me within upon the lips with its tail many times."[48]

Whatever the etiology of Leonardo's reluctance about sexuality, his adult feelings are evident from his writings and drawings. Although his well-known sectional diagram of heterosexual intercourse (Windsor, Royal Library No. 19097v) shows that his scientific curiosity extended to sex as well as to other anatomical and physiological subjects, he wrote in his notebooks of his distaste for the experience: "The act of procreation and the members employed therein are so repulsive, that if it were not for the beauty of the faces and the adornments of the actors and the pent-up impulse, nature would lose the human species." In the passage entitled _Della verga_, Leonardo complains about the penis, which seems to him a problematic, almost magical organ because it rises and falls of its own accord, refusing to obey the higher dictates of the conscious will. Elsewhere, he writes that, ideally: "Intellectual passion drives out sensuality. Whoever does not curb lustful desire puts himself on a level with the beasts. One can have no greater mastery than that over one's own self."[49]

In two drawings from the 1490s Leonardo visualizes struggles between opposing forces as a double or hermaphroditic being. The drawing usually entitled _Allegory of Virtue and Envy_ (fig. 2.9) depicts a pair of figures joined at the waist, grappling as if in conflict: the right, male figure is gripping the female's neck while she sets fire to his hair. The absence of legs on the female heightens the impression that the two combatants constitute one figure and creates an image very close to the two- or three-legged hermaphrodites common in alchemical illustrations of the late medieval and Renaissance periods (see fig. 2.11). The inscription on the sheet points up Leonardo's idea that these two forces, of opposite moral value, are inextricable yet antagonistic: "No sooner is Virtue born than Envy comes into the world to attack it and sooner will there be a body without a shadow than Virtue without Envy."[50]

In another drawing, the _Allegory of Pleasure and Pain_ (fig. 2.10), Leonardo fuses two figures even more explicitly, depicting two male figures back-to-back on the same trunk; in this case the polarity is of ages rather than sexes. The long inscription on both recto and verso of this sheet explains, "Pleasure and Pain are represented as twins, as though they were joined together, for there is never the one without the other; and they turn their backs because they are contrary to each other."[51]

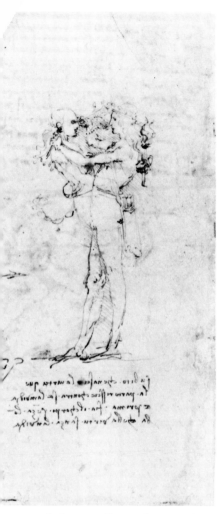 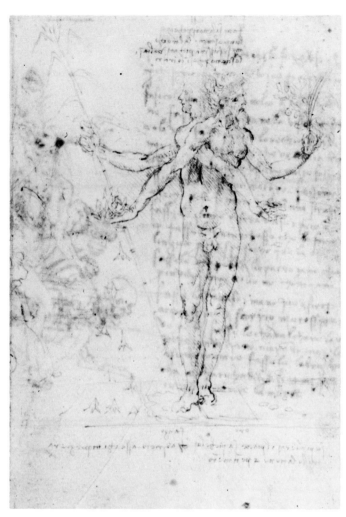

.9 Leonardo da Vinci, *Allegory of Virtue and Envy.* 2.10 Leonardo da Vinci, *Allegory of Pleasure and Pain.*

Eissler, following Freud, declares that the *Allegory of Virtue and Envy* indicates Leonardo's misogyny and anxiety about physical contact with females. However, given that Leonardo expressed a similar anxiety in *Pleasure and Pain* in terms of two males, it seems more accurate to interpret these drawings together as showing anxiety about all submission to physical drives, whether heterosexual or homosexual. In other words, it is not simply the literal intercourse of male and female individuals that Leonardo finds problematic but the metaphorical conjunction of masculine and feminine traits within one individual. He seems to have associated the combined male and female halves of his hermaphroditic figure with the conflict between the rational, "masculine" will to virtue and the more "feminine" aspect of sexual passion.[52]

Leonardo's solution to this conflict was to sublimate his erotic longings through his art—specifically, in the lifelong search for a beauty that could fuse opposing experiences into one self-contained and undifferentiated whole. In the works we have examined here, he moved from juxtaposing two conflicting principles (in the two allegories) to the late _St. John_, which fuses the qualities of male and female into a single being whose mysterious smile seems to bespeak the unearthly peace of a timeless, quasi-divine unity. The earlier allegories are hermaphroditic in the precise sense of combining two opposing poles which still retain elements of their distinctive identities, while the _St. John_ subsumes those oppositions into a single, more truly androgynous being who so thoroughly integrates the polarities as to make them indistinguishable.[53]

The germ of this unified aspect of the androgyne was present in Plato and can be traced more or less continuously through Western occult traditions. According to the account of the origin of human sexuality given by Aristophanes in the _Symposium_ (189D–193D), human beings were originally rounded double figures with two faces and eight limbs, and were of three types: half man and half woman, both halves male, and both halves female. They had no need of sexuality until Zeus, angered by their conspiracy against the gods, sliced them in half. Ever since this disruption of their primordial unity, "each is ever searching for the tally [half] that will fit him." Here the hermaphrodite is not the result of an act of union but represents rather a preceding, lost state of idyllic unity, an image of completeness and self-sufficiency that transcends any desire or need for another person. In this incarnation, as Delcourt writes of the Hermaphroditus in Ovid's _Metamorphoses_, the creature becomes "less a doubled god than an asexual one."[54]

Ganymede and the Alchemical Hermaphrodite

Leonardo, with his desire to transcend sexuality, was not alone in his fascination with the image of a primordial unity promising idyllic freedom from sexual longing. The hermaphrodite represented much the same ideal to late Greek Hermetic philosophers and early Christian Gnostics, and to alchemists and Renaissance Neoplatonists.[55] These eclectic and syncretic mystical systems shared a community of sentiment and language, and both alchemical and Neoplatonic authors asserted that a continuous, unified set of philosophical truths underlay their seemingly divergent metaphors. As early as 1330, the northern Italian alchemical writer Petrus Bo-

nus stated in his _Margarita pretiosa novella_ that hermetic wisdom—the occult teachings behind both alchemy and later forms of Renaissance mysticism—had been handed down in concealed form by Homer, Virgil, and Ovid, whose _Metamorphoses_ "treated the secret of the Philosopher's Stone in an esoteric way." This fundamental precept opened the way for numerous detailed explications of Ovid and other classical texts in terms of alchemical allegory. In the fifteenth century Pico della Mirandola and Marsilio Ficino, who traced their orphic and Neoplatonic thought to Hellenistic hermetic sources, believed that all ancient philosophical works derived from the metaphysics of Plato.[56]

Representations of Ganymede in the visual and literary traditions of these various forms of Renaissance mysticism are few in number and widely separated. His figure appears frequently only in cycles of astrological images, where his role is usually minor: an attribute of the planet Jupiter or the personification of the constellation Aquarius, the water-carrier, into which he was metamorphosed. He is illustrated once before the seventeenth century in an alchemical manuscript, the so-called _Nozze_ of 1480. The following investigation cannot, therefore, claim to have discovered any detailed or continuous tradition of an "alchemical Ganymede." It can, however, describe the common points of alchemical and Neoplatonic thought and examine two aspects of Ganymede that lent themselves to alchemical interpretation: his hermaphroditic beauty and his uplifting by the eagle, a bird vested with multiple alchemical significance. The currency of these two metaphors will suggest a supplemental layer of associations that artists and patrons familiar with alchemy read into the myth in Correggio's time, associations which continued into the seventeenth century.[57]

The principles of alchemy are complex and obscure and can only be outlined here. The general goal of the alchemists was the creation of the "philosopher's stone," which could transmute base metal into gold. This quest represented both an exoteric physical process, the combining of particular chemicals to create precious matter, and an esoteric process of psychological maturation and inner harmony resulting from the individual's fusion of masculine and feminine principles. Both of these goals were to be achieved by uniting two opposite substances or psychic principles, variously referred to as white/black, sun/moon, and male/female. Alchemical texts discuss the elements of this mysterious union in terms that recall both Leonardo's vision of opposing psychic forces and the contemporary theories of masculine and feminine identity that we have observed in Castiglione and other writers. An English alchemical text of 1652 that cites a compilation of earlier sources says of the polar elements of the _opus alchymicum_:

"Besides the masculine part of it which is wrought up to a solar quality . . . that which is lunar and feminine . . . will mitigate it with its extreme cold. . . . For though they are both made out of one natural substance, yet in working they have contrary qualities; nevertheless, there is such a natural assistance between them, that what the one cannot do, the other both can and will perform."[58]

Sexual metaphors and images predominate in alchemical texts: their term for one critical stage in the laborious process of joining complementary opposites is *coniunctio*, a word also used for sexual union. The illustrations in such alchemical manuscripts as the sixteenth-century *Rosarium philosophorum* depict this harmonious and blissful fusion of crowned male and female principles as a sexual embrace, and the ideal figure resulting from this eroticized melding as a two-headed, crowned hermaphrodite with one parti-colored body and two arms and legs (fig. 2.11).[59] Although this use of the hermaphrodite is rather remote from the explicit symbolism of the androgynous Ganymede, at the symbolic level there remains an implicit affinity between the alchemical ideal of hermaphroditic personality and the Renaissance notions discussed above of homosexuality as a psychic hybrid or third gender.

The only visual application of Ganymede in an alchemical context appears in the woodcut frontispiece of a treatise by Andreas Libavius, *Alchymia . . . recognita, emendata et aucta*, published at Frankfurt in 1606 (fig. 2.12).[60] This print is closely related in composition and iconography to a group of less esoteric depictions of Ganymede from the same period and thus provides evidence for an exchange of ideas and imagery between alchemical and Neoplatonic philosophy. Libavius's book is one of several alchemical texts published in Germany in the first quarter of the seventeenth century, within the territory and often under the patronage of Emperor Rudolf II. A misanthropic, neurasthenic, and politically ineffectual recluse who devoted much of his long reign (1576–1612) to patronage of the arts and sciences, the emperor was profoundly engaged by the occult arts and supported mystics, cabbalists, and astrologers in addition to more modern scientific figures such as Tycho Brahe and Kepler. Among his honored guests and advisors were the English adept John Dee and the Rosicrucian Michael Maier.[61] Rudolf purchased Correggio's *Ganymede* and *Io* from his Spanish Habsburg cousins in 1603/4 along with Parmigianino's *Cupid Carving his Bow* (fig. 3.24). Any inference based on the emperor's ownership of a few related paintings must be qualified in view of the vast scope of his collections. Nonetheless, our evidence about his interests and those of his intellectual circle suggests that this later generation continued to

2.11 *Rosarium Philosophorum*, fol. 92, Crowned Hermaphrodite.

2.12 Woodcut title page, Andreas Libavius, *Alchymia . . . recognita, emendata et aucta.*

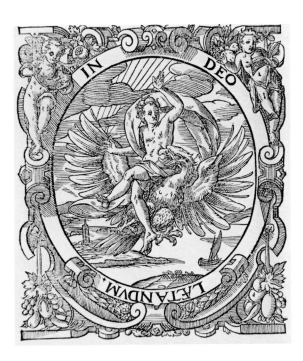

read into the Ganymede myth meanings that, though diverging in part from Correggio's original iconography, overlap and amplify some of the artist's intentions and sources.

The anonymous illustrator of Libavius has chosen Ganymede riding atop the eagle as a prefatory emblem for the entire alchemical text. He surrounds the central image with an oval strapwork border in which is inscribed the legend, IN DEO LAETANDUM ("rejoicing in God"), the motto we have already seen associated with Ganymede in Alciati's *Emblemata* (figs. 1.3, 1.4). The woodcut shows that Neoplatonism and alchemy exchanged visual sources as well: the compositional typology of boy-on-bird above a riverine landscape and the surrounding motto-bearing band are strikingly similar to the illustration of Ganymede in Crispin van de Passe's book of Neoplatonic emblems published at Cologne in 1611/13 (fig. 5.10) and other nearly contemporary minor German compositions whose relation to van de Passe's example is evident.[62] Hence, on a first level of symbolism, Ganymede represents for the alchemists the same idea that he does in Neoplatonism, the questing soul caught up and enraptured by the promised experience of knowledge of the divine.

In addition to its affinities with nearly contemporaneous Neoplatonic images, the Libavius frontispiece also has affinities with the iconography expressed in the widespread and influential writings of Count Michael Maier (1568–1622). Maier was a court favorite of Rudolf's and published his comprehensive occult studies in the decade following Libavius, like him in Frankfurt. Like his fellow alchemists, Maier believed that hermetic wisdom inhered in Greek and Latin literature: his *Arcana arcanissima* (1614) outlined a detailed alchemical explanation of classical mythology.[63] Thus, although Maier never mentions Ganymede, the youth's presence may well be implied by Maier's frequent symbolic use of the familiar alchemical hermaphrodite along with the closely connected characters of Jupiter and his eagle.

Two of Maier's major works, the *Atalanta fugiens* and the *Symbola aurea*, were published in 1617 with detailed illustrations by the engraver Matthäus Merian. In *Atalanta*, one of the most comprehensive of all alchemical emblem books, the sexual union of male and female principles is shown in Emblem XXXIV, and the resulting hermaphrodite appears in Emblems XXXIII and XXXVIII (fig. 2.13).[64] Having achieved this preliminary synthesis, the alchemical adept and his material substance undergo four further transformations; this process and its active agent, heat (or the sun), were symbolized by an eagle. In the illustrations to the *Symbola aurea*, an eagle soaring aloft is contrasted with an earthbound toad as em-

2.13 Michael Maier, *Atalanta Fugiens*, Emblem XXXVIII. 2.14 Michael Maier, *Atalanta Fugiens*, Emblem XLVI.

bodiments of spirit and matter. The eagle is further glorified in Emblem XLIIII of *Atalanta*, where he is identified with the four color stages of the transformation for which he serves as psychopomp or spiritual guide, and in Emblem XLVI Maier makes explicit the bird's connection with Jupiter, who looses two eagles from his outstretched hands (fig. 2.14).[65]

Hence, although Maier himself never says as much, the rape of Ganymede, already used by Libavius a decade earlier, contained further potential for an alchemical reading. By yielding to the uplifting ardor of the eagle, who simultaneously represents Jupiter, sun, and heat, the androgynized alchemical initiate can rise, like Ganymede, to the heights of celestial bliss, *in deo laetandum*; as Maier writes, "The eagle flies up to the clouds and receives the rays of the sun in his eyes." With this understanding of alchemical goals and symbols, we can look again at Libavius's frontispiece and conclude with Johannes Fabricius that it personifies "the alchemist as Ganymede."[66]

The symbolic association of Ganymede with alchemical striving helps us to understand the artistic inclinations of Maier's patron, Rudolf II. Although Rudolf's tastes in art were catholic, he may have had more than a passing interest in the Ganymede theme. He pursued negotiations to obtain Correggio's painting (and its companions) for close to twenty years and on at least one other occasion commissioned a work on the same subject, an elaborate bronze table support composed of a kneeling Ganymede bearing a nectar-dish and backed by a crouching eagle.[67] To some extent, of course, any such Jovian themes were part of the conventional iconography of all

monarchs, particularly of the theoretically supreme and "Roman" emperor. However, the fact that the pictures Rudolf purchased in Spain (the loves of Jupiter and a Cupid) were all on erotic subjects is consistent with his general fondness for idealized beauty bordering on the lascivious: he commissioned or purchased numerous other mythological subjects, often nudes, both female and male.

Rudolf's esthetic ideals apparently included particular sensitivity to male beauty and the ambiguities of androgyny, which may have contributed to his persistent interest in acquiring the *Ganymede*. The Czech poet Vrchlicky described the emperor in ecstasy before one of his favorite antique artworks, a marble torso of a male youth (christened Ilioneus after the son of Niobe). Although Rudolf continually resisted his family's insistence that he marry and produce an heir, he maintained an ongoing quasi-marital relationship with his mistress, Caterina Strada. Suggestively, he seems to have been captivated by Caterina because of her extraordinary resemblance to her brother Octavio.[68]

Since Maier was Rudolf's court alchemist, and since Libavius's opus was printed in the emperor's realm and during his reign, it seems justifiable to suppose that the alchemical meanings of Ganymede were familiar to Rudolf. And if, as Fabricius puts it (*Alchemy*, p. 146), "the agony of spiritual elevation and solar transformation expressed by the legend aptly explains its alchemical popularity," then it seems likely that the high-strung, withdrawn Emperor, obsessed with mystical yearnings and fearful of such adult responsibilities as marriage, would have responded enthusiastically to the alchemical figure of Ganymede, the eternally young seeker after divine revelation.

·3·

PARMIGIANINO
AND GIULIO ROMANO:
Ganymede's Associations with
Apollo, Hebe, and Cupid

*I*n the work of two major artists who were close to Correggio Ganymede carries several interconnected strands of symbolism that extend and amplify the erotic associations given him by Correggio. As we have seen, Giulio Pippi, called Romano (1499–1546), was principal court artist to Federigo II Gonzaga during the period of Correggio's Mantuan commissions. Francesco Mazzola, called Il Parmigianino (1503–40), could not escape the ubiquitous example of his older Parmesan compatriot; the literature on both artists makes constant reference to their mutual stylistic and iconographic influence.[1]

Giulio and Parmigianino were themselves acquainted and traveled in the same cultural circles. Although the sole documented exchange between them dates from April 1540, only a few months before Parmigianino's death, its content implies that they were friends. This letter, sent by Parmigianino to Giulio in Mantua, protests Giulio's acceptance of the commission to replace him on a fresco project in Parma; Parmigianino could hardly be expected to take offense at this or write to the offender about it unless he considered it disloyal to an existing friendship.[2] It seems unlikely that they could have avoided meeting earlier while in Rome. When Parmigianino arrived there in 1524, Giulio was the acknowledged leader of Raphael's surviving *scuola* (though he left soon after). Parmigianino met Pope Clement VII, Giulio's employer, and gave him a painting, the celebrated self-portrait in a convex mirror. The pope gave the picture to Aretino, who was then in his service. Parmigianino subsequently worked di-

rectly for Aretino, who, as we have seen, also knew Giulio in Rome and Mantua. Castiglione too was in Rome during this time, as Federigo's ambassador, and was responsible for hiring Giulio to go to Mantua, so Parmigianino could have met the author of *Il libro del Cortegiano* then, although we have no evidence that he did.[3] A secondary link between Giulio and Parmigianino is the engraver Giulio Bonasone (fl. 1521–74), who made graphic reproductions of both artists' works.

Parmigianino and Giulio are responsible for more depictions of Ganymede than any other Renaissance artists. The uses to which they put this myth cover the same range as many images we have already seen, from plainly erotic illustrations to complex mythological or astrological narratives and personal or dynastic symbolism. Three patterns of symbolism best exemplified by their works, but seen as well in representations by other contemporary artists and in the literature of the time, are particularly relevant to understanding Ganymede's erotic significance: his relationships to his fellow Olympian residents Hebe, Cupid, and Apollo. Jupiter's decision to replace his earlier cupbearer, the girl Hebe, with a boy had been understood since late antiquity as a parable of the superiority of the male, both as a sexual object and more generally. In later adaptations of this iconography we can glimpse important psychological and social connections between homosexuality and misogyny. Ganymede's conflation with Cupid and Apollo is based on physical as well as iconographic affinities. Cupid, the very personification of eros, was at times linked specifically with male-male love, and Apollo's numerous amours with mortal boys predated Jupiter's infatuation with Ganymede. In addition, both were conceived as boyish or androgynous figures—Cupid virtually the same age as Ganymede, Apollo older but still youthful—and the overlapping visual sources for the three males' appearance suggest that the erotic ideal exemplified by Ganymede extended to related mythological subjects, with additional specifics of sexual imagery.

Parmigianino: The First Ganymede

Parmigianino's work stands out in any survey of Ganymede imagery because of the repeated appearance of the subject among his surviving drawings. Depending on the interpretation of the problematic relations between various drawings and their engraved reproductions, Parmigianino illustrated Ganymede at least five, and possibly six or seven times—the largest number of major depictions by any Italian Renaissance artist. (Giulio ac-

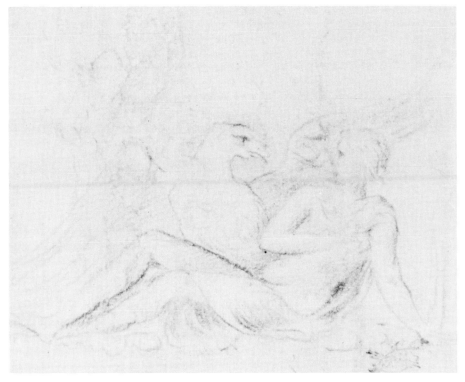

3.1 Parmigianino, drawing after antique sarcophagus, *Ganymede with the Eagle and Cupid.*

tually drew more, but most of his Ganymedes are supporting elements in other scenes.) Parmigianino's Ganymedes are distinguishable by their uniform depiction of the handsome, androgynous adolescent, not in the midst of his dramatic abduction, but standing or sitting in poses that present him as a passive object of attention in his own right.

The first of these drawings (fig. 3.1) testifies to the environment and sources shared by Parmigianino and Giulio as well as to the embryonic association of Ganymede, Cupid, and Apollo. This copy after an antique sarcophagus relief[4] shows a moment of intimate dalliance while the boy and the eagle are still on earth. Ganymede reclines on the ground with knees bent and right arm held across his torso, turning slightly to meet the gaze of the eagle, who stands behind the youth and spreads his wings laterally. In the left background are faint suggestions of a standing figure, probably a winged Cupid; at the right is the rough outline of a tree trunk.

The original carving has been lost, but four drawings by other artists of the fifteenth and sixteenth centuries bear witness to its appearance and accessibility well before and after Parmigianino's time. The first of these

3.2 Drawing after antique sarcophagus, *Codex coburgensis.*

3.3 Giulio Romano, *Apollo with the Eagle of Jupiter.*

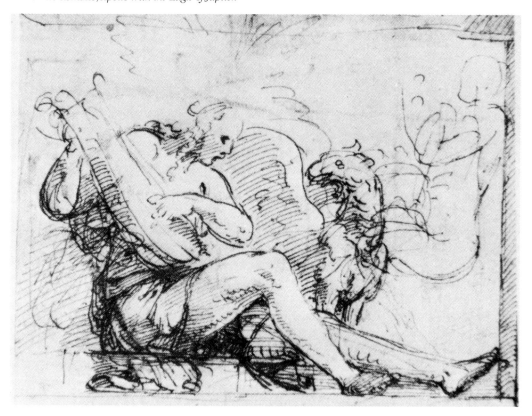

copies is part of a late fifteenth-century sheet recording details from various classical sarcophagi, attributed to the circle of Jacopo Bellini.[5] The lower left panel clearly displays the elements that Parmigianino copied: a male figure reclining before an eagle with spread wings, a winged putto at the left, and a tree (here in the center, not at the right as Parmigianino drew it). The right panel portrays Leda in a pose that mirrors that of the male figure; she too is being courted by Jupiter in avian form (here as a swan).[6] Although the male has been identified as Ganymede, he is an older, strongly muscled man with a long beard. In other essential elements, however, the drawing corresponds to three later copies that clearly depict Ganymede in this panel; such alteration of original sources is typical of Jacopo.

Two manuscripts from the early sixteenth century illustrate the same sarcophagus with some variations from the Bellinesque version; the almost exact correspondence between Parmigianino's drawing and these two sheets leads to the conclusion that as a group they record the antique panel more accurately than the Quattrocento example. A drawing from the *Codex Coburgensis* (fig. 3.2)[7] agrees with the earlier drawing in having two main panels but differs in various secondary and flanking motifs. Most important, the reclining figure in the large left panel, a beardless youth wearing a Phrygian cap, is clearly Ganymede, as he is in the nearly identical drawing from the *Codex Pighianus* and in a later copy by the French artist Pierre Jacques from the 1570s.[8]

The *Codex Pighianus* drawing bears the inscription "in domo Corneliorum," indicating that in the early sixteenth century the sarcophagus was located on the Quirinal hill in Rome, then believed to have been the site of the palace of the Cornelii. Parmigianino was in Rome from 1524 until forced to flee to Bologna by the imperial sack of the city in 1527, and it seems most likely that his drawing was made directly from the sarcophagus.[9] The antique marble would also have been accessible to Giulio Romano, who was in Rome as Raphael's chief assistant and who stayed on as head of the shop after the master's death in 1520 until departing for Mantua in 1524. Giulio's later drawing *Apollo and the Eagle* (fig. 3.3), a preparatory sketch for the Palazzo del Te in Mantua,[10] shows strong parallels with the known drawings of the sarcophagus, though its direction is reversed. The eagle, the central tree, and the sketchy figure at right closely resemble the original; the handsome youth has simply been given longer hair and a lyre to identify him as Apollo.

Parmigianino's Later Drawings: Ganymede Serving Nectar

Four later drawings by Parmigianino (figs. 3.4, 3.9, 3.10, 3.11), all dating from his last years in Parma (1531/2–1540), can be classified as variations on one formal conception: a slender, androgynous blond adolescent stand-ing nude with arms upraised, holding his symbol of office, and viewed in three cases from the rear (*da tergo*), an angle that accentuates his back, thighs, and buttocks. These illustrations, closely intertwined in their visual sources, also contain iconographic elements that suggest they share over-lapping meanings, from alchemical to Neoplatonic, astrological, and erotic. None of the four can properly be called a narrative, for none depicts the rape or any other event in the myth. Rather, Parmigianino focused on isolating a static, idealized image of male beauty and endowing it with both implicit and explicit erotic attraction.

The most highly eroticized of the three back-view variants is the elabo-rate pen and wash presentation drawing *Ganymede Serving Nectar to the Gods* (fig. 3.4).[11] Both of Ganymede's arms are raised; the left hand holds a vessel (partly cut away) and the right a goblet, identifying his function. At his feet lies a figure who also holds a drinking vessel in one hand and seems to gaze into a stream. The group of figures in the background against a grove of trees is the gods assembled for a banquet; a seated ado-lescent male at far left, perhaps Bacchus, holds an upturned pitcher. The composition arrests attention by facing Ganymede toward the gods and presenting the viewer with his exposed buttocks. This pose, which Parmi-gianino typically reused for a variety of both secular and sacred subjects, derives from a terra cotta figurine in the Casa Buonarroti, Florence, sup-posedly Michelangelo's bozzetto for his marble *David* of 1501–04. Parmi-gianino's drawing of this model (fig. 3.5) was probably made in 1524 when he could have passed through Florence en route to Rome.[12] The only differ-ences between this sketch and the serving Ganymede are the positions of the arms (the right one was missing from the original) and the direc-tion of curvature of the spine, which simply reverses that of the earlier drawing.

As if the mere presence of Ganymede, the archetypal young male be-loved of Jupiter, in a provocative pose (to which we shall return) were not sufficient to establish the erotic intent of *Ganymede Serving Nectar*, Parmi-gianino places at the left margin of the group of deities a seated youth similar to Ganymede in age and body type, and even holding a ewer in his raised arm. This figure is virtually identical to the young shepherd in an-

3.4 Parmigianino, *Ganymede Serving Nectar to the Gods*.

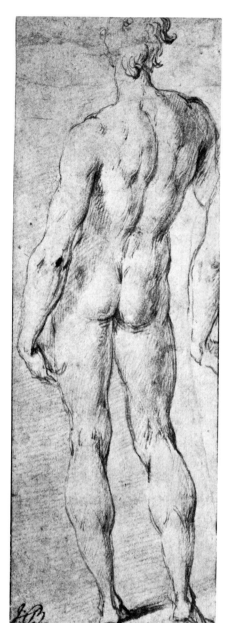

3.5 Parmigianino,
Nude Man Seen from Behind.

3.6 Parmigianino, *Two Nude Shepherds Seated against a Tree.*

other drawing by Parmigianino that captures a moment of affectionate, if somewhat restrained, playfulness between two men. In _Two Nude Shepherds Seated against a Tree_ (fig. 3.6),[13] the Ganymede-like youth holding a reed pipe sits close to an older bearded figure and gestures toward a wreath which the older man holds in his left hand.

Although the precise identity, if any, of this intimate couple is unclear, the scene demonstrates Parmigianino's awareness of the classical literary tradition of idyllic pastoral subjects with homoerotic connotations. The goats over which the two men are watching reinforce the erotic mood: like Pan, satyrs are half goat in reference to that animal's proverbial randiness. The youth's reed pipe is the attribute of Olympos, the mortal boy whom Pan first seduced and then made into his disciple. This story was well known in the Renaissance; for example, in Luca Signorelli's _School of Pan_, painted about 1490, Olympos is a reed-playing nude youth.[14]

Parmigianino's nude shepherds seem to be acting out a similar dalliance, complete with sylvan setting and pipe music, but the older figure has human legs instead of hooves. Even if he is not Pan, however, his affection for the boy fits a pattern of relationships that antique literature also recognized among mortal shepherds and other types (Ganymede himself, it will be recalled, was in some accounts a shepherd). Perhaps the clearest examples of this topos occur in Virgil's _Eclogues_, a group of ten lyric poems extolling the rustic life and ending with the familiar exhortation, "Love conquers all; let us, too, yield to Love!" Three of the _Eclogues_ feature homoerotic characters or references; in _Eclogue_ 2, "Corydon, the shepherd, was aflame for the fair Alexis." The older Corydon, fleeing to the woods, laments his unrequited love in a bucolic fantasy that—with its goats, pipes, and wreaths—is close in mood and detail to Parmigianino's drawing:

> O if you would but live with me in our rude fields and lowly cots, shooting the deer and driving the flock of kids to the green mallows! With me in the woods you shall rival Pan in song. Pan it was who first taught man to make many reeds one with wax; Pan cares for the sheep and the shepherds of the sheep. . . .
>
> Come hither, lovely boy! See, for you the Nymphs bring lilies in heaped-up baskets. . . . My own hands will gather quinces. . . . You too, O laurels, I will pluck, and you, their neighbor myrtle. . . .
>
> The grim lioness follows the wolf, the wolf himself the goat, the wanton goat the flowering clover, and Corydon follows you, Alexis.[15]

This tradition of rustic sensuality must have appealed to Parmigianino's Mantuan contemporary the hedonistic Federigo Gonzaga. In fact, one of

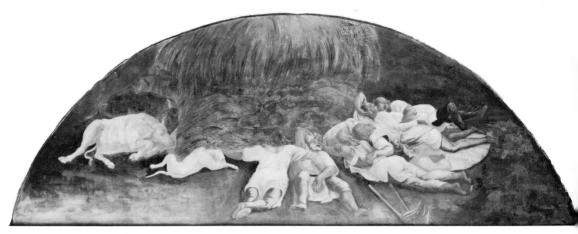

3.7 Giulio Romano, *Harvesters.*

Giulio Romano's lunette frescoes for the Casino della Grotta in Federigo's Palazzo del Te is a scene of sleeping harvesters (fig. 3.7)[16] whose mood of easy, outdoor physical intimacy is consonant with Parmigianino's drawings and the *Eclogues.* It depicts a group of men with their animals before a clump of haystacks. The men lie nestled together, probably resting from the noonday heat, their arms and legs intertwined. Some of the sleepers hold others around the waist as Parmigianino's older shepherd holds the younger one. Given the warm weather of the harvest season, the face-to-face cuddling of the two figures at upper right is presumably motivated by desires other than bodily warmth. The implicit animal passion of their embrace is underscored by the gestures of the harvester at lower center, whose arms are outstretched to touch a man on one side and a sleeping animal on the other. The similarity in rustic subject and homoerotic focus between this work and Parmigianino's, although not so precise as to suggest mutual influence, may be due in part to the artists' shared familiarity with classical erotic pastoral.

Conflation of Ganymede and Apollo

Four other drawings by Parmigianino that also show Ganymede as a somewhat iconic principal figure are close to the serving Ganymede (fig. 3.4) in date, provenance, and sources in antique art and mythology. All of them date from the same late period of activity in Parma, roughly 1532–40, and the pen and brown wash drawing often titled *Ganymede and Hebe* (fig. 3.8) seems to have belonged to the same patron, Francesco Baiardo,

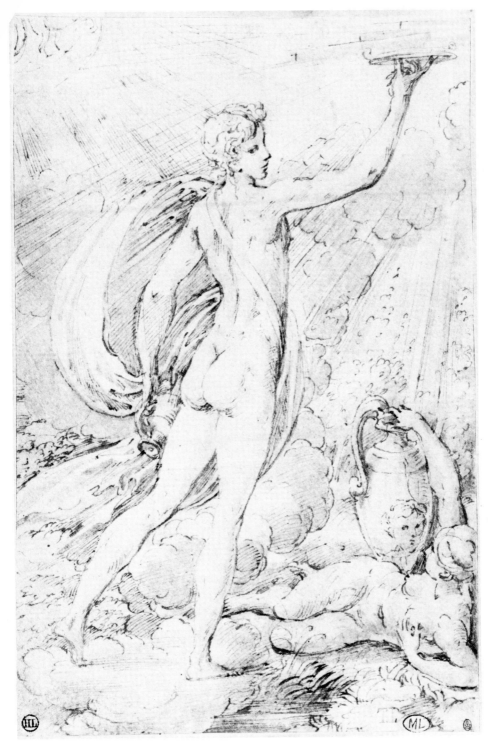

3.8 Parmigianino, *Ganymede and Hebe.*

who owned the serving Ganymede.[17] The principal visual source for all these figures is the well-known Hellenistic sculpture of the *Apollo Belvedere* (figs. 3.12, 3.13). As we have seen, Giulio converted an antique Ganymede into an Apollo; Parmigianino's reversal of this process further demonstrates the formal and iconographic affinities between the two subjects.

In *Ganymede and Hebe*, the figure of Ganymede strides forward to the right, viewed in a three-quarter *da tergo* pose that displays his buttocks, spread legs, and thighs almost as much as in the serving Ganymede. The curve of the spine and the *contrapposto* of the torso are reminiscent of the same figure, and the raised right arm holding a vessel is nearly a mirror image of the serving Ganymede's left arm. On the ground at right, near the stream, a reclining female figure gazes at her reflection in a large amphora; this obscure motif is somewhat similar to the prostrate figure who stares into the water in *Ganymede Serving Nectar*.

The upper half of this striding Ganymede is virtually identical with that of a black chalk preparatory drawing that probably also represents Ganymede, here in a more bent-legged running pose (fig. 3.9).[18] The correspondence between the two is clear from a truncated sketch for *Ganymede and Hebe* (fig. 3.10)[19] that could serve almost as well as a version of the running

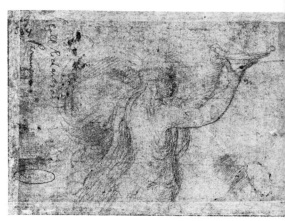

3.10 Parmigianino, study for *Ganymede and Hebe*.

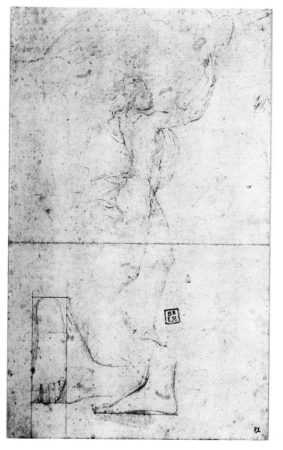

3.9 Parmigianino, sketch for *Running Ganymede*.

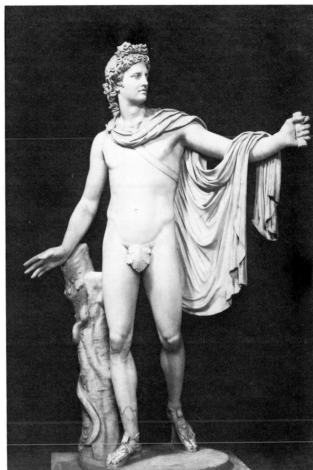

3.11 Hellenistic marble, *Apollo Belvedere*, back view.

3.12 Hellenistic marble, *Apollo Belvedere*, front view.

figure. Although the lower body of the running Ganymede differs some-what from that of the striding youth, all three drawings share the upraised arm, the torsion of the back, the turned head revealing a three-quarter view of the face, and the swayed back and protruding buttocks.

Parmigianino had probably seen the original of the much-admired Apollo; it was already on display in the Belvedere court of the Vatican, from which its nickname derives, when the artist was a guest of Pope Clement. The recto of his running Ganymede sheet bears a highly finished study of Apollo's sandaled left foot, and the feet on the verso directly beneath Gany-mede are also derived from the Apollo (figs. 3.12, 3.13).[20] Parmigianino's adoption of this prototype is clearest in *Ganymede and Hebe*: the pelvis and

the legs of Ganymede—the left extending back with foot lifted, right planted to bear the weight—are those of the Belvedere sculpture presented in a three-quarter rear view. Although Parmigianino removed the *Apollo Belvedere*'s cloak to expose the buttocks and back, the outstretched arm, the hanging arm, the head rotated on the neck, and the Apollonian hair style are all preserved. Ganymede's upper body exchanges the positions of Apollo's raised and lowered arms, but the incomplete original left artists some leeway in respect to any "canonical" position of the arms.[21] In the running Ganymede (fig. 3.9), Parmigianino took further liberties with specific elements of his prototype, particularly in the legs, but the twisted neck and extended arm remain.

The influence of the *Apollo Belvedere* also lies behind one more version of Ganymede by Parmigianino now lost, but known through a chiaroscuro woodcut by Giovanni Battista Frulli (fig. 3.13).[22] Entitled by Fagiolo dell'Arco *Olympus with Ganymede and Saturn*, this composition includes Mercury, Jupiter, and several frolicking putti, all on a heavenly cloud bank, with the eagle below. Ganymede is the central and most prominent figure; as in the other depictions by Parmigianino, he is shown standing, legs

3.13 G. B. Frulli, chiaroscuro woodcut after Parmigianino, *Olympus with Ganymede and Saturn*.

Fran. Mazzola Inu. *Extat apud Ioan: Anton: Armanum Venetum.* Io. Bap. Frulli aer del

3.14 Parmigianino, *Apollo and Marsyas*.

apart, with one arm raised to hold his symbol of office. Unlike the other three versions, however, here he is seen from the front. This view makes the derivation even clearer: the striding pose, positions of the arms, and twist of the head directly reproduce the more familiar frontal view of the *Apollo Belvedere* (fig. 3.12).

The dependence of Parmigianino's various Ganymedes on the *Apollo Belvedere* is grounded in significant visual parallels between the two mythological figures. In his Hellenistic personifications, Apollo was conceived as a long-haired androgyne easily conflated with Ganymede. Parmigianino, like Correggio, was familiar with the gender ambiguities of the classical androgyne: while in Rome he copied the antique sculpture now known as the *Apollo Citharoedus*, then thought to represent Hermaphroditus.[23] On one occasion, a drawing of *Apollo and Marsyas* (fig. 3.14),[24] Parmigianino depicted the viol-playing Apollo as a lithe ephebe with a shoulder strap and billowing drapery similar to the youth in *Ganymede and Hebe*, with a striding pose not unlike that of the *Running Ganymede*.

These formal conflations of the two figures may also reflect their shared literary associations: both were strongly identified with the love of other

3.15 Giulio Romano,
Apollo and Cyparissus (?).

3.16 Engraving after Jacopo
Caraglio, *Apollo and Hyacinthus.*

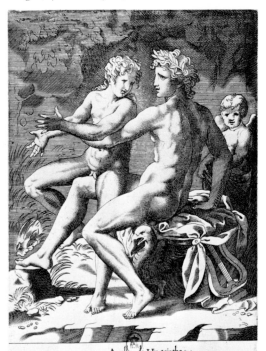

~: Apollo di Hyacintho ~

Nefun min colpi, se del mio donzello Perofon fatto aquel defio ribello,
Le guance io prezzo piu che gemme et oro E tanlo fol per questo, et difcoloro
Dapoi che mi fu amor fi crudo, et fello Et fi mi piace ognhor la noua salma,
Per quella onde uerdeggia il uago alloro Chio le concedo dogni honor la palma

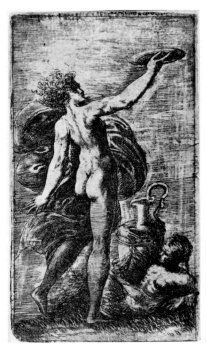

3.17 Andrea Schiavone, etching after
Parmigianino, *Ganymede and Hebe.*

men. By tradition, Apollo was the first god to woo one of his own sex—
Hyacinthus, who had earlier been loved by Thamyris, the first mortal to
love another male. Various antique sources enumerate no fewer than six-
teen young men beloved by the sun-god, the best known of whom are
Hyacinthus and the hunter Cyparissus.[25] These tales were familiar to Ren-
aissance authors and mythographers as early as Poliziano, who in *Orfeo*
(see chapter 1) alluded to Hyacinthus in his catalogue of the gods' homo-
sexual *amori*.[26]

Although Parmigianino's numerous drawings of Apollo do not illustrate
these amorous tales, a drawing by his friend Giulio shows Apollo with a
youth tentatively identified as Cyparissus by his bow (fig. 3.15). The god
dandles him on his knee, taking the boy's face in one hand and kissing him,
while embracing him and fondling his genitals with the other hand. A
female figure observes them with her finger in her mouth, a gesture of
puzzlement or dismay. The position of the youth, one leg slung over Apol-
lo's and placed between the god's thighs, recalls a frequent motif in Ren-
aissance art denoting sexual possession or provocation.[27] Another six-
teenth-century composition, known through an engraving by Jacopo
Caraglio (fig. 3.16), depicts Apollo and Hyacinthus in a similar position;
here a winged Cupid looks on. The engraving is the only homoerotic sub-
ject in a series of twenty loves of the gods.[28]

The Myth of Ganymede and Hebe

The drawing by Parmigianino here called *Ganymede and Hebe* (fig. 3.8)
offers a richly suggestive example of the complexity of Parmigianino's sym-
bolism and, in particular, of the overlap between erotic and occult mean-
ings already seen in Correggio's *Rape of Ganymede*. The identification of
this drawing's subject originated with Bartsch, who applied the title to an
etching by Andrea Schiavone that reproduces the drawing's principal fig-
ures with proportions rather more stocky than in the prototype (fig.
3.17).[29] Bartsch's interpretation is supported by precedents and parallels in
classical and Renaissance literature and related works of Renaissance art.

Ganymede's relationship to Hebe stems from a secondary episode in his
mythography, developed only in later classical literature. According to Vir-
gil, Ovid, and other Latin authors, when Ganymede was brought to Olym-
pus to serve as cupbearer, Jupiter made way for the boy by ousting the
previous holder of that office, Juno's daughter and favorite, Hebe—either
because of Jupiter's love for the boy or because Hebe had stumbled while

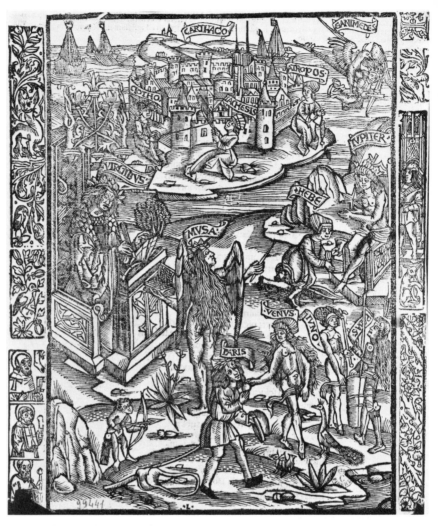

3.18 Woodcut frontispiece, Virgil, *Opera omnia.*

serving him and deserved to be dismissed. Juno's anger and resentment at this slight to her honor are cited by Virgil in the opening lines of the *Aeneid* (1:28) as contributing to the goddess's role in provoking the Trojan War—Ganymede being, of course, a Trojan prince.[30]

Ganymede's acrimonious triumph was widely familiar because of the enormous respect that the Renaissance accorded Virgil's epic, which was frequently reprinted. The woodcut frontispiece to Sebastian Brandt's illustrated *Aeneid* (fig. 3.18), which appeared at Strasbourg in 1502, was reused for two editions of Virgil's *Opera omnia* published in Italy in 1512 and

1522.[31] In rather stiff, still medievalizing tableaux the woodcut presents the author inspired by his muse and surrounded by principal episodes of his story identified on banderoles. Hebe with her cup stumbles at the feet of Jupiter, while above him the eagle transports a robed "Ganimedes." In the foreground, Paris, judging the three goddesses, is attended by Cupid, who prepares to inflame him with a love-arrow. Both Cupid and Ganymede carry a bow; this attribute fits Virgil's description (5:253–57) of Ganymede's abduction while hunting.

Parmigianino's drawing contains enough elements to justify a correlation with the story of Hebe's downfall. The handsome nude male strides forward, his hand raised as if triumphantly brandishing his emblem of office, while below him lies a literally debased female holding an amphora, possibly referring to Hebe's previous activity as wine-pourer. Rays of light emanating from what may be a fragmentary heavenly chariot at upper left and from Ganymede's own vessel add to the impression of an apotheosis of the central figure.

Despite these correspondences, several scholars have questioned, rather inconclusively, Bartsch's interpretation. Popham, for example, has suggested that the motif of the woman's reflection in the amphora calls for a more complex allegorical interpretation, though he finds none that might apply. Mayo doubts that Parmigianino meant to illustrate Ganymede and Hebe simply because depictions of the two together are "practically nil," while Kempter finds it unlikely that Hebe would be shown as disgraced and fallen; both observe that she was of more ancient and divine origin than the mortal boy who replaced her.[32] In fact, however, the literary and visual tradition linking the pair is older and more extensive than Mayo's single example (fig. 3.18), and the comparisons made between the two cupbearers usually do exalt Ganymede at the expense of Hebe, who is disparaged or rejected.

In Hellenistic and medieval literature, Ganymede and Hebe were paired as protagonists in a familiar *topos*, the debate about the relative merits of men and women as sexual partners for men. The most directly applicable of these examples is in the late third-century A.D. Greek novel by Achilles Tatius, *Leucippe and Clitophon*, which was published in a complete Italian translation in 1550.[33] To enliven a long sea voyage, the narrator, Clitophon, instigates an argument between himself, in love with the woman, Leucippe, and Menelaus and Clinias, both lovers of fair boys. In their lighthearted but inconclusive debate, Menelaus invokes the authority of Homer (*Iliad* 20:234) and refers pointedly to Hebe at the end of his misogynistic gloss:

"The gods to be Jove's cup-bearer in heaven him did take,
To dwell immortal there with them, all for his beauty's sake."

But no woman ever went up to heaven by reason of her beauty—yes, Zeus had dealings with women too . . . but if his affections fall upon this Phrygian youth, he takes him to heaven to be with him and to pour his nectar for him; and she whose was formerly this duty, was deprived of the honour—she, I fancy, was a woman.[34]

The opposition of the two cupbearers as advocates of male and female sexual superiority was later dramatized explicitly in an anonymous medieval poem, *Ganymede and Hebe*. In this dialogue the title figures themselves present reasons for preferring their own gender in love. Hebe, speaking on behalf of Juno, goddess of marriage, who "bemoans in her chambers the cup stolen from Hebe," complains bitterly to the assembled gods:

You who restrain the unjust by divine law,
I seek justice from the just; I ask that rights be restored to the injured.
I was Jove's cupbearer while grace allowed,
With the . . .[?] of Jove, and with the sanction of your blessing.
But a new arrival has occupied my place: a unique enemy.
Should I keep silent, boy? Why? You know all.
The Phrygian youth and Troy's shame have invaded the heavens
And founded Trojan strongholds in the skies. . . .
Has the abducted come to ravish the rights of goddesses?[35]

Jupiter's preferment of Ganymede over Hebe and Juno's consequent jealous resentment were often interpreted as a parable of two closely connected social phenomena: the subordinate status or worth of women and the potentially disruptive effect of a man's homosexual infidelities on the relations between husband and wife. The occasional use of Ganymede in marital symbolism is intimately bound up with his broader implications as a classical sanction for, and paradigm of, a generalized misogyny, which in turn served as one justification for male homosexuality.

Jupiter's conflict with Juno over his attraction to Ganymede was utilized by Martial in his *Epigrams* (11:43), where the writer compares the complaints of his wife about his amours with boys to the complaints of Juno and crudely advises her of his preference for the sexual apparatus of boys:

Oh wife, you rebuke me with angry words when you catch me in the company of a boy and insist that you, too, have buttocks. How many times Juno says the same to lascivious Jupiter the Thunderer! Even so,

he lies with the great Ganymede. . . . The fleeing Daphne tormented Apollo, but the boy Oebalius extinguished his ardour. . . . Therefore content yourself by giving masculine names to your possessions, and imagine, wife, that you have two vaginas.[36]

Another epigram (11:104) asserts that Ganymede ministered to Jupiter sexually when not busy as cupbearer, and describes Juno in a belittling comparison to the boy, noting that before his arrival "Juno served as a Ganymede for Jupiter." The resulting tension between the divine couple was also a common parable in medieval literature about homosexuality, "suggesting that marital infidelity is a primary (if not the sole) issue" in the later condemnation of homosexuality.[37]

In the sixteenth century, the god's infatuation with Ganymede was related to his conflict with Juno by Christopher Marlowe. The English poet emphasized the wife's righteous anger at seeing her prerogatives usurped and the husband's almost vindictive unconcern for her complaints. In the first scene of *Dido, Queen of Carthage* (ca. 1590), Marlowe establishes the background of this later episode in the *Aeneid* through a dialogue between Jupiter and Ganymede. When the curtain rises, "There is discovered Jupiter dandling Ganymede upon his knee," while they discuss Ganymede's desire for gifts and Juno's angry attacks on both him and her husband. Both bewitched and defiant, Jupiter says:

> Come, gentle Ganymede, and play with me.
> I love thee well, say Juno what she will . . .
> Hold here, my little love; these linked gems
> My Juno ware upon her marriage-day,
> Put thou about thy neck, my own sweet heart,
> And trick thy arms and shoulders with my theft.

When told of Juno's "shrewish blows" to his favorite, Jupiter threatens to repeat a punishment he had earlier imposed for his wife's rebelliousness, a prospect that makes the boy giggle in anticipation:

> *Jupiter.* What, dares she strike the darling of my thoughts?
> I vow, if she but once frown on thee more,
> To hang her, meteor like, 'twixt heaven and earth,
> And bind her hand and foot, with golden cords,
> As once I did for harming Hercules!
>
> *Ganymede.* Might I but see that pretty sport a-foot,
> O, how would I with Helen's brother laugh,
> And bring the gods to wonder at the game.[38]

3.19 Giovanni Mannozzi, *Jupiter Choosing Ganymede over Hebe.*

The event to which Jupiter refers—he punished Juno by hanging her from her thumbs with an anvil attached to each foot—was illustrated in Parmigianino's time by Correggio and Bonasone.[39] One illustration of *Jupiter Choosing Ganymede over Hebe* demonstrates that the symbolism of their *discordia* persisted well into the seventeenth century: Giovanni Mannozzi's fresco for the Villa Corsini at Mezzomonte, near Florence, painted about 1634 (fig. 3.19).[40] This dramatic *di sotto in sù* ceiling panel shows Jupiter grasping Ganymede's arm and guiding him upward to his side. The god gestures with his other hand to expel Hebe, who tumbles ignominiously backward down the clouds, spilling the contents of her vessel.

The possibility of tension induced between husband and wife by forays into homosexual love may be implied by the *Rape of Ganymede* on a Florentine *cassone* now in Boston (fig. 1.10). This small panel, one of a pair of *testate* or end panels painted about 1475 for a bridal chest by an artist in the circle of Apollonio di Giovanni, has for its pendant the myth of Io and Argos. Many pairs of *testate* exhibit a symbolic parallelism in which the subjects of the related scenes are to be read as "one an example for the groom, the other a warning to the bride."[41] If such a pattern pertains here, the Io panel, representing Jupiter's transformation of his adulterous love into a cow to placate the outrage of his wife, could be taken as a warning to the bride against marital infidelity. If the *Rape of Ganymede* is an ex-

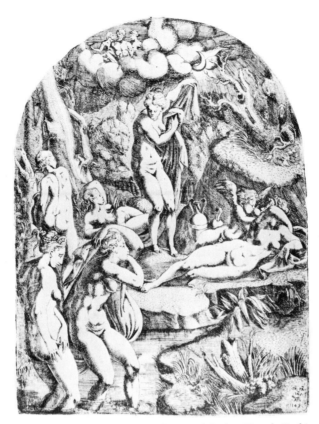

3.20 Antonio Fantuzzi, engraving after Parmigianino, *Nymphs Bathing.*

ample to the groom, however, its apparent exaltation of Jupiter's infidelity with a male seems highly unlikely in a nuptial context. Alternatively, it is possible to read Io's plight as a caution to the husband against indulging his own extramarital desires for women at the expense of conjugal harmony. Ganymede could then be interpreted as a warning to the bride that her husband might seek gratification in the company of men, particularly if she behaves like the rebellious Juno about his infidelities with women. Both of these readings seem somewhat forced or more lighthearted in tone than most such marriage pictures. Whatever the precise intent of the *cassone* scheme, the presence of Ganymede on a bridal chest suggests that male homosexuality was somehow acknowledged as a potential factor in the relations between husband and wife.

An engraving by Antonio Fantuzzi after Parmigianino's drawing of *Nymphs Bathing* (fig. 3.20, ca. 1543) suggests the same message. Fantuzzi added in the upper center a bank of clouds where Jupiter sits with his eagle. Behind him to the left is Ganymede holding a dish; to the right Juno

(wearing a fillet) stares balefully at Ganymede behind Jupiter's back. This interpolation may be a kind of ironic note on the scene below, contrasting Juno's displeasure at Jupiter's erotic adventures with the power and allure of the goddess below: either Diana, who protects chastity, or Venus, who inspires passion.[42]

Ganymede as a Symbol of Misogyny

Although it is often expressed purely in terms of sexual preference, Jupiter's replacement of Hebe with Ganymede may be seen as just one manifestation of the preference for men over women in a much wider context. Renaissance social theories justified male homosexuality in part by assuming men's superiority over women—a belief for which this incident offered a particularly apt symbol. This attitude derived from classical antiquity, but it was also independently affirmed and amplified in Renaissance literature. Although some writers took pains to explain away the homosexual implications of their disparagement of women, their disclaimers are feeble countercurrents in the sea of voices that judged men more worthy of male respect and companionship.[43]

Despite fluctuation in women's legal status and social prestige, in European society men have almost universally assigned women an inferior position and abjured qualities and activities considered distinctively feminine. Western subordination of women has its roots in Greece, where in social and legal standing women were little more than sequestered childbearers, and as a result even romantic love was oriented toward male objects. Greek poets, playwrights, and social theorists from Hesiod to Plato and Aristotle—all widely esteemed in the Renaissance—were essentially misogynistic, or at least gave voice to prevailing social realities. Euripides, for example, may not have been without sympathy for the lot of women, but the complaint he puts in the mouth of Medea still bears witness to the constraints of their social role:

> We women are the most unfortunate creatures.
> Firstly, with an excess of wealth it is required
> For us to buy a husband and take for our bodies
> A master; for not to take one is even worse.[44]

Greek writers criticized women for intellectual and moral weakness. Plato and Aristotle assumed that women were inferior in intelligence, a notion expressed metaphysically by Plato and biologically by Aristotle, who

stated flatly that "between male and female the former is by nature superior and ruler, the latter inferior and subject." In Hesiod's *Theogony*, Pandora, the first woman, is responsible through her curiosity and disobedience for unleashing all evils upon humanity; generalizing from her as Christian theology would later do from Eve, Hesiod concluded that all women are eternally troublesome to men and incur divine punishment through their moral failings.[45]

These ideas, which had a long resonance in many areas of philosophy, were well known in the Renaissance. In his commentary on the *Symposium*, Ficino paraphrased Plato in stating that homosexual relationships are superior to heterosexual ones both intellectually and spiritually:

> Some men, either on account of their nature or their training, are better equipped for offspring of the soul than for those of the body. Others, and certainly the majority of them, are the opposite. The former pursue heavenly love, the latter earthly. The former, therefore, naturally love men more than women, and those nearly adults rather than children, because the first two are much stronger in mental keenness, and this because of its higher beauty is most essential to knowledge, which they naturally wish to cultivate.[46]

Renaissance literature provides numerous instances of the assumption of male superiority, sometimes citing Ganymede as an example. Both Poliziano and Ariosto described men as "the better sex." In Castiglione's *Cortegiano* the longest single debate, occupying the whole of book 3, concerns the nature and value of women. Although, as we saw in chapter 2, Castiglione's characters argue both sides of the question, even the more sympathetic speakers testify to the subordination of Renaissance women to men in many spheres of activity. Among the examples given, marriages are arranged for women, divorce is difficult, and female chastity is considered subject to male property rights. A double standard applies to transgressions of sexual morality, declares the outspoken Gaspare Pallavicino, "for since women are very imperfect creatures, and of little or no dignity compared with men, they are incapable in themselves of performing any virtuous act, and so it was necessary, through shame and fear of disgrace, to place on them a restraint which might foster some good qualities."[47]

The transition from misogyny to advocating homosexuality is expressed most directly and poetically by the title character in Poliziano's verse drama *Orfeo*, first performed in Mantua in 1480. Angered by Eurydice, who tempted him to look back at her as they left Hades and was thus lost to him a second time, Orfeo bitterly denounces women as fickle and

treacherous. Citing a catalogue of divine precedents, he asserts that love of men is preferable to love of women and ends his tirade by advising other men to desert their wives before they too are made to suffer as he was:

> And since such cruel fate I must abhor,
> I shall not love a woman evermore.
>
> Henceforth I prefer to gather different flowers:
> The springtime of the better sex I'll reap,
> So graceful and so lovely in their bowers.
> This is a love more sweet, more soft, more deep.
> Let there be none who prate of woman's powers,
> For she who held my heart lies dead asleep.
> If you would share in my society,
> Do not discourse on female love to me.
>
> How pitiful the man who changes his mind
> For woman, or for her feels joy or dismay,
> Or who permits her his liberty to bind,
> Or trusts her words or glances that betray.
> For she wavers more than a wind-blown leaf, I find:
> She will, she won't, a thousand times a day;
> Trails him who flees, from him who trails her, hides;
> And comes and goes as do, on shore, the tides.
>
> Great Jupiter bears witness to this creed
> Who, by the knot of sweet love held in thrall,
> Enjoys in heaven his fair boy Ganymede
> As Apollo on earth for Hyacinth does call.
> To this holy love did Hercules concede,
> He who felled giants till Hylas made him fall.
> I urge all husbands: seek divorce, and flee
> Each one away from female company.[48]

Ganymede was also invoked as an exemplar of the homosexuality that derives from misogyny by the unknown author of another text from the late fifteenth century, entitled *Il manganello* (*The Cudgel*). This appears in a list of his books that Leonardo made in the *Codex atlanticus*. The treatise, about which little is known, is cast as an attempt to persuade the dedicatee, one Silvestro, to disdain marriage and avoid all women. The author's misogynistic and polemical arguments end with the admonition that if Silvestro wishes to live "happy and well as if you were a god . . . and

not a peasant," he should follow the example of Jupiter, who "withdrew into heaven with Ganymede."[49] We do not know what Leonardo thought of this work; but he appears as a misogynist in the *Libro dei sogni* (*Book of Dreams*, ca. 1563) of Giovanni Paolo Lomazzo. In the fifth dialogue of this work, Lomazzo imagines an exchange between Leonardo and the Greek sculptor Phidias in which Leonardo admits to his own sodomy and defends it on the Platonic grounds that homosexual attachments are the only ones worthy of truly philosophical men or artists. He cites examples of accomplished homosexuals in antiquity and in contemporary Florence and opines that heterosexual intercourse is merely necessary for reproduction.[50]

Those Renaissance women fortunate enough to have the power to protest such attitudes sometimes did so, at least symbolically. In the *Cortegiano*, the revolt of the female characters against Gaspare's attacks is described by its male author in terms that recall explicitly the now familiar ending of *Orfeo*: "At this, seeing the Duchess make a sign, a large number of the ladies present rose to their feet and, laughing, they all ran towards signor Gaspare as if to rain blows on him and treat him as the Bacchantes treated Orpheus, saying at the same time: 'Now you shall see whether we care whether evil things are said about us.'"[51] Parmigianino was familiar with this myth, as can be seen in his drawing *The Death of Orpheus* (fig. 3.21).[52] As if illustrating the Duchess's attack or Poliziano's finale, Parmigianino depicts the maenads of Thrace pummeling the hapless singer who had introduced homosexuality to their homeland. Just as Jupiter rejects Hebe for Ganymede and suffers the wrath of Juno, so Orpheus rejects Eurydice and suffers at the hands of the bacchantes.

We can now understand fully the implications of Parmigianino's *Ganymede and Hebe*. Both the tale of Orpheus and the orphic combat between Gaspare and the Duchess's companions encapsulate the dual psychological basis that links Renaissance misogyny and homosexuality. On the one hand, Gaspare and Orpheus exemplify disdain or contempt for women, whose supposed inferiority we have already examined. At the same time, however, the fate of both speakers at the hands of their resentful auditors bespeaks a deep anxiety about the power of women to lure men or resist male control, an anxiety easily alleviated by following Orfeo's injunction, "Let each one flee from female company." Male homosexuality thus offers both a positive advantage—finding a desirable equal—and a negative one—avoidance of a powerful and potentially violent antagonist. In modern psychological terminology, the latter phenomenon is subsumed under the dynamic of castration anxiety; we need not subscribe to Freud's theory

3.21 Parmigianino, *The Death of Orpheus.*

in detail to accept that "the narcissistic rejection of the female by [the] male is liberally mingled with [both] fear and disdain."[53]

Ganymede served as both a symbol of the androgynous ideal of male beauty and, in his triumph over Hebe, of the superiority of that ideal over feminine beauty and character. Hence it is significant that even those scholars who propose alternatives to the traditional identification of Parmigianino's *Ganymede and Hebe* still interpret the image as an archetypal opposition of masculine and feminine principles. Alchemical symbolism, for example, offers an important supplementary key to many of Parmigianino's works. In view of the connections between Ganymede and alchemical imagery outlined in chapter 2 and the later interest in Parmigianino's works shown by the alchemically minded Emperor Rudolf II, it seems more than coincidental that Parmigianino eventually became so obsessed with alchemical experimentation that he defaulted on his commissions, squandered his money, and changed "from a dainty and gentle person into an almost savage man with long and unkempt beard and locks . . . melancholy and eccentric."[54]

Several symbols current in alchemical writings and images that appear frequently in Parmigianino's oeuvre are present in *Ganymede and Hebe*,

notably the amphora and the woman's reflection in it as well as the androgynous Ganymede himself. The repeated classical urns or amphorae recall the *vas hermeticum*, the urnlike vessel in which components of the *coniunctio* were heated to produce the androgyne. Similarly, the motif of the woman's reflection had mystical overtones of the self-examination that leads to higher knowledge. Parmigianino's interest in such reflective examination is evident in numerous works, particularly in his *Self-Portrait in a Convex Mirror*, later purchased by Rudolf II. The androgyne, as we have seen, represented the ultimate alchemical goal of fusion of opposites, the sexually ambiguous product of the *coniunctio* of masculine and feminine substances or forces. Hence we can interpret the reclining woman's action in *Ganymede and Hebe* as representing a lower level of spiritual self-examination, still tied to earthly concerns, while the standing androgyne is the fulfillment of that process, the triumphant realization of self-knowledge.[55]

This additional interpretation of Parmigianino's drawing, far from ruling out mythological identification for the two figures, reinforces it, since both Neoplatonism and alchemical literature drew constant parallels between classical myth and esoteric teachings. Whether the drawing represents the contrast of full alchemical self-knowledge with its earlier primitive stage or, as Mayo sees it, the Neoplatonic ranking of spiritual intellect above the worldly and carnal sphere, the fundamental theme is the same as that of the episode of *Ganymede and Hebe*: the androgynous perfected male is triumphant over the earthbound, imperfect female. In this incarnation, Ganymede fuses Neoplatonic, alchemical, erotic, and misogynistic aspects into one complex image encompassing all these complementary readings without contradiction.

Ganymede from the Rear: The Eroticism of Male Buttocks

If, as we have seen, the myth of Ganymede and Hebe expresses the belief that men are preferable to women as sexual partners, then the question arises whether Parmigianino's Ganymedes embody any physical characteristics that appeal distinctively to men. Besides showing Ganymede as an androgyne reminiscent of the bisexual Apollo, the salient feature of the illustrations is the presentation of Ganymede fully or partially from behind. The erotic connotations of a boy's posterior were well established in the art and literature of both antiquity and the Renaissance; Ganymede figures often in these references.

The representation of a figure from a variety of perspectives including the back was a basic concern of Renaissance art and art theory;[56] Parmigianino had shown an interest in rear views as early as the 1520s, when he sketched the back of Michelangelo's terra-cotta (fig. 3.5). Even within this venerable artistic tradition, however, his Ganymedes, particularly *Ganymede Serving Nectar*, are exceptional in their insistence on the rear view, nudity, and the centrality of the nude figure to the composition. Though many artists copied or adapted the *Apollo Belvedere*, Parmigianino's derivations are the only ones that reveal the back and the buttocks. His serving Ganymede departs from the expected treatment of an elevated mythological personage to such a degree as to suggest that the blatantly confrontational pose was meant to evoke an irreverent or at least, in the strictest sense, profane response: that is, sexual desire.

Ganymede serves most often merely as a generalized paragon of the desirable male adolescent, but he is occasionally linked implicitly or explicitly with coitus *in ano*, to which many antique precedents refer. The Greeks considered large buttocks and thighs desirable physical characteristics, and numerous examples of Greek art depict anal play or intercourse between men or between a man and a woman.[57] Although, as we have seen, male sexual passivity was socially acceptable only prior to maturity, literary references attest to it among Greek men of all ages. Almost the whole of book 12 of the *Greek Anthology* is devoted to erotic epigrams concerning young boys. A few of these praise the "glorious bum" of this or that boy, in one case specifically lamenting that the youth's incipient maturity "declares war on those who mount from behind."[58] The erotic implications of Ganymede's relation to Zeus are a constant theme;[59] thus, although no epigram expresses it directly, the association of Ganymede with beautiful buttocks, a stereotypical criterion for adolescent beauty, seems plain. Other literary comments regarding anality are comic or derisive, as in Aristophanes' *Clouds* (1085–1104), in which Wrong forces Right to concede that the majority of prominent Athenians "have a wide arse."[60] Even when the implicit judgment is favorable, the tone can be quite blunt. In several of his *Epigrams* Martial uses Ganymede as a symbol for the love of boys, most graphically in the rebuke issued to his wife when she catches him with a boy (11:43), discussed above, where he tells her flatly that he prefers a masculine receptacle to a feminine one. As in the Greek epigrams, the connection of Ganymede's name to anal intercourse, though rare, is clear enough from the generally graphic context.[61]

Renaissance literature and art both refer to the prevalence of anal intercourse. As we have seen in preceding chapters, the Florentine *Facetiae* of

the Quattrocento mention it in several joking tales; one of Castiglione's characters holds that old men devise ways to gratify their sexual desires "for which potency is not required," through passive sodomy; and Ariosto wrote of a humanist poet, "It is a great peril to turn your back if you sleep next to him." In Lomazzo's *Libro dei sogni* dialogue, Phidias asks Leonardo about the details of his love for the beautiful young Salai, "Did you perhaps play with him the game in the behind that the Florentines love so much?" The painter answers, "Oh, many times! After all, he was a most beautiful young man, at most fifteen years old."[62] Leonardo's fictional admission implies that the ideal object of such erotic play is, like Ganymede, young and beautiful, but the parallel between the cupbearer and coitus *in ano* was made explicit in France somewhat later in the sixteenth century. During the reign of the effeminate Henri III (1574–89), satirical attacks on the dissolute hedonism of the king and his male favorites (*mignons*) left no doubt as to the sexual practices imputed to various courtiers, drawing a parallel between the actions of heavenly and earthly rulers. The most notorious of these men was the Sieur de Caylus. Public broadsides declared at his death in 1578 that "Caylus doesn't know how to take people from the front"; called him "Monsieur Culus" (a pun on *cul*, rectum); and wrote sarcastically, "Here lies Caylus, called up to the heavenly realm, so he can be seated closest to Jupiter, with Ganymede."[63]

Within this matrix of associations linking Ganymede to a specific ideal of adolescent male beauty and its corresponding sexual practices, Parmigianino's preference for the back view seems calculated to dramatize the erotic allure of his Ganymedes. Hence it seems suggestive that a number of artists, attracted by the suitability of the youth's aerial abduction as a subject for ceiling paintings, chose to depict the event in foreshortened views from below (*di sotto in sù*) or other poses that similarly accentuate the boy's buttocks and thighs. The clearest example of this type is an octagonal fresco from Novellara long attributed to Correggio, now generally ascribed to Lelio Orsi, which was painted for the Este family between 1546 and 1567 (fig. 3.22). The eagle's wings, its neck stretched across the boy's torso, and Ganymede's head and arms recall Michelangelo's drawing, but the youth's bent and flailing legs and the foreshortened pose revealing his buttocks are closer to the prototype by Correggio.[64] A foreshortened *Rape of Ganymede* ascribed to Damiano Mazza, ca. 1575 (fig. 3.23) was originally also an octagonal centerpiece for a ceiling.[65] The boy's golden-pink flesh tones and fluttering rose-colored drapery, contrasting with a dark brown eagle, are much like those of Correggio's youth (fig. 2.1). In pose, he is essentially Correggio's figure viewed from the other side; like him, he

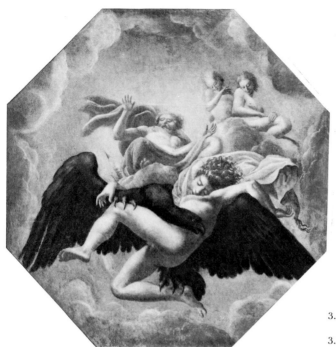

3.22 Lelio Orsi, *Rape of Ganymede.*

3.23 Damiano Mazza, *Rape of Ganymede.*

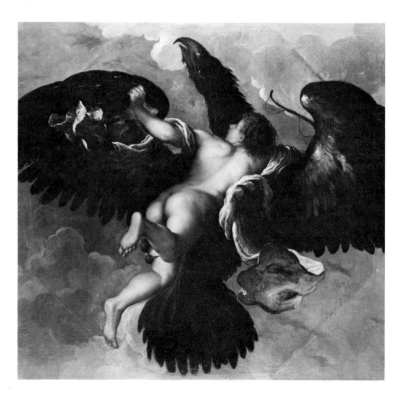

twists his head sharply to the left and tucks it into his shoulder—where, in a unique expressive gesture, he looks into the eye of the eagle.

Conflation of Ganymede and Cupid

The erotic intent behind Parmigianino's drawings of Ganymede is reinforced by their close relation to his painting of *Amor*, or *Cupid Carving His Bow* (fig. 3.24) and to many other depictions of Cupid by Parmigianino, Giulio, Correggio, and other artists. The association or conflation of Ganymede and Cupid in Renaissance art was based (as was that with Apollo) on the two characters' shared formal and iconographic attributes. At times they are so nearly equated that Ganymede is endowed with Cupid's powers and erotic associations, including some specifically homoerotic ones.

Many characteristics of Cupid encourage his confusion or conflation with Ganymede. Both are pretty boys sometimes shown with bow and arrow, and both are associated with flight—that is, with the rapturous uplifting sensation of love.[66] In classical literature they once play together: in a subsidiary incident of the tale of the Golden Fleece, Venus seeks out Cupid to shoot a love-arrow and finds him rolling dice with Ganymede (and cheating).[67] Even where such explicit narrative connection is absent, antique literature utilized Cupid as a conventional symbol or type of ideal male adolescent beauty in terms essentially the same as those used for Ganymede. Among a number of epigrams in praise of young boys (some of whom are compared to Ganymede), the *Greek Anthology* preserves this typical simile: "If thou wert to grow golden wings above, and on thy silvery shoulders were slung a quiver full of arrows, and thou wert to stand, dear, beside Love in his splendor, never, by Hermes I swear it, would Cypris [Aphrodite] herself know which is her son." The special appeal of Cupid's erotic power is made even more explicit in another epigram declaring, "It is Cypris, a woman, who casts at us the fire of passion for women, but Love himself rules over desire for males."[68] Both Cupid and Ganymede have a close relationship with Jupiter and are sometimes shown being kissed or embraced by him (see figs. 3.26 to 3.30); in Parmigianino's earliest drawing of *Ganymede and the Eagle* (fig. 3.1), Cupid hovers in the left background as a comment on the erotic nature of the youth's dalliance with the disguised god (cf. fig. 3.16, where he watches Apollo).

The *Amor*, probably painted in 1532–33, portrays a boyish Cupid viewed, like Parmigianino's Ganymedes, obliquely from the rear, bending over in the act of carving his love-inflaming bow. As if interrupted by the viewer,

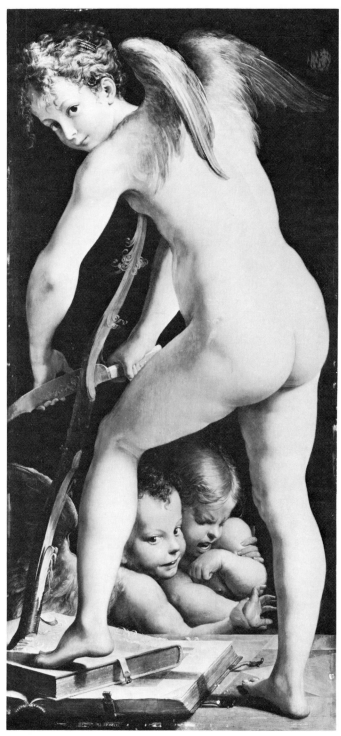

3.24 Parmigianino, *Amor (Cupid Carving His Bow)*.

he turns his head and looks out over his shoulder. To symbolize the awe-
some, irrational force of love, he steps triumphantly on two books, flaunt-
ing his supremacy over the intellect. Cupid's air of calculating sexual prov-
ocation is present in all of Parmigianino's depictions of youth, but *Amor*
pushes it to its extreme: buttocks and thighs seductively displayed, this
triumphant deity coolly shapes the weapon with which he will ensnare the
observer and looks back with a sensual yet slightly threatening appeal.
Between his legs two putti struggle; Vasari interpreted these children, one
of whom cries out in pain on touching Cupid, as an allegory of the burning
dangers of passion.[69]

Some features of the *Amor* suggest that Parmigianino was familiar with
Correggio's recently completed mythological pictures for Federigo Gonzaga
in Mantua, which had already visualized Ganymede and Cupid in similar
terms. Cupid's *da tergo* pose and the turn of his head to engage the viewer,
for example, resemble Correggio's *Ganymede*. The stylistic consonance be-
tween Parmigianino's and Correggio's treatments is attested by the confu-
sion of subsequent viewers, who frequently interchanged their attributions
of the two artists' works.[70] But Parmigianino's salacious yet vaguely omi-
nous vision of sensuality is as far removed from Correggio's frank lustiness
as this lustiness was from Michelangelo's spiritualized transport. Correg-
gio's Ganymede, however coyly he may look out at us, is innocent: he has
been taken by surprise and embraced by a passionate creature whose
wings carry him ecstatically aloft. In contrast, Parmigianino's Amor, de-
spite having his own wings, chooses instead to plant himself firmly on the
ground while simultaneously arousing us and dispassionately making a
weapon to use against us.

In Parmigianino's works the parallels between Cupid and Ganymede re-
main on the level of implicit formal similarities. Their shared erotic impli-
cations are more fully realized in a group of related works associated with
Giulio Romano. Several were executed by Giulio from Raphael's designs;
most of the rest are products of other members of Raphael's circle, in
which Giulio was the central figure from about 1518 until his departure
from Rome for Mantua six years later.

The clearest and most iconographically complex linkage of the two
youths occurs in *Jupiter Overcome by Love for Ganymede* (fig. 3.25), a print
by the Master of the Die, after a composition by Raphael, which dates from
about 1532–33.[71] The engraving depicts Jupiter in a cloud-borne chariot,
falling backward as if struck in the face and dropping his shield and thun-
derbolts. Next to him in the sky, a girlish, elaborately coiffed Ganymede
rides on the back of the eagle, while below Cupid sleeps in the lap of his

mother, who is attended by the three Graces and Mercury. The narrative caption printed below the illustration spells out the connections between the three principals:

> Jupiter in his high chariot,
> Brandishing his thunderbolt and his mighty shield,
> Assaulted Love, who was overcome by a deathlike sleep,
> And who had been so cruel to him.
>
> And Love, without using arrows or wings,
> While sleeping stripped Jupiter of his weapons;
> What trials will he aim against mortal men
> If Love, while sleeping, can take away Jupiter's weapons?

The earliest appearance of Ganymede and Cupid together in the work of Raphael and his Roman followers occurs in the elaborate decorations for the Villa Farnesina, suburban pleasure retreat of the papal banker Agostino Chigi. Both youths appear in close proximity to Jupiter in the loggia known as the Sala di Psiche from the subject of its fresco cycle, the marriage of Cupid and Psyche—a symbolic tribute to Chigi and his celebrated mistress, Imperia. The decorations, illustrating Apuleius's *Metamorphoses* (4:28–6:24), consist of two adjoining ceiling panels, *The Council of the Gods* and *The Wedding Banquet of Cupid and Psyche*, surmounting putto-filled lunettes and spandrels depicting various secondary episodes of the legend. In the *Wedding Banquet*, Ganymede kneels before Cupid's nuptial table and stretches out a serving bowl toward Jupiter.[72]

More erotically suggestive is the spandrel depicting *Jupiter Kissing Cupid* (fig. 3.26), in which Jupiter bestows a kiss of blessing on Cupid's request for Psyche. Embracing the ringleted youth with his right arm, he fondles the boy's face with his left hand and bends his head to kiss him on the mouth. The gesture of Jupiter's left hand, which caresses the youth's chin with one finger extended, was a conventional indicator of tenderness and sexual love. Although it seems unlikely that Raphael meant Jupiter's gesture here to imply actual physical attraction—the god is, after all, blessing Cupid's impending marriage—the scene is so similar to the god's parallel action toward his beloved cupbearer that it was in the past mistakenly identified as *The Kiss of Ganymede*.[73]

The same or related gestures reappear in several later illustrations of Ganymede, Cupid, and other homoerotic figures, all similar to Raphael's spandrel, in which the erotic overtones of this gesture are more appropriate and pronounced. Raffaelle da Montelupo (ca. 1505–66) adopted the

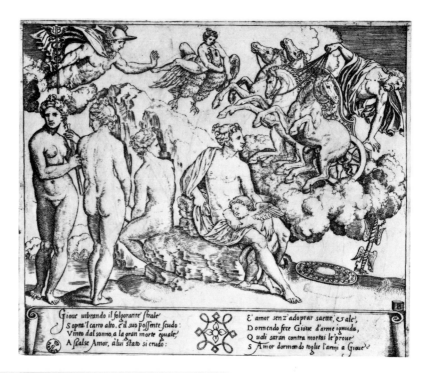

3.25 Master of the Die,
*Jupiter Overcome by Love
for Ganymede.*

Gioue uibrando il folgorante' ſtrale'
S opra'l carro alto, e il ſuo poſſente ſcudo:
Vinto dal ſonno, a la gran morte equale,
A ſcalſe Amor, a lui ſtato ſi crudo:

E' amor ſenz'adoprar ſaette, e ale',
D ormendo fece Gioue d'arme ignuda,
Q uali ſaran contra mortai le'proue
S A mor dormendo toglie l'armi a Gioue'?

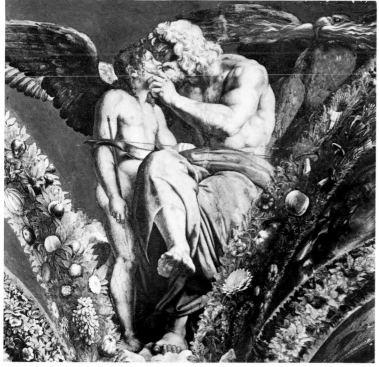

3.26 Raphael (executed by Giulio Romano),
Jupiter Kissing Cupid.

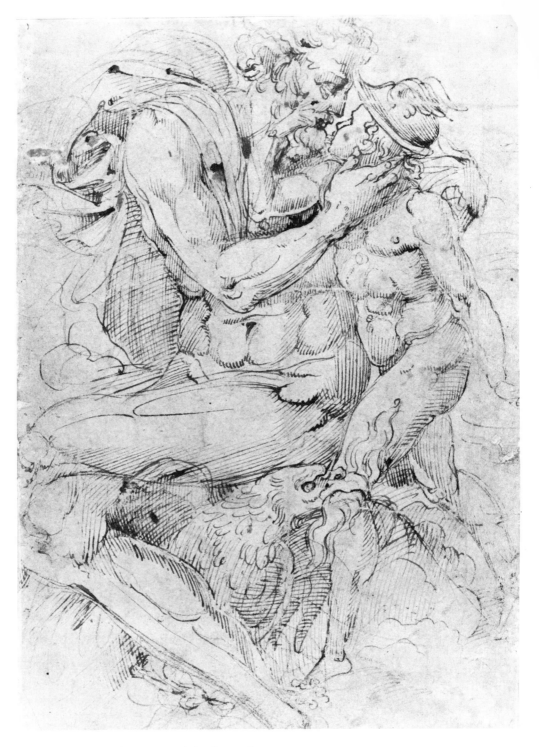

3.27 Raffaelle da Montelupo, *Jupiter Kissing Ganymede*.

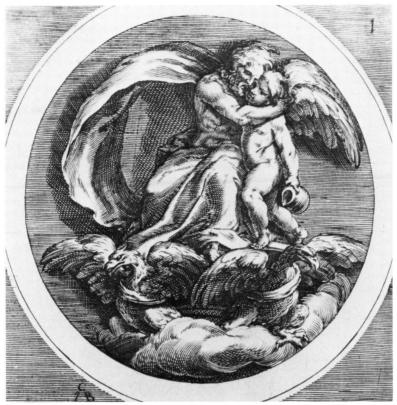

3.28 Cherubino Alberti, engraving after Polidoro da Caravaggio, *Jupiter Embracing Cupid.*

eagle and the upper half of Raphael's group nearly intact for his own draw-
ing of an intimate embrace between Jupiter and a nude youth (fig. 3.27).
Identification of this subject as *Jupiter and Ganymede* might be questioned,
since the youth's winged cap is customarily an attribute of Mercury, but no
mythological incident involving a "kiss of Mercury" is known. Raffaelle
may have meant to identify Ganymede by his traditional Phrygian cap and
confused or embroidered upon his knowledge of classical headgear. As-
suming that the youth does represent Ganymede, this version is a unique
depiction of a tender moment after the abduction, which allows Raffaelle
to show Jupiter restored to his anthropomorphic form. The artist's altera-
tions of the Farnesina prototype further emphasize the erotic relationship
between the two males: Jupiter's left arm now rises to caress the boy's neck,
and Ganymede raises his right arm to stroke the older man's beard in a
reciprocating "chin-chuck."[74]

 Three of the roundels in a series of mythological engravings after designs
by Polidoro da Caravaggio (1490–1543) illustrate similar male-male em-
braces: *Jupiter Embracing Cupid* (fig. 3.28), *Jupiter Embracing Ganymede*

(fig. 1.15), and the *Bacchanal* (fig. 1.16). *Jupiter Embracing Cupid* shows the bearded god drawing a child close to his cheek with an outstretched, slightly bent arm. The face-to-face contact of the pair and the movement of Jupiter's arm are generally similar to the Farnesina spandrel, though Jupiter grasps the boy around the neck more as in Raffaelle's drawing. The boy's wings clearly identify him as Cupid, but in place of a bow and arrow he holds a pitcher, an attribute more usually belonging to Ganymede-Aquarius. The same face-to-face position and arm crooked around the neck of the younger party are present in the *Bacchanal* in the two standing satyr-like men, one older and bearded, who embrace athwart a large wine-vat. The third picture, in which Jupiter's embrace of Ganymede is probably conflated with the castration of Saturn, shares with the others only the men's face-to-face position, as Jupiter here holds the younger figure around the waist.[75]

The face-to-face embrace with a chin-chuck was also used by Giulio himself in several erotic Mantuan works, both heterosexual and homosex-

3.29 Giulio Bonasone, engraving after Giulio Romano, *Neptune Taking Possession of the Sea.*

ual, notably the dual embrace of two *amorini* (cupids) in the loggia of the Palazzo Ducale. He depicted Ganymede and Cupid together in *Neptune Taking Possession of the Sea* (fig. 3.29), part of a series painted about 1530–35, possibly for the Palazzo del Te. In the print after this lost painting, Jupiter observes the principal action from a cloud bank at upper right, flanked by Ganymede and a winged Cupid; he holds the chins of both boys with identical gestures. The meaning and relevance of this subsidiary Jovian group, which may be an interpolation by the engraver, are unclear. On a literal level, Cupid and Ganymede may simply be attributes of Jupiter as god of the air; such a reading is suggested by Jupiter's unusual possession of wings. However, the emotional implications of Jupiter's gestures toward the boys would have been obvious to Giulio, who had executed the original Farnesina *Jupiter Kissing Cupid*. Since the overall theme of the engraved series emphasizes the concord attending the major gods' division of the universe, Cupid and Ganymede may have been inserted here to recall Jupiter's benevolence and affection.[76]

These narrative associations and formal correspondences between Ganymede and Cupid, though not frequent, demonstrate that the boys were thought of in similar visual and iconographic terms. Both were conceived as beautiful youths capable of inciting erotic interest, and both are embraced and kissed by Jupiter in related gestures that are somewhat interchangeable signs of affection.

Giulio's Later Ganymedes

Besides the lost *Neptune*, during his years in Mantua Giulio designed six other compositions that include Ganymede. In most of these the cupbearer is little more than an attribute of Jupiter;[77] in two scenes where he does play a larger role, his erotic significance is subordinated to the broader iconographic interests of Giulio's patron, Federigo Gonzaga.

Giulio's Roman training no doubt influenced his ceiling for the Camerino dei Falconi in the ducal palace, painted between 1536 and 1540. A series of interlocking geometric panels culminates in a central stucco relief of the *Rape of Ganymede*. The subject was chosen for its relevance to the theme of the chamber, whose twelve lunettes were originally decorated with falcons; the decorative scheme celebrates the Gonzaga love of hunting and sport. But the sensual element of the myth is far from forgotten. A school drawing after the central medallion (fig. 3.30) provides a clearer sense of the composition than does the badly damaged fresco; it shows Ganymede

3.30 School of Giulio Romano, drawing after ceiling fresco, *Rape of Ganymede*.

gripped from behind, the eagle's claws clutching him tightly. The hand-some nude youth, holding both ewer and bowl, is manifestly an object of erotic desire: his genitals are prominently displayed by his parted legs, and he twists his head to meet the kiss of the eagle's beak.[78]

On the ceiling of another room in the ducal palace, the Sala di Troia, Ganymede looks on dispassionately in *Venus Swoons in the Arms of Jupiter* (fig. 3.31). In this episode from the *Aeneid* (1:229–96), the goddess of love, who has interceded with Jupiter after the defeat of her faction in the Trojan War, is comforted by the god's prediction that Aeneas will survive and ul-timately found Rome. The scene must be understood in conjunction with the martial wall panels below it and the room's function as an armory. The ensemble seems to indicate a shift in the interests of Federigo Gonzaga in the later 1530s to an avowal of faith in manly, military virtues. This superseded his earlier worship of Venus and made the erotic abandon of Giulio's other works for him and Correggio's mythologies inappropriate.

3.31 Giulio Romano (executed by assistant), *Venus Swoons in the Arms of Jupiter.*

Although the change in emphasis is clear, the subject chosen for this armory still offers a pretext for a sensually posed, seminude female and an equally sensual nude male who occupies the center of the composition despite his irrelevance to the immediate narrative.[79]

Ganymede's repeated appearance in Giulio's Mantuan decorations also owes something to the artist's own independent concerns. Among these predilections the most significant is his long interest in and particular sensitivity to erotic subject matter. Giulio might be termed the sexual polymath of Renaissance art, in terms of both the successive environments he experienced and his artistic responses to them. Well before his warm reception by Federigo in 1524, he was already absorbing from his Roman milieu the attitudes and influences that made Castiglione see in him the ideal painter-architect for Federigo. As we have seen, Giulio was exposed to homoerotic subjects (and one notoriously homosexual artist) from the beginning of his career, when he worked at the Farnesina in the shadow of

Sodoma's *Marriage of Alexander*, Peruzzi's *Ganymede*, and the antique statue of *Pan and Olympos* described by Aretino. He assisted in the Loggia di Psiche as well as in a Ganymede and other Ovidian scenes at the nearby Villa Madama. His knowledge of contemporary sexual practices and his fascination with them is attested by his scandalously graphic drawings for the Aretino-Raimondi *Modi* (chapter 2). Finally, Giulio was treated with admiring generosity by one of the great libertine nobles of the day, who brought him into the orbit of Correggio and Parmigianino, artists for whom eroticism was also a central esthetic impulse. While in Mantua, Giulio was engaged for more than twenty years in filling Federigo's palaces and retreats with traditional erotic subjects as well as more individual renderings of cuddling harvesters, affectionate putti, and pederastic gods.

Conclusion: *Final Flowering, Seeds of Change*

In the numerous depictions by Giulio and Parmigianino, Ganymede appears both as an isolated erotic object and in various suggestive associations or conflations with three other mythological figures—Apollo, Hebe, and Cupid. The form and content of these three broad groups of images are distinct but related. If, as was seen in chapter 2, the central assumption behind Correggio's erotic visualization of Ganymede was that boys are equivalent to women, the illustrations by Giulio and Parmigianino derive from two complementary attitudes implicit in Renaissance conceptions of homoeroticism: that boys also possess their own distinctive erotic traits, and that they (and males in general) are superior to women sexually.

We have seen that Parmigianino's focus on the rear view of both Ganymede and Cupid forms part of a topos in which the particular beauty and the attractiveness of boys are identified with their buttocks and with submission to an older man in anal intercourse. Misogyny, or at least a belief in women's inferiority, was closely linked to men's sexual preference for boys over women, particularly over their wives. This attitude created some tension in marital relations, a conflict symbolized by Juno's resentment of Ganymede for having supplanted her favorite and, in some respects, herself as well. The treatments of Ganymede and other related homoerotic figures vary from lighthearted wedding symbolism to the Virgilian lyricism of Parmigianino's dallying shepherds and the crudeness of Giulio's *Modi* or the classical epigram that bluntly advises a wife to compete with boys by making available to her husband the same orifice they do.

We noted in Parmigianino's *Amor*, similar in form and composition to

several of his Ganymedes, a note of discomfort or danger implicit in the icy remoteness of the god of love, who tramples on the intellect and burns those who come into contact with him. In view of the artist's more accessible and idealized Ganymedes, it is perhaps too much to see Parmigianino as a Counter-Reformation artist *avant la lettre*. Like his compatriot Correggio, he could still transpose his drawings from sacred to secular contexts or the reverse, adapting the *Apollo Belvedere* for both Ganymede and the St. Jerome in his *Madonna of the Long Neck*. Yet only five years after Parmigianino's death and a year before Giulio's, the first session of the great Church council that codified the ecclesiastic and artistic changes of the Counter-Reformation convened at Trent. The artistic role of pagan mythology in general, and of Ganymede in particular, was profoundly altered by the spirit of that movement.

In 1546, the year Giulio died, the Florentine sculptor Benvenuto Cellini reconstructed an antique torso into the last major depiction of Ganymede still within the erotic frame of reference outlined in the first three chapters of this book. Cellini's social environment and personal life betrayed the outlines of an intensified conflict between erotic and spiritual imperatives that soon rendered Ganymede and much of what he had symbolized far less acceptable in art. This shift in attitudes and the resultant changes in images of Ganymede through the first half of the seventeenth century will be the focus of the remaining two chapters.

·4·

BENVENUTO CELLINI:
The Libertine and the
Counter-Reformation

*B*envenuto Cellini (1500–71) was equally renowned for his skill as a goldsmith and sculptor and for his colorful exploits of sex, swordplay, and braggadocio. Florentine by birth, he was a fervent admirer of his older compatriot Michelangelo, with whom he shared the quality of awesome personal forcefulness (*terribilità*) and a passionate fondness for young men. Also like Michelangelo, Cellini bequeathed to history letters and poems, as well as a celebrated autobiography, that allow us to understand the connections between his artworks and his private life. The Ganymede theme was important to Cellini in both spheres: he sculptured two versions of the subject, for one of which he himself suggested the theme to the patron, and he wrote of Ganymede in both poetry and autobiography with explicit reference to his own sexual experiences.

But the comparison between Cellini and Michelangelo is more instructive in its contrasts than its continuities. Chronologically the last Ganymede by any of the five major artists in this study, Cellini's marble sculpture of 1546 (fig. 4.1) came at a critical conjunction of historical, artistic, and personal events that followed shortly after the deaths—or, in Michelangelo's case, profound transformation—of our other artists. Although not quite the youngest of the major artists dealt with here, Cellini survived all of them and participated in the funeral rites for Michelangelo. His *Ganymede* belongs to the beginning of a new and fundamentally different phase of Renaissance art and culture: this restoration of a fragmentary classical ephebe, separated from Michelangelo's drawing by less than fifteen years, is simultaneously the culmination of the homoeroticism *all'antica* celebrated in Michelangelo's youth and a milestone in the dramatic change of attitude that caused that tradition to atrophy.

In Cellini, we find an artist and a man radically different from Michelangelo, one whose prodigious sexual appetite for both men and women could not be contained within the poetic strictures (and justifications) of a chaste Neoplatonism. Examination of his marble *Ganymede* in the light of his life and related works will show how the myth served him as a symbol of important patterns of relation between older and younger men—some purely sexual, others quasi-legitimized within the complexities of teacher-apprentice and master-page interaction. Later in life, however, Cellini's overt libertinism ran afoul of a society grown less tolerant of "pagan" practices and philosophy. The changed moral tone of the Catholic Counter-Reformation was exemplified and codified by the Council of Trent (1545–63), whose first session was in progress while Cellini was carving his *Ganymede*. The artist's work and actions after the early 1550s reveal that his response to the shift toward religious orthodoxy and sobriety was usually sympathetic, if at times ambivalent.

A similar trend is evident in the life of Cellini's principal patron, Cosimo I de' Medici, duke of Florence (later grand duke of Tuscany, r. 1537–74), an active supporter of the Counter-Reformation. The history of this influential patron and his circle of court artists, which included Cellini, illustrates how changing social attitudes gradually transformed a series of Ganymedes, of which Cellini's was among the first, into symbols of different, less erotic concerns. Many of the later examples utilize the myth for the same princely iconography developed for Federigo Gonzaga and Rudolf II; others are more purely decorative works with little discernible symbolism.

Cellini's Character and Career

Cellini's marble *Ganymede* cannot be fully understood without a brief outline of his character and career. As a personality, he was unique and flamboyant; Vasari characterized him as "spirited, proud, vigorous, most resolute, and truly terrible." As an artist, he had many experiences and influences in common with the other artists studied here, all of whom (with the possible exception of Correggio) were in Rome some time between 1517 and 1527.

Apprenticed to a goldsmith in his youth, Cellini excelled in that art, which gave him a highly successful and peripatetic career throughout Italy and in France. Until the age of forty-five, he never stayed more than five years in any one place; the reasons for his frequent and sometimes hasty departures varied from resentment at pay or working conditions to imagined slights of his honor, political upheavals, plague, and frequent criminal

accusations. After 1545 he remained in Florence, where, despite imprisonment and stormy relations with his patron, he worked principally for Cosimo I. From 1557 to 1561, during a period of house arrest resulting from a conviction for sodomy, he began dictating his *Vita*. In 1564, apparently considered rehabilitated from his crime, he was chosen along with Bartolommeo Ammannati to represent the art of sculpture in the funeral procession for Michelangelo. At about the same time he married the mother of some of his illegitimate children, and when he died in 1571 he was buried with full honors in the church of the Santissima Annunziata before an overflow crowd.[1]

In his early career, Cellini's travels brought him into the same Italian milieus introduced in previous chapters. In 1519 he went to Rome, where he resided intermittently through 1540, surviving the sack of 1527 and four criminal accusations. During this time he worked for Pope Clement VII, patron also of Giulio Romano and Parmigianino, and later for Paul III Farnese. He was intimately familiar with such *raffaelisti* as Giulio and Gianfrancesco Penni, with whom in about 1523 he formed a social club that "included the best painters and sculptors and goldsmiths that there were in Rome." He copied the works of Raphael in the Farnesina and Michelangelo's ceiling in the Sistine Chapel, and during the sack he helped defend the Pope's stronghold beside Raffaelle da Montelupo. He also kept up a childhood friendship with Niccolò Tribolo, who later modeled another Ganymede for Cosimo's circle, and served as godfather to Tribolo's son.

Although he maintained a functioning workshop in Rome, Cellini often left it for long sojourns elsewhere, especially in his native Florence. When he went to Mantua in 1527 for four months, his old friend Giulio warmly recommended him to Federigo II, who commissioned work from him. Cellini then returned to Florence, where according to his own testimony he was often visited by Michelangelo. In 1529 he was back in Rome pursuing a friendly rivalry with Michelangelo's protégé Sebastiano del Piombo and extending hospitality to Vasari. In 1536 he first visited France, where his compatriot Rosso was already in the service of François I, returning there in 1540. During his ensuing five years in François' employ he modeled the earlier of his two Ganymedes, one of a pair of mythological bas-reliefs adorning the base of a large silver candelabrum, now lost. In 1545, angered by court intrigues against him, Cellini returned to Florence, where he stayed for the rest of his life. There he earned renown for his famous statue of Perseus (1545–54), executed at the urging of Duke Cosimo.[2] Cosimo was also the patron of Cellini's major statue of Ganymede, to which we shall now turn.

The Marble Ganymede: Commission and Sources

After leaving France permanently, Cellini paid his respects to Cosimo in August 1545, and the duke immediately engaged his services, requesting him to begin with the large *Perseus*. Cellini was at work on this bronze and on the marble figures of *Ganymede* (figs. 4.1, 4.2), *Narcissus* (fig. 4.7), and *Apollo and Hyacinthus* (fig. 4.6) for the next three years; his own account of these works moves back and forth as he concentrated on one or another.

Cellini's interest in the Ganymede theme is evident from his having suggested the subject. Arriving one day at the Duke's palace, Cellini found Cosimo with a small chest sent as a gift. Upon opening the chest to find a fragmentary classical torso, the artist exclaimed: "My lord, it's a statue in Greek marble, and it's a splendid piece of work: I don't remember ever having seen such a beautiful antique statue of a little boy, so beautifully fashioned. Let me make an offer to your Most Illustrious Excellency to restore it—the head and the arms and the feet. I'll add an eagle so we can christen it Ganymede."[3]

As restored by Cellini in 1545–46, *Ganymede and the Eagle* (fig. 4.1) is a white marble sculpture somewhat under four feet tall, which Cosimo originally placed over a doorway in the Pitti Palace. As Cellini had suggested, he added to the anonymous male torso the head, arms, lower limbs, and accompanying eagle.[4] A precise moment in the encounter of Jupiter with the youth is implied in Cellini's restorations. The drapery on the ground and the flattened sack beneath the eagle's left wing, probably Ganymede's shepherd's bag (cf. the bundle on the ground in Michelangelo's drawing, fig. 1.1), indicate that the two are still on earth. Ganymede's relation to the eagle suggests that we are witnessing an imagined interlude of playful seduction before their ascent. The nude boy raises his right hand, which holds a small bird, as if to attract or tease the eagle, and lowers his head to look down at the much smaller eagle, who cranes his neck upward to return the glance. Most touchingly evocative of the gentle and tentative stage of their acquaintance is the gesture of the youth's left hand: one finger delicately ruffles a single tuft of the bird's neck feathers (fig. 4.2).[5]

Several classical prototypes for a standing Ganymede embracing a bird could have been known to Cellini. This compositional type was common in antiquity and continued in provincial Roman centers until the sixth century A.D.[6] Two surviving examples are documented in Italy in the sixteenth century; although there is no evidence that Cellini saw either of these, one of them was on display in Rome during his years there. The resemblances

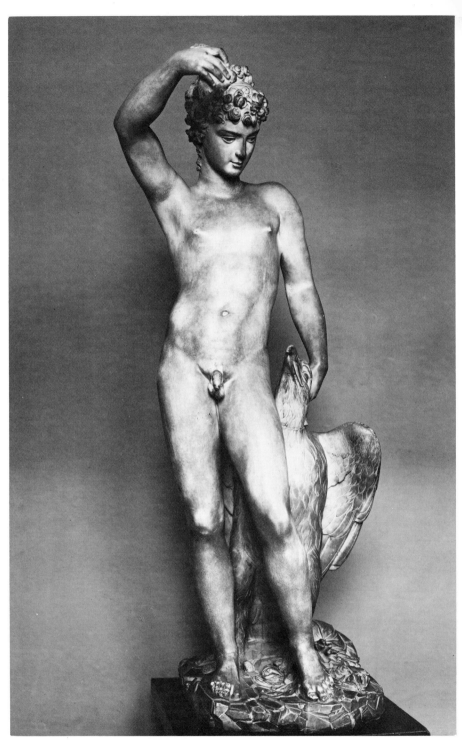

4.1 Cellini, *Ganymede and the Eagle*.

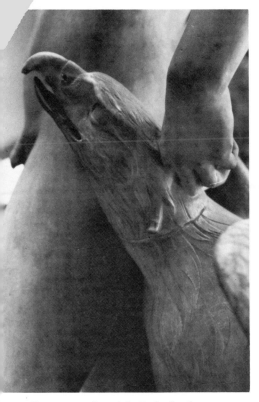

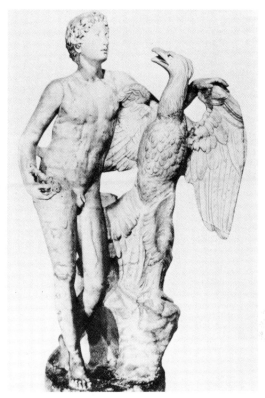

4.2 Cellini, *Ganymede and the Eagle*, detail. 4.3 Roman marble, *Ganymede and the Eagle*.

between Cellini's composition and this antique model are in any case more typological than specific. What is important is not the precise forms Cellini borrowed but his probable awareness of the iconographic tradition behind them.

The more likely sculpture to have influenced Cellini is the marble group *Ganymede and the Eagle* now in the Uffizi (fig. 4.3). This group and a nearly identical version in Naples share with Cellini's conception the elements of a boy standing next to an earthbound bird, the two united by direct eye contact and a hesitant arm-in-wing embrace. Throughout most of the sixteenth century this sculpture was in the possession of the della Valle family, who displayed it in the courtyard of their Roman town house as early as 1513. Cellini might well have studied this Ganymede when he came to Rome six years later, particularly since the della Valle collection of ancient sculptures was highly esteemed by artists and antiquarians. In his sketchbook dating from about 1532–35 the Bolognese painter Amico Aspertini made sketches of nine of them, *Ganymede* included; thus, even if

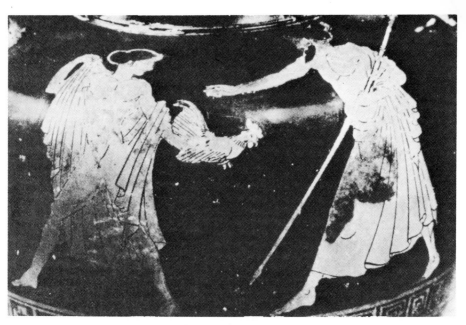

4.4 Amphora, Attic red-figure, *Zeus and Ganymede*.

Cellini himself never had access to the courtyard, he could have learned of the work at second hand.[7]

The sentiment that unites the two figures in Cellini's conception can be determined from the small bird in Ganymede's right hand, a distinctive attribute differing from the traditional Jovian thunderbolt held by the two antique youths. Numerous classical Greek representations of Jupiter and Ganymede in both sculpture and vase-painting show the boy holding a similar bird (fig. 4.4 is an example).[8] Comparison of these works with antique depictions of similar exchanges between mortal men and boys (e.g., fig. 4.5) shows that the bird recalls the Greek custom of courting gifts in homosexual affairs. The *erastes*, an adult man enamored of a youth, was expected to give his *eromenos* tokens of his interest. The conventional offering was a bird, usually a cockerel, although other birds or small animals were sometimes presented.[9]

Although we cannot establish a sufficiently early date of discovery for any antique bird-bearing Ganymede to prove that Cellini could have seen it, it seems highly unlikely that his use of this feature was an independent invention. Birds, particularly the cockerel, had strong sexual connotations for the Greeks, and the same symbolic connection is found in Italian Renaissance literature and art. Pietro Aretino, for example, makes an obscene pun on the word "sparrow" as a synonym for the penis in his *Dialogues*.

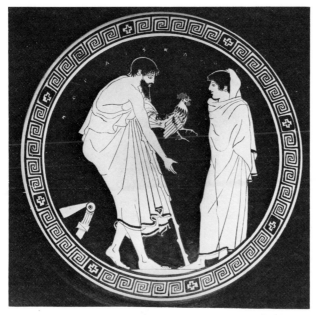

4.5 Interior of cup, Attic red-figure, *Man Offering a Cockerel to a Youth.*

The use of *uccello* (bird) to refer to the male organ persists in modern Italian (cf. English *cock*). These punning references were illustrated in about 1470 by an anonymous northern Italian engraver who represented a penis with the wings, tail, and talons of a bird, a conceit very similar to several antique prototypes.[10]

Cellini's Sexual Behavior and Attitudes

The sexual significance that Ganymede held for Cellini can be seen more precisely in two significant incidents when he spoke or wrote of the Trojan youth by name. The first of these arose directly from the circumstances surrounding the commission for Cellini's restoration. After Cellini had suggested completing the antique fragment as a Ganymede, the sculptor Baccio Bandinelli entered the room and began criticizing the torso. Always ready to quarrel with his detested rival, Cellini defended the marble and in turn excoriated Bandinelli's own *Hercules and Cacus.* Outraged, Bandinelli erupted, "Oh keep quiet, you dirty sodomite." The courtiers, who had hitherto been laughing at the exchange, suddenly became silent and glared at Bandinelli. Cellini, "choked with fury," immediately denied the slur. His reply shows that he was aware both of the connection between Ganymede

and homosexuality and of the existence of such practices in his social milieu: "You madman, you're going too far. But I wish to God I did know how to indulge in such a noble practice; after all, we read that Jove enjoyed it with Ganymede in paradise, and here on earth it is the practice of the greatest emperors and the greatest kings of the world. I'm an insignificant humble man, I haven't the means or the knowledge to meddle in such a marvelous matter."[11]

Although the laughter provoked by Cellini's jesting retort smoothed over the courtiers' shock and his own indignation, the remark is hardly what one would expect to hear from a man genuinely innocent of homosexuality in either knowledge or action. Cellini had, after all, only moments before (if we accept his narrative) finished suggesting that he would like to make a sculpture of Ganymede for the Duke, and his final remarks leave no doubt that he knew exactly what connotations attached to his proposal.

Bandinelli's accusation was in fact amply justified by Cellini's own acts and reputation. The artist was formally charged with the crime of sodomy on two occasions and was publicly accused of it twice more. The verdict of his first court appearance in Florence in 1523 has been lost, but he was presumably found guilty since he was sentenced to pay a fine. More complete court records from March 1557 describe his conviction for sexual relations some five years earlier with a young man named Ferdinando di Giovanni, probably a shop assistant. On that occasion he was sentenced to four years' imprisonment; an appeal to Duke Cosimo succeeded in commuting the penalty to four years' house arrest, during which period Cellini dictated the bulk of his *Vita* (Greci, 20, 65–75).

Cellini's public reputation for homosexuality was also based on accusations that, while less legally conclusive, are equally revealing of his sexual attitudes and behavior. He himself is the source for these anecdotes, but he recounts them only in order to assert his wounded innocence. Although his *Vita* is not strictly chronological, one incident occurred about 1545–47 and might have been known to Bandinelli when he accused Cellini. A prostitute named Gambetta accused Cellini of misconduct, presumably sexual, with her son Cencio, a "little apprentice lad" who Cellini admits was "very pretty" and who also served him as a model; the sculptor indignantly drove the boy and his mother from the house. According to Cellini, Cencio denied any mistreatment and no formal proceedings were instigated; the sculptor nevertheless felt it prudent to flee Florence for several weeks "to let that devilish business blow over." His flight, coupled with the similarity between this episode and his later confirmed relations with the apprentice

Ferdinando, suggest that his protestation of innocence should not be taken at face value.[12]

Cellini unwittingly reveals another reason for public suspicion—and an uncommonly tender aspect of his own personality—in his ardent descriptions of two youthful attachments that suggest his emotional susceptibility to other men. The first of these was to Francesco di Filippo, son of the painter Filippino Lippi. Cellini's attraction, like Michelangelo's for Cavalieri, was based on shared esthetic interests: "I formed a close and intimate friendship with a charming young man of my own age who was also in the goldsmith's trade. . . . We came to love each other so much that we were never apart, day or night. Also, his house was still full of the wonderful studies that his brilliant father had made. . . . When I saw these, I completely lost my head. Francesco and I went together for about two years."

Slightly later, Cellini recalls another young man of his own age, one Piero Landi, saying, "We loved each other more than if we had been brothers." Their relationship was, if not expressly sexual, emotionally intense and physically intimate. Describing their touching farewell when Cellini was forced to flee a murder charge, he tells us that Piero's eyes were "continually wet with tears" and that before departing, "I asked him to pull out a few hairs that were on my chin, the first sign of my beard" (_Vita_, 1:13, 18; tr. Bull, 31, 39).

There can be no doubt that Cellini's _Ganymede_ is the creation of a man who was intimately familiar with homosexual emotions and behavior and was widely believed or known to be so by others. Hence it is no surprise that he made use of Ganymede a decade later in a literary allusion that sums up both his awareness of the myth's significance and his consistent denial of its relevance to him. In 1556, at the end of two months' imprisonment for assault on a rival goldsmith, Cellini wrote a sonnet acknowledging the rumors then current as to the cause of his punishment and ironically protesting his innocence:

> I've struggled through two months here in despair:
> Some say I'm here on Ganymede's account;
> Others, because I spoke out too audaciously.
> To love anyone but women is unknown
> To Perseus; I don't have the fair winged youth's
> Respected prize that everybody sees.[13]

Cellini's Further Homoerotic Sculptures: Androgyny and Bisexuality

In the period immediately following the commission for the *Ganymede* and the accusation by Bandinelli, Cellini carved two other related works whose subjects are equally surprising for a man ostensibly concerned to clear his reputation: *Apollo and Hyacinthus* and *Narcissus*. Since neither sculpture was commissioned by a patron, these mythological subjects—the first explicitly homoerotic, the second implicitly so—provide further evidence of the sculptor's personal interest in such themes and of his responsiveness to young, androgynous male beauty.

Pressed by Cosimo during the initial altercation, Bandinelli conceded that he had promised Cellini a block of marble. When the block was delivered to Cellini's house the next morning, it turned out to be defective. Cellini nevertheless set to work impatiently, saying, "All the same I carved what I could from it—that is, the *Apollo and Hyacinth*, which can still be seen in its imperfect form in my shop" (*Vita* 2:71–72; tr. Bull, 339). The life-size sculpture (fig. 4.6)[14] shows god and boy in a relationship which, if not overtly sexual, is certainly intimate and sensual: the standing nude Apollo plays with the kneeling boy's hair with the same extended forefinger Cellini subsequently used to indicate Ganymede's erotic stroking of the eagle (fig. 4.2). The image recalls one of Cellini's poems addressed to Apollo. Declaring that "to love one another is a matter of compassion," the poem contrasts the acquiescence of Hyacinthus with the resistance of Daphne:

> Your fleeing Daphne shares but poorly
> With your fair Hyacinthus the incurable wound,
> Since in her great error she keeps her distance.[15]

Somewhat later, probably in 1548, Cellini took a second block of marble connected with the Ganymede project and carved from it yet another attractive, eroticized nude youth, the *Narcissus* (fig. 4.7). In this case, the block had been provided by Cosimo, who intended it to be used for the head and limbs to be added to the antique torso. But the sculptor, declaring it a shame to dismember a good stone, procured other marble for the *Ganymede* and instead carved Cosimo's gift into a single figure.[16] The myth of Narcissus, who fell in love with his own reflection, had earlier served Leonardo's circle as one pretext for depicting the beautiful young Salai. Cellini's version takes full advantage of the implicitly homoerotic opportunity to portray a slender, swaying ephebe with richly textured hair and sensuously parted lips, his left arm curved languidly over his head.

4.6 Cellini, *Apollo and Hyacinthus*.

4.7 Cellini, *Narcissus*.

The eroticized androgyny of this cluster of languorous classical nudes that Cellini produced from 1545 to 1548 can also be understood as a manifestation of the prevalent form of bisexuality, which considered boys to be similar to and interchangeable with women (see chapter 2). It is clear that Cellini was fully bisexual: though silent or defensive about his sexual relations with boys, throughout the *Vita* he describes with boastful relish numerous affaires with women. A practical joke that Cellini played on his club of Roman artists in the 1520s demonstrates strikingly how he and his contemporaries appreciated the physical ambiguity of boys. Invited to a supper party to which each male guest was to bring a female companion, Cellini, temporarily without a mistress, "hit on a trick that would amuse everyone enormously." He had a sixteen-year-old neighbor named Diego, whom he often used as a model, and whom he describes as "a handsome boy, with a wonderful complexion, and his head was even more beautifully modelled than that of the ancient statue of Antinous," the young beloved

154

of the emperor Hadrian. Cellini dressed Diego in women's clothes and presented him to the party as "Pomona"; the guests declared "her" the most beautiful girl present. When the ruse was discovered, the women "began insulting him [Diego] in words usually reserved for pretty young men," but the company ultimately turned to laughter and praised Cellini for "a perfect trick" (_Vita_ 1:30; tr. Bull, 58–61).

Ganymede as a Symbol of Master-Servant Relations

On the basis of Cellini's own remarks, it is possible to argue that Ganymede represented for him a special case of the intimacy between older and younger man: relations between masters and servants. As cupbearer and beloved of the king of the gods, Ganymede could easily be taken as a symbol of two parallel forms of such relationships on earth, both of them familiar to Cellini and his circle and acknowledged in classical literature. One is the relation between master and apprentice (or teacher and pupil), which existed in Cellini's own life and in the lives of his fellow artists. The other is the same relationship transposed to a higher social class—nobles and their pages, to whom Cellini alluded in his assertion to Bandinelli that the love of Ganymede was "the practice of the greatest emperors and the greatest kings of the world."

Intimacy between masters and their servants was a familiar topos in classical literature, with Ganymede frequently serving as a metaphor for relationships whose passion was at times emotional, at others physical, and often both. The richest source of examples is the _Greek Anthology_, whose twelfth book is devoted entirely to praise of boys and boy-love, from poetic to ribald. Sometimes the comparison with Ganymede is simply a rhetorical convention for praising beautiful slaves or servants (12:65, 254). Other epigrams demonstrate that mortals who play Ganymede's role, whether or not they bear his name, are like him in their ability to arouse the desires of their superiors: "Either be not jealous with your friends about your slave boys, or do not provide girlish-looking cupbearers. For who is of adamant against love, or who succumbs not to wine, and who does not look curiously at pretty boys? This is the way of living men."

In one epigram, a pleasantly drunken dinner guest enamored of his earthly waiter makes explicit the connection to a heavenly counterpart: "Not only am I in a flutter for the wine-pourer, but I look, out of season, at the Water-pourer too" [Aquarius-Ganymede]. Other types of servants are also included in the general category of those who may have sex with their

masters, including valets or assistants: "Theodorus, as once Idomeneus brought from Crete to Troy Meriones to be his squire, such a dexterous friend have I in thee; for Meriones was in some things his servant, in others his minion [εταιροσυνος]. And do thou, too, all day go about the business of my life, but at night, let us essay Meriones."[17]

In Martial's *Epigrams* we learn that the same pattern existed at the highest Roman social stratum. Several times Martial compares Earinos, cupbearer to the emperor Domitian, to Ganymede, calling him "that boy . . . in all the palace most dear to his master." Elsewhere, he has Jupiter say to Ganymede that "Caesar hath a thousand servants like to thee, and his hall, mighty as it is, scarce holds his youths divinely fair."[18]

We have already seen that in Cellini's time the social patterns connecting men and boys tended to follow classical models, and that many Renaissance men were sexually attracted to youths rather than to men of their own age. We have observed that Cellini and other artists, who lived and worked in close proximity to their teenage apprentices, were open to allegations of pederasty. Cellini's *Vita* alludes several times to close relations between masters and their apprentices. One comic story about his fellow painter Vasari (*Vita* 1:86; tr. Bull, 160) lends credence to the common supposition that artists slept with their assistants. Although this spiteful tale is too brief to establish whether Vasari actually had intercourse, it assumes that masters could share their apprentices' beds and even, at least on this occasion, assign the young men's company to their house guests: "I had entertained him [Vasari] in Rome . . . and he had turned my house topsy-turvy. . . . He had slept with a good-natured young man I had, called Manno, and thinking that he was scratching himself he had taken the skin off one of Manno's legs, with those filthy little claws whose nails he never cut."

While such relations between artists and their apprentices were not necessarily sexual, they were often emotionally intense and of long duration: in the intimacy of the all-male workshop atmosphere, they could hardly have been otherwise. Cellini waxed poetic about his fondness for and devotion to his shop assistants, such as the thirteen-year-old Ascanio, "the most handsome young fellow in Rome," whom the sculptor "began to love and look after . . . as if he were my own son." He is particularly touching when writing of the fourteen-year-old Paulino:

> This Paulino had the most perfect manners, the most honest character, and the prettiest face of any I have come across in all my life . . . [which] made me love him in turn almost more than I could bear. I

loved him so passionately that I was always playing music for
him. . . . Whenever I took up the cornet such a frank, beautiful smile
came over his face that I am not at all surprised at those silly stories
the Greeks wrote about their gods. In fact if Paulino had been alive in
those days he might have unhinged them even more.[19]

Cellini's dismissal of classical mythology is comically disingenuous; he was
obviously familiar with its erotic content, and he himself illustrated three
of these same "silly stories" about beautiful classical ephebes much like
Paulino: Ganymede, Apollo and Hyacinthus, and Narcissus.

Cellini knew Michelangelo and the older artist's faithful servant of
twenty-six years, Urbino. Michelangelo's touching letter to Vasari on the
death of Urbino (1555) is perhaps the clearest surviving statement of the
deep emotional attachment that could arise between an older man and his
younger retainer. Calling Urbino's death "a grave loss and an infinite grief
to me," Michelangelo recalls how he had looked forward to having Urbino
as "the staff and repose of my old age" and concludes sadly, "The greater
part of me is gone with him, and nothing is left me but infinite misery."[20]

Artists and other craft workers were not the only social class to establish
patterns of close relationships between older and younger men; among the
nobility, the parallel institution was that of the page. In continuation of the
medieval knightly tradition, it was common practice in the sixteenth cen-
tury to assign a boy of good birth to serve a courtier as his valet, secretary,
or standard-bearer; this service, like apprenticeship, provided a close long-
term relationship with undertones of physical intimacy.

Cellini describes one typical example of the dual nature of young men's
service to lordly (in this case ecclesiastical) masters. According to his nar-
rative, a beautiful young man in Rome named Luigi Pulci, who had earlier
captivated Michelangelo and was, like Cavalieri, an accomplished human-
ist, appealed to older men for reasons beyond platonic intellectual sympa-
thy: "This young man was a wonderfully talented poet, was a good Latin
scholar, and could write well. At the same time he was very graceful and
extraordinarily handsome. He had just left some bishop or other, and he
was riddled with the French pox [syphilis]." Pulci entered the service of
another bishop, whose nephew Giovanni befriended him. "It soon became
only too clear that Giovanni's love for him was dirty rather than disinter-
ested," Cellini comments, adding that he admonished Pulci "that he had
allowed himself to become enslaved to the sort of bestial vices that would
one day break his neck" (*Vita*, 1:32; tr. Bull, 64).

Numerous Cinquecento portraits of noblemen and their pages testify to

4.8 Parmesan school, *Alessandro Alberti with a Page*.

the opportunity for physical intimacy. In *Alessandro Alberti with a Page* (fig. 4.8),[21] for example, the splendidly dressed noble's young attendant turns toward the viewer in the act of lacing his lord's doublet and breeches, his elbow adjacent to Alberti's prominent codpiece. However, such works are erotic only, if at all, by implication. Documentation of sexual activity between Italian nobles and their attendants, apart from Cellini's anecdotes, is scarce.[22] We do, however, possess more evidence that pages were objects of desire in France and England at a slightly later date. In view of the frequent assertion in both countries that sodomy was a vice imported from Italy, it seems likely that these foreign examples reflect practices current in Italy.[23] In both countries the symbolic vehicle for the accusations is Ganymede.

As was seen in chapter 3, the debauched behavior of Henri III of France and his beautiful young *mignons* gave rise to a general suspicion of homosexual behavior at court; the Seigneur de Caylus was explicitly referred to as the king's Ganymede.[24] In England, Ganymede was widely understood as a symbol of boy-love, and numerous literary examples specifically refer

to the relations of master and page. In addition to citations by Shakespeare and Marlowe (see chapters 2 and 3), Ganymede stood for aristocratic homosexuality in the comment by the seventeenth-century historian John Aubrey about Sir Francis Bacon (1561–1626): "He was a παιδεραστης [pederast]. His Ganymedes and favourites took bribes; but his lordship [did not]."[25]

Thomas Carew's use of Ganymede in the text for the Stuart court masque *Coelum britannicum* (1634) provides the most specific evidence for the pederastic undertones of the noble-page relationship. The character of Momus, announcing a moral transformation of Olympus (a metaphor for his audience, the court of Charles I), declares, "*Ganimede* is forbidden the bedchamber, and must only minister in publique. The gods must keepe no Pages, nor Groomes of their chamber under the age of 25, and those provided of a competent stocke of beard." This euphuistic proscription, recalling the many "Ganymedes" of Francis Bacon and Shakespeare during the preceding reign of James I, implies several characteristics of pederasty. It is (or was previously) practiced by the gods (i.e., the king or his nobles) upon their pages and grooms; pages were understood to perform two functions, one public and official, the other private and sexual; and the preference for young and still beardless boys is considered so powerful that those who are older or prematurely hairy will not incite similar lust in their masters.[26] The similarity between Carew's language and symbolism and Cellini's discussion of "emperors and kings" suggests that Carew's more detailed description of aristocratic English "Ganimedes" may also apply to the Italian customs to which Cellini alludes.

The master-servant dynamic of the Ganymede myth may also have appealed to Cellini on a more personal level as a means of expressing or resolving his psychological attitudes and motivations. At least one study of Cellini's psychology has pointed out his pronounced narcissism, megalomania, and phallic exhibitionism, characteristics that can be traced back even to his early childhood through reminiscences in the *Vita*. From the moment of his birth, when Cellini's overjoyed father (who had been expecting a girl) raised his eyes to heaven and exclaimed repeatedly, "Lord, I thank You with all my heart. This is a great gift, and he is very welcome," the boy was raised with a sense of his own unique worth and charmed life—or at least later constructed an autobiographical myth to support his feelings of importance.[27]

His adult relations with both men and women were impersonal, even offhand, suggesting that Cellini identified psychologically with Jupiter, the all-powerful and superior god. He always chose partners who were

younger than himself and lower in status, whether female servants or male apprentices. The four girls about whom Cellini gives sexual details are all teenagers from the lower classes in the employ of Cellini or his friends. He praises these girls for their beauty and charm, but it is clear that his interest in them is at best utilitarian. Aside from his feelings for Piera near the end of his life, when he seems to have acquired an orthodox sense of responsibility, there is no suggestion of love or eventual marriage in his amours, whose stated purpose is "to satisfy my youthful desires."[28] This attitude and the sordid circumstances of his homosexual affairs bear out Symonds' observation (*Cellini*, xxxv) that "the loves to which he yielded were animal, licentious, almost brutal; determined to some extent by an artist's feeling for beauty, but controlled by no moral sense and elevated by no spiritual enthusiasm." They recall the classical stories of Jupiter's bisexual affairs and that god's self-centered and misogynistic lack of concern for Juno's feelings, a legend familiar from Martial to Marlowe.

At the same time, there is some evidence to suggest that Cellini may also, like Michelangelo, have identified with Ganymede as the favorite and beloved of a powerful paternal figure. The sculptor's early memories of ambivalent treatment by his father (who wanted him to be a musician, not a goldsmith) and grandfather (who prevented him from playing with a dangerous scorpion by cutting off the animal's claws and tail) can be interpreted as evidence of castration anxiety, pointing to the coexistence of a threatening aspect of internalized paternal superego beside its benign and encouraging one. As a result of this psychological duality, as with Michelangelo, "throughout Cellini's life, the expectation of a positive response from father surrogates was crucial to his psychological equilibrium." The greatest threat to such approval and attention was sibling rivalry: the artist's possible early dismay at seeing his younger brother Cecchino displace him as favorite son and a later incident where the boys' sisters gave away Benvenuto's clothes to Cecchino seem to have established the pattern of hurt, angry suspicion that underlay his subsequent violent and outspoken rivalry with Bandinelli. Misogyny also makes its contribution: Cellini is always ready to blame neglect by his male patrons on the supposed machinations of their wives or mistresses, particularly the Duchesse d'Etampes, mistress of François I, and Eleonora di Toledo, consort of Cosimo I.[29] Thus, although Cellini does not describe the event in such terms, the circumstances of his offer to carve a Ganymede for Cosimo suggest that it can be read as an expression of devotion from "Ganymede" to "Jupiter" and an assertion of Cellini's superior claim to paternal support against the rival "sibling" (the myth's Hebe) and despite the opposition of "Juno."

Influence of the Counter-Reformation

After the cluster of homoerotic works produced by Cellini in the late 1540s, artistic representations of Ganymede decreased dramatically in number and suggestiveness. This reduction was but one aspect of a profound change in moral and esthetic values that occurred in the third quarter of the sixteenth century, critically affecting the use of all pagan imagery. As the High Renaissance gave way to the first wave of the Counter-Reformation, an increasing religiosity developed in Cellini, his patron Cosimo I, and many of their contemporaries. Their lives both reflected and contributed to the change in the artistic and social climate codified by the Council of Trent, which took place during the middle and later years of Cosimo and Cellini.

The Council, which met intermittently between 1545 and 1563, was charged with purging the Church of many errors and excesses that had occasioned the Protestant revolts begun by Luther in 1517. In 1564, the Council finally enacted a series of reforms in a wide variety of ecclesiastical doctrines and practices, from liturgy to music and the visual arts. Stricter controls were instituted on lavish material display and on moral laxity, including the establishment of the Index of Prohibited Books. Religious art was now propagandistic: features that distracted from Christian sentiment, such as pagan mythology, were proscribed, as was nudity, which might give rise to inappropriate earthly stimulation. While the Council primarily concerned itself with ecclesiastical settings, pagan imagery was discouraged in private homes as well, and its use was carefully limited. Serious philosophical parallels between classical and Christian iconography, so beloved by the Neoplatonists, were ruled an error, and classical myth was reduced to a pretext for purely decorative treatments. In Anthony Blunt's phrase, the aim of these policies was a return to "medieval purity and monastic simplicity."[30]

The precise impact of the Tridentine spirit on art and artists is still being debated, but the overall effect was clear and dramatic. In 1559, Pope Paul IV ordered Daniele da Volterra to paint draperies over the nudes in Michelangelo's _Last Judgment_, a process continued by Pius V. Artists like the sculptor Ammannati were caught up in repenting their lascivious youthful works in a manner reminiscent of Savonarola's Bonfires of Vanities of the 1490s.[31] Artists' use of Ganymede in the later sixteenth century was inevitably influenced by the changed perception of Ovidian allegory. Apart from a few ceilings by Mazza (fig. 3.23) and others and numerous adaptations

of Michelangelo's venerable motif, the myth nearly disappeared from Italian art as a major subject.

One painter from this period, Jacopo Zucchi (ca. 1541–1589), has left us both a typical later example and some revealing personal commentary on artists' new attitudes. Zucchi, a Florentine pupil of Vasari, decorated two ceilings in the Palazzo Firenze, the Roman home of Cardinal Ferdinando de' Medici, in 1574–75. The vault of his Sala delle Stagioni (Hall of the Seasons) includes allegorical representations of time, the sun, the seasons, and associated signs of the zodiac. One of the twelve subsidiary compartments in the curved soffit depicts Ganymede, here standing for Aquarius. Zucchi's youth is asleep on the ground, reclining in a languid pose with his left arm curved over his head, while the eagle stands next to him with wings raised as if keeping watch. The pose of the boy, similar to that of the reclining female in Titian's *Bacchanal of the Andrians*, may reflect an antique prototype. The nude youth thus does not lack erotic associations, but there is no narrative in the scene; this Ganymede is meant simply as an emblematic representation of one among the various constellations. Zucchi's writings show that he was disinclined to assign the classical myths any high philosophical significance or erotic value. In the treatise outlining the program for his slightly later fresco cycle in the Palazzo Rucellai in Rome, published in 1602 as *Discorso sopra li dei de' gentili* (*Discourse on the Pagan Gods*), he dismisses the gods and other mythological characters as embodiments of the "vain and false religion of the pagans" who were "blinded by false doctrine." Then he attacks the gods as not merely false but immoral, accusing Jupiter of "many infamous and disreputable acts"; quoting Dante, he says that it is better not to speak of them in detail.[32]

Such censoriousness never entirely succeeded in eliminating Neoplatonic allegory or eroticized treatments of classical myth, though it did leave them open to criticism. In the first decade of the seventeenth century, the Lombard artist Caravaggio—like Cellini a brawling bisexual scofflaw—was commissioned by wealthy Romans of pederastic tastes to paint a number of young boys as Bacchus or other classical figures.[33] Although Caravaggio never painted Ganymede, the rape of the cupbearer appears in a complex mythological scheme by his contemporary in Rome, Annibale Carracci (1560–1609): the ceiling of the Farnese Gallery, painted between 1596 and 1600 (figs. 4.9, 4.10). The iconographic program of this enormous chamber in the Palazzo Farnese remains a matter of some dispute. According to Bellori's seventeenth-century account, its theme is the familiar Neoplatonic celebration of the power of heavenly love to inspire and elevate the mortal soul; recently it has been suggested that the tone is more

worldly and satirical, showing the gods themselves at the mercy of love. In either case, the cycle provided Annibale with numerous pretexts for sensuous classical nudes of both sexes.

The erotic character of the series is made clear by the seated satyrs that frame many of the rectangular panels. The homoerotic content of the _Rape of Ganymede_ (fig. 4.9) is underscored by its pairing with another scene representing _Apollo and Hyacinthus_ (fig. 4.10). These two panels are further related by the poses of Hyacinthus and Ganymede, which are virtually front and back views of the same horizontal figure. The relationship of Ganymede to the eagle is particularly intimate: he cradles the eagle's neck in his left arm and gazes smilingly into its eye. These elements of the pose may have been suggested to Annibale by the antique marble _Ganymede and the Eagle_, which, since at least 1574, had occupied one of the wall niches in the room (cf. fig. 4.3). At least one later observer found the ceiling's eroticism blatant and scandalous; in 1688, Jean de la Bruyère—singling out both heterosexual and homosexual examples—noted contemptuously: "That the filthy stories of the gods, Venus, Ganymede, and the other nudities of Carracci, were made for the princes of the Church, and those who call themselves successors of the Apostles, the Farnese Palace offers proof."[34]

Cosimo's Attitudes and Patronage

One group of Ganymede images dating from the 1540s through the early 1570s illustrates the changes that the myth underwent in Cellini's artistic milieu, the court of Cosimo I. In addition to readily accepting Cellini's pro-

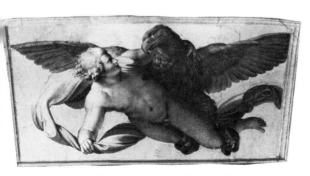

4.9 Annibale Carracci, _Rape of Ganymede_.

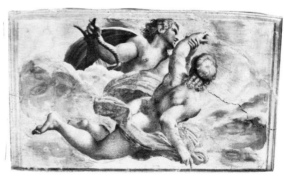

4.10 Annibale Carracci, _Apollo and Hyacinthus_.

posal of the theme, Cosimo can be documented or assumed to have had some connection to at least six other works of art on this subject created at his court. The artists for these works included Tribolo, Vasari, Franco, and Allori, all of them intimately acquainted with each other and with Cellini. Their changing interpretations correlate with Cosimo's evolving personal concerns, providing a clear individual case of the effects of broader social changes of the period. Moreover, the gradual but conclusive change in Cellini's career and attitudes after the completion of his own _Ganymede_ for Cosimo closely parallels these social developments, which his patron actively fostered. The loosely connected group of Cosimo's Ganymede images, reflecting the Counter-Reformation's mood, progressively devalues the myth's sexual significance and visual potential in favor of more political and dynastic concerns or purely decorative usage.

The two earliest Ganymede sculptures for Cosimo date from the first decade of his reign: Cellini's _Ganymede_ of 1545–46 and the _Ganymede Riding on the Eagle_ (fig. 4.11), once attributed to Cellini but probably the nearly contemporary work of his childhood friend Niccolò Tribolo (1500–50), Cosimo's principal sculptor and landscape architect in the decade 1540–50.[35] The confusion of attribution is not surprising, for the slender grace and rippling musculature of Tribolo's Ganymede are much like that of Cellini's own bronzes of this period, such as the _Perseus_. Tribolo's bronze resembles Cellini's treatment in marble of the same subject: both youths, their faces sharply modeled and rather stiff in expression, raise one arm and touch the eagle's feathers with the other, and in both groups the boy's thick and broadly carved cap of hair contrasts with the finely detailed plumage of the bird.

However, Tribolo chose to illustrate Ganymede and the eagle at a very different moment in the story. They are past the interlude of seduction or getting acquainted depicted by Cellini and at the point of departure for the heavens. The pair are not yet quite airborne: one of Ganymede's feet still touches the ground, and the eagle remains in a standing pose. Their ascent is anticipated by the vertical gesture of the boy's extended left arm and by the twisting of the eagle's head slightly upward to follow it. Although Tribolo's sculpture continues the course of events begun by Cellini's, Tribolo's scene has none of that sculpture's overtly erotic elements, no cockerel-gift or caressing finger. Some erotic allure is certainly present in the handsome nude youth, but his compositional relation to the eagle downplays any suggestion of physical intimacy between them.

Tribolo's Ganymede has just climbed aboard the eagle's back, indicating that—in contrast to the swooning, involuntary, and ecstatic abductions

4.11 Niccolò Tribolo, *Ganymede Riding the Eagle.*

imagined by Michelangelo and Correggio—he is, like Cellini's Ganymede, a willing and active partner in his incipient ascent. This compositional type, which can be described as "boy-riding-bird," tends to de-emphasize Ganymede's earthly aspect. It takes the myth's theme of ecstatic transport more literally: flight here is not passionate abandon, but a heavenward joyride susceptible of more spiritual interpretations. The airborne youth astride the back of an eagle was familiar in the Renaissance from imperial Roman coins and medallions. This motif both glorified and sanctified an emperor by showing his ascension to the heavens on Jupiter's eagle, with an implicit analogy to the use of the rape of Ganymede on funerary monuments representing the ascent of the soul after death. As we saw in chapter 1, this complex of spiritualized associations was taken up by the authors of the Renaissance emblem books. The earliest editions of Alciati's *Emblemata*—before the emblem book illustrators succumbed to the powerful example of Michelangelo's swooning Ganymede—depict him as a chubby child riding atop the eagle's back (cf. fig. 1.3). This format ren-

dered the myth more suitable for Cosimo's later commissions, in which it predominates (see figs. 4.12 to 4.14). While Tribolo's Ganymede is the first of these to use the boy-on-bird type, there is little to suggest a specifically Neoplatonic reading of his group; the subject was probably chosen as a decorative motif, whose original purpose and location remain unknown.[36]

Cellini's and Tribolo's sculptures are, respectively, the most expressly sexual and the most seductively finished of the Medicean Ganymedes. At this early date Cosimo's cultural circle could still appreciate classical homoerotic figures rendered in exquisite detail. But the limits of their tolerance were already evident in the shocked response to Bandinelli's blunt assertion of Cellini's actual sexual behavior, which suggests that it was a severe breach of decorum to discuss the subject openly. Within a few years, the increasingly strict morality of Cosimo's court, influenced by his sober and pious consort, Eleonora di Toledo, curtailed most expression of pagan eroticism in art. As Cosimo grew older he too became more concerned with religion. In 1550 he ordered the burning of occult astrological books and began to take an active role in Church affairs, possibly even exerting his influence to reconvene the Council of Trent after a lapse of several years. His alliance with the Popes and the emperor Charles V may have been motivated in part by political considerations; but the Duke's personal physician and biographer, Baccio Baldini, who witnessed such private events as Cosimo's touching benediction at Eleonora's deathbed in 1562, declared that "the Grand Duke's religious zeal was truly very great."[37]

The de-eroticization of Florentine Ganymedes also reflects another central aspect of the patron's personality: homosexuality per se held no interest for Cosimo, who was an ambitiously heterosexual paterfamilias. Throughout his long and eventful reign, the Duke consciously sought to promulgate through artistic patronage an idealized vision of the glory and legitimacy of his fledgling and insecure dynasty. He was fond of classical or mythological subjects extolling those victories and virtues which, by more or less direct implication, Cosimo shared. Although Ganymede figured less often in these schemes than Augustus, Hercules, or Apollo (Richelson, chapters 2 and 3), he appears in one work with a major propagandistic purpose as well as in two elaborate cycles with political and dynastic overtones.

In Battista Franco's *Allegory of the Battle of Montemurlo* (fig. 4.12), Cosimo's symbolic conflation with Ganymede served as an explicitly political reference. This picture, painted about 1555, refers to events of 1537, when Cosimo, at the age of eighteen, had been forced to defend his claim to the duchy of Florence against a rival coalition. It was his initial defeat of that army at Montemurlo, aided by the emperor Charles V, that Franco memo-

4.12 Battista Franco, *Allegory of the Battle of Montemurlo.*

rialized. Above a landscape filled with nude and seminude warriors and
backed by a distant view of Florence, Franco places an exact copy of Mi-
chelangelo's *Rape of Ganymede*. Vasari, both as chronicler and as Cosimo's
artistic overseer, knew this painting well; his detailed analysis touches on
Franco's unusual mixture of historical and mythological motifs and the
influence of Michelangelo, explaining the conceit in which Ganymede rep-
resents the victorious young Cosimo who "had risen by the grace of God
. . . into heaven." The eagle was a conventional symbol of Jovian and im-
perial prestige, and the God Vasari refers to is not merely the heavenly
power but, by implication, its temporal agent, the emperor. Cosimo, al-
ways eager to acknowledge his gratitude and loyalty to Charles, thus mod-
estly casts himself as the swooning youth literally plucked from defeat—
allegorically "raised up to heaven"—by powerful divine intervention.[38]

167

This conceit is expanded to personify Cosimo as both Ganymede and Jupiter in two nearly contemporaneous examples of Medici court art by Vasari himself. In both, Ganymede is only one element in an elaborate allegorical cycle, but his meaning, explained by Vasari, clearly relates to Franco's picture and to the Duke's developing dynastic and political concerns. From 1556 to 1562, Vasari supervised the remodeling and decoration of Cosimo's family quarters in the Palazzo Vecchio in Florence. The decorative program combined mythological and historical subjects in a series of erudite parallels that glorified each Medici ruler by comparison to a classical deity. Ganymede appears, naturally, in the Sala di Giove, the room devoted to Cosimo. In Vasari's *Dialogues*, cast as discussions with Cosimo's son and successor, Francesco, he outlined the program of this room, which had been developed with the help of court humanists. The primary metaphor of the six ceiling panels compares Cosimo to the king of the gods, and their message is dynastic: the *Wedding of Jupiter and Juno*, for example, symbolizes the future succession that will come of Cosimo's union with Eleonora. Elsewhere the mythological identifications change: the *Partition of the Universe among Jupiter, Neptune, and Pluto* represents Francesco and his brothers inheriting the family power and responsibilities. At the same time, Vasari's lengthy description of the *Rape of Ganymede* and the duke's identification with this figure could almost be a more detailed gloss on the identical elements of political allegory in Franco's slightly earlier picture. Comparing the son of Troy's King Tros to "our Duke, the son of the great Giovanni de' Medici," Vasari explains that his painted abduction and elevation to cupbearer signify Cosimo's "having been called in his youth by his fellow-citizens to be prince of the city, and by Caesar, that is the eagle, carried up to heaven and confirmed as Duke."[39]

Jupiter and Ganymede appear with a propagandistic intent again in 1565, when Vasari designed a suite of allegorical floats and masque costumes for the *Trionfo de' sogni*, a splendid public procession celebrating the marriage of Francesco de' Medici to the Habsburg archduchess Joanna, niece of Charles V. Most elaborate of the painted chariots, each bearing a large statue of a classical deity or allegorical figure, was the *carro* of Jupiter. As we know from Vasari's surviving drawing (fig. 4.13) and from his detailed description of this festival, the cart was pulled by two eagles and bore a seated figure of the god, presumably representing Cosimo. On the drawing Vasari sketched four oval cartouches to be painted on the sides of the chariot, depicting Jupiter's rapes of Europa, Ganymede, Aegina, and Danaë. Except for Ganymede, the implications are heterosexual and dynastic. Most of the statues on the float and the costumed figures who walked

4.13 Giorgio Vasari, design for *Carro of Jupiter*.

beside it represented the offspring of Jupiter's liaisons with these and other mortal women and nymphs, among them Cosimo's favorite, Perseus (by Danaë), Hercules, Helen, and Castor and Pollux.

In order to understand the possible significance of the Ganymede cartouche in this familial context, we must take note of one of its pendants. Although Vasari's drawing shows only four designs, his written account tells us that there was also a fifth cartouche illustrating Jupiter delivering his father, Saturn, from imprisonment by the Titans.[40] We have already seen how the trio of Saturn, Jupiter, and Ganymede could symbolize the shifting emotions between fathers and sons (chapter 1), and that for Cosimo, as for Michelangelo, the love of god for boy (though Ganymede is only figuratively the "son" of Jupiter) had overtones of paternal affection and support. Such associations would have been particularly meaningful to Cosimo, who only a year earlier, because of declining health, had appointed his son Francesco as regent.[41] The conjunction of Saturn and Ganymede on Cosimo's chariot thus seems to bespeak the same concern for father-child relationships embodied in the attendant figures of Jupiter's actual children. No longer the young and invincible Perseus himself (as he

had been implicitly in Cellini's statue of that figure begun two decades earlier), the aging Cosimo-Jupiter now takes satisfaction in being the father of a new Perseus. Jupiter is represented as Cosimo would presumably have liked to see himself at this stage in his life: a mature and literally sedate paterfamilias and elder statesman surrounded by his ample brood of offspring who have grown, like Francesco, to adult power and marriages of their own. In the cartouche depicting Ganymede riding Jupiter's back in the familiar boy-on-bird format, Cosimo seems to be saying to Francesco, "I have raised you up to the pinnacle of power and influence, just as my own divine father-figure the emperor once raised me." And in the companion cartouche of Jupiter and Saturn, we can almost see him imploring his own son, now become Jupiter himself, to remember his father with gratitude and to succor him in his imprisonment by old age and ill health.

One later work by a younger Florentine artist illustrates a similar shift in the significance of Ganymede to a strongly heterosexual patron. Federico Zuccari (1542/3–1609), a contemporary of Jacopo Zucchi and his fellow student under Vasari, frescoed this subject on the ceiling of the Sala di Ganimede in his own house in Rome, decorated between 1593 and 1598 (fig. 4.14). His dramatically foreshortened view of boy and eagle above a receding open colonnade is the first illustration of the rape to exploit fully its potential for the illusionistic perspective common in Baroque art. There is little reason to suppose, however, that Zuccari had any personal interest in Ganymede's erotic aspect. In the more private parts of his palazzo, the artist's chosen themes are elaborately familial, including portraits of his male ancestors, parents, brothers, wife, and children, as well as a Sala degli Sposi celebrating the joys and virtues of marriage. The Sala di Ganimede forms part of a suite of five semipublic chambers, replete with mythological allegories, that were used for meetings of the Accademia di San Luca, the artists' guild of which Zuccari was named head in 1598. Although he never wrote of Ganymede, in his influential treatises on art Zuccari twice referred to a flying eagle as a symbol of the "divine spark of Design" and of the "power of creative thought [that] sets us apart from brute beasts."[42] His symbolism harks back to the myth's Neoplatonic interpretation, the artist-Ganymede representing the human mind drawn upward to higher realms through the quasi-spiritual transport of artistic inspiration.

170

4.14 Federico Zuccari, *Rape of Ganymede*.

Cellini, Cosimo, and the Final Ganymede

The changes in social values and artistic methods that run from Cosimo's middle years through the end of the sixteenth century greatly affected Cellini both in putting external constraints on his behavior and in his own psychological development. From the mid-1550s onward, the aging artist gradually abandoned the generally cavalier bisexuality of his youth and middle years, becoming more religious and observant of social norms and more concerned with family and respectability; a corresponding change of emphasis occurred in his art. The chronological interlocking of principal events in his life with those of his patron and of the Tridentine reforms illustrates in summary the course of the changes that led to the gradual de-eroticization of Ganymede.

After the productive nexus of 1545–48 that gave rise to *Ganymede*, *Narcissus*, and *Apollo and Hyacinthus*, Cellini created no more homoerotic works, nor do we have any record of homosexual activity after about 1552, the date alleged in his last conviction for sodomy (1557). The sentence of four years' imprisonment suggests an increase in official revulsion toward

171

the crime that, in 1523, had earned him merely a fine. During this same decade, Cosimo had burned heretical books (1550), and by 1555 Franco's *Montemurlo*, like Vasari's Palazzo Vecchio decorations begun the following year, transformed Ganymede into a political and dynastic rather than erotic symbol. Cellini's 1557 conviction seems not to have disturbed the duke, who continued to praise and patronize the sculptor (Palamede Carpani, 2:462, no. 20); but he would not or could not altogether set aside the verdict, merely moderating the sentence. Hence it is hardly surprising that Cellini's *Vita*, composed during his arrest, omits all mention of his homosexual affairs, records the allegations of Bandinelli and others only in order to deny them, and makes no reference to the circumstances through which he had the leisure to begin his book. Comments like his criticism of the young Pulci's "bestial vices" (1:32), so at odds with Cellini's own homosexual behavior during those years, seem inserted to create a retroactive appearance of orthodox morality.

Although Cellini's growing discretion about homosexuality may have been in part a prudent response to increased social disapproval, his imprisonment of 1557 seems to mark a genuine turning toward pious sobriety. He was proudest of such deeply religious later works as the Escorial crucifix carved from 1556 to 1562 (and purchased by Cosimo), and in 1558 he took minor orders. But this did not prevent him from taking a last mistress, his servant and model Piera de' Parigi. In 1560, noting his desire for children, Cellini renounced his monastic vows; by May of that year Piera had borne a son, whom Cellini successfully petitioned the Duke to legitimize. In 1562 he wrote of his intention to marry and produce further legitimate offspring, and the marriage took place in 1563 or 1564, just as the Council of Trent completed its decrees. Cellini and Piera had three more children, of whom the artist boasted that "they were all born virtuously [santamente] legitimate."[43] One year after their wedding, the secular imagery of Francesco de' Medici's nuptial procession treated Ganymede and his female companions less as a celebration of physical passion than of childbearing and Cosimo's parallel family ambitions.

The series of Medicean Ganymedes that began with Cellini's ended with a sculpture that showed the myth's continuing loss of erotic meaning and form. The marble group *Ganymede Riding the Eagle* (fig. 4.15) that now surmounts a fountain in the Boboli Gardens was originally carved separately from its present base, probably by Battista Lorenzi (1527–94). The figural group, which is first documented over a doorway in the villa at Poggio Imperiale in 1625, was most probably commissioned between 1565, when Cosimo gave the villa to his daughter Isabella, an active patron of the arts, and her death in 1576.[44]

4.15 Battista Lorenzi, *Ganymede Riding the Eagle*.

Lorenzi, a pupil of Cellini's rival Bandinelli, worked with Tribolo and other Medici court artists on the obsequies for Michelangelo in 1564 and on the decoration of Florence for the entry of the archduchess Joanna prior to the *Trionfo de' sogni*.[45] His Ganymede shows him clearly familiar with the boy-on-bird type introduced by Tribolo (fig. 4.11). Moreover, the narrative moment chosen by Lorenzi is almost the same as that of Tribolo's bronze: this Ganymede, too, has one foot still on the ground and is just mounting the back of the standing eagle. But there is even less suggestion here of any intimate interaction between boy and bird. Ganymede gazes pensively at the earth, not yet anticipating his upward flight, while the self-absorbed eagle faces in the opposite direction. The effect is static rather than narrative, and we have no evidence to suggest any deliberate iconographic program. In this final incarnation Ganymede, while still an attractive nude, seems to serve little purpose beyond architectural decoration. The sculpture may also indicate the myth's declining emotional significance in another respect. Michelangelo and Cellini, themselves homosex-

ual, had identified with Ganymede as a symbol of ecstatic or at least adventurous passion, while the heterosexual and dynastic Cosimo saw the myth as embodying his somewhat less intense desires for paternal alliance and filial affection. If Lorenzi's sculpture is in fact the first Ganymede commissioned by a woman, then the subject probably held even less personal meaning for this patron—who would have had little stimulus to self-identification with a male character—than for any male artist or patron of either orientation.

By the time Isabella de' Medici had ceased her decoration of *Poggio Imperiale*, both her father and Cellini were dead. More than a decade had passed since Michelangelo, the ancient survivor of the High Renaissance, had died in the same year as the Tridentine decrees and Cellini's marriage. The harmonious synthesis once envisioned between classical and Christian ideals had splintered and suffered virtual defeat. With the victory of the Christian pantheon over its classical predecessors, the beloved cupbearer was expelled from the heavens and fell from the zenith of his importance as both social symbol and artistic image. The mythological tradition continued to serve as a source of subject matter well into the seventeenth century and beyond, but later depictions of Ganymede seldom recaptured the erotic appeal or iconographic importance he had enjoyed in the first half of the Cinquecento.

·5·

The Seventeenth Century
and Diffusion to the North

Ganymede continued to figure in Italian art well into the seventeenth century, by which time the subject had diffused into France, the Low Countries, England, and Germany. After 1600 Italian representations of Ganymede declined significantly in frequency; nor did Ganymede ever become a widely popular subject in the northern countries. French examples number about a half dozen; Dutch images, except for variations on a unique use of the myth by Nicolas Maes, perhaps a dozen. This sporadic and iconographically diverse group of images was in part a symptom of the decreasing artistic role of all classical mythology. More specifically, although the Neoplatonic symbolism developed by Italian humanists was known in other countries, by the time its influence had crossed the Alps, social and artistic conditions were less favorable to the often erotically tinged applications of Ganymede popular in Italy before the Counter-Reformation.

The social and psychological concerns most readily and aptly symbolized by Ganymede had given way to new attitudes to which the myth was less deeply or immediately relevant. As was seen in chapter 4, political events during the reign of the French king Henri III (1574–89) militated against public recognition of the myth's erotic associations, and the Caroline masque of 1634, Ganymede's sole appearance in English art, was expressly disapproving of them. Elsewhere such condemnation was less explicit, and Ganymede suffered more from indifference than from distaste. Images from Italy and the Low Countries, for example, showed an increasing interest in the familial and dynastic symbolism used by Cosimo I de' Medici. Though erotic treatments of the myth persisted throughout seventeenth-century Europe, the majority of representations neutralized Ganymede's eroticism by reducing him in age to a child, by posing him on top of the bird rather than showing him in its embrace, or by altering his

traditional iconography, sometimes toward interpretations with special appeal to heterosexual, family-oriented parents.

Medici Family Iconography

Ganymede appeared three times in the art of the later Medici between 1640 and 1663. All three allusions referred to the dynastic preoccupations of Grand Duke Ferdinand II (r. 1621–70) and thus continued the pattern of paternal symbolism introduced under his ancestor Cosimo I. Ferdinand had been deeply concerned about the birth and upbringing of a male heir from the moment of his marriage to Vittoria della Rovere in 1635; when Vittoria became pregnant in 1639, the poet Margarita Costa dedicated a long epithalamic poem to Ferdinand praising Vittoria's fertility and joyfully anticipating a baby boy. Unfortunately the child died shortly after his premature birth, and Costa had to append a final canto lamenting this mishap, in which she compared the infant to Ganymede, using the traditional Christian-Neoplatonic conceit of the innocent child-soul drawn upward to God.[1]

In 1641, Vittoria became pregnant again, and Ferdinand commissioned an ambitious decorative project for a suite of large ceremonial "Planetary Rooms" on the *piano nobile* of the Pitti Palace, painted by Pietro da Cortona (1596–1669). The program for these rooms, again anticipating the birth of a male heir—by then a familial *idée fixe*—comprised the odyssey of an ideal young prince seeking the gifts of the principal planetary gods. On the ceiling of each room he is greeted by a major deity, whose precepts are explained by cartouches containing Latin epigrams. Taken together, the rooms "constitute a series of *exempla* for the ideal ruler," though even when the cycle was completed the future ruler—Grand Prince Cosimo, later Cosimo III—was only an infant. The ceiling of the Sala di Giove (fig. 5.1) depicts the young prince, *di sotto in sù*, striding toward a seated Jupiter who reaches for a crown. Over the god's head a flying figure, probably Ganymede, swoops down in a sunburst, trailing stars of a heavenly constellation.[2] Ferdinand obviously entertained high hopes for his son and wished to impress upon him the positive virtues and character traits traditionally ascribed to the various deities. However, while the figure of Jupiter symbolizes Ferdinand, he chose to represent Cosimo directly, and Ganymede is no longer an allegory of the youthful disciple, but is reduced to one of Jupiter's attributes.

In a later example of Ferdinand's personal iconography, also directed

5.1 Pietro da Cortona, allegorical ceiling fresco, detail.

toward his son, Ganymede plays a more important though significantly altered role. In 1663, Pietro da Cortona's pupil and assistant Ciro Ferri illustrated an allegorical poem by Giovanni Rimbaldesi in praise of the Medici house; this work is now known through an engraving by François Spierre (fig. 5.2). The theme of Ferri's elaborate tableau is the moral upbringing of Grand Prince Cosimo, by then twenty-one years old. The prince stands at bottom center surrounded by female figures who press upon him symbols of strong and virtuous rulership. In the clouds above this group are seated five male figures, representing the young Cosimo's five predecessors as grand duke. In the center sits Cosimo's father, flanked by portraits of his own four ancestors, each associated with one of the cardinal virtues, which they bestow upon the younger Cosimo.

Another layer of symbolism in Rimbaldesi's and Ferri's conceit derives from an important scientific discovery intimately associated with the Medici family. Galileo observed the four moons of the planet Jupiter by telescope in 1610; in that same year he accepted an offer of patronage from Grand Duke Cosimo II, and the group became commonly referred to as the *stellae mediceae* (Medicean stars). Galileo named them after four of the

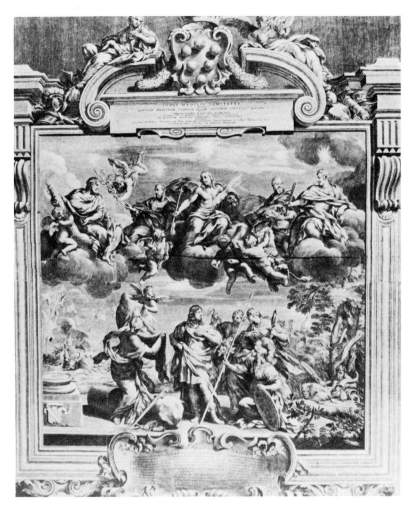

5.2 François Spierre, engraving after Ciro Ferri, *Medicean Allegory*, detail.

god's *amori*: Io, Europa, Callisto, and Ganymede. Ferri, building on this honorific connection, depicts the reigning Ferdinand in the familiar princely role of Jupiter, with eagle and thunderbolt; each of the four previous grand dukes who "revolve" around him is associated with one of the planetary Jupiter's four satellites. The written program does not, unfortunately, detail which moon is represented by which ancestor, but it reveals a fundamental shift from astrology to astronomy as a metaphor for understanding the heavenly bodies.[3]

While the traditional function of Ganymede-Aquarius as an attribute of the planetary god was retained in the new astronomical language, in the

process of cultural translation he lost much of his earlier meaning. The original content of the myth is not simply irrelevant to whichever grand duke bears the name of the satellite; it actually contradicts the symbolism of Ferri's image, since the relation of Ferdinand to his ancestors is not that of a paternal figure to a younger subordinate, but the reverse. The conceit works only because Ferri no longer makes any reference to the older astrological or horoscopic mythology utilized by such patrons as Agostino Chigi and Paul III Farnese. Instead, he has reinterpreted the symbolism of the planets and moons in a highly artificial set of parallels to both Christian allegory and current scientific data. Ganymede and his three lunar companions have become denatured hybrids of physical rock and abstract virtue.

Ganymede in France

The artistic pedigree of Ganymede in France can be traced to the influence of Cellini and Primaticcio, Italian artists who worked for François I at Fontainebleau in the 1540s. In 1543, during his tenure with François, Cellini modeled a *Rape of Ganymede* as one of a pair of bronze reliefs ornamenting the base of a giant silver candlestick representing Jupiter. So far as is known, this candelabrum, one of a projected series of twelve life-size gods and goddesses, marks the first significant appearance of Ganymede in French Renaissance art. Nothing can be determined about the appearance of this composite sculpture, which has been lost. Cellini paired the *Ganymede* with another relief, *Leda and the Swan*,[4] suggesting that the theme of the base was the loves of Jupiter, with equal weight given to heterosexual and homosexual passions.

Apart from a tiny carved shell copied from an antique motif of Ganymede serving the eagle,[5] only two French depictions of Ganymede survive from the sixteenth century. In both of these examples, Ganymede is but one element among a large and rather random series of mythological illustrations and seems not to have been assigned any distinctive iconographic role. Both are of the boy-riding-bird type already seen in works at the court of Cosimo I. Although it is not possible to specify which, if any, Italian models influenced these two similar French examples, some connection is highly likely. Close family ties between the Medici and the Valois kept Tuscany and France in frequent contact, and Italian artists frequently worked in France—Cellini, Primaticcio, and Rosso in the sixteenth century, Romanelli and della Bella in the seventeenth.[6]

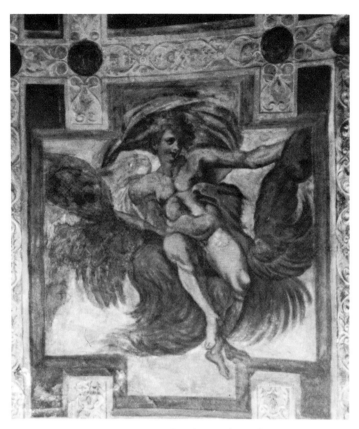

5.3 Francesco Primaticcio, *Ganymede Riding on the Eagle.*

The earlier and more imposing of the two representations derives directly from the cultural milieu in which Cellini worked: the royal court at Fontainebleau. Cellini mentions meeting the principal artist to whom François entrusted the architectural decoration of the palace from 1532 onward. This was Francesco Primaticcio (1504–70), who had earlier served as assistant to Giulio Romano at the Palazzo del Te. Ganymede appears among Primaticcio's designs for the Salle du Bal, a cycle including nearly sixty classically inspired panels executed between 1552 and 1556 by Primaticcio's premier assistant, Niccolò dell'Abate (fig. 5.3). The fresco offers the front view of a coarsely detailed youth riding sidesaddle on the back of a small eagle. Ganymede is given slightly more prominence than most scenes in the cycle by his placement in one of the large, cross-shaped frames above the room's ten window alcoves, but scenes and subjects selected for this cycle are too diverse to suggest any precise overall literary or philosophical program.[7]

In the other French example from this period (fig. 5.4) Ganymede is

reduced to a small, cherublike infant waving at his excited dog as the eagle carries him away. This tiny print is part of a series of miniature engravings of mythological, allegorical, and pastoral subjects attributed to Stephanus (Etienne) de Laune (1518/19–95). The series, stylistically related to the Fontainebleau school of engraving, is dated 1569.[8] As with the Salle du Bal cycle, this suite is too diverse to imply a complex iconographic reading; most of the subset of twelve scenes that includes Ganymede are subjects drawn at random from Ovid's *Metamorphoses*.

Following this small group of images, Ganymede disappears from French visual art—with the exception of the illustration to Philostratus's *Imagines* published in 1619 (see chapter 3)—until the 1640s. Since both Ovid and Neoplatonism were familiar and popular in French literature, this long absence of corresponding visual material is surprising. As was seen in chapters 3 and 4, polemics from the 1570s through the early 1600s amply record the reputation of the king and his "ganymedes" for effeminacy, transvestism, pederasty, and spendthrift hedonism. In view of the moral austerity that followed the Tridentine reforms and the public outrage against Henri by Catholics and Protestants alike, it seems likely that the artistic hiatus is due in part to reluctance to illustrate a subject with controversial and distasteful topical associations.[9]

5.4 Stephanus de Laune, *Ganymede Riding on the Eagle.*

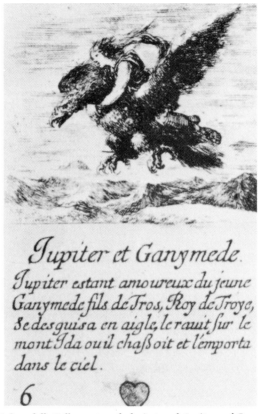

Jupiter et Ganymede.

Jupiter estant amoureux du jeune Ganymede fils de Tros, Roy de Troye, Se desguisa en aigle, le rauit sur le mont Ida ou il chaßoit et l'emporta dans le ciel.

6

5.5 Stefano della Bella, engraved playing card, *Jupiter and Ganymede.*

When Ganymede did reappear in French art, it was only in four unimportant works unrelated to each other except for their common provenance. All were executed in Paris during the early years of the reign of Louis XIV. Of these four, two are by Italians working in France; although three represent the actual rape, only one of these is erotic in its treatment. The first not only shows Ganymede as a child but was also intended for the use of a child. This *Rape of Ganymede* (fig. 5.5) is one of a pack of fifty-two cards for a mythological game, commissioned in 1644 by Cardinal Mazarin for the instructive amusement of his charge, the six-year-old Louis XIV. Ganymede is depicted riding on the back of the eagle, which he embraces around the neck. Like each card in the series, all designed by the Italian engraver Stefano della Bella (1610–64), this one bears in addition to the rather simple illustration a number and suit (six of hearts) and a brief account of the myth: "Jupiter, being in love with the young Ganymede, son of Tros, King of Troy, disguised himself as an eagle, abducted him from

Mount Ida where he was hunting, and carried him off to heaven."[10] The combination of image, caption, and numerological symbols is reminiscent of the emblem books, but compared to Alciati's spiritual intensity or Michael Maier's alchemical quest, Ganymede has here dwindled in significance to a schoolboy's literary "flash card."

Two illustrations of Ganymede by Eustache LeSueur (1616–55) are among his decorations for the Hôtel Lambert in Paris, a splendid private residence begun in 1642 by the wealthy financier Jean-Baptiste Lambert. Although LeSueur, a pupil of Vouet known as the French Raphael, painted in a rather sober classicizing style, his elaborate cycle depicting the life of Cupid for the hôtel's Cabinet de l'Amour demonstrates his sensitivity to erotic themes. His painting of *Ganymede Riding on the Eagle* (fig. 5.6) exhibits a close formal correspondence with the Cabinet depiction of Cupid fleeing Olympus on Jupiter's eagle (fig. 5.7), a late instance of the conflation

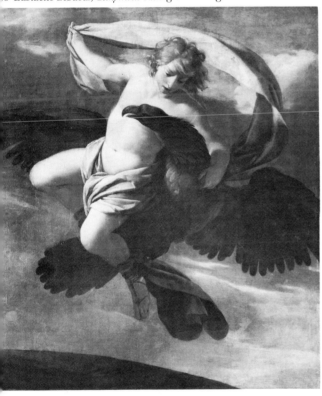

.6 Eustache LeSueur, *Ganymede Riding on the Eagle.*

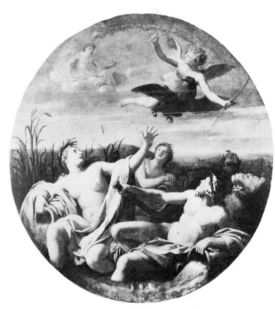

5.7 Eustache LeSueur, *Cupid Escaping from Olympus.*

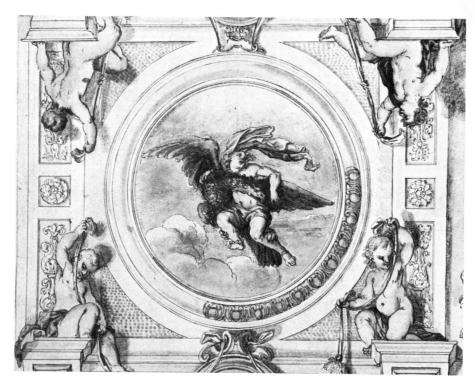

5.8 Giovanni Francesco Romanelli, project for a ceiling, detail.

of Ganymede and Cupid.[11] Ganymede rides sidesaddle atop an eagle nearly identical with the one transporting Cupid; although the postures of the two youths are different, both exemplify the boy-riding-bird type that predominated in earlier French depictions of the rape. LeSueur also painted a narrative ceiling panel for the Hôtel Lambert, *Ganymede Offering the Cup to Jupiter*.[12] The subject belongs to the tradition of "serving Ganymedes" that dates back to Raphael's Farnesina *Banquet of the Gods*; the pose of LeSueur's kneeling boy, seen from behind with his rear leg outstretched, is reminiscent of that earlier composition.

Among the Italians drawn to Paris by the extensive building activity of this period was Giovanni Francesco Romanelli (1610–62), who had trained in Rome under Pietro da Cortona. On his first visit, in 1646–47, Romanelli was invited to decorate Cardinal Mazarin's palace and contributed one canvas to the Hôtel Lambert, where he probably met LeSueur. Romanelli's cartoon for a ceiling decoration featuring the *Rape of Ganymede* (fig. 5.8) has not been dated or connected with any extant project.[13] Its two finished medallions (a third is implied but not shown) illustrate the moon goddess

Diana on her chariot in the center oval and Ganymede in the left tondo. These otherwise unrelated aerial subjects seem to have been chosen because of their suitability for a ceiling; both are depicted with a moderate degree of perspective foreshortening. The Ganymede scene reveals the artist's knowledge of an important Italian prototype: the eagle is almost identical with that in Michelangelo's drawing for Cavalieri (fig. 1.1), as is the upper part of the youth's body and his fluttering drapery. His lower limbs, gripped at the calves by the eagle's talons, reproduce Michelangelo's image in reverse. Romanelli's Ganymede, however, is much younger than Michelangelo's, more a putto like those framing the scene than an attractive adolescent. This alteration, which reduces the apparent sexual content of the myth to childlike playfulness, is another example of the infantilizing tendency observed in de Laune and della Bella.

With this last brief confluence of Ganymede imagery, the subject effectively vanishes from French art. Apart from an occasional garden sculpture, the myth seems to have held little appeal for later patrons and artists.[14] Although LeSueur was still able to wring a measure of erotic impact from the story, the childlike Ganymede of della Bella's contemporaneous deck of cards—erudite playthings for a little boy—perhaps better illustrates the incipient decline of classical mythology. In its reduction of the once erotically charged ephebe to an innocent child and its softening of the action from passionate abduction to effortless free flight through the use of the boy-riding-bird format, della Bella's *Ganymede*, like de Laune's before him, parallels similar tendencies in Dutch art, to which we will now briefly turn.

Ganymede in the Netherlands: Further Infantilization

Only two Dutch illustrations of Ganymede date from the sixteenth century; one, Cornelis Bos's engraving after Perino del Vaga, initiated a pattern of Italian stylistic influence similar to that in France, but less consistent and direct. The handful of compositions that follow at intervals through the mid-1600s, like contemporaneous images in Italy and France, show only occasional interest in the myth's erotic potential.[15] Rembrandt's *Rape of Ganymede* and the later group by his pupil Nicolas Maes best exemplify Dutch artists' distinctive adaptation of the myth to suit the more earthly and bourgeois concerns of their culture.

As Margarita Russell observed in reviewing the long-standing controversy over the iconography of Rembrandt's picture, this work of 1635 (fig.

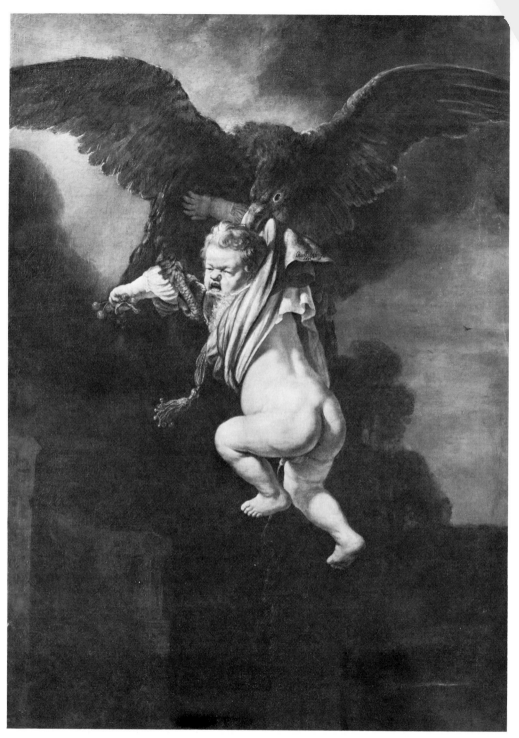

5.9 Rembrandt, *Rape of Ganymede*.

5.9) "is perhaps the strangest of Rembrandt's paintings and one that has never been satisfactorily explained."[16] Rembrandt portrays the classic moment in the story, in which a fierce, flapping eagle has seized Ganymede by the right arm and is bearing him aloft out of a shadowy garden landscape. In three key respects, however, Rembrandt deviates sharply from previous depictions of the event. First, the physical relationship of boy to bird is not intimate or even friendly: the eagle is biting the boy's arm through his nightshirt, and the awkwardly dangling child grimaces and cries out in pain and protest. Second, Ganymede is not a mythologized adolescent, but a contemporary infant. We have already observed the gradual decrease in Ganymede's age in other countries; Rembrandt carries it a step further by reducing him to a baby complete with a "modern" tasseled nightshirt in place of classical drapery. Finally, he adds a unique narrative element: the child, as if in terror, lets loose a stream of urine that falls between his flailing, chubby legs.

Traditional interpretations of this puzzling picture have generally stressed its anticlassicism, taking it to indicate a deliberate "de-heroization" of the elevated Neoplatonic symbol of homoerotic love. Kenneth Clark viewed it as "a protest not only against antique art, but against antique morality, and against the combination of the two in sixteenth century Rome. . . . I think that Rembrandt was shocked, and he was determined that his picture would shock. . . . By showing the physical consequences of Ganymede's fear Rembrandt has gone out of his way to make it repulsive."[17] Such moralizing interpretations, however, reveal more about the values of modern observers than about those of seventeenth-century Holland. There is little evidence that Rembrandt or his contemporaries particularly disapproved of homosexuality or associated Ganymede with such practices. Nor would the image of a child relieving himself have evoked scatological revulsion: urinating boys were a popular tradition in northern art, the best-known example being Jerôme Duquesnoy's *Manneken-Pis* fountain (ca. 1619) in Brussels.[18]

References to Ganymede in Dutch literature and emblem books suggest that his erotic aspect occasioned not so much hostility as indifference. Karel van Mander's influential artists' handbook and chronicle *Het Schilderboek*, first published in 1604, discusses Ganymede in detail among various Ovidian subjects. While acknowledging the classical sources for the myth, van Mander draws particular attention to the Neoplatonic interpretation of the rape and to Ganymede's transformation after death into the watercarrier Aquarius. The spiritualized Ganymede, representing the innocent soul enraptured by God, had of course been familiar since antique sarcoph-

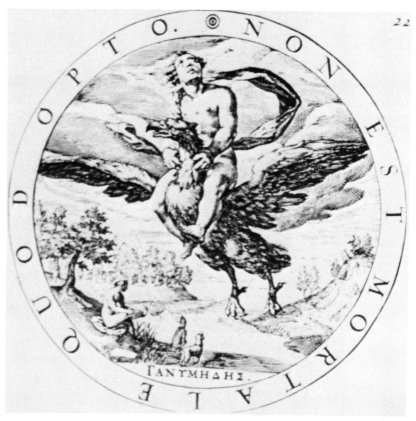

5.10 Crispin van de Passe, *Ganymede*.

agi and the comparison in the fourteenth-century *Ovidius moralizatus* to
Jesus' words, "Suffer little children to come unto me." Another source for
this reading is an emblem book by Gabriel Rollenhagen first published in
Arnhem and Cologne between 1611 and 1613 with illustrations by Crispin
van de Passe. This book illustrates Ganymede (fig. 5.10) riding on the
eagle's back with his face raised toward heaven, surrounded by the caption
"What I wish for is not mortal."[19] A design by the Italian artist Antonio
Tempesta, who made one hundred fifty illustrations with Latin captions
for an edition of Ovid's *Metamorphoses* published in Amsterdam in 1606
(fig. 5.11)[20] was van de Passe's apparent source. He exactly copied Tempes-
ta's eagle with its distinctive rear-facing talons and the boy's seated pose
with arms around the eagle's neck, but he moved the boy's legs forward
and intensified the upward glance of the eyes by turning the whole head
skyward.

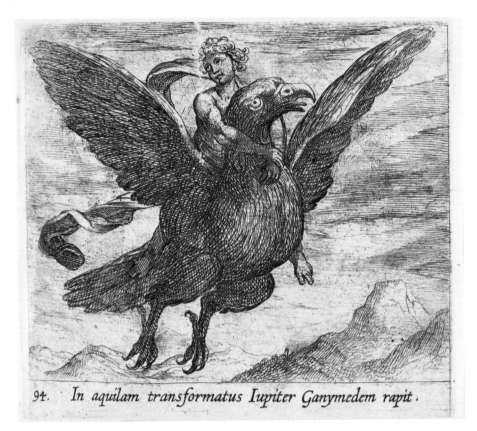

94. *In aquilam transformatus Iupiter Ganymedem rapit.*

5.11 Antonio Tempesta, etching, *Rape of Ganymede*.

Both the religious emphasis of such images and Ganymede's astrological component seem to have been foremost in Rembrandt's mind: his Ganymede holds a bunch of cherries in his left hand, a Christian symbol of childlike purity and the heavenly rewards of virtue, and the howling boy may have been derived from a weeping angelic putto sculptured by Hendrick de Keyser for the tomb of William of Orange.[21] The motif of urination recalls van Mander's description of Aquarius "pouring down for us if not nectar yet water in abundance"; the urinating putto as a source of heavenly liquid dates back through the *Manneken-Pis* to the illustrations for Francesco Colonna's allegorical romance, the *Hypnerotomachia Poliphili*, first published in 1499.[22] Hence, despite the realism with which he invested Ganymede's howling and loss of control, Rembrandt seems to be portraying a fertilizing demiurge as well as a spiritual symbol. His Ganymede is a two-part allegory representing both the soul rising to God and the heavens

returning sustenance to the earth below. Rembrandt's realistic, infantil-
ized, and yet allegorical treatment of what had been a pretext for idealiz-
ing adolescent male beauty demonstrates how little classical homoeroti-
cism interested him compared to more particularly northern iconographic
traditions.

The Neoplatonic idea of Ganymede as the pure, childlike soul ascending
to God also appealed to the Dutch fondness for domestic genre subjects, as
an expression of mourning for a dead child. Rembrandt may have thought
of this association in the preliminary stages of his *Ganymede* (Russell, 9–
10), but the parallel was explicitly evoked by his pupil Nicolas Maes (1632–
93) in a series of memorial portraits of small children. These pictures,
which date from the 1660s through at least 1678, provide a concluding
glimpse of how far the erotic aspect of Ganymede had receded by the later
seventeenth century in favor of a sentimental, worldly, and familial appli-
cation of his spiritual aspect. Nine portraits are recorded; they vary from
several examples with one small boy riding an eagle to group portraits of
up to five children of both sexes, one of whom is always depicted as Gany-
mede, while the others bear the attributes of such deities as Diana or Ceres.
The single *Ganymede Riding on the Eagle* now in Moscow (fig. 5.12), signed
and dated 1678, is typical of the five pictures showing only one child.[23] Like
all of Maes's Ganymedes, this one bypasses Rembrandt's model and reverts
to the more prevalent late format of the boy-riding-bird, with hands
clasped around the eagle's neck. This type de-emphasizes the horror of
being snatched from life by presenting, instead of the moment of death/
abduction, an effortlessly happy flight toward eternity—presumably the
kind of consoling image that parents of a deceased child would find com-
forting.

Maes's series shows that by his time the antique use of Ganymede to
represent the ascent of the soul after death had come full circle. The spir-
itual associations that began with Plato and Xenophon and were developed
on Roman sarcophagi, absorbed into Christianity by the *Ovidius morali-
zatus*, and reaffirmed by the Neoplatonists were in the end adapted for the
glorification of individual deceased children. A similar symbolic use of
Ganymede occurred in Medicean family iconography at about the same
time, when Margarita Costa eulogized the infant son of Ferdinand II as
Ganymede. The coincidence suggests that concern for children was a wide-
spread development in this period, contributing to the general tendency
to depict Ganymede as younger and less erotic than in the preceding
century.[24] In these images no trace remains of the other Ganymede, the
beautiful adolescent ephebe who had evoked for so many Italian artists

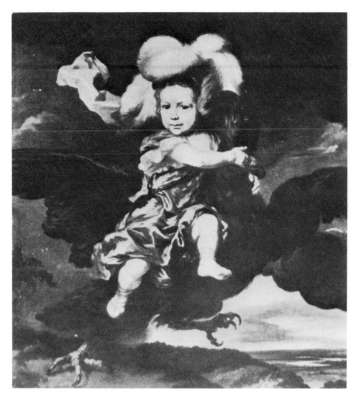

5.12 Nicolas Maes, *Ganymede Riding on the Eagle.*

thoughts of adult love and sensuality. Such thoughts would be irrelevant, even tasteless, in a picture idealizing a dead child. Whereas in Italy the spiritual purity of the youth had once served as a refined symbolic justification for various forms and degrees of pederasty, by the midseventeenth century both the Dutch and the Italians took the same references more literally, ignored the erotic undertone, and immortalized the young Ganymede not as lover but as offspring.

Peter Paul Rubens' Further Neutralization of Ganymede

In Flanders, as in the other Habsburg territories of Spain and Germany, Ganymede was never a frequent subject. Only about ten works by Flemish artists are known to include Ganymede, and most of these are decorative works of minor importance or primarily landscapes.[25] Among the latest, however, are two large oil paintings by Peter Paul Rubens (1577–1640) in which the figure of Ganymede is the principal visual and iconographic

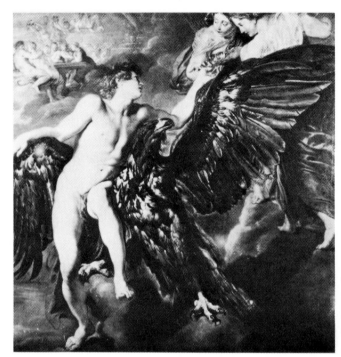

5.13 Rubens, *Ganymede and Hebe.*

5.14 Rubens, *Rape of Ganymede.*

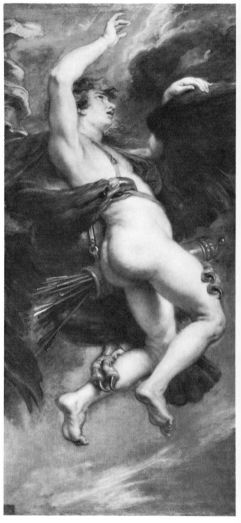

focus. Although the later image seems to acknowledge Ganymede's erotic aspect, the earlier one presents him in a unique, sexually neutralized interpretation.

The first of Rubens' illustrations (fig. 5.13), painted about 1611, has traditionally been called *Ganymede Receiving the Cup from Hebe*. It shows the youth borne aloft while seated on the eagle's wing, with his right arm stretched upward toward two female figures, one of whom gestures at the goblet in his hand. In the upper left background is a smaller scene of the Olympian banquet; this double composition, recalling Franco's *Allegory of the Battle of Montemurlo* (fig. 4.12), is an example of Rubens' careful study of Italian art. The picture may have formed part of a series including *Cupid Supplicating Jupiter*. The correspondences between these works, including the almost identical eagles and the heads of both youths, are another late instance of the formal conflation of Cupid and Ganymede.[26]

The usual explanation of *Ganymede Receiving the Cup from Hebe* emphasizes the orderly and willing transition of office from the girl to the boy, an unprecedented conception that differs from the traditional discordant results of Hebe's replacement. More recently it has been proposed that Ganymede is offering the cup to Hebe as a gesture of reconciliation "eliminating any motivation for Juno's jealousy and purifying the Ganymede myth even further." Whatever the direction of the cup's movement, the result is the same: the transformation of a subject usually invested with homoerotic overtones into a sexually neutralized Neoplatonic allegory. The picture may even presage the use of Ganymede in the memorial art of Dutch families, if we accept the suggestion that Rubens intended it as an image of the immortal soul memorializing his brother Philip, who died in 1611.[27]

Rubens' second painting depicts the actual rape of Ganymede. It is part of the extensive series of Ovidian decorations painted about 1635 for the royal hunting lodge, the Torre de la Parada, in Spain (fig. 5.14). This picture, in which the nude torso of the dramatically serpentine youth, seen from below, is encircled by the eagle's craning neck (not unlike Michelangelo's version), may even contain a phallic visual pun—a quiver that seems to penetrate Ganymede from behind. This treatment suggests that Rubens was aware of the myth's erotic significance, and could make imaginative use of this pretext for painting a handsome nude male, though without any complex iconographic intent.[28] But the limits of his susceptibility to Ganymede's full meaning are suggested by his copy after Titian's *Worship of Venus*, which more emphatically demonstrates the neutralization of homoerotic implications seen in *Ganymede Receiving the Cup from Hebe*. In Titian's original, as in the drawing after it by Giulio Romano, the *amorini*

are, in accordance with classical tradition, all male. In his own otherwise fairly faithful transcription, Rubens deliberately altered the sex of the frolicking putti, making half of them female, and changed the boy at the right who is pursued by another young male into a girl. This pointed reversal of classical homoeroticism implies that, however appealingly he may have rendered his two Ganymedes, Rubens was fundamentally unsympathetic to the myth's erotic significance.[29]

Ganymede in England: A Final Expulsion

The progressive de-eroticization and heterosexualization of Ganymede reached its ultimate philosophical, if not quite chronological, development in England, in the Stuart court masque entitled *Coelum britannicum*, performed in 1634, whose stage designs by Inigo Jones include Ganymede's sole appearance in British art. Thomas Carew's allegorical text arose from the opposing sexual mores of King Charles I (r. 1625–49) and his late father, James I. The theme of Carew's propagandistic pageant was the moral renovation of the kingdom by Charles and his consort, Henrietta Maria of France, after the licentious excesses of James's reign. The central literary and visual conceit of *Coelum britannicum* is implied in its title: Olympus stands for the British court, and each constellation represents a particular vice that must be expelled at Jupiter's order, "so to remove all imputation of impiety from the Coelestiall Spirits, and all lustful influences upon terrestriall bodies." In the triumphant finale, Jupiter-Charles rekindles the national firmament with a new and purer light.

The action unfolds before a vast painted backdrop (fig. 5.15) on which Jones depicts the giant Atlas kneeling to support the celestial orb, "a Sphaere with Stars placed in their several images." The character of Momus reads a series of prescriptions for sweeping reforms, each identified with a mythological character. The surviving design does not include drawings of the corresponding constellations, each of which may have incorporated a flaming torch that would be extinguished at the appropriate decree. Aquarius is naturally implied by Momus' declaration, "*Ganimede* is forbidden the bedchamber, and must only minister in publique. The gods must keepe no Pages, nor Groomes of their chamber under the age of 25, and those provided of a competent stocke of beard."[30]

As was noted in chapter 4, this statement alludes to sexual relations between aristocratic men and their pages or servants, which were particularly prevalent during the reign of James I, perhaps the most notorious of

5.15 Inigo Jones, *Atlas*.

Britain's homosexual monarchs.[31] The son's distaste for his father's behavior is hinted at by the masque's introduction, where the new Jupiter inspires the old Jupiter (implicitly Charles and James) to repent of his "loathsome staines" (Carew, 212). During his personal reign the happily married Charles sought to project the monarchy as an ideal example of marital concord and benign rulership. The contemporary diarist Lucy Hutchinson recorded that he disavowed the frivolous excesses of his father's regime—pederasty explicitly among them—and reestablished a strict standard of public decorum: "The face of the court was much changed in the change of the King, for King Charles was temperate, chaste, and serious; so that the fools and bawds, mimics and catamites of the former court grew out of fashion; and the nobility and courtiers, who did not quite abandon their debaucheries, yet so reverenced the king as to retire into corners to practice them."[32]

In this ignominious expulsion of Ganymede we see the most extreme resolution of the ambivalence toward all that he personified of profane love—an ambivalence that was already evident a century earlier in Michel-

angelo's series for Tommaso de' Cavalieri, and whose social and artistic resolution had become an increasingly urgent problem. Whereas Rembrandt, Maes, and French artists softened the youth's eroticism by infantilizing him, and Rubens by iconographic transposition, for Carew's compatriots courtly pederasty had grown too scandalous to be overlooked or euphemized; it had to be identified and subjected to explicit moral condemnation. Even Ganymede's traditional role in dynastic and familial iconography was inverted. Where the Medici saw Ganymede as a paradigm for benign father-son relationships, and the Dutch as a symbol of parental affection for a lost child, for the English Ganymede symbolized the very failing that caused Charles's antipathy toward his own dead father.

·6·

Conclusion

With the late examples of chapter 5, we have come well along on the descending curve of Ganymede's popularity in western European Renaissance culture. By the seventeenth century, the great variety of erotic meanings read into the myth in the late Quattrocento and early Cinquecento—as a symbol of passionate attachments or casual encounters among various social classes and occupational groups, or of beliefs about androgyny, effeminacy, misogyny, and bisexuality—seem to have run their course. Although artists continued to illustrate Ganymede sporadically through the seventeenth century and beyond, the examples decrease greatly in frequency and iconographic significance. The few important Ganymedes outside Italy clustered in the 1630s and 1640s, a century after the principal images produced in Italy, and two centuries after Alberti's evocation of the boy with the beautiful thighs. These works, together with the later art of Medicean Florence, exhibited a complex of related attitudes and interests that were markedly different from the erotic and idealized treatment in earlier Italian examples.

In addition to the general demotion of classical subject matter concomitant with its exclusion from the arena of religious art, Ganymede suffered in particular from the less tolerant attitude toward homosexuality after the midsixteenth century. Although throughout medieval and Renaissance times sodomy was technically both sin and crime, its increasing social unacceptability is best illustrated by the contrasting legal proceedings against Leonardo and Cellini. In 1476, the twenty-four-year-old Leonardo, still merely an assistant to Verrocchio, was able to escape a verdict in his sodomy accusation on the strength of his father's respected but far from powerful position. In 1557, the much older and more prominent Cellini received a four-year sentence for a similar affair, despite his favored position with the duke.

The turning point, at least with respect to Ganymede, can be located in

the late 1540s. Although the full force of change would not be felt until the Tridentine promulgations, Michelangelo's religious awakening had already begun in that decade, when he befriended Vittoria Colonna. In 1545 the Council held its first session, and from 1545 to 1548 Cellini carved his valedictory group of homoerotic works. His *Ganymede*, who holds a courting gift in his raised hand and fondly strokes the eagle, is probably the last depiction in Italian art to emphasize the sexual aspect so explicitly; it is certainly the last by an artist with a known proclivity for homosexual love. The death in 1546 of Giulio Romano—surviving doyen of the heady atmosphere of Rome before the sack (the period of Luigi Pulci and of Cellini's tranvestite prank), decorator of the Chigi villa, friend of Aretino and illustrator of his bawdy, pansexual *Modi*—marks a similar transition in northern Italy. Further events consolidated the substitution of new values. In 1549 Paul III, convener of the Council and the only pope to adopt Ganymede as one of his personal emblems, was succeeded by Pius IV, who ordered the draping of the Sistine *Last Judgment* and implemented the Tridentine program in his bull of 1564, the year of Cellini's marriage and Michelangelo's death. The series of Ganymedes created for Cosimo de' Medici from the 1540s through the 1560s illustrated both the breakdown of toleration toward homoerotic expression and the declining interest in all sexual themes. These changes exemplified a broad conflict that eventually spread outward from Italy, limiting the use of Ganymede throughout Europe.

The moral battle between Greek and Christian conceptions of love was clearest in the Ganymedes of the two artists whose individual psychology is most readily accessible: Michelangelo and Cellini. Michelangelo forged a powerful and convincing amalgam of antique eroticism and spiritualized Neoplatonic ardor. His image, a testimony of passionate affection for Tommaso de' Cavalieri, was (in a poetic if not strictly chronological sense) the culmination of that productive fusion of classical and Christian ideals that had animated the early humanist milieu of Michelangelo's youth and the Rome of Raphael, Giulio, Parmigianino, and Cellini. Although cultivated art lovers knew that Michelangelo's *Ganymede* was a homage to Cavalieri, neither his art nor his love provoked the kind of scandalized public reaction that Cellini experienced only fifteen years later. There are two reasons why Michelangelo escaped censure (except from the scurrilous Aretino), and both of them contrast instructively with Cellini's case. First, by all accounts his love for Cavalieri was never physically expressed, thus remaining well within the bounds of pure Neoplatonic ideals, whereas Cellini was a chronic libertine with both sexes, given to bragging and joking about his

exploits—and getting caught. Second, Michelangelo always insisted on the intermingled spiritual, esthetic, and comradely roots of his intense and lasting affections, while Cellini, acting Don Juan *avant la lettre*, spoke of his passing amours in offhand and bluntly selfish terms. Where Michelangelo declared himself "the most inclined to love persons" of talent and intellect, Cellini acknowledged the purpose of love primarily as the need to "satisfy my youthful desires." Although an idealized, celibate love might be tolerated, profligate carnalizing could not, especially as it claimed no justification by transcendent concerns.

Both approaches to love proved to contain pitfalls, the first internal, the second external. In Michelangelo's *Ganymede*, faith in the effortless unity and bliss of Neoplatonic transport was purchased at the price of sexual expression, indulgence in which presented the insurmountable psychic obstacles visible in Ganymede's pendants. By contrast, the blunt sensuality of Cellini earned him physical satisfaction at the cost of scandal and disgrace. The inherent tension between carnal and spiritual values could not be reconciled in a world staggering under the self-doubt engendered by the sack of Rome and religious schism. When the tentative High Renaissance fusion of these systems separated once again into opposed principles, Michelangelo could no more sustain his desexualized longing than Cellini could continue his despiritualized satiety. Both avenues of homoerotic expression were closed, the one ending in spiritual friendship with a woman, the other in house arrest for sodomy with an apparently unwilling shop assistant. Michelangelo's admired Savonarola foreshadowed the strain of antisexual (and specifically antihomosexual) thought that later predominated throughout Catholic Christendom and affected moral attitudes in the Protestant countries as well. Michelangelo's and Cellini's lives exemplified a widespread response, both individual and collective, to the conflict: suppression of the pagan in favor of heightened religious fervor and orthodoxy.

This extreme alternation between two polar views of eros—if we may, between the descendants of Ficino and of Savonarola—was a particularly Florentine phenomenon. As was seen in chapters 2 and 3, the artists active in the more permissive and iconographically eclectic atmosphere of Mantua and its northern Italian neighbors accepted and glorified Ganymede with less sense of moral or intellectual conflict. Even there, however, the voluptuous androgyny of Correggio's angelic Ganymede was countered by Parmigianino's more ambivalent Amor, in whom there were premonitions of Counter-Reformation sensibility. Giulio never fully abandoned the pronounced erotic interests that had initially endeared him to Federigo Gon-

zaga, but Federigo, like his slightly younger contemporary Cosimo de' Medici, gradually increased Ganymede's regal and dynastic use at the expense of his erotic meaning.

The effect of these changes on art was clear and rapid. Although Ganymede continued to appear in major Italian decorative programs such as the Palazzo Spada and the Farnese Gallery throughout the second half of the sixteenth century, he never again attracted the repeated attention from a single artist that he had from Giulio and Parmigianino or informed the personal iconography of an artist known to be homosexual. The absence of Ganymede from the series of mythologized *ragazzi* painted by Caravaggio, the one major painter of the late Cinquecento whose homosexuality is otherwise freely expressed in his oeuvre, perhaps reinforces the progression outlined here. Ganymede may have become so closely identified with sodomy that to represent him would have invited grave disapproval. Instead Caravaggio painted such relatively indirect subjects as Bacchus and Cupid.

By the time Ganymede imagery reached the north, it was already the dawn of the seventeenth century. The struggle between Catholics and Protestants had resulted in an independent Netherlands increasingly indifferent to the erotic connotations of classical mythology and a France appalled by the foppish ineffectuality of Henri III and his "Ganymedes." Although the appetitiveness of the images of Giulio or Parmigianino still lingered in attenuated form in the Italy of Carracci and Mannozzi, the myth's erotic aspect was scarcely acknowledged by most ultramontane artists. Only in England was there a brief vogue for Ganymede, primarily in the extensive homoerotic poetry and drama of the 1590s. Yet even during the reign of James I, who was privately as flamboyant as Henri but outwardly married and dynastically responsible, no visual representations of the theme occur, and after his accession James's son Charles made Ganymede a symbol of outlawed vice. James's contemporary in Prague, Rudolf II, indulged a secondary interest in Ganymede, but his patronage of the theme, which had as much to do with mysticism as with eroticism, was only one among innumerable projects, acquisitions, and personal symbols.

Antonio Tempesta's Ovidian illustration published in Amsterdam in 1606 and its adaptation by van de Passe cemented the typology of boy-riding-bird that had predominated in France since Primaticcio and was adopted by Rubens for his *Ganymede Receiving the Cup from Hebe* of 1611. Rubens' lack of interest in the boy's emotional relation to the eagle, coupled with his distinctive attempt to defuse the erotic *discordia* implicit in the rivalry of the two cupbearers, evinces the same intent as van de Passe's Neoplatonic illustration: to present Ganymede in a sexually neutralized

and thus less morally questionable interpretation. This process, begun in Florence under Cosimo I, was equally evident in Catholic Flanders, Calvinist Holland, and Anglican Britain. Excluding the works executed by Rubens for the Torre de la Parada and by LeSueur for the Hôtel Lambert, artists of the 1630s and 1640s tended to infantilize Ganymede; to domesticate, trivialize, or heterosexualize him; or, when his eroticism could not be denied, to expel him. In Italy Margarita Costa, like the Dutchman Maes, limited the mythical youth to a learned allegorical conceit applied to mortal children, and in France, during the minority of Louis XIV, a baby Ganymede ·was one among fifty-two quaint tales presented with no allegorical embellishment for the educational diversion of the boy king. Ganymede never recovered the impassioned philosophical richness, at once sublimated and sublime, given to him by Michelangelo, or the sensual splendor he attained at the hand of Correggio.

As a final metaphor for the development of Ganymede imagery traced here, I would propose a poetic analogy implicit in the myth itself. Over the course of the two centuries between Alberti and Rembrandt, Ganymede's social and artistic fortunes paralleled the events of the mythical youth's own saga. Born (or, rather, reborn) in the resurgence of classical learning in the early Quattrocento, Ganymede grew to promising adolescence in the encouraging homoerotic milieu of Laurentian Florence, where he was best exemplified by Poliziano's enraptured descriptions in *Orfeo* and the *Stanze*. Plucked, Ida-like, from this pastoral cradle, the beautiful youth was dramatically lifted up to artistic prominence by the great outpouring of images between 1520 and 1550 in Florence, Rome, Mantua, and Emilia.

If we may compare the intense appeal of the subject for major patrons and such olympian artists as Michelangelo and Correggio to Ganymede's climactic seduction and elevation, then the ensuing seventy-five years, during which he served succeeding artists and patrons continually but with gradually decreasing frequency and erotic interest, correspond to Ganymede's own career after his triumphant ascension. Glorious as it was, this service could not last indefinitely, for Ganymede was as mortal and earthly as the passion he represented. In the myth, Jupiter intervened to spare him old age and death by the gift of immortality. In history, however, no such magical salvation was available, and changing cultural values left him a diminishing role in the symbolic pantheon of art and philosophy.

And so, by the 1630s, when Ganymede had outlived his usefulness, artists (along with Galileo) performed the very same transformation of his image that Jupiter had bestowed upon the actual youth: they turned him into a constellation. No longer able to attract and embody the changed

passions of mortal men, Ganymede was unceremoniously retired to the remote heaven of obsolescent archetypes. In Rembrandt's metamorphosis of the superannuated motif, Ganymede-Aquarius lost his ideal beauty; in Carew and Jones's masque, the very torch of love for which he had once stood was extinguished. In art as in legend, Ganymede became merely the discarded shell of his once seductive self.

And yet we can imagine his parting, amid the ignominious decay of former beauty and position, transfigured by the consolation of divine memory. Ganymede had known the highest honor and greatest love of any mortal man, and he rose in a last apotheosis to take his eternal place in the firmament of history.

ƝOTES

Introduction

1. On the revival of antique literature, art, and thought see Erwin Panofsky, *Renaissance and Renascences in Western Art* (New York, 1960); Roberto Weiss, *The Renaissance Discovery of Classical Antiquity* (Oxford, 1969); and Edgar Wind, *Pagan Mysteries in the Renaissance* (New York, 1968); and further bibliography below, chapter 1.

2. *De pictura*, bk. 2, ch. 37, ed. Cecil Grayson (Rome and Bari, 1975), 66–67. For the frequent paraphrases of this prescription by later art theorists, see Roberto Ciardi, ed., *Giovanni Paolo Lomazzo: Scritti sulle arti*, 2 vols. (Florence, 1973–74), 2:249, n. 4.

3. See Paul Barolsky, *Infinite Jest: Wit and Humor in Italian Renaissance Art* (Columbia, Mo., 1978), intended as a corrective to the excesses of Neoplatonic exegesis. The problem of how much validity to ascribe to satirical or moralistic invectives against the prevalence of homosexuality is to tread a careful path between taking these often sweeping comments at face value and discounting them altogether. It is unlikely that a social critic would inveigh against a practice that was altogether non-existent or that a comedian would expect to elicit laughter from a totally foreign situation. For a judicious discussion of this problem, see Alan Bray, *Homosexuality in Renaissance England* (London, 1982), 35–36. Bray is perhaps too willing to dismiss allusions to homosexuality as gratuitous.

4. *Iliad*, 5:265, 20:230, with scholiast; Apollodorus, *Bibliotheca*, 2:5:9, 3:12:2; for additional sources, see A. F. Pauly and G. Wissowa, *Real-Encyclopädie der klassischen Altertumswissenschaft* (Stuttgart, 1895–), 7:738, s.v. "Ganymed."

5. *Metamorphoses*, tr. Frank Justus Miller (Cambridge, Mass., 1916), 75.

6. *Aeneid*, tr. H. R. Fairclough (Cambridge, Mass., and London, 1978), 463.

7. Elegy 2, lines 1345–50: Douglas Young, ed., *Theognis, Pseudo-Pythagoras ... Fragmentum Teliambicum* (Leipzig, 1961), 80; similarly in Pindar, *Olympian Odes*, 1:44, 10:105; for a full review of references to Ganymede in antique literature, see Penelope Mayo, "*Amor spiritualis et carnalis*: Aspects of the Ganymede Myth in Art" (Ph.D. diss., New York University, 1967), 1–20. The progressive eroticization of the myth in these sources is outlined in Pauly-Wissowa, 7:837, and recently by Thomas S. W. Lewis, "Brothers of Ganymede," *Salmagundi* 58–59 (1982–83), 164–65.

8. On love-gifts see K. J. Dover, *Greek Homosexuality* (New York, 1978), 92.

9. Euripides, *Orestes*, 1390–92; *Cyclops*, 582ff.; *Iphigenia in Aulis*, 1048–49. Martial, *Epigrams* 11:22, 26, 43, 104. See also *The Fragments of Sophocles*, ed. Alfred C. Pearson (Cambridge, 1917), 2:22, fragment 345 and Pauly-Wissowa, 7:738.

10. See Charlton Lewis and Charles Short, *A New Latin Dictionary* (New York and Ox-

ford, 1879), s.v. "catamitus," "pathicus"; *Oxford English Dictionary*, 1971 ed., s.v. "catamite." For the continuous use of the term *ganymede* in sexual contexts throughout the Middle Ages, see Panofsky, *Renaissance and Renascences*, 78, n.1; John Boswell, *Christianity, Social Tolerance, and Homosexuality* (Chicago, 1980; hereafter cited as Boswell).

11. Pseudo-Eratosthenes, *Catasterismus*, 26; Scholiast on Aratus, *Phaenomena*, line 283; Hyginus, *Fabula*, 224; Servius, commentary on *Aeneid*, 1:28:394; and additional sources in Pauly-Wissowa, 7:740.

12. For the largest and most complex medieval image see Ilene Forsyth, "The Ganymede Capital at Vézelay," *Gesta* 15 (1976), 241–46. Gerda Kempter, *Ganymed: Studien zur Typologie, Ikonographie and Ikonologie* (Cologne and Vienna, 1980), 178–80, lists eighteen depictions of Ganymede in medieval manuscripts. Some discussion of visual representations as well as numerous literary references are provided by Boswell, 243–68. On the general topic of mythological art in the Middle Ages see Jean Seznec, *The Survival of the Pagan Gods*, tr. Barbara F. Sessions (New York, 1953).

13. *De deorum imaginibus libellus*, in Thomas Munckerus, ed., *Mythographi latini . . .* , 2 vols. (Amsterdam, 1681), 2:302; Berchorius, *Metamorphosis Ovidiana moraliter . . .* , in his *Reductium morale*, bk. 15, ch. 1 (Utrecht: Instituut voor Laat Latijn der Rijksuniversiteit, 1960), 9–10. On Landino's gloss see Erwin Panofsky, "The Neoplatonic Movement and Michelangelo," in his *Studies in Iconology* (New York, 1939), 179, 214.

14. "*Ovide moralisé*, poème du commencement du quatorzième siècle publié d'après tous les manuscrits connus," ed. C. de Boer, vol. 4, bk. 10, lines 3383–85: *Verhandelingen der koninklijke Akademie van Wetenschappen te Amsterdam*, n.s. 37 (1936), 91. "The First Apology of Justin the Martyr," in C. H. Richardson, ed., *Early Christian Fathers*, 2 vols. (Philadelphia, 1953), 1:256.

15. Boswell, 207–66. See also Ernst R. Curtius, *European Literature and the Latin Middle Ages*, tr. Willard R. Trask (New York, 1953), 113–17.

16. Petrarch, *Africa*, 3:140ff.; Boccaccio, *Genealogia de gli dei . . .* , Italian translation by Giuseppe Betussi (Venice, 1564), 102; Seznec, 221. For additional medieval sources see Mayo, 59–75.

17. The term *sodomy* was used in a broad and rather vague sense in the Middle Ages and afterward, leading to a necessity for some caution in interpreting these references. Medieval writers tended to lump together as *sodomia*, or Aquinas's "sin against nature," all forms of nonprocreative sexuality, chiefly masturbation and bestiality, as well as homosexual coitus (Boswell, 52, 183–84, 205).

18. Most images of Ganymede as Aquarius have little meaning if isolated from their astrological context, a visual and iconographic tradition that deserves to be studied in its own right; for an outline of this aspect, see James M. Saslow, "Ganymede in Renaissance Art: Five Studies in the Development of a Homoerotic Iconology" (Ph.D. diss., Columbia University, 1983), app. 2. For homosexuality in Venice, see Giovanni Scarabello, "Devianza sessuale ed interventi di giustizia a Venezia nella prima metà del XVI secolo," in *Tiziano e Venezia: Convegno internazionale di studi, Venezia, 1976* (Vicenza, 1980); for France, Marc Daniel, "Homosexuality in France during the Reign of Louis XIII and Louis XIV," *Homophile Studies: ONE Institute Quarterly* 14–15 (1961), 77–93, 125–36. A seminal work on sexual practices and attitudes in early Renaissance Italy (including Florence and other cities) that came to my attention as this book was going to press is Guido Ruggiero, *The Boundaries of Eros: Sex Crime and Sexuality in Renaissance Venice* (London and New York, 1985).

19. A few articles on particular types of antique images have added to Sichtermann's catalogue without substantially altering his categorizations: see, e.g., Kyle M. Phillips, Jr., "Subject and Technique in Hellenistic-Roman Mosaics," *Art Bulletin* 42 (1960), 243–62; Elaine K. Gazda, "Ganymede and the Eagle: A Marble Group from Carthage," *Archaeology* 34:4 (1980), 56–60. For articles prior to 1967, see Mayo, iii–iv.

20. On women in antiquity see Sarah B. Pomeroy, *Goddesses, Whores, Wives and Slaves:*

Women in Classical Antiquity (New York, 1975); N. E. Paoli, _La donna greca nell'antichità_ (Florence, 1966); and the art-historical exegesis of female roles by Christine Mitchell Have-lock, "Mourners on Greek Vases: Remarks on the Social History of Women," in Norma Broude and Mary Garrard, eds., _Feminism and Art History: Questioning the Litany_ (New York, 1982). Broader surveys include Renata Bridenthal and Claudia Koonz, eds., _Becoming Visible: Women in European History_ (Boston, 1977), esp. Joan Kelly Gadol, "Did Women Have a Renaissance?"; Patricia Labalme, _Beyond Their Sex: Learned Women of the European Past_ (New York, 1980); Vern R. Bullough and Bonnie Bullough, _The Subordinate Sex: A History of Attitudes toward Women_ (Urbana, Ill., 1973), a compilation of secondary sources useful for references to literature, issues, and personalities. A conference at Yale University in March 1982 explored "Renaissance Woman/Renaissance Man: Studies in the Creation of Culture and Society."

On women as artists and as subject matter in art see Anne Sutherland Harris and Linda Nochlin, _Women Artists, 1550–1950_ (exh. cat., Los Angeles County Museum of Art, 1977); Germaine Greer, _The Obstacle Race: The Fortunes of Women Painters and Their Work_ (New York, 1979); Thomas B. Hess and Linda Nochlin, eds., _Woman as Sex Object: Studies in Erotic Art, 1730–1970_, in _Art News_ Annual 38 (New York, 1972).

A major difference between feminist methodology and this book is that women artists had fewer opportunities to paint subjects where their self-identification with the theme was possible; for an important exception that falls within the time period of the present book, see Garrard's study "Artemisia [Gentileschi] and Susanna," in Broude and Garrard, 147–72. For further bibliography see below, chapter 3.

21. Sigmund Freud, _Leonardo da Vinci and a Memory of His Childhood_, tr. Alan Tyson (Harmondsworth, 1963); Ernst Kris, _Psychoanalytic Explorations in Art_ (New York, 1952); Kurt R. Eissler, _Leonardo da Vinci: Psychoanalytic Notes on the Enigma_ (New York, 1961); Adrian Stokes, _Michelangelo: A Study in the Nature of Art_ (London, 1955). Individual ar-ticles on the psychological aspects of works by homosexual artists include Laurie Schneider, "Donatello and Caravaggio: The Iconography of Decapitation," _American Imago_ 33 (1976), 76–91; Peter Fuller, "Moses, Mechanism and Michelangelo," in his _Art and Psychoanalysis_, who contrasts Freud's approach with that of Melanie Klein. The opposing view has been stated by Meyer Schapiro, "Leonardo and Freud: An Art-Historical Study," _Journal of the History of Ideas_ 17 (1956), 147–78; more recently by Martin Kemp, _Leonardo da Vinci, The Marvellous Works of Nature and Man_ (Cambridge, Mass., 1981). For the diverse responses to Liebert's work see reviews by Leo Steinberg, _New York Review of Books_ (June 28, 1984), and by Jerome D. Oremland, _International Journal of Psychoanalysis_ 65 (1984):369–74.

22. The term _gay_ is used by contemporary scholars in this field, and by many homosex-ual individuals, in preference to _homosexual_, a term whose roots lie in a nineteenth-century medical model for sexual behavior that is now considered outdated and pejorative. Boswell, 41–46, attempts to make a case for extending the use of _gay_ back to the early Middle Ages. Whatever the validity of his argument for that period, the term seems anachronistic for the Renaissance, when there was no identifiable and self-defining homosexual subculture such as Boswell sees in the eleventh and twelfth centuries, and the present study does not follow his precedent. _Gay_ is used here, however, in reference to modern scholars who adopt it for themselves. For discussion of the changing definitions and terminology for homosexuality, see below, chapter 2.

23. For an overview of the state of research in contemporary gay studies encompassing biography, literature, history, and social science, see Salvatore J. Licata and Robert P. Peter-sen, introduction to _Historical Perspectives on Homosexuality_, reprint of _Journal of Homo-sexuality_ 6:1–2 (1980–81), 3–10. For a comprehensive list of studies to 1980, see William Parker, "Homosexuality in History: An Annotated Bibliography," ibid., 191–210, and issues of the _Journal of Homosexuality_ published since 1974 by the Center for Homosexual Edu-cation, Evaluation and Research, San Francisco State University. Among the more important

studies of specific cultures are Bray; Félix Buffière, *Eros adolescent: La pédérastie dans la Grèce antique* (Paris, 1980); and Jonathan Katz, *Gay American History* (New York, 1976). The most recent survey based on secondary sources is Vern R. Bullough, *Sexual Variance in Society and History* (Chicago and London, 1976), which provides useful references to primary sources and raises most of the important issues.

24. Theodore Bowie and Cornelia V. Christenson, eds., *Studies in Erotic Art*, Studies in Sex and Society 3 (New York and London, 1970). Studies making frequent use of secondary sources include Peter Webb, *The Erotic Arts* (Boston, 1975) and Edward Lucie-Smith, *Eroticism in Western Art* (New York, 1972). I am grateful to Prof. Webb for the opportunity to discuss some of his ideas with him in person. Lucie-Smith is often insightful but at times fails to give the provenance of or documentation for specific works—e.g., his fig. 201, a prankishly graphic Quattrocento drawing after the antique of satyrs engaging in fellatio.

25. On the legal proscriptions and the punishments exacted, see below, chapter 1. An allied problem is defining homosexuality or "a homosexual." Current psychological conceptions of homosexuality as a distinct personality type were less clearly defined in the Renaissance, and individuals whom we would now consider homosexual may not have thought of themselves as such. The most recent, and extremely judicious, analysis of this question is by Bray, 55–57, who concludes that homosexuality was viewed in the Renaissance (at least in England) as one among many options of sexual behavior rather than as the basis for a distinctive sense of identity or self-defining subculture. See further Arthur N. Gilbert, "Conceptions of Homosexuality and Sodomy in Western History," *Journal of Homosexuality* 6:1–2 (1980–81), 57–68; Robert A. Padgug, "Sexual Matters: On Conceptualizing Sexuality in History," *Radical History Review* 20 (1979), 3–33.

26. John Addington Symonds, tr., *The Life of Benvenuto Cellini* (New York, 1896), xxxv. On the altered poems see Symonds, *The Life of Michelangelo Buonarroti*, 2 vols. (London and New York, 1899), appendix 5, 2:381–85, and text, 2:132–40, 166, n. 1. On Symonds' own life see Phyllis Grosskurth, *John Addington Symonds: A Biography* (New York, 1975); Grosskurth, ed., *The Memoirs of John Addington Symonds* (New York, 1984). Compare Walter Pater, *The Renaissance*, 1st ed. (London, 1873), especially his essays on Botticelli, Leonardo, Michelangelo, and Winckelmann.

Others of this period include Symonds' sometime collaborator, Havelock Ellis, *Studies in the Psychology of Sex*, vol. 2: *Sexual Inversion* (1897); Albert Moll, *Berühmte Homosexuelle*, Grenzfragen des Nerven- und Seelenlebens 11:75 (Wiesbaden, 1910); and Magnus Hirschfeld, whose Institut für Sexuelle Wissenschaft in Berlin published the important *Jahrbuch der sexuelle Zwischenstufen* from 1899 until destroyed by the Nazis. Bray, 59–60, notes that these early scholars were at times too eager to exalt the Renaissance as a time of great freedom of homosexual expression, which led to skepticism and overreaction to their claims. Where I have made use of early work not corroborated by modern research, the material is offered only in the notes.

27. Arno Karlen, *Sexuality and Homosexuality: A New View* (New York, 1971), 109. For a recent example of the continuing denial that homosexuality was a formalized institution in ancient Greece, see Lewis, "Brothers of Ganymede," 150–55. The most cogent rebuttal of this resistance to recognizing and exploring the history of minorities is John Boswell, "Revolutions, Universals, and Sexual Categories," *Salmagundi* 58–59 (1982–83), 89–113.

28. See, e.g., Giuseppina Fumagalli, *Eros di Leonardo* (Milan, 1952); Raymond Stites, *The Sublimations of Leonardo da Vinci* (Washington, 1970). For an example of naive or willful misreading, see Parmigianino's clearly homoerotic drawing of two nude shepherds (fig. 3.6) identified in an old inventory as Adam and Eve.

29. Eugène Plon, *Benvenuto Cellini* (Paris, 1883), 77–79; Mayo, 137, 141–42, 163; Kemp, 341. Compare the Oxford English Dictionary definition of "catamite" as "a boy kept for unnatural purposes." On the types of resistance to acknowledgment of homoerotic content, see James M. Saslow, "Closets in the Museum," in Karla Jay and Allen Young, eds., *Lavender*

Culture (New York, 1978), 215–27. Boswell, 18–22, has outlined the difficulties of working with modern editions of literary sources that omit references to homosexuality or, as in various volumes of the Loeb Classical Library, translate explicitly sexual passages obliquely or only into Latin or Italian (e.g., Loeb translations of Martial and of the *Greek Anthology*). Similarly, in an otherwise useful article, "Luca Signorelli's *School of Pan*," *Gazette des Beaux-Arts* 33 (1948), 77–87, Robert Eisler cited a classical text dealing with masturbation only in the original Greek. For a chronicle of the progressive desexualization of Ganymede in mythographic compilations through the eighteenth and nineteenth centuries, see Lewis, "Brothers of Ganymede," 147–65.

30. Andrée Hayum, *Giovanni Antonio Bazzi, "Il Sodoma"* (New York, 1976), xi; Bowie and Christenson, *Studies in Erotic Art*, x; Leo Steinberg, "The Metaphors of Love and Birth in Michelangelo's *Pietàs*," in *Studies in Erotic Art*, 259. Steinberg's recent study, *The Sexuality of Christ in Renaissance Art and Modern Oblivion* (New York, 1984), challenges the policy of disregarding evidence for Christ's sexual nature rather than seeking its spiritual connotations.

Chapter 1. Michelangelo: Myth as Personal Imagery

1. Symonds, *Michelangelo*, 2:137 and n. 1. The most recent treatments of the two men's relationship are Christoph L. Frommel, *Michelangelo und Tommaso de' Cavalieri* (Amsterdam, 1979), and Liebert, chapter 16.

2. Giorgio Vasari, *Le vite de' più eccellenti pintori, scultori, ed architettori . . .* , 1550/1568, ed. Gaetano Milanesi, 9 vols. (Florence, 1865–79), 7:223, 271–72 (hereafter cited as Vasari/Milanesi): "ed infinitamente amò più di tutti messer Tommaso de' Cavalieri." See also Paola Barocchi, *La vita di Michelangelo nelle redazioni del 1550 e 1568* (Milan, 1962), 1:86, n. 626, and 1:118; Symonds, *Michelangelo*, 2:138, n. 1, and 151–57; Frommel, 76–90; Liebert, 270–311; Charles de Tolnay, *Michelangelo*, 5 vols. (Princeton, 1943–60), vol. 3: *The Medici Chapel*, 23 (hereafter cited as *Medici Chapel*).

3. *Il carteggio di Michelangelo*, ed. Giovanni Poggi, Paola Barocchi, and Renzo Ristori, 4 vols. (Florence, 1965–79; hereafter cited as *Carteggio*), 3:DCCCXCVIII, tentatively dated January 1, 1533; see also 4:CMXIX, CMXXXII. Vasari/Milanesi, 7:271; Barocchi, *Vita*, 1:118. For the other drawings in the series see A. E. Popham and Johannes Wilde, *The Italian Drawings of the Fifteenth and Sixteenth Centuries in the Collection of H. M. the King at Windsor Castle* (London: Phaidon Press, 1949), nos. 429–431. The order and dating of the Cavalieri series cannot be precisely determined. The terminus ante quem for the major drawings is Cavalieri's letter of September 6, 1533, which acknowledges receipt of the *Phaethon* and notes that the *Tityos* and *Ganymede* are already in his possession. The earliest apparent reference to the *Ganymede* is in a letter to Michelangelo from Sebastiano del Piombo dated July 17, 1533 (*Carteggio*, 4:CMX), on which see below. For an alternative view of the sequence of these drawings, see William E. Wallace, "Studies in Michelangelo's Finished Drawings, 1520–1534" (Ph.D. diss., Columbia University, 1983), which suggests that the *Tityos* and *Ganymede* were preceded by the *teste divine*.

4. *Carteggio*, 4:CMXXXII. Several of these copies are discussed below, e.g., Figs. 1.4, 4.12. For a comprehensive list of known or recorded copies and variants see Saslow, "Ganymede," 593–606.

5. Vasari/Milanesi, 7:271; Barocchi, *Vita*, 1:118. On the artistic tastes and activities of Cavalieri, see Ascanio Condivi, *Vita di Michelangiolo*, 1553 (Florence, 1927); Frommel, 69–90. Alexander Perrig, "Bemerkungen zur Freundschaft zwischen Michelangelo und Tommaso de' Cavalieri," in *Stil und Überlieferung in der Kunst des Abendlandes*, Acts of the 21st International Congress of the History of Art, Bonn, 1964 (Berlin, 1967), 2:164–71, has suggested that one of the surviving versions of the *Fall of Phaethon* was executed by Cavalieri as an exercise.

6. On this controversy, dating back to Freud and Meyer Schapiro, see above, Introduction. Condivi's text is generally considered an "autobiographical myth"—a version of Michelangelo's life that distorts or omits certain facts in order to conform to a scenario generated from the artist's unconscious conflicts. On the development of this concept see Liebert, 5, n. 5, with earlier bibliography.

7. Charles de Tolnay, *Corpus dei disegni di Michelangelo*, 4 vols. (Novara, 1975–80), 2:344r; Michael Hirst, "A Drawing of the Rape of Ganymede by Michelangelo," in Sergio Bertelli and Gloria Ramakus, eds., *Essays Presented to Myron P. Gilmore*, 2 vols. (Florence, 1978), 2:253–60 (Hirst first called attention to this sheet in a note in *Burlington Magazine* 117 [1975], 166); Bernard Berenson, *The Drawings of the Florentine Painters*, 3 vols. (Chicago, 1938), 2:218; Kempter, no. 146.

8. Popham and Wilde, 265, no. 457 (as a copy); Tolnay, *Medici Chapel*, 116; Dussler, no. 722 (as a copy by Giulio Clovio); Berenson, 2:218, no. 1614 (as autograph); Mayo, 107–11; Kempter, 85–89, no. 145.

9. The Windsor drawing, at one time believed to be the actual piece presented to Cavalieri, has more recently been judged only a copy. Hirst's argument for the autograph status of the Fogg sheet is plausibly based on stylistic analysis, though Tolnay, *Corpus*, no. 344r, considers this sheet merely the best of many contemporary copies. Since several versions exist of both the larger vertical composition and of the isolated central motif, Michelangelo may have made more than one version of the subject, as we know he did for the *Phaethon* (see fig. 1.8). The primacy of the Fogg sheet is further supported, though indirectly, by the presence of incised stylus marks, which indicate that it was traced by a copyist; no such marks are found on the Windsor sheet.

10. Erwin Panofsky, "The Neoplatonic Movement and Michelangelo," in *Studies in Iconology*, 213–14. The references are to Plato, *Laws*, 1:636C, and Xenophon, *Symposium*, 8:30. Virtually all subsequent scholars, including Mayo and Kirschenbaum, have conceived their own contributions to the iconography of Michelangelo's *Ganymede* as amplifications or clarifications of Panofsky's inclusive typology.

11. Marsilio Ficino, *Commentarium in Convivio Platonis* (1474), tr. Sears R. Jayne (Columbia, Mo., 1943), 191 (hereafter cited as Ficino/Jayne). On the earlier history of this duality see Robert Hollander, *Boccaccio's Two Venuses* (New York, 1977); George Economou, "The Two Venuses," in Joan Ferrante et al., eds., *In Pursuit of Perfection: Courtly Love in Medieval Literature* (Port Washington, N.Y., 1975).

12. Panofsky, "The Neoplatonic Movement in Florence and North Italy," in *Studies in Iconology*, 141. On Ficino's central role in Quattrocento thought, see Paul Oskar Kristeller, *The Philosophy of Marsilio Ficino* (New York, 1943): André Chastel, *Marsile Ficin et l'art* (Geneva and Lille, 1954). On Neoplatonism and the importance it attached to love, see Nesca A. Robb, *Neoplatonism of the Italian Renaissance* (London, 1935); John Charles Nelson, *Renaissance Theory of Love* (New York, 1958).

13. Ficino/Jayne, 191. Classical sources of these contrasting tales are Hesiod, *Theogony*, 188–200, 353; Festus Grammaticus, 3:2; *Homeric Hymn to Aphrodite*, 2:5; Apollodorus, *On the Gods*, 1:1:3.

14. Symonds, *Michelangelo*, 2:161. For the medieval roots of the concept of anagogy, as described by Abbot Suger, see Erwin Panofsky, *Meaning in the Visual Arts* (Garden City, N.Y., 1955), 108–45.

15. Seznec, 103. The connection was noted earlier by Franz Cumont, *Recherches sur le symbolisme funéraire des romains* (Paris, 1942), 97–99, with reference to earlier bibliography. For further discussion of Ganymede in late antique and early Christian art and religion, with examples possibly known in the Renaissance, see Wind, *Pagan Mysteries*, 152–54; Mayo, ch. 1.

16. Arthur Henkel and Albrecht Schöne, eds., *Emblemata: Handbuch zur Sinnbildkunst des XVI. und XVII. Jahrhunderts* (Stuttgart, 1967), col. 1726. A complete bibliography of

editions of Alciati may be found in Henkel and Schöne, supplement; for other emblem book references to Ganymede see cols. 1727, 2146.

17. *Andreae Alciati emblematum flumen abundans*, ed. Henry Green, The Holbein Society's Fac-simile Reprints (London, 1872); Mayo, 109–11, fig. 42; Kempter, nos. 101, 233.

18. Marsilio Ficino, *Opera omnia* (Basel, 1576), 306; translated by Kristeller, *Ficino*, 267.

19. Achille Bocchi, *Symbolicarum quaestionum de universo genere*, Bologna, 1574; facsimile reprint ed. Stephen Orgel (New York, 1979), clxvi–clxix; Adam Bartsch, *Le Peintregraveur*, 21 vols. (Vienna, 1803–21), XV.163.255, 256; Mayo, 111; Kempter, nos. 22, 23; for additional bibliographical data on editions of Bocchi see Henkel and Schöne, col. 1727. Panofsky, *Studies in Iconology*, 216, suggests a classical text as precedent for the draping of one figure.

20. Benedetto Varchi, *Due lezzioni* (Florence, 1590), 183. These were delivered in 1547 and first published in 1550; English translation in John Addington Symonds, *The Renaissance in Italy* (New York, 1893), 2:126–27. On Varchi's lectures and their references to Cavalieri, see Symonds, *Michelangelo*, 2:126; David Summers, *Michelangelo and the Language of Art* (Princeton, 1981), 214–16; Leatrice Mendelsohn, *Paragoni: Benedetto Varchi's "Due Lezzioni" and Cinquecento Art Theory* (Ann Arbor, 1982). On the poetry see further Enzo Noè Girardi, *Studi su Michelangelo scrittore* (Florence, 1974); Walter Binni, *Michelangelo scrittore* (Turin, 1975). The reference to "un cavalier armato" occurs in Girardi's poem no. 98; subsequent citations of the poems are identified by the numbering of this edition: Enzo Noè Girardi, ed., *Michelangelo Buonarroti, Rime*, Scrittori d'Italia No. 217 (Bari, 1960).

21. Girardi, no. 89. The English translation cited throughout is by Creighton Gilbert, tr., and Robert N. Linscott, ed., *Complete Poems and Selected Letters of Michelangelo* (New York, 1970); this poem is their no. 87.

22. In other passages, even though no bird is mentioned, Michelangelo continues to characterize his love as an upward flight (Girardi, nos. 83, 260); see also references to wings and flight in nos. 49, 89, 99.

23. Written for Cavalieri in 1532. Charles de Tolnay, *The Art and Thought of Michelangelo* (New York, 1964), 104–05, also relates this poem to the *Rape of Ganymede*, and places Michelangelo's feelings for Cavalieri in the context of Neoplatonic ideas of *raptus*, *ascensio*, and *deificatio* (pp. 53–55).

24. Donato Giannotti, *Dialoghi di Donato Giannotti* (1545), ed. Dioclecio Redig de Campos (Florence, 1939), 68; tr. Symonds, *Michelangelo*, 2:132; Liebert, 529.

25. Plato, *Laws*, 1:636C; tr. R. G. Bury, *Plato*, vol. X (Cambridge, Mass., and London, 1967), 41. A thorough survey of the influence of this passage on Renaissance thought may be found in Virgil Gordon Lell, "The Rape of Ganymede: Greek-Love Themes in Elizabethan Friendship Literature" (Ph.D. diss., University of Nebraska, 1970), 32ff. I am indebted for this source to Prof. William Koelsch of Clark University.

26. Hyginus, *Fabula*, 224. This and other classical accounts were anthologized by Boccaccio in his *Genealogia deorum*; on the *Ovide moralisé* and *Ovidius moralizatus*, fourteenth-century Christianized interpretations of classical characters, including Ganymede, see Introduction.

27. Alciati, *Emblemata* (Padua, 1621), 28, 744; Boswell, 79, n. 87. See also Panofsky, *Renaissance and Renascences*, 78, n. 1: "In the middle ages Ganymede was so typical a representative of homosexuality that a prelate so inclined could be ridiculed as 'ganimedior Ganimede.'" I know of no explicit literary references to Ganymede as a sexual symbol in the Quattrocento, but the sexual connotation reappeared in the sixteenth-century translations of *Leucippe and Clitophon* (see below, chapter 3), in remarks by Cellini of 1545–46 (chapter 4), and as a euphemism for male concubines at the court of James I of England (chapter 5) in the seventeenth century.

28. Jean Festugière, *La Philosophie de l'amour de Marsile Ficin* (Paris, 1941), 1.

29. Ficino wrote of Cavalcanti that the two "have only one soul." On the inseparability of the two forms of platonic affection in Ficino and his circle, see André Chastel, *Art et humanisme à Florence au temps de Laurent le Magnifique* (Paris, 1959), 289–99; Phillippe Monnier, *Le Quattrocento: Essai sur l'histoire littéraire du XVe siècle italien*, 2 vols. (Paris, 1931); Kristeller, *Ficino*, 17; Festugière, passim.

30. Paolo Giovio, *Elogia clarorum virorum*, cited and discussed in Symonds, *The Renaissance in Italy*, 2:344–57, with additional examples of Poliziano's sonnets and couplets to young men (on Poliziano's death see Symonds, *The Renaissance in Italy*, 1:39). Recent biographical scholarship on Poliziano is scanty, the studies focusing primarily on literary criticism. Cynthia Munro Pyle, "Politian's *Orfeo* and other *Favole mitologiche* in the Context of Late Quattrocento Northern Italy" (Ph.D. diss., Columbia University, 1976), summarizes this literature; for biographical material see esp. pp. 4–10. Data of more particular relevance to the present study were assembled by Symonds in *The Renaissance in Italy* and by two of the pioneering scholars in the history of sexuality who paid particular attention to Poliziano's erotic interests: Havelock Ellis, *Sexual Inversion*, 31; Magnus Hirschfeld, *Homosexualität des Mannes und des Weibes* (Berlin, 1920), 1:669.

31. Condivi, 18–19; Condivi, *The Life of Michelangelo*, tr. Alice Sedgwick Wohl, ed. Hellmut Wohl (Baton Rouge, La., 1976), 15. See also Summers, *Michelangelo*, 242–49; Howard Hibbard, *Michelangelo* (New York, 1974), 22.

32. Angelo Poliziano, *Epigrammi greci* (Venice, 1498), tr. and ed. Anthos Ardizzoni (Florence, 1951), 55, no. XXVI, "Carme amoroso per Chiomadoro," with original Greek text. Additional examples of erotic epigrams to young men include nos. V, VII, VIII, X, XXIII, XXIX.

33. Angelo Poliziano, *Stanze per la giostra*, book I, stanza 107; ed. Bruno Maier, *Stanze per la giostra, Orfeo, Rime* (Novara, 1968), 68.

34. Nino Pirrotta, *Li due Orfei* (Turin, 1969), 17; M. Vitalini, "A proposito della datazione dell'*Orfeo* del Poliziano," *Giornale storico della letteratura italiana* 146 (1969), 245–51; Alessandro d'Ancona, *Origini del teatro italiano*, 2 vols., (1891; reprint Rome, 1966), 2:2, 106; Pyle, 7. *Orfeo* remained popular for at least half a century. It was later produced at Milan with stage machinery by Leonardo: Carlo Pedretti, "La macchina teatrale per l'*Orfeo* di Poliziano," in *Studi vinciani* (Geneva, 1957), 90–97.

35. *Orfeo*, lines 339–56; Maier, 111. The translation is my own, from a full translation in progress.

36. Ovid, *Metamorphoses*, 10:83–85; for additional sources see Robert Graves, *The Greek Myths* (Harmondsworth, 1960), 1:111–15. Poliziano used Orpheus in his epistle to Gioviano da Monopoli as a symbol of his own longings for this *fanciullo: Epigrammi greci*, no. X. Ficino, who translated the so-called Orphic Hymns, believed that these texts were part of the chain of knowledge leading from Hermes Trismegistus to Plato: Kristeller, *Ficino*, 15, 25–26; Chastel, *Art et humanisme*, 272–75.

37. In addition to the early *Rape of Deianeira* (Hercules' wife) recorded by Condivi, Michelangelo also carved a statue of Hercules which, according to both Vasari and Condivi, was intended as an expression of grief at the death of the artist's revered mentor, Lorenzo de' Medici (Vasari/Milanesi, 7:145; Condivi, 19). A hypothetical reconstruction of this lost sculpture suggests that it was nearly a mirror image of the *David*: Charles de Tolnay, "L'Hercule de Michel-Ange à Fontainebleau," *Gazette des Beaux-Arts* 64 (1964), 125–40. Although we have little information regarding the personal meaning, if any, of Michelangelo's drawing of *Three Labors of Hercules* (Windsor, Royal Library, no. 12770; Popham and Wilde, no. 423r; Tolnay, *Corpus*, no. 335r), toward the end of his life the artist again chose Hercules as a bearer of personal appreciation and gratitude. When the sculptor Leone Leoni made a medallion portrait of Michelangelo about 1560, the artist reciprocated with a wax statuette of Hercules and Antaeus: Vasari/Milanesi, 7:257–58.

38. On Michelangelo's knowledge of Dürer see Giannotti, _Dialoghi_, 43 and note; Condivi, 93 (tr. Wohl, 99); Summers, _Michelangelo_, 21, 380–81, 489.

39. Erwin Panofsky, _Albrecht Dürer_, 3d ed. (Princeton, 1948), 32, noting the derivation of _Orpheus_ from an engraving from the circle of Mantegna; Edgar Wind, "'Hercules' and 'Orpheus': Two Mock-Heroic Drawings by Dürer," _Journal of the Warburg and Courtauld Institutes_ 2 (1938–39), 209–14. Cf. fig. 3.21. For extensive background on Greek courting rituals see Dover, 92–93, fig. R758. For later etymological development of the bird as a sexual symbol, see below, chapter 2 (Leonardo) and chapter 4 (Cellini).

40. Wind, "'Hercules and Orpheus,'" 206–18; Dürer's debt to Poliziano is suggested by Aby Warburg, "Dürer und die italienische Kunst," _Gesammelte Schriften_ (1932; reprint, Nendeln and Liechtenstein, 1969), 2:443–50. For a provocative discussion of Dürer's other works alluding to homosexuality, and the possible emotional connotations of his relationship with Willibald Pirckheimer, see David Martocci, _The Male Nude_ (exh. cat., Clark Institute, Williamstown, Mass., 1980), no. 3. Martocci notes that the German _Hahn_ (cock) has the same sexual connotations as in English.

41. In "'Hercules and Orpheus,'" 215, Wind calls them mock-heroic travesties meant as bitterly ironic satires on the disparity between Platonic ideals of chaste affection and the carnal practices of many humanists. Dürer and his circle, however, were intimately acquainted with both Poliziano and Pico (ibid., 215, n. 2), and it is hard to see why he would so fiercely attack the very figures from whom he drew his inspiration.

42. Gyraldus, _Herculis vita_ (1548), in his _Opera_, 1696 ed., 1:578ff.; see Wind, "'Hercules and Orpheus,'" 214, n. 7. Ariosto, _Satire_ VI, line 25 (1525); _The Satires of Ludovico Ariosto_, ed. and tr. Peter DeSa Wiggins (Athens, Ohio, 1976), 152. Reprinted with the permission of The Ohio University Press, Athens.

43. Barocchi, _Vita_, 1:118. The _Archers Shooting at a Herm_, once considered a gift to Cavalieri, was removed from this group by Popham and Wilde, 248, no. 424r.

44. Baruch D. Kirschenbaum, "Reflections on Michelangelo's Drawings for Cavalieri," _Gazette des Beaux-Arts_ 38 (1951), 99.

45. Popham and Wilde, no. 429; Tolnay, _Corpus_, no. 345r; _Medici Chapel_, 115; Frederick Hartt, _The Drawings of Michelangelo_ (London, 1971), no. 353; _Carteggio_, 4:CMXXXII; Symonds, _Michelangelo_, 2:400. As Popham and Wilde note (p. 253), the two were treated as companion pieces from the start, as the pair of cameos engraved after them by Bernardi bears witness. However, Wallace, "Michelangelo's Finished Drawings," maintains that the two need not be considered as belonging together.

46. Panofsky, _Studies in Iconology_, 217–18; the source is Lucretius, _De rerum natura_, 3:982–84. For interpretations of _Tityos_ see also _Medici Chapel_, 111–12; Hartt, _Michelangelo_, no. 353.

47. Berenson, 218, no. 1615: "The eagle is the bird that we have seen in the _Ganymede_." The similarity is accepted and developed by Kurt R. Eissler, _Leonardo da Vinci: Psychoanalytic Notes on the Enigma_ (New York, 1961), 131.

48. _Medici Chapel_, 112. Summers, _Michelangelo_, 214, observes that Varchi's _Lezzioni_ organize love into positive and negative categories just as do _Ganymede_ and _Tityos_, and suggests that this categorization came from Michelangelo himself.

49. _Medici Chapel_, 112, including citations of parallel imagery in Michelangelo's poetry; Panofsky, _Studies in Iconology_, 218. Kirschenbaum, 103, in an explicit qualification of Panofsky, concurs with Tolnay's view: "We have here, not the representation of sacred and profane love, but rather two inextricable elements to be found in love."

50. Liebert, chapter 16, argues that, as a heterosexual myth, the passion of Tityos for Latona is irrelevant to Michelangelo's feelings for Cavalieri, and suggests various psychic meanings of the artist's use of this story. The story's acknowledgment that love can bring guilt and punishment may reflect Michelangelo's awareness of the sanctions against homo-

erotic love. For the misogyny implicit in Michelangelo's hierarchy of love, see further below, chapter 3.

51. For the version illustrated see Popham and Wilde, no. 430; Dussler, *Die Zeichnungen des Michelangelo: Kritischer Katalog* (Berlin, 1959), no. 238; Tolnay, *Corpus*, no. 343r; *Medici Chapel*, 119; Berenson, 219, no. 1617; Hartt, *Michelangelo*, no. 358. The other two versions are in London, British Museum 1895-9-15-517 (Tolnay, *Corpus*, no. 340r; Johannes Wilde, *Italian Drawings in the British Museum: Michelangelo and his Studio* [London, 1953], 55); and in Venice, Accademia, no. 177 (Tolnay, *Corpus*, no. 342r; Dussler, *Michelangelo*, no. 234; Hartt, *Michelangelo*, no. 357). Alexander Perrig (pp. 164–71), attempted to demonstrate that the Venice version is by Cavalieri. This theory is not acknowledged by Frommel, 61–68, where he treats these variants. It is rejected by Wallace.

52. Ovid, *Metamorphoses*, 1:747–79, 2:1–400. See analysis in *Medici Chapel*, 112–14; Panofsky, *Studies in Iconology*, 218–20.

53. *Carteggio*, 4:DCCCXCIX, CM (alternative drafts of his first letter to Cavalieri), and CMXVIII. For references to fire and fall in Michelangelo's poetry, see *Medici Chapel*, 114; Girardi, nos. 24, 27, 42, 49, 59, 65, 72, 74, 87, 96, 243, 272.

54. Panofsky, *Studies in Iconology*, 180. A similar point of view is expressed by Rudolf Wittkower and Margot Wittkower, *Born under Saturn* (London, 1963), 152: "It seems unlikely that Michelangelo should have suffered from feelings of guilt because of these friendships [with Cavalieri, Perini, et al.], less probable still that his Platonic love should have been 'rejected by the self,' as has recently been asserted." The reference is to Eissler, *Leonardo*, 130–31.

55. Eissler, *Leonardo*, 130, adding to Tolnay's reading of the *Tityos*, *Medici Chapel*, 114. A related study that suggests Michelangelo's internal conflict about his erotic feelings is Mirella Levi d'Ancona, "The Doni Madonna by Michelangelo," *Art Bulletin* 50 (1968), 43–50, which interprets the nude males in the background as homosexuals waiting at the baptismal pool for the purification of Christ's new order.

56. Although the emotional expressiveness and implied eroticism of Michelangelo's drawing break significantly with such elementary antecedents, as does the relative lack of background or landscape in the horizontal version, at least one classical source more closely resembles his front-to-back, intimate interlace of boy and bird. An antique marble sculpture of Ganymede and the eagle, which belonged to the Grimani family of Venice in the sixteenth century, is typologically close to Michelangelo's conception, though the youth hangs more statically and the eagle's beak does not stretch across his torso: Hellmut Sichtermann, 82, no. 108, based on an original by Leochares. For similar prototypes see Sichtermann, 38–40, 47, no. 106; A. Hekler, "Michelangelo und die Antike," *Wiener Jahrbuch für Kunstgeschichte* 7 (1930), 201–23.

57. *De deorum imaginibus libellus*, 2:302. On the widespread and continuing influence of Albricus's text, see Warburg, "Kirchliche und höfische Kunst in Landshut," in his *Gesammelte Schriften*, 2:457.

58. Paul Schubring, *Cassoni: Truhen und Truhenbilder der italienischen Frührenaissance* (Leipzig, 1915), 438; Lazzaroni-Muñoz, *Filarete* (Rome, 1908), fig. 32; Mayo, 100, n. 4; Kempter, no. 66. On the iconography of the doors, see Helen Roeder, "The Borders of Filarete's Bronze Doors to St. Peter's," *Journal of the Warburg and Courtauld Institutes* 10 (1947), 150–53. On their visual sources, see Charles Seymour, Jr., "Some Reflections on Filarete's Use of Antique Visual Sources," *Arte lombarda* 38/39 (1973), 36–47. For a more explicitly homoerotic scene on these doors see Fig. 1.15.

59. Roeder, 151. Illustrations of Ganymede's abduction in the *Ovide moralisé* generally adhere to the same stiffly literal type. For example, a manuscript now in Paris (Bibliothèque Nationale, MS fr. 373, folio 24r) patterned after the sculptural version of the theme on the Romanesque Ganymede capital at Vézelay, emphasizes that artists in this tradition still

interpreted the subject in essentially medieval terms; on the sculptural prototype see Forsyth, "Ganymede Capital," 241–47; Boswell, 251; Kempter, 22–26. For additional illuminated manuscripts of the *Ovide moralisé* depicting Ganymede, see Kempter, 27–33; Mayo, 103.

60. Boston, Museum of Fine Arts, no. 06.2441, as "Scenes from the Aeneid(?)." Ellen Callmann, *Apollonio di Giovanni* (Oxford, 1974), 69, no. 36; Mayo, 99–100; Kempter, no. 67. For interpretation of this chest's marital symbolism, see chapter 3. The second, unattributed panel is in the Musée Jacquemart-André, Fontaine-Châalis (Oise), France, Inv. no. 21; Schubring, 319, no. 420, as Florentine, ca. 1470. This *testata* shows, in a more detailed Tuscan landscape, two similar hunting companions who gesture lightly at the boy hanging down between the eagle's talons, which grasp him by the left arm and hair; equally ludicrous, the hunters' arrow has wounded Ganymede instead of his abductor. Schubring, 85, refers to a third panel on the same subject, in Pisa.

61. Liebert, 173. See also Eissler, *Leonardo*, 111–12, 130–31. The genitalia are most observable in the Windsor drawing and in the engraving after it by Nicholas Beatrizet: Hartt, *Michelangelo*, no. 306.

62. This broad cultural process and its outcome are neatly traced in Stokes, *Michelangelo*, 139: "In the Gothic age, [classical] themes had had no classical treatment, and the classical motifs were applied to Christian subjects. It follows that the motifs, reunited in the Renaissance with classical themes, brought with them a wealth of medieval iconography." On the general topic, see Weiss, *Renaissance Discovery of Classical Antiquity*; Panofsky, *Renaissance and Renascences*; Seznec; Fritz Saxl, *Classical Antiquity in Renaissance Painting* (London, 1938).

63. The entire work, titled *Reductium morale*, was compiled ca. 1340–42; some manuscripts bear an attribution to Thomas Walleys. The version cited is a transcription of book 15, *Metamorphosis Ovidiana*, ch. 1, "De formis figurisque deorum," pp. 9–10, "De Iove et eius figura."

64. Dante had earlier used Ganymede as a symbol of *mens humana*, the intellect transported by Supreme Being to the heights of contemplation: *Purgatorio*, 9:19–24, interpreted by Panofsky, *Studies in Iconology*, 179–80, 215, in connection with Michelangelo's drawing. On Michelangelo and Dante see below, n. 90. Such interpretations were still current in the sixteenth century; the same gloss was applied to Ganymede by Claude Mignault in his commentary on Alciati published in 1571: Panofsky, *Studies in Iconology*, 213, n. 130 and 215, n. 141; Seznec, 103, n. 89.

65. de Boer, "*Ovide moralisé*," 91 (vol. 4, bk. 10, lines 3380–85). For other versions, see Panofsky, *Renaissance and Renascences*, 78–80, n. 2.

66. *Summa theologica*, 1a.2ae.94.3 ad 2: "concubitus masculorum, quod specialiter dicitur vitium contra naturam"; see also Boswell, 302–32. In addition to outlining how Aquinas turned the Church away from the permissive attitude toward homosexuality that had prevailed in the eleventh and twelfth centuries, Boswell cites a wealth of references in the literature of the period that use Ganymede as a paragon of homosexual lust; see esp. pp. 243–69, "The Triumph of Ganymede: Gay Literature of the High Middle Ages."

67. Located along the right edge of the columned pavilion in the large lower right-hand panel depicting the martyrdom of St. Peter.

68. Popham and Wilde, no. 431r; Tolnay, *Corpus*, no. 338; *Medici Chapel*, 120; Berenson, 219, no. 1618; Dussler, *Michelangelo*, no. 365.

69. See also the Quattrocento drawing by the school of Squarcione after an antique relief of satyrs engaging in fellatio, illustrated by Lucie-Smith, *Eroticism in Western Art*, 196, no. 201 (unfortunately without provenance). On the symbolism of satyrs see Louis Réau, *Iconographie de l'art chrétien*, 4 vols. (Paris, 1955), 1:109; cf. *The Greek Anthology*, tr. W. R. Paton, 5 vols. (Cambridge, Mass., 1956–60), 12:41, 128.

70. See also the analysis in Liebert, 40–44, 289–95, which interprets the drawing as a "renunciation of the conventional social order and the substitution of a fantasized all-male world in which lewdness and aggression are accommodated."

71. Tolnay, *Corpus*, 106, no. 336r, noting a message on the verso dated April 1530. On the consonance of the drawing's theme with that of the Cavalieri drawings, see Judith A. Testa, "The Iconography of the *Archers*: A Study of Self-concealment and Self-revelation in Michelangelo's Presentation Drawings," *Studies in Iconography* 5 (1979), 45–72; Liebert, 277. For comparisons of love to an archer or to arrows in Michelangelo's poems, see Girardi, nos. 23, 74, 137, 260.

72. Tolnay, *Corpus*, 2:103, no. 333r, dated 1535–36; Wilde *Italian Drawings*, 95; Berenson, no. 174B, as an exact copy of a design made by Michelangelo while he was creating the Cavalieri series; Dussler, *Michelangelo*, no. 589 (doubting its autograph status); Hartt, *Michelangelo*, no. 359. On the drawing's iconography see Vasari/Milanesi, 6:431; Panofsky, *Studies in Iconology*, 223–25; Liebert, 307–11, who observes that the masturbation detail is clearer in the engraving by Beatrizet (Liebert's fig. 16–13). Although not documented as a gift for Cavalieri, this drawing has been suggested as the one to which Benedetto Varchi referred in his *Lezzioni* (Florence ed., 1549), 50, where he calls Cavalieri "that beautiful person or thing who sometimes awakens us from the dream of human life" (Summers, *Michelangelo*, 215). Additional support for the possibility that *The Dream* was part of the Cavalieri series has been given by Judith A. Testa in an unpublished article, "Interactions of Art, Poetry, and Personality: The Intimate Iconography of Michelangelo's Cavalieri Drawings," cited in Liebert, 309. Testa suggests that *The Dream* may form a quartet with three of the known Cavalieri drawings because of the similar male figure in all four. This figure, distinguished by its bent knee, appears in four cardinal positions in this putative series: Tityos is horizontal facing right, the dreamer horizontal facing left, Ganymede vertical and ascending, Phaethon vertical and descending.

73. *Inferno*, canto 15, esp. lines 103–24. On the sodomy of Latini and his fellow sufferers see John D. Sinclair, tr. and ed., *The Divine Comedy*, 3 vols. (New York, 1976), 1:199, n. 8, and 1:202. While the Italians nicknamed syphilis "the French disease," the French referred to homosexuality as "the vice of Florence." For the use of these terms in the writings of Benvenuto Cellini, see below, chapter 4; Bullough, *Sexual Variance*, 426–27, n. 51; Chastel, *Art et humanisme*, 290, n. 2, and 291–93, with further references. For a brief survey of legislation in Florence and Venice in "the relentless but unsuccessful fight against homosexuality," see Wittkower and Wittkower, 169–70, who cite the lament of Dante's Florentine contemporary Fra Giordano: "Oh, how many sodomites are among the citizens! Or rather, all of them indulge in this vice!"; and Giovanni Scarabello, "Devianza sessuale," 75–84. According to Marvin S. Becker, *Florence in Transition*, 2 vols. (Baltimore, 1967), 1:228–29, "After 1343 marked efforts were made to clarify and render explicit legal definitions for . . . sexual perversion. . . . Later, conviction for sodomy required only . . . a single witness." The laws were progressively tightened at least until 1506. Patricia Labalme has discussed similar legal action and its social background in an unpublished talk, "Sodomy and the Venetian Constitution," New York, 1979. The records of the Florentine *Ufficiali de' notti*, which survive for the period 1432–1502 (Bullough, *Sexual Variance*, 416), provide documentation for accusations of sodomy against Leonardo da Vinci in 1476 and against Botticelli in 1502 and one of his *garzoni*. On the last two see Jacques Mesnil, *Botticelli* (Paris, 1938), 98, 204.

The Wittkowers suggest that the frequent leniency of punishment was in part due to the tolerance toward homosexuality that arose among humanists aware of its sanction in Greek tradition. On the other hand, archives of the *Atti del esecutori* record at least one trial for sodomy in 1429 in which a certain Piero di Jacopo was convicted and burned at the stake; at another, in 1425, the guilty party was whipped through the streets wearing a miter. For

transcriptions of these and other primary documents and a review of Florentine legal activity, see Gene Brucker, *The Society of Renaissance Florence: A Documentary Study* (New York, 1971), 203–06.

74. P. Villari and E. Casanova, *Scelte di prediche e scritti da Fra Girolamo Savonarola* (Florence, 1898), 61, 63. See also Wittkower and Wittkower, 169, who translate Savonarola's speech and a remark by the Florentine Benvenuto del Bianco (Villari and Casanova, 507), expressing his relief upon hearing of the death of Savonarola: "And now we can practice sodomy again!" It would appear that public toleration varied, at times forcing extreme discretion. On the artists' responses see Vasari/Milanesi, 4:179; Chastel, *Art et humanisme*, 393–95; Ronald Steinberg, *Fra Girolamo Savonarola, Florentine Art, and Renaissance Historiography* (Athens, Ohio, 1977), chs. 2 and 5.

75. Condivi, 98; tr. Wohl, 105. Vasari's similar account (Vasari/Milanesi, 7:275) was in all likelihood based on the information in Condivi (Tolnay, *Art and Thought*, 59). Tolnay (ibid., 56–82) summarizes the literature attempting to establish that Michelangelo was a "faithful follower of the Frate" (Joseph Schnitzler, *Savonarola* [Milan, 1931], 2:409). R. Steinberg, *Savonarola*, 42, questions the degree to which this long-standing assumption is accurate, asserting that "we have found instead only parallels between some of Michelangelo's art and Savonarola's ideas." This degree of correspondence is sufficient for our present purposes.

76. *Letters of Pietro Aretino*, tr. Thomas Caldecott Chubb (Hamden, Conn., 1967), 224; *Lettere sull'arte di Pietro Aretino*, ed. Fidenzio Pertile and Ettore Camesasca, 3 vols. (Milan, 1957–60), no. CCCLXIV (see 3:177, n. 1); Giovanni Gaye, *Carteggio inedito d'artisti dei secoli XIV–XVI*, 3 vols. (Florence, 1839–40), 2:332–34.

77. On Michelangelo's friendship with Perini, their correspondence, and gifts of drawings to him, see Vasari/Milanesi, 7:276; Popham and Wilde, 264, no. 453.

78. Condivi, 98–99; tr. Wohl, 105. This passage is joined to Condivi's account of Michelangelo's admiration for Savonarola, suggesting that the point of the whole section is to assert Michelangelo's religious devotion and orthodox morality in the face of persistent rumors to the contrary.

79. On Sodoma, the most outspokenly homosexual artist of the Renaissance, see Vasari/Milanesi, 6:379–86; on Leonardo and his workshop see below, chapter 2. The incidence of homosexuality among artists is surveyed by Wittkower and Wittkower, 170–73. Sodomy seems to have been a practice evoking humor, ridicule, or censure, though not always punishment. As early as Donatello, Michelangelo's artistic grandfather, the Florentines delighted in a humorous anecdote illustrating the sculptor's attraction to male beauty: see A. Wesselski, ed., *Angelo Polizianos Tagebuch 1477–79* (Jena, 1929), 118, no. 230; Albert Czogalla, "David und Ganymedes: Beobachtungen und Fragen zu Donatellos Bronzeplastik 'David und Goliath,'" in Albrecht Leuteritz et al., eds., *Festschrift für Georg Scheja* (Sigmaringen, 1975), 119–27; Laurie Schneider, "Some Neoplatonic Elements in Donatello's *Gattamelata* and *Judith and Holofernes*," *Gazette des Beaux-Arts* ser. 6, vol. 87 (1976), 41–48; H. W. Janson, *Donatello*, 2 vols. (Princeton, 1957), 1:85. On accusations of sodomy against Leonardo and Botticelli, along with their models or shop assistants, see above, n. 73. Cellini was accused of sodomy several times, once with one of his *garzoni*; see below, chapter 4.

80. *Carteggio*, 1:CXIV, dated 1514 or 1518, except for E. H. Ramsden, ed. and tr., *The Letters of Michelangelo*, 2 vols. (London, 1963), vol. 1, no. 195, dated 1533.

81. Barocchi, *Vita*, 1:125: "E stato nel suo dire molto coperto et ambiguo, avendo le cose sue quasi due sensi." This passage from Vasari's 1550 edition was deleted from the second version.

82. *Carteggio*, 4:DCCCXCIX, CM, letters of January 1, 1533; tr. Gilbert, p. 253, no. 49. The implication seems to be that although it is generally permissible, even customary, to identify the subjects of gift drawings, in this case to do so might be considered improper;

see also Liebert, 271; Ramsden, vol. 1, no. 191. Testa, "Interactions of Art, Poetry, and Personality," has also argued that Michelangelo was alluding to passions that could not safely be named in writing.

83. Letters between the three men from July to September 1533 report that Tommaso visited Sebastiano at Michelangelo's request (*Carteggio* 4:CMXXXII, in which Tommaso also mentions the *Tityos* and *Ganymede*) and that Sebastiano acted as an intermediary between the other two (ibid., 4:CMXIII, CMXXIII). For further evidence of their artistic relationships, see Vasari (Barocchi, *Vita*, 1:118).

84. As summarized by Hirst, 257–58, numerous historians have concurred with Berenson (2:218, no. 1614) that "the jovial and frivolous Sebastiano" was merely making "a frivolous suggestion." As Hirst rightly points out, however, Sebastiano's proposal is quite in keeping with Michelangelo's practice of reusing poses: his *Risen Christ*, for example, is traced from the *Tityos* and given new attributes.

85. Vasari/Milanesi, 7:143–46; Condivi, 15; tr. Wohl, 12.

86. Liebert, 171–74. The theme of parental yearning and strife is discussed in detail, with reference to Ludovico, Popes Julius II, Leo X, and Paul III, and other figures (170–80; see also Eissler, *Leonardo*, 101n).

87. *Carteggio*, 4:CMXLII. On the relationship between Michelangelo and Febo see Symonds, *Michelangelo*, 2:157–58; Liebert, 299–302.

88. In dictating to Condivi, Michelangelo pointed out his paternal feelings and behavior toward his younger pupils, contradicting popular opinion: "Nor is it true, as many people charge, that he has been unwilling to teach; on the contrary, he has been glad to do so": Condivi, 101–02; tr. Wohl, 106. Characteristically, Michelangelo provides an excuse for the failure of these attempts by citing the failings of his students. In a recent paper delivered to the symposium on Raphael at Columbia University (October 1983), Robert Liebert explored the possibility that Michelangelo's gradual loss of interest in collaborating with Sebastiano del Piombo occurred after the older artist met Cavalieri and found in him a more desirable focus for "parental" nurturing and guidance.

89. Scholiast on Apollonius Rhodius, *Argonautica*, 1:1124; Apollodorus, *On the Gods*, 1:1:5–7; Hesiod, *Theogony*, 453–67; Hyginus, *Poeticon astronomicon*, 2:13; Hyginus, *Fabula*, 118; Dante, *Inferno*, 14:100; see also Graves, *The Greek Myths*, 1:39–44. The motif of Saturn devouring his children appears in Quattrocento art, e.g., Sinibaldi's illuminated miniatures (ca. 1475) for Petrarch's *Trionfi* (Prince D'Essling and Eugène Müntz, *Pétrarque, ses études d'art, son influence sur les artistes* [Paris, 1902], 161).

90. *Africa*, III, lines 140ff.; see Seznec, 173. Condivi (tr. Wohl, 93) praises Petrarch as the best of modern poets; later (p. 103) he records that Michelangelo regarded this poet as second only to Dante.

91. Cornazzano, *De excellentium virorum principibus*; Rome, Biblioteca Vittorio Emmanuele, *Codice sessoriano*, 413; cited in Adrian Stokes, *Stones of Rimini* (New York, 1934), 246. Cornazzano's book was dedicated to Borso d'Este, whose love for his own "Ganymede," Teofilo Calcagnini, is discussed by Werner L. Gundersheimer, *Ferrara: The Style of a Renaissance Despotism* (Princeton, 1973), 293.

92. Illustrated in Graham Smith, *The Casino of Pius IV* (Princeton, 1977), fig. 42.

93. "The First Apology of Justin the Martyr," in C. M. Richardson, ed., *Early Christian Fathers*, Library of Christian Classics (Philadelphia, 1953), 1:256. I am indebted for this citation to Prof. William Koelsch of Clark University.

94. Bartsch XVII.78.78–88 (Alberti was active principally from 1571 to 1602). Polidoro's interest in Ganymede produced another illustration of the myth, an unrelated red chalk drawing depicting the rape of the youth in more traditional fashion, as an aerial abduction above a sprawling landscape; see Philip Pouncy and John A. Gere, *Italian Drawings in the British Museum Department of Prints and Drawings: Raphael and His Circle* (London,

1962), no. 205; Alessandro Marabottini, *Polidoro da Caravaggio*, 2 vols. (Rome, 1969), 1:318, no. 78; Kempter, no. 184.

95. Bartsch XVII.79.86. For the only other known illustration of erotic intimacy between the two figures where Jupiter appears in human form, see the drawing by Raffaelle da Montelupo, fig. 3.27.

96. Svetlana Alpers, *The Decoration of the Torre de la Parada*, Corpus Rubenianum Ludwig Burchard 9 (London and New York, 1971), 29, 110; the two paintings are nos. 155 (Saturn) and 24 (Ganymede), discussed on pp. 259 and 210, respectively; Kempter, no. 198. On Rubens' illustrations of Ganymede see further below, chapter 5.

97. Among innumerable parallels drawn between the Old and New Testaments, the most clear-cut example is the typology that viewed Mary as "the new Eve," whose purity is the agent of Christ's reversal of the suffering visited upon humanity by her predecessor's original sin: Réau, 2:2:83.

98. As Tolnay observes (*Medici Chapel*, 113–14), in ancient sculpture "the figure of Jupiter with his thunderbolt . . . was invariably omitted."

99. *Metamorphoses*, 2:391; tr. Miller, 1:87.

100. As Berenson observed (218, no. 1615), the drawing of the risen Christ on the verso that evolved into the Christ of the *Last Judgment* is virtually a tracing of the figure of Tityos, turned to an upright position; the figure of Jupiter is similarly derived from the *Tityos*. See also Popham and Wilde, 252, no. 429; *Medici Chapel*, 113.

101. *Metamorphoses*, 1:758–775, 2:19–31, 90–100; tr. Miller, 57, 60–62, 67. On the theme of light or the sun in Michelangelo's poetry see *Medici Chapel*, 113; Stokes, *Michelangelo*, 140; Girardi, nos. 30, 34, 40, 87, 89. In several poems Michelangelo puns on the name of his correspondent Febo (= Phoebus, Apollo) di Poggio: Girardi, nos. 99, 100, and appendix, no. 10.

102. *Metamorphoses*, 2:367–69; *Orfeo*, lines 348–56. The erotic nature of Phaethon's relation to Cycnus is supported or strongly implied by *Medici Chapel*, 113; Liebert, 288; Panofsky, *Studies in Iconology*, 220–21.

103. Leo Steinberg, "Michelangelo's 'Last Judgment' as Merciful Heresy," *Art in America* 63 (1975), 52–53, attempts to show that Michelangelo's vision of morality and final judgment is both less fearful and more merciful than normative Christian doctrine of the time. If true, such a view would make any ascription of Michelangelo's guilt and fear to external pressures even more problematic. Steinberg concedes that his theory cannot be proved; it is rejected by Charles Dempsey, *Rome in the Renaissance* (New York, 1982), 65–71.

104. See the marginal notes in a first edition of Condivi, apparently written by a contemporary of Michelangelo and based on remarks by the artist to the effect that he always practiced the sexual continence noted by Condivi: Ugo Procacci, "Postille contemporane in un esemplare della Vita di Michelangiolo del Condivi," *Atti del convegno di studi michelangioleschi* (Rome, 1966), 277–94; Liebert, 306.

105. Giannotti, *Dialoghi*, 68; tr. Symonds, *Michelangelo*, 2:132; Liebert, 172–76.

106. Liebert, 302. For Cavalieri's possible ambivalence toward or lack of interest in sexual relations with Michelangelo, see ibid., 294, including the hypothesis that the *Tityos* was meant to reassure Cavalieri that Michelangelo's physical desire for him would remain restrained.

107. For example, that by Masaccio in Santa Maria Novella, Florence, which Michelangelo certainly knew. The same theme of an older man tenderly supporting a younger one from behind is evident in Michelangelo's Florence Pietà; see L. Steinberg, "Metaphors of Love and Birth." Michelangelo's poems speak of his desire for just such a loving embrace, e.g., Girardi nos. 72, 285.

108. Frommel, *Michelangelo und Cavalieri*, 73–76, outlines Tommaso's marriage and later life; see also Liebert, ch. 16.

109. *Medici Chapel*, 115; Tolnay, *Art and Thought*, 54.

110. *Pietà*, Florence, 1545–54; the description of a falling action dates to Condivi, 126; tr. Wohl, 87. L. Steinberg, "Metaphors of Love and Birth," concentrates on the eroticized relationship of Christ and Mary, but the autobiographical reference in the face of Nicodemus suggests that his relationship to Christ, while subordinate, is of some importance. Steinberg's assessment of the sculpture's personal significance is questioned by Robert Liebert, "Michelangelo's Mutilation of the Florence *Pietà*: A Psychoanalytic Inquiry," *Art Bulletin* 59 (1977), 47–54.

Chapter 2. Correggio at Mantua: Libertinism and Gender Ambiguity in Northern Italy

1. For biographical information and fundamental documentation about Correggio's works, see Vasari/Milanesi, 4:115ff.; Cecil Gould, *The Paintings of Correggio* (Ithaca, N.Y., 1976); Augusta Ghidiglia Quintavalle, ed., *L'opera completa del Correggio* (Milan, 1970); A. E. Popham, *Correggio's Drawings* (London, 1957), Introduction.

2. As first noted by Hugo von Tschudi, the figure of Ganymede is directly adapted from the flying angel on the northwest pendentive supporting the cupola of the Duomo at Parma, frescoed by Correggio ca. 1525–30: "Correggio's mythologische Darstellungen," *Die graphischen Künste* 2 (1880):8–9. See also Corrado Ricci, *Antonio Allegri da Correggio: His Life, His Friends, and His Time*, tr. Florence Simmonds (New York, 1896), 319–21; Karl Swoboda, "Die Io und der Ganymed des Correggio in der Wiener Gemäldegalerie," in his *Neue Aufgaben der Kunstgeschichte* (Brünn, 1935), 96–97. Suggestive points of comparison also link Ganymede to the flying angel sketched by Correggio for his *Madonna della Scodella*: Popham, *Correggio's Drawings*, no. 77.

3. Tr. J. H. Mozley, 2 vols. (Cambridge and London, 1967), 1:381; Mayo, 138.

4. Bernardo da Siena, *Triomphi di Messer Francesco Petrarca con la loro optima sposizione* (Venice, 1519), f. 14; Egon Verheyen, "Correggio's *Amori di Giove*," *Journal of the Warburg and Courtauld Institutes* 29 (1966):184, n. 1. On Petrarch's adoption by later philosophers, see Robb, *Neoplatonism*, 19–20, 179; Panofsky, *Renaissance and Renascences*, 39.

5. *Libro di natura d'Amore* (Venice, 1525), 74v–75r. Correggio's reuse of his own angel from the Parma Duomo for the figure of Ganymede might be taken to indicate his intention of "spiritualizing" Ganymede in this way ("converting the good to the beautiful"), but such reuse is hardly unusual in his oeuvre: Gould, *Paintings*, 274; Popham, *Correggio's Drawings*, 92. On Equicola, see Domenico Santori, *Della vita e delle opere di Mario Equicola* (Chieti, 1960); Nelson, 69–72, 112–16. Equicola advised Isabella d'Este, was tutor to Federigo Gonzaga, and wrote a history of Mantua that was relevant to the decorative programs for several rooms in the Palazzo del Te: see Egon Verheyen, *The Palazzo del Te in Mantua: Images of Love and Politics* (Baltimore and London, 1977), 40; Frederick Hartt, *Giulio Romano*, 2 vols. (New Haven, 1958), 1:138–40.

6. For the various hypotheses regarding the original location and layout of the series, see below, n. 13, and Gould, *Paintings*, 130, n. 2; Mayo, 139; Verheyen, "Amori," pls. 37–39; Elfriede R. Knauer, "Zu Correggios Io und Ganymed," *Zeitschrift für Kunstgeschichte* 33 (1970), 61.

7. *Iconologia*, 1775 ed., 2:183; Réau, 1:82; Verheyen, "Amori," 186–87, pl. 43d; Knauer, 67. The association of a deer with Io seems to call for some symbolic reading since it departs from her obvious mythological attribute, the cow into which Jupiter transformed her (Ovid, *Metamorphoses*, 1:611–728). Kempter, 118–19, raises some doubt about the identity of the deer, which may have been altered in restoration, but concedes that a spiritual reading of both pictures is still possible.

8. Alciati, Emblem no. 4: "Potest quoque infra appingi (non tamen ex necessitate) canis latrans tum quia fabulam sic Vergilius et Statius enarrent." Bocchi, Emblem LXXVIII;

Verheyen, "Amori," 187, nn. 151–52. For Bonasone's illustrations to Bocchi and other versions of Ganymede that include a dog very similar to Correggio's, see above, fig. 1.5.

9. Other pictures by Correggio were also viewed by later observers as exemplifying Neoplatonic ideals. In the early seventeenth century, a cataloguer of works collected by Charles I identified copies of the artist's *Education of Cupid* and *Antiope* as illustrations of the Ficinian concepts *Venerie mundano* and *Venerie coeleste*: Cecil Gould, *The "School of Love" and Correggio's Mythologies* (London, n.d.), 7.

10. The fundamental work on Federigo's relationship to Boschetti is Stefano Davari, *Federico Gonzaga e la famiglia Paleologa del Monferrato, 1515–1533* (Genoa, 1891). On Boschetti's privileges and Isabella d'Este's resentment, see Paolo Giovio, *Dialogo dell'imprese militari e amorose* (Venice, 1556), 75–76; Giovio, *Historiae sui temporis*, cited in George R. Marek, *The Bed and Throne: The Life of Isabella d'Este* (New York, 1976), 206. The judgment that Federigo was extremely licentious was made by his biographer, Alessandro Luzio, in *Fabrizio Maramoldo* (Mantua, 1883); see also Hartt, *Giulio*, 1:70–73. Vasari/Milanesi, 5:546, records a commission by Federigo for a painting of a couple embracing on a bed watched by a voyeur. On Federigo's patronage of erotic mythologies see also Charles Hope, "Problems of Interpretation in Titian's Erotic Paintings," in *Tiziano e Venezia: Convegno internazionale di studi, Venezia 1976* (Vicenza, 1980), 112–13, who compares Federigo's taste to that of Alfonso d'Este and François I. For the sequence of building campaigns at the Palazzo and Giulio's activities in Mantua through the 1540s, see Verheyen, *Palazzo*; Hartt, *Giulio*, 73–77; Vasari/Milanesi, 5:548–51; and below, chapter 3.

11. On Isabella's patronage see Egon Verheyen, *The Paintings in the Studiolo of Isabella d'Este at Mantua* (New York, 1971); Gould, *Paintings*, 239–42.

12. On the commission see Vasari/Milanesi, 4:115. The modern consensus on the date 1530–32 is noted by Ghidiglia Quintavalle, *L'opera completa*, 110, no. 80; the slightly earlier date of 1528–30 suggested by Verheyen, "Amori," 160, n. 1, and accepted by Kempter, 117, is rejected by Gould, *Paintings*, 130, n. 2. Correspondence between the emperor Rudolf II and his ambassador in Madrid, Hans Khevenhüller, locates the works there by 1585 (see below, n. 68). On the somewhat clouded provenance of the pictures prior to 1585, see Ghidiglia Quintavalle, *L'opera completa*, nos. 77–80; Gould, *Paintings*, 194, 275.

13. There is general agreement that the loves were originally intended for Federigo's quarters, though the specific location is disputed. Verheyen's detailed attempt to place them in the Sala di Ovidio ("Amori," 168–69) is rejected by Gould, *Paintings*, but accepted by Knauer, 61, and Kempter, 116. Frederick Hartt, *History of Italian Renaissance Art* (New York, 1974), 514, asserts that the series was intended instead for the Ducal Palace. For the second set of cartoons see Gould, *Paintings*, 131; Verheyen, "Amori," 174, assumes these are a continuation of the original series, which need not be the case.

14. On Aretino and Federigo see Alessandro Luzio, *Pietro Aretino nei primi suoi anni a Venezia e la corte dei Gonzaga* (Turin, 1888), who recounts the periodic difficulties in their relationship; Patricia Labalme, "Personality and Politics in Venice: Pietro Aretino," in David Rosand, ed., *Titian: His World and His Legacy* (New York, 1982), 124; *Dizionario biografico degli italiani*, 25 vols. to date (Rome, 1960–), s.v. "Aretino," 4:92–96.

15. Aretino/Chubb, 33–34, no. 5. For the Italian original see Aretino, *Lettere*, no. II.

16. Aretino/Chubb, 240, no. 155; *Lettere*, no. CCCLXXV (Dec. 1547), For the letter to Sebastiano, see *Lettere*, no. XXXI (June 1537). In another letter not included in Camesasca's edition, Aretino writes, "To anyone who asserts that by assuaging our appetite we hasten death, I reply that a man just so much lengthens his life as he fulfills his desires. I say that, by the way, and not Plato" (Aretino/Chubb, 242, no. 156, Dec. 1547).

17. Aretino/Chubb, 123–25, no. 58; *Lettere*, no. LXVIII (Dec. 1537). On Aretino's role in the affair of *I modi*, see commentary in *Lettere*, 3:143.

18. "Oh quanti giovani ti farei godere!" (*Lettere*, 3:199, n. 266). For the sonnet and

letters, ibid., 3:112, 150, 235; in an excursus on Aretino's "socratic propensities," Camesasca and Pertile conclude that "sodomy was at that time so widespread as not to raise the least scandal." On Aretino's flight from Venice see further Labalme, "Personality and Politics," 124, nn. 45–50.

19. Ariosto, tr. Wiggins, *Satire VI*, lines 15–22; *Orlando furioso*, canto 45, stanza 14. On the poet's connections to Mantua see Michele Catalano, *Vita di Ludovico Ariosto ricostruita su nuovi documenti* (Geneva, 1930–31); Verheyen, *Palazzo*, 40–43. Ariosto mentions Ganymede three times in the *Orlando* with varying associations, all of minor importance: cantos 4:47, 7:20, 26:98–100.

20. *The Book of the Courtier*, tr. George Bull (Harmondsworth, 1967), 168; *Il libro del cortegiano*, ed. Amadeo Quondam (Milan, 1981), bk. 2, ch. 61. On the author and his work see Vittorio Cian, *Un illustro nunzio pontificio del Rinascimento: Baldassar Castiglione* (Vatican City, 1951); Robert W. Hanning and David Rosand, eds., *Castiglione: The Ideal and the Real in Renaissance Culture* (New Haven and London, 1983).

21. *Tutte le opere di Matteo Bandello*, ed. Francesco Flora, 2 vols. (Verona, 1942), 1:95, novella VI; *The Novels of Bandello*, tr. John Payne, 2 vols. (London, 1890), 1:94–98. Their contemporaneity, and the influence of Castiglione, are noted by J. R. Woodhouse, *Baldesar Castiglione: A Reassessment of "The Courtier"* (Edinburgh, 1978), 103.

22. Margarete Bieber, *Sculpture of the Hellenistic Age* (New York, 1955), nos. 625ff.; Marie Delcourt, *Hermaphrodite: Mythes et rites de la bisexualité dans l'antiquité classique* (Paris, 1958), 95–96, referring to freestanding sculptures, cameos, and bas-reliefs. For examples in vase-painting, see Dover, figs. RS 12, RS 20.

23. Rome, Galleria Borghese, no. CLXXII, copy of a Hellenistic marble (the original Borghese sculpture is now in the Louvre). Numerous versions are extant; see Bieber, no. 625; Delcourt, 95.

24. The story is a late literary, not mythological, invention and derives from Ovid, *Metamorphoses*, 4:285–388; see also Martial, *Epigrams*, 14:174; Pauly-Wissowa, 8:715–16, s.v. "Hermaphroditos," with additional literary sources. For Renaissance adaptations of this symbolism see Seymour Howard, "The Dresden *Venus* and Its Kin: Mutation and Retrieval of Types," *Art Quarterly* n.s. 2 (1979), 92.

25. *Greek Anthology*, 9:783; tr. Paton, 3:423. According to Ovid, Hermaphroditus was originally male; his sex was altered after bathing in a magic spring. This theme of gender alteration also figured in the myths of Teiresias, Kaineus, and others: Pauly-Wissowa, 8:715–20.

26. Clement of Alexandria, *Paedagogus* 2:10; tr. in Boswell, 308. Cf. Pliny, *Natural History*, 7:3:34: "Persons are also born of both sexes combined—what we call Hermaphrodites, formerly called androgyni": tr. H. Rackham (Cambridge, Mass., 1969), 2:529. Pliny describes various antique sculptures of hermaphrodites, ibid., 34:52, 80. For later etymological developments see Boswell, 68, n. 30, and 375, n. 50.

27. On these medieval developments see Boswell, 184–85, 196, 246–51. The sixth-century work is *Liber monstrorum de diversis generibus*; similarly, a contemporaneous poem about lesbianism is titled *In puellam hermaphroditam*. The sexual duality of the hermaphrodite also made it an appropriate erotic symbol for those medieval men who, like the French abbot Baudri de Bourgueil (1046–1130), were attracted to both men and women. Of his erotic poetry, Baudri declares that "I write to boys, neither do I neglect girls." For him, as for numerous medieval writers, the customary symbol for male homosexuality in this ambisexual milieu is Ganymede: "Many an altar still has Ganymede running about it, / And many a lusty man still wishes to be Jupiter." *Les Oeuvres poétiques de Baudri de Bourgueil*, ed. Phyllis Abrahams (Paris, 1926), nos. 139, 147 (similarly in nos. 161, 231); Boswell, 246–47. Boswell adds (251, n. 29) that examples of Ganymede in literature of Baudri's time are "too numerous to be catalogued."

28. Antonio Beccadelli, *L'ermafrodito*, ed. J. Tognelli (Rome, 1968). On the debate, see

Chastel, _Art et humanisme_, 292; Lell, 161. For references to similar themes in other contemporaneous Florentine courtly poetry, see Howard, "Dresden _Venus_," 92, 101, and 107, n. 8.

29. Aretino/Chubb, 181, no. 93; _Lettere_, no. CLXVII (to Guidobaldo della Rovere, 1542).

30. Gian Maria Mazzuchelli, _Vita di Pietro Aretino_ (Brescia, 1763), reprinted in Aretino, _Lettere_, 3:76–77. Mazzuchelli found the ascription to Aretino doubtful but conceded that it was of long standing. Whether or not Aretino was the author, the meaning of the term was clear in his time; the editors cite a contemporary variant of the same epitaph, "Qui giace Paol Giovio ermafrodito, / che vuol dir in volgar: moglie e marito" (_Lettere_, 3:227–28, n. 414).

31. Written by Thomas Artus and originally published in Paris, 1605. The emperor of this mythical isle is called by the suggestive titles Gomorricus and Eunuchus, and the principal gods of the place are Bacchus, Venus, and Cupid: Cologne ed., 1724, 30–35. On the court of Henri III see further below, chapters 4 and 5.

32. For further discussion on the etymology of the term _homosexual_ and its implication of a distinct personality type, see the introduction. Benvenuto Cellini is perhaps the clearest instance in this study of a bisexual who seems not to have fused his sexual relations with both men and women into a unified identity; see below, chapter 4. In fact, it is not clear that Renaissance Italian possessed a discrete, fixed notion of "the homosexual" that embraced both parties equally. The word itself—_omosessuale_ in modern Italian—was not coined until the mid-nineteenth century; see Michel Foucault, _The History of Sexuality_, vol. 1: _An Introduction_ (New York, 1978), 42–43; Arthur N. Gilbert, "Homosexuality and Sodomy," 57–68. To the extent that "the homosexual" was a definable personality type, discussion centered primarily on the passive partner in sexual acts. Very different terminology and values were attached to active as opposed to passive behavior. See discussion of effeminacy, below.

33. Robert J. Stoller, _Sex and Gender: On the Development of Masculinity and Femininity_ (New York, 1968–74), 1:9. See also numerous studies from the Gender Identity Clinic at Johns Hopkins Hospital, Baltimore, by John Money et al., esp. Money, J. G. Hampson, and J. L. Hampson, "An Examination of Some Basic Sexual Concepts: The Evidence of Human Hermaphroditism," _Bulletin of the Johns Hopkins Hospital_ 97 (1955): 301–19; and the many investigations of similar issues by Lionel Ovesey and Ethel Person, e.g., "Gender Identity and Sexual Psychopathology in Men," _Journal of the American Academy of Psychoanalysis_ 1 (1973):53–72.

34. Dover, 168–69, discusses the ambiguity of this passage, and concludes that Aristotle is concerned to condemn only passive homosexual activity. He cites a similar passage in the pseudo-Aristotelian _Problemata_ (4:26) that more clearly identifies passivity as the issue: the text uses the passive form of the verb _aphrodisiazesthai_, best translated as "to be subjected to intercourse," rather than the active form _aphrodisiazein_, "to perform intercourse." On dominance and submission between _erastes_ and _eromenos_, see Dover, 16, 91, 100–109.

35. In _Frogs_ 48, 57, Kleisthenes is also spoken of as "mounted" by Dionysos. See also _Thesmophoriazusae_ 235, 574–81; _Acharnians_ 119–24; _Knights_ 1372–74; _Clouds_ 355; _Birds_ 829–31.

36. Peter Cantor, _De vitio sodomitica_, tr. in Boswell, 375–78. Male passivity was allowed, indeed praised, only in its spiritual sense of submission to the will of God. In his _On the Special Laws_ (3:7:37–42), the Hellenized Jewish author Philo (b. A.D. 75) maintained that homosexuality was a contradiction of the male's proper role, since the homosexual was not guided by the active, masculine mind. Though the soul must become passive in its relationship to God, for a man to become effeminate or womanish within the sexual sphere was wrong; see Richard A. Baer, Jr., _Philo's Use of the Categories Male and Female_ (Leiden, 1970). For summaries of Jewish and Christian proscriptions of homosexuality, with further references to the vast bibliography on this subject, see Boswell; Bullough, _Sexual Variance_, 74–92, 159–204; Michael Goodich, _The Unmentionable Vice: Homosexuality in the Later Medie-_

val Period (Santa Barbara, Cal., 1979), chs. 2–4. The Neoplatonists were similarly at pains to dissociate their notions of the male soul's passive yielding to divine love from any homosexual implication. Equicola pointedly declares (_Libro di natura d'Amore_, 112r) that "I do not wish any word in this work to be understood as [having to do with] love of youths or sexual acts against nature" (see Nelson, 71–73).

37. Tr. Bull, 222. The other speakers often protest the misogynistic excesses of Gaspare (3:7; tr. Bull, 214), but share certain of his basic assumptions in more moderate form. On Gaspare's role see Dain A. Trafton, "Politics and the Praise of Women: Political Doctrine in the _Courtier's_ Third Book," in Hanning and Rosand, 32; on women in the _Cortegiano_ see below, chapter 3.

38. Tr. Bull, 94. Although Gaspare's intemperate accusation is immediately refuted by the Count, other speakers express the same idea in more balanced terms. Such interests may be indulged only in moderation, says Ottaviano (4:4), "For these elegances of dress, devices, mottoes and other such things that belong to the world of women and romance often . . . serve simply to make men effeminate" (tr. Bull, 284). Other remarks disparaging effeminacy occur in 1:19, 2:2, 2:28, 3:30.

39. Aretino, _Sonnetti lussuriosi_ (Rome, 1524), no. 3; tr. cited by James Cleugh, _The Divine Aretino: A Biography_ (New York, 1966), 69–70. Although some of the _Sonnetti_ survive in the original, some, such as this one, appear to be known only through various early translations; most of the original prints of the _Modi_ were presumably destroyed in the wake of the scandal that followed their publication. For remaining texts, fragmentary prints, and later copies and translations, see Henri Delaborde, _Marc-Antoine Raimondi_ (Paris, 1888), 238–47; Aretino, _Lettere_, 3:142–44; Louis Dunand, _Les Compositions de Jules Romain intitulées Les Amours des dieux_ . . . (Lausanne, 1977), illustrating a set of putative copies; Henri Zerner, "L'Estampe érotique au temps de Titien," in _Tiziano e Venezia_, 85–87.

40. _Hieronymi Morlini Parthenopei: Novellae, fabulae, comoedia_ (Paris, 1855), Novella XXXI, 65–68; the basic situation is borrowed from Apuleius, _Metamorphoses_, bk. 9. The underlying note of violent retribution is made clear at the end of the tale: of the husband's satisfaction, Morlino writes, "The husband found cruel delight in this pleasure which the inhabitants of Sodom had once honored, and which, in this case, was doubled by the satisfaction of revenge."

41. Aretino/Chubb, 249, no. 169. On homosexual prostitution and transvestism, see the annals of the Consiglio dei Dieci for July 28, 1526, A.S.V. Reg. 40, c. 61, cited by Giovanni Scarabello, "Devianza sessuale," 82–83.

42. Benvenuto Cellini, _Vita_, bk. 1, ch. 30; ed. Ettore Camesasca (Milan, 1954), 61–64.

43. _Tutte le opere di Pietro Aretino: Teatro_, ed. Giorgio Petrocchi (Verona, 1971), 5. For the date of composition, which may have been as early as 1527 (and thus contemporaneous with Correggio's major works in Mantua), when Aretino was still in Mantua, see ibid., 49, n. 3, and 761–66.

44. Ibid., 41. The sense of the passage is that Mantua is full of effeminate Ganymedes and hermaphrodites who disgrace the reputation of the city of Virgil's birth. On the frequent connection, or confusion, between misogyny and homosexuality, see below, chapter 3.

45. The documents relating to these charges were assembled by Luca Beltrami, _Documenti e memorie riguardanti la vita e le opere di Leonardo da Vinci_ (Milan, 1919), 4ff.; the case is briefly summarized by Wittkower and Wittkower, 170–73, who explain that the nickname Salai refers to a character in Luigi Pulci's _Morgante_. As so often happened in cases of this kind where the sons of prominent citizens were involved, the charges resulted in probation without verdict, which has allowed later commentators to vary widely in their interpretation of Leonardo's sexual orientation. Freud held that Leonardo's sexual life "was restricted to what is called ideal (sublimated) homosexuality": _Leonardo_, 1910, tr. Alan

Tyson (Harmondsworth, 1963), 115. This position is accepted in Eissler, _Leonardo_, 104–40; Kenneth Clark, _Leonardo da Vinci_ (Harmondsworth, 1961), 58–59; and Wittkower and Wittkower. The most extreme contrast to this view is Giuseppina Fumagalli, who attempts unconvincingly to rescue the artist from the taint of abnormality by fabricating an elaborate heterosexual love life based on speculative inference. A similarly unfounded hypothesis of "normality" is advanced by Raymond Stites, _Sublimations_, and discredited in a review by Laurie Schneider, _Art Quarterly_ n.s. 1 (1978), 128–32.

46. For these two paintings see Ludwig Heydenreich, _Leonardo da Vinci_, Engl. ed. (New York, 1954), 53, 180–81; Carlo Pedretti, _Leonardo da Vinci: A Study in Chronology and Style_ (Berkeley and Los Angeles, 1973), 165–70; Angelina Ottino della Chiesa, _The Complete Paintings of Leonardo da Vinci_ (New York, 1969), 109–110. The etymology of Bacchus's androgyny is discussed in Delcourt, 72.

47. Washington, National Gallery; Fern R. Shapley, _Catalogue of the Italian Paintings_ (Washington, 1979), 137–38, no. 1620, noting Leonardo's influence; Gould, _Paintings_, 39. On the general topic see most recently David A. Brown, _The Young Correggio and His Leonardesque Sources_ (New York, 1979). For the identification of Salai in works by Leonardo and his _scuola_, see Emil Möller, "Leonardo und Salai," _Jahrbuch der kunsthistorischen Sammlungen in Wien_ N.F. 2 (1928), 139–61. Möller tends toward overinclusiveness, but his basic thesis seems sound; among the more convincing examples are the school work _Narcissus_ (London, National Gallery) and _St. Sebastian_ (Leningrad, Hermitage). It is ironic that Möller goes to great lengths to deny that the very obsession for which he uncovers so much evidence was in any way erotic.

48. _Codex atlanticus_, 66v.; E. MacCurdy, tr. and ed., _The Notebooks of Leonardo da Vinci_ (New York, 1956), 1122. The absence of Ganymede from Leonardo's oeuvre is due more generally to his lack of interest in mythological themes. For Freud's discussion see his _Leonardo_, 103–05, 115–30 (on birds as a sexual symbol, see further below, chapter 4). Freud's theory is accepted in broad outline by most psychologically oriented writers, e.g. Eissler, _Leonardo_, 104–86; Wittkower and Wittkower, 152, 172. Meyer Schapiro, "Leonardo and Freud: An Art-Historical Study," _Journal of the History of Ideas_ 17 (1956), 147–78, questioned Freud's translation and some of his admittedly meager data and asked whether knowledge of such psychological factors necessarily added to what could be inferred about Leonardo's art from more traditional iconographic methods. While Schapiro offers a useful caution about the excesses of psychohistorical speculation, for the present study internal psychological data are of prime importance.

49. Fogli A, 10r.; Fogli B, 13r.; _Codex atlanticus_, 358v.; Ms. H 119, 24r. (MacCurdy, 90, 97, 120); Eissler, _Leonardo_, 152–54, 178–86. See also the inscription on the verso of _Aristotle and Phyllis_: A. E. Popham, _The Drawings of Leonardo da Vinci_ (New York, 1945), pl. 110B.

50. Oxford, Christ Church College, fol. 108r.: Popham, _Drawings of Leonardo_, 117–18, no. 107. The legend is translated in Jean Paul Richter, ed., _The Literary Works of Leonardo da Vinci_ (London and New York, 1939), 1:386, no. 677; see also Eissler, _Leonardo_, 132–34. The interpretation of this allegory was provided by Lomazzo, who learned it from Leonardo's close associate Melzi.

51. Oxford, Christ Church College, fol. 107r.; Popham, _Drawings of Leonardo_, 118–19, no. 108; MacCurdy, 1097; Eissler, _Leonardo_, 109–121. This connection of pleasure and pain was to some extent a conventional topos: see Panofsky, _Studies in Iconology_, 217.

52. Eissler, _Leonardo_, 132. In addition to his internal motivations for resisting overt sexual expression, Leonardo was apparently aware (as we saw with Michelangelo, chapter 1) that revealing a fascination with male beauty too clearly in his work could have negative social consequences. He writes in his notebooks, "When I painted Our Lord as a boy [putto], you put me in prison. If I now paint him as a grown man, you would do worse to me!": _Codex atlanticus_, 252r.; Pedretti, _Chronology_, 161–62. We need not accept Pedretti's spec-

ulative identification of the precise works or models alluded to here to infer that Leonardo wanted to create images of beautiful men, and that he resented public hostility to his erotically charged treatment of a religious figure.

53. This distinction between hermaphrodite and androgyne—between process and product, or between an unstable, dynamic suspension and a unitary, static solution—was seldom observed precisely in classical or Renaissance language. Just such a duality was already implicit, however, in antique art, which developed two contrasting sculptural types for the ανδρογυνος—one a simple combination of male and female organs in one figure, the other a more profound and ambiguous synthesis of body types. See Delcourt, 87; Paul Richer, *Le Nu dans l'art*, vol. 5: *L'Art grec* (Paris, 1926), 291–306.

54. *Symposium*, 191D; tr. W. R. M. Lamb (Cambridge, Mass., and London, 1975), 141. The theory is thus inclusive of heterosexuality (halves of the original man-woman), male homosexuality, and lesbianism. The text, translated into Latin by Leonardo's fellow Florentine Ficino, was readily available. On Ovid see Delcourt, 79–80.

55. For a thorough summary of the hermaphrodite in antique thought from Plato onward and its continuation in these later philosophies, see Delcourt, 104–29. The same dream of idyllic freedom from sexual longing is exemplified in the Christian myth by the prelapsarian innocence of Adam and Eve, who also were originally a single body.

56. Petrus Bonus Lombardus de Ferrara, *Margarita pretiosa novella*, in *Theatrum chemicum praecipuos selectorum . . .* , 6 vols. (Strasbourg, 1659–61), 5:639 (first published Venice, 1546); cited and discussed by H. M. E. de Jong, *Michael Maier's "Atalanta fugiens": Sources of an Alchemical Book of Emblems*, in *Janus*, Supplements 8 (Leiden, 1969), 8, n. 15, and 37. De Jong's introduction, pp. 1–54, is an exhaustive account of alchemical philosophy, texts, and sources from the fourteenth to the eighteenth centuries, with bibliography. On the mystical writings of Pico, Ficino, and other Renaissance writers, and their sources, see Edgar Wind, *Pagan Mysteries*, esp. 1–26. On the cross-fertilization between orthodox Neoplatonism and the alchemists see ibid., 214–37; among the most important of the Renaissance alchemists was Paracelsus (1493–1541), whose "work and views were based on Neoplatonic and Gnostic ideas" (de Jong, 38–39).

57. For a catalogue of astrological and planetary images of Ganymede, see James M. Saslow, "Ganymede," appendix 2. The alchemical illustration of 1480, attributed to Nicola d'Antonio degli Agli, also depicts Ganymede as an attribute of Jupiter: Rome, Biblioteca Apostolica Vaticana, Cod. Urb. lat. 899, f. 99; illustrated in Stanislas Klossowski de Rola, *Alchemy: The Secret Art* (New York, 1973), 61, pl. 32. Alchemy was generally popular throughout Renaissance Europe and figured in the visual imagery of diverse Italian and northern artists. For general background see Jacques van Lennep, *Art et alchimie: Etude de l'iconographie hermétique et de ses influences* (Paris and Brussels, 1966); G. F. Hartlaub, "*Arcana artis*: Spuren alchemistischen Symbolik in der Kunst des 16. Jahrhunderts," *Zeitschrift für Kunstgeschichte* 6 (1937), 298–324; and numerous psychological studies by Carl Jung, *The Collected Works of Carl Jung*, tr. R. F. C. Hull (Princeton), vol. 5, *Symbols of Transformation* (1956).

58. *Theatrum chemicum britannicum*, ed. Elias Ashmole, London (1652; reprint, New York and London, 1967), Prolegomenon, par. 5. See further Johannes Fabricius, *Alchemy: The Medieval Alchemists and their Royal Art* (Copenhagen, 1976), a useful and profusely illustrated attempt to collate numerous manuscripts and present their symbolism in one unified narrative. His conclusions, however, are not always carefully documented and are heavily colored by a Jungian interpretation that, though not inconsistent with the psychological goals of the alchemists, sometimes leads him into anachronisms.

59. St. Gallen, Stadtbibliothek Vadiana, MS. 394a, ff. 34, 92; de Rola, pls. 21, 41, with commentary. A similar but three-legged hermaphrodite is illustrated in the endpapers of the late fourteenth-century *Aurora consurgens* (Zurich, Zentralbibliothek, Cod. rhenovacensis 172; de Rola, pl. 4). For the term *coniunctio* see Fabricius, 80–97, 130–39. On the artistic

representation of the alchemical hermaphrodite and its psychological significance, see Maurizio Fagiolo dell'Arco, *Il Parmigianino: Un saggio sull'ermetismo nel Cinquecento* (Rome, 1970), 20–24, 62–64, and below, chapter 3; S. K. Heninger, Jr., *Touches of Sweet Harmony* (San Marino, Cal., 1979); Jung, *Collected Works*, vols. 12, *Psychology and Alchemy* (1968); 13, *Alchemical Studies* (1969); and 14, *Mysterium coniunctionis* (1970); Wind, *Pagan Mysteries*, 211–17.

60. Fabricius, 147, fig. 279; and 223nn.

61. Philippe Erlanger, *Rodolphe II de Habsbourg, 1552–1612: L'Empéreur insolite* (Paris, 1971), 99–105. For Rudolf's intellectual and mystical pursuits, see also R. J. W. Evans, *Rudolf II and His World: A Study in Intellectual History, 1576–1612* (Oxford, 1973), 136–54 (on Kepler), and ch. 6, "Rudolf and the Occult Arts," 196–242; Hans W. Holzer, *The Alchemist: The Secret Magical Life of Rudolf von Habsburg* (New York, 1974).

62. Van de Passe's engraving may have been influenced by Antonio Tempesta's engraving of the rape of Ganymede printed at Amsterdam in 1606 (Fig. 5.11). Two small bronze plaquettes of this period similarly show Ganymede riding atop the eagle (for this formal typology see further below, chapter 4). One is part of a calendrical series attributed to Matthias Wallbaum, ca. 1600, the other part of a mythological series modeled after Guglielmo della Porta; see Ingrid Weber, *Deutsche, niederländische und französische Renaissanceplaketten, 1500–1650*, 2 vols. (Munich, 1975), 207–09, no. 401, pl. 110, and 294, no. 673.1, pl. 184.

63. De Jong, Introduction; J. B. Craven, *Count Michael Maier: Life and Writings* (1910; reprint, London, 1968). On the Rosicrucian movement see Frances A. Yates, *The Rosicrucian Enlightenment* (London and Boston, 1972).

64. Published in Oppenheim with engravings signed by Merian; close stylistic similarities suggest Merian's authorship of the *Symbola aurea* engravings as well: de Jong, 6. For each of the fifty complex emblems, de Jong provides translation, commentary, and Maier's sources in preceding alchemical literature; see also Mario Praz, *Studies in Seventeenth-Century Imagery* (Rome, 1964), 410; Craven, 77.

65. *Symbola aurea mensae duodecim nationum* (Frankfurt, 1617), 192; de Jong, 374, 429, and fig. 53; Fabricius, 55, fig. 85, and 219; Craven, 69–74. For the *Atalanta* emblems see de Jong, pp. 268–72, 282–85, figs. 43, 46. The alchemical eagle had earlier been pictured hovering behind the hermaphrodite in the illustration to the *Aurora consurgens* discussed above, n. 59.

66. Maier, *Symbola aurea*, ed. de Jong, 200; Fabricius, 200; Jung, *Mysterium coniunctionis*, section 2. In reference to the Libavius frontispiece, Fabricius states categorically that "the rape of Ganymede by the eagle of Zeus is a popular [alchemical] allegory for the colouring of the soaring hermaphrodite" (146–47, unfortunately without citing his sources). He would also have it (p. 159) that Emblem XXIII of *Atalanta* (de Jong, 181–86, fig. 23) represents "the alchemist in the dual shape of Ganymede and Vulcan"; such a conflation may well be implicit, but nothing in the image alludes to Ganymede.

67. The table, carved by Adrian de Vries about 1601, is now lost but is known from various paintings by David Teniers the Younger; see Lars Olof Larsson, *Adrian de Vries* (Vienna and Munich, 1967), 124, no. 51, fig. 88; Kempter, nos. 215, 245. On de Vries's position as one of Rudolf's court artists, see Erlanger, 129; Evans, 168–69. For the table's female companion, which may represent Hebe, Ganymede's predecessor as Olympian cupbearer, see below, chapter 3.

68. Erlanger, 109–14; Evans, 129, and ch. 5, "Rudolf and the Fine Arts," 162–95. This taste for androgyny, coupled with the relations between Rudolf and his closest male attendants, upon whom the indecisive monarch was often emotionally dependent, led a succession of earlier scholars to suggest that he was homosexual: Hirschfeld, *Homosexualität*, 1:670; Albert Moll, *Berühmte Homosexuelle*, 30; A. von Schrenk-Notzing, *The Use of Hypnosis in Psychopathia Sexualis with Especial Reference to Contrary Sexual Instinct*, tr. C. G.

Chaddock (1895; reprint, New York, 1956), 124. I have found no documentary evidence for this inference, which is based on an outmoded connection between homosexuality and emotional weakness. Rudolf began negotiations to purchase the _Ganymede_ and its companions in 1585 from Antonio Pérez (1534–1611), a Spanish statesman who was more certainly bisexual: _Encyclopaedia Britannica_ (11th ed.), 21:139, s.v. "Perez," with further bibliography; _The Cambridge Modern History_ (Cambridge, 1904), 3:514–21. Like Rudolf, Pérez owned numerous paintings; whether he, too, looked upon the _Ganymede_ with any special interest is not known. The documents regarding Rudolf's long pursuit of these pictures are transcribed by Hans von Voltelini, ed., "Urkunden und Regesten aus dem K. u. K. Haus-, Hof-, und Staats-Archiv in Wien," _Jahrbuch der kunsthistorischen Sammlungen des allerhöchsten Kaiserhauses_ [Wien] 13 (1892), pp. xxvi–clxxiv, nos. 9409, 9419, 9433; and 15 (1894), pp. xlix–clxxix; see also Evans, 267–68. A copy by Eugenio Caxes was commissioned in 1603 to remain behind when the _Ganymede_ was finally sold to Rudolf, but this myth was not a popular subject in Spanish art; for the only two known examples by a Spaniard, Francisco Pacheco, see D. A. Iniguez, _La Mitologia y el arte español del Renascimento_ (Madrid, 1952), 139, fig. 107, and 152; Kempter, nos. 172–73.

Chapter 3. _Parmigianino and Giulio Romano: Ganymede's Associations with Apollo, Hebe, and Cupid_

1. While still in his teens, Parmigianino worked beside the older artist in the church of San Giovanni Evangelista: Vasari/Milanesi, 5:223. Parmigianino copied some of Correggio's work there: A. E. Popham, _Catalogue of Drawings by Parmigianino_, 3 vols. (New Haven and London, 1971), 1:1–5 (hereafter cited as _Parmigianino Catalogue_). From the beginning, Correggio exercised "an obsessive influence" on him. Later in their careers, Correggio in turn adopted some of his disciple's innovations: Gould, _Paintings_, 133–45. The overlap of style and subject matter between them was so marked that Antonio Pérez, who owned Correggio's _Ganymede_ and Parmigianino's _Amor_ (see below), attributed them both to Parmigianino (Gould, _Paintings_, 274). On their stylistic intertwining see S. J. Freedberg, _Parmigianino: His Works in Painting_ (Cambridge, Mass., 1950), 88ff., 184–86.
2. A. E. Popham, _The Drawings of Parmigianino_ (New York, 1953), 12, 25. The letter is transcribed in A. O. Quintavalle, _Il Parmigianino_ (Milan, n.d.), 173–74, n. 43; see further Wittkower and Wittkower, 86.
3. On the relations of these individuals see Vasari/Milanesi, 5:220–23, 227, 531, 535 n. 1, 547; Hartt, _Giulio_, 67–68, 81, 328, and document no. 239.
4. _Parmigianino Catalogue_, 202, no. 680; Kempter, no. 176.
5. Paris, Louvre, no. R.F. 524. Bernhard Degenhart and Annegrit Schmitt, "Ein Musterblatt des Jacopo Bellini mit Zeichnungen nach der Antike," in J. A. Schmoll, Marcell Restle, and Herbert Weiermann, eds., _Festschrift Luitpold Dussler_ (Munich, 1972), 154–56, attribute it to the workshop of Jacopo, rejecting the suggestion of his son Giovanni made by Giuseppe Fiocco in "I disegni di Giam-Bellino," _Arte veneta_ 3 (1949), 47.
6. This Leda motif later served as the prototype for Michelangelo's illustration of that myth: Dussler, _Michelangelo_, no. 43.
7. C. Robert, _Die antiken Sarkophagreliefs_, 5 vols. (Berlin, 1890), 2:7; Degenhart and Schmitt, 155–56.
8. Berlin, Staatsbibliothek, _Codex Pighianus_, f. 301, no. 156. The later drawing (Paris, Bibliothèque Nationale) is discussed and illustrated by Salomon Reinach, _L'Album de Pierre Jacques, sculpteur de Reims, dessiné à Rome de 1572 à 1577_ (Paris, 1902), pl. 50bis; _Parmigianino Catalogue_, 202, no. 680; Kempter, no. 98.
9. On the inscription see Robert, 2:7; Degenhart and Schmitt, 165, n. 30. _Parmigianino Catalogue_, 202, dated the copy less probably to 1527–30; for Parmigianino's itinerary see Vasari/Milanesi, 5:225–26. A print by Giulio Bonasone, Bartsch XV.135.87, corresponds

fairly closely to Parmigianino's drawing in composition and dimensions; Bonasone reproduced numerous originals by that artist, on which see Fagiolo dell'Arco, 285–86. The only other possible example of this rare formal type, in which a reclining Ganymede is the object of the bird's almost possessive glance, is a puzzling drawing by the Ferrarese artist Battista Dossi, dating from the late 1530s or 1540s: Felton Gibbons, *Dosso and Battista Dossi: Court Painters at Ferrara* (Princeton, 1968), 264, no. 188, fig. 225.

10. Hartt, *Giulio*, no. 176a; Verheyen, *Palazzo*, 117. On Giulio's biography and his work at the Te see Vasari/Milanesi, 5:523–26; Hartt, *Giulio*, 13–17.

11. *Parmigianino Catalogue*, 217, no. 752; Mayo, 116–18; Kempter, no. 174. Popham refers to this and a number of other completed sheets as "presentation drawings" because of their high degree of finish, but concedes that we have no evidence that they were ever presented to anyone.

12. *Parmigianino Catalogue*, 89, no. 175r. On Michelangelo's figurine see Charles de Tolnay, *The Youth of Michelangelo* (Princeton, 1943), pls. 286–87; Tolnay, "Hercule," 125–40. For additional drawings by Parmigianino adapting this same pose, see *Parmigianino Catalogue*, nos. 254, 326, 329.

13. *Parmigianino Catalogue*, 82, no. 150; in the presentation drawing style of 1532–40.

14. Robert Eisler, "Luca Signorelli's *School of Pan*," 77–78, notes that antique sources for the story were well known in the Renaissance, including Pliny's description of a sculpture by Heliodorus, *Pan Trying to Rape Olympos*, and several still extant versions. For examples in Cinquecento art, see fig. 1.12 and Aretino's reference to the sculpture in the Villa Farnesina (Chigi) of Pan trying to rape a boy, chapter 2. On the symbolism of goats and satyrs see Pauly-Wissowa, 3:35–54, s.v. "Silenos und Satyros." Eisler also notes (p. 84) that the *School of Pan*, based on a tale of multiple unrequited loves by the Greek poet Moschos, includes in the left background a lesbian incident: Lyde sits dejectedly near her female beloved, who has turned her back to Lyde's advances.

15. Eclogue 10, line 69; tr. H. Rushton Fairclough, 2 vols. (Cambridge, Mass., and London, 1978), 1:75 (see fig. 4.10); Eclogue 2, lines 28–66, tr. Fairclough, 1:13–15. Similar sentiments are central to Eclogue 3; *Parmigianino Catalogue*, 82, no. 150, suggests Eclogue 1 as a source for Parmigianino's drawing. The antique glorification of love between men extended beyond simple shepherds to include such mortal heroes as Achilles and Patroclus (Homer, *Iliad*, 18:22–34, 80–115); Harmodios and Aristogeiton, the liberators of Athens; and Alexander and Hephaestion; on these see esp. Dover. On medieval continuations of these formulas see Boswell and Curtius, *European Literature and the Latin Middle Ages*, 113–17. The classical heroes were early used as analogies for earthly relationships, e.g., *Greek Anthology* 12:217, "Most blessed he . . . who, some new Achilles, shall take his pleasure in the tent with such a Patroclus!": tr. Paton, 4:393.

16. Hartt, *Giulio*, 141–42, fig. 277 (executed by an assistant, probably 1529–31); Verheyen, *Palazzo*, 129.

17. *Parmigianino Catalogue*, 163, no. 512, dated 1532–40; Mayo, 118–19; Kempter, 110–13, no. 175; A. E. Popham, "The Baiardo Inventory," in *Studies in Renaissance Art Presented to Anthony Blunt* (London and New York, 1967), 29, nos. 230, 238.

18. *Parmigianino Catalogue*, 179, no. 571v. The preparatory drawing bears on its recto studies for Parmigianino's *Madonna with the Long Neck*, commissioned in late 1534, so this conception is clearly from the artist's last six years; see Robert Wark, "A Sheet of Studies by Parmigianino," *Art Quarterly* 22 (1959), 245–48, fig. 1. Popham entitles fig. 3.9 merely *Running Figure*, but there is little doubt that it represents Ganymede; at the top of the sheet are faint indications of the Jovian eagle, and in a later etched copy the principal figure holds the cupbearer's amphora and patera (*Parmigianino Catalogue*, 151, no. O.R. 61, pl. 376). The pose of Ganymede in the print corresponds almost exactly to that of Correggio's *Ganymede* (Fig. 2.1), though the similarity is less evident in the original drawing owing to its reversed direction.

19. *Parmigianino Catalogue*, 43, no. 3v, dated after 1534.

20. The sculpture was originally set in a niche of the Belvedere in 1503–04; A. Michaelis, "Geschichte des Statuenhofes im vatikanischer Belvedere," *Jahrbuch des königlichen deutschen archäologischen Instituts* 5 (1890), 5–10. The *Apollo* was widely known through drawings, casts, and small bronze copies; since Parmigianino was no longer in Rome at the time of his Ganymede studies, they were presumably made from some such available copy. On these copies see Heinz Ladendorf, "Antikenstudium und Antikenkopie," *Abhandlung der Sächsischen Akademie der Wissenschaften zu Leipzig* 46:3 (1953), chapter 6. Wark, fig. 1, p. 246, compares Parmigianino's drawing to one such bronze made by Primaticcio, the casting of which is recorded by Benvenuto Cellini in his *Vita*, 2:37–41.

21. Both of its hands were missing, and a restoration in 1532 removed its original forearm and replaced it with one that apparently differed somewhat from the earlier limb: Matthias Winner, "Zum Apoll vom Belvedere," *Jahrbuch der Berliner Museen* 10 (1968), 184–85.

22. Fagiolo dell'Arco, 61, n. 13, and 497, no. 181. The lost source for Frulli's print has not been dated; on the basis of similarities in source, pose, and subject to the other Ganymedes discussed here, it seems likely to date also from the mid- to late 1530s.

23. *Parmigianino Catalogue*, 165, no. 518. Also like Correggio, he readily adapted the same prototype for figures of both genders: cf. his drawing of Lucretia (ibid., 200, no. 670), who is identical to the male figure in *Ganymede and Hebe*, fig. 3.8, as are some of the Virgins in his vault for the Madonna della Steccata, Parma (Quintavalle, *Parmigianino*, pl. 56).

24. *Parmigianino Catalogue*, 124, no. 319, part of a series illustrating the contest of Apollo and Marsyas.

25. On Hyacinthus see Homer, *Iliad*, 2:595–600; Ovid, *Metamorphoses*, 10:162–217; Hyginus, *Fabula*, 271. On Cyparissus, see Ovid, *Metamorphoses*, 10:120–54; Servius, commentary on the *Aeneid*, 3:64:680. Martial, *Epigrams* 11:43, cites Oebalius as the youth who relieved Apollo's frustration after the loss of Daphne. For additional youths and sources see Pauly-Wissowa, 2:28, s.v. "Apollon," which also lists the god's ten female amours.

26. *Orfeo*, line 352; ed. Maier, 112.

27. Oswald Sirén, *Italienska Handteckingar från 1400- och 1500-talen i Nationalmuseum* (Stockholm, 1917), no. 326; Hartt, *Giulio*, 305, no. 298. L. Steinberg, "Metaphors of Love and Birth," 240–42, demonstrates the "slung leg" motif in a wide variety of contexts.

28. Charles LeBlanc, *Manuel de l'amateur d'estampes*, 4 vols. (1854–90; reprint Amsterdam, 1970), 1:588, no. 20. Fig. 3.16 is a later copy in reverse after Caraglio's print: Dunand, 196–97.

29. Bartsch XVI.67.74, under Meldolla; Frances Richardson, *Andrea Schiavone* (Oxford and New York, 1980), 17, 76, 95, no. 74, accepts Bartsch's title and dates the print about 1538–40. Discrepancies between this print and a later Dutch engraving suggest that Parmigianino made another version of the original drawing, now lost: *Parmigianino Catalogue*, 252, no. O.R. 60.

30. See also Ovid, *Fasti*, 6:43, and *Metamorphoses*, 10:155–61; Lucian, *Dialogues of the Gods*, 8:5; and the Vatican Mythographers, I:184, II:198, III:15,22, in W. Bode, ed., *Scriptores rerum mythicarum latini tres Romae nuper reperti* (Cellis, 1834). For the continuation of stories of Juno's anger by later classical and medieval writers, see Boswell, 260, n. 64, noting the prominence of Ganymede in the fourth-century commentary by Servius that profoundly influenced later readings of Virgil.

31. *Opera omnia* (Venice, 1512), frontispiece; on the earlier Strasbourg edition see Wilhelm Worringer, *Die altdeutsche Buchillustration* (Munich, 1919), fig. 65; Mayo, 103.

32. *Parmigianino Catalogue*, 163, no. 512, acknowledges the earlier tradition but calls this drawing simply "Allegorical Composition"; Mayo, 118–23; Kempter, 110–13, explicitly rejects Mayo's hypothesis, proposing instead an equally speculative astrological reading.

33. Ludovico Dolce published a partial Italian translation in Venice in 1546; the complete version was by Angelo Coccio. Numerous manuscripts of the Greek original circulated in the fifteenth and sixteenth centuries; for a review of the various texts and translations see *Achilles Tatius*, tr. and ed. S. Gaselee (Cambridge, Mass., and London, 1961), xi–xvi. Tatius was a source for such artists as Titian; see David Rosand, "*Ut pictor poeta*: Meaning in Titian's *Poesie*," *New Literary History: A Journal of Theory and Interpretation* 3 (1971–72), 527–46.

34. Achilles Tatius, bk. 2, par. 36; tr. Gaselee, 125–27.

35. *Post aquile raptus*, anonymous poem of the twelfth or thirteenth century: Munich, Bayerische Staatsbibliothek, clm. 17212, ff. 26v–27r, transcribed and translated by Boswell, 392–98, lines 15–26. In an earlier medieval poem, *Ganymede and Helen*, the same debate is undertaken with Helen taking the place of Hebe: Boswell, 381–89.

36. Ed. and tr. Walter C. A. Ker, 2 vols. (Cambridge, Mass., 1927), 2:268–70; this rather prim edition gives only an Italian translation of Martial's text.

37. Boswell, 237–38; Martial, ed. Ker, 2:310. The context, as in 11:43, is a discussion of anal intercourse; for the importance of this preference to an understanding of Parmigianino's Ganymedes, see below. Martial's use of Juno vs. Ganymede is related to the broader question of attitudes toward women by Lell, 86.

38. *Dido, Queen of Carthage*, act 1, sc. 1, lines 1–18, 42–45; in *Christopher Marlowe: The Complete Plays*, ed. J. B. Steane (Harmondsworth, 1969), 45–46. In his narrative poem *Hero and Leander*, Marlowe describes "Jove slylie stealing from his sister's [Juno's] bed / To dallie with Idalian Ganimed": Sestyad 1, lines 147–48; *Christopher Marlowe: The Complete Works*, ed. Fredson Bowers, 2 vols. (Cambridge, 1973), 2:435. Ganymede appears again, in Sestyad 2, lines 155–75, in a humorous incident of mistaken identity: when Leander throws himself into the Hellespont, he is amorously pursued by Neptune, thinking he is Ganymede who has forsaken Jupiter.

39. Homer, *Iliad*, 15:18–22, and scholiast, 21:444. The bickering between the king and queen of the gods and her humiliation at his infidelities are alluded to throughout the *Iliad*, e.g., 1:547, 8:397–408, 14:197–223. For the illustrations see Gould, *Paintings*, 51, 244; Bartsch XV.144.14.

40. O. H. Giglioli, *Giovanni da San Giovanni* (Florence, 1949), 101; Mayo, 120–21; Kempter, no. 3 (as Albani).

41. Callmann, 44–45, 69, no. 36, pls. 178–80. For another bridal chest decorated with Ganymede, see above, chapter 1, n. 59.

42. Henri Zerner, *Ecole de Fontainebleau: Gravures* (Paris, 1969), p. xliv, no. 59; *Parmigianino Catalogue*, 66, no. 74, pl. 119. Two other isolated illustrations of Ganymede and Hebe together unaccountably use the two cupbearers as symbols of marital harmony rather than strife. Part of a series of wall paintings designed by Giulio Romano about 1533–35, possibly for the Palazzo del Te, they are recorded in prints by Giulio Bonasone, Bartsch XV.137.93–96. In *Jupiter, Neptune, and Pluto Dividing the Universe*, the attributes of Jupiter's sphere are two youthful figures, one male and one female, flanking his throne; the same two urnbearers welcome the king and queen of the gods in *Jupiter and Juno Taking Possession of Heaven*. See Vasari/Milanesi, 5:550; Hartt, *Giulio*, 214–15. The only other combination of Ganymede and Hebe in a possibly pacific rather than conflicting relationship is *Ganymede Being Received into Olympus* by Rubens (fig. 5.12); this novel interpretation is, however, only a recent suggestion.

43. On the connections between misogyny and homosexuality, see Saul H. Fischer, "A Note on Male Homosexuality and the Role of Women in Ancient Greece," in Judd Marmor, ed., *Sexual Inversion: The Multiple Roots of Homosexuality* (New York, 1965), 165–72. Fischer argues that homosexuality was not common in Homeric times, when women enjoyed high status, but increased as women's status began to decline. Vern R. Bullough, *Subordinate Sex*, 55, concedes that the linkage of the two concepts is not alone sufficient to

explain the prevalence of homosexuality, but even if "pederasty and misogyny are . . . not necessarily the opposite sides of the same coin . . . it would seem to follow that when the female is condemned the male will be exalted."

44. _Medea_, lines 231–34; tr. Rex Warner, in D. Greene and R. Lattimore, eds., _The Complete Greek Tragedies_, 4 vols. (Chicago, 1959), 3:67; cf. Euripides, _Hippolytus_, 664–66, tr. Warner, 3:190. The bibliography on the history of women is vast and growing; Bullough, _Subordinate Sex_, provides a general survey with useful references to primary and secondary sources, some of which overlap with the subject of his _Sexual Variance in Society and History_; see esp. pp. 17, 69–76. For an overview of feminist studies see above, introduction. On the status of women in Greek and Roman culture see Pomeroy, esp. 57; Mary R. Lefkowitz and Maureen B. Fant, _Women in Greece and Rome_ (Toronto and Sarasota, 1977). Greek women were legally the property of their husbands and were not even allowed to attend the theater, one of the Attic world's principal public rituals; within the domestic sphere, however, they maintained considerable importance. The introduction of male homosexuality to Greece is interpreted as a mythic parallel to the gradual victory of patriarchy in Graves, _The Greek Myths_, 1:117, ch. 29.3. Historians contend with some justification that as compared to those in Greece, women in Rome were emancipated (e.g., Pomeroy, 151), but Bullough (_Subordinate Sex_, 95) claims that this improvement was only relative. The present discussion must be seen within the related context of issues of gender roles and the perceived links between effeminacy and homosexuality, above, chapter 2.

45. _Theogony_, 590–612; tr. Hugh G. Evelyn-White (London and New York, 1926), 123. Aristotle, _Politics_, 1:5; tr. William Ellis (London, 1948), 8; see also his _Natural History_, in _The Works of Aristotle_, tr. D'Arcy Thompson (Oxford, 1910), 4:608B. Plato's attitude toward women varied from the earlier _Republic_ to the _Laws_; even in the _Republic_, however, which advocated equality of male and female in the ideal state, he claimed that woman's capacity for learning was inferior to man's (454D–456C). For the parallel treatment of Eve by Christian mythographers see Réau, 1:197; and most recently J. A. Phillips, _Eve: The History of an Idea_ (San Francisco, 1984).

46. Ficino/Jayne, 207. For similar conceptions in this period see Wind, _Pagan Mysteries_, 1–25; Bullough, _Subordinate Sex_, 106–09. The same fundamental concept informs the corpus of Christian theology developed from the church fathers to Aquinas and Savonarola. Aquinas held that "man is the head of woman" and that "the active power of generation belongs to the male sex, and the passive power to the female"; while denying that men should treat women with outright contempt, he identified them as the source of sexual temptation that was to be avoided: _Summa theologica_, tr. and ed. the Fathers of the Dominican Province, 3 vols. (New York, 1947), vol. 1, pt. 1, question 92, "The Production of Women," and vol. 2, pt. 2, question 153, "Of Lust." Savonarola, citing the biblical curse on Eve, advised his followers to "flee from women": Emmanuel-Ceslas Bayonne, _Oeuvres spirituelles choisies de Jérome Savonarole_ (Paris, 1879), 1:229, 2:8. The most prominent late medieval voice of women's protest against the characterizations of them by male authors was Christine de Pisan, whose visionary book extolling women's nature and achievements explicitly counters theorists of this tradition from Ovid to the author of the medieval French poem _Roman de la rose_; see her _Book of the City of Ladies_ (1405), tr. Earl Jeffrey Richards (New York, 1982).

47. _Cortegiano_, 2:91; ed. Quondam, 246; tr. Bull, 195 (cf. 3:37, 56). On the themes and personages of this particular debate see Woodhouse, _Castiglione_, chapter 5; Trafton, 29–44. For the reference in Poliziano (_Orfeo_, line 334), see Poliziano, ed. Maier, 111; for Ariosto see _Orlando furioso_, canto 25, stanza 42, line 8, ed. Remo Ceserani, 2 vols. (Turin, 1962–66), 1:967.

48. _Orfeo_, lines 331–56; ed. Maier, 111–12; a similar attitude is found in the poetry of Michelangelo, once a pupil of Poliziano (see above, chapter 1).

49. Described and quoted in part by Fumagalli, 106–08.

50. Lomazzo, ed. Ciardi, 1:lxxxi, 104. Leonardo's contemporary Botticelli was a confirmed bachelor who may also have been homosexual and was certainly among the most outspokenly misogynistic of Renaissance artists. The Anonimo Gaddiano recorded a revealing anecdote about Botticelli's fear of women, or more specifically of marriage: "On one occasion, being pressed by Messer Tommaso Soderini to take a wife, he replied to him: I would have you know, that not many nights since, it happened to me, that I dreamed I had taken a wife, and I was so greatly troubled at the thought of it, that I awoke; and in order that I might not fall asleep a second time and dream it over again, I arose and wandered about all night, through Florence, like one distracted: by which Messer Tommaso knew that that was no soil in which to plant a vineyard." The text is transcribed and translated by Herbert Horne, _Alessandro Filipepi, Commonly Called Sandro Botticelli . . ._ (London, 1908), 326 and appendix. I have treated this subject in my master's essay, "Botticelli's Image of Woman" (Columbia University, 1977).

51. _Cortegiano_ 2:96; tr. Bull, 200.

52. _Parmigianino Catalogue_, 115, no. 281. Giulio also drew the same subject: Hartt, _Giulio_, 305, no. 299, fig. 515. Cf. Dürer's drawing of the death of Orpheus in which he is labeled "the first sodomite" (fig. 1.6).

53. Bullough, _Subordinate Sex_, 15; Sigmund Freud, "Some Psychical Consequences of the Anatomical Distinction between the Sexes," in his _Collected Papers_ (New York, 1959), 5:186–97. It should be emphasized that these authors are speaking of a phenomenon common to all males, not merely to homosexual ones. Many subjects popular in Renaissance art present images of threatening or vengeful females, e.g., Judith, Delilah, and Salome. Two studies by Laurie Schneider explore such images from a psychoanalytic point of view: "Ms. Medusa: Transformations of a Bisexual Image," in Werner Muensterberger, L. Bryce Boyer, and Simon A. Grolnick, eds., _The Psychoanalytic Study of Society_, vol. 9 (New York, 1981), 105–54; "Donatello and Caravaggio," 76–91, pays special attention to the psychodynamics of two artists who were probably homosexual.

54. Vasari/Milanesi, 5:183, 218, 231–34; tr. deVere, 2:1147. See also Fagiolo dell'Arco; Claudio Mutti, _Pittura e alchimia: Il linguaggio ermetico del Parmigianino_ (Parma, 1978); Freedberg, _Parmigianino_, 87, 143.

55. On these symbols see Mutti and Fagiolo dell'Arco; Kempter, 113; and, with reference to other artists, van Lennep; Jung, _Psychology and Alchemy_, 236–39. On the mirror _Self-Portrait_ and similar images among Parmigianino's associates see Fagiolo dell'Arco, 3–35, figs. 258–63; when in the collection of Rudolf II this picture was attributed to Correggio, another instance of the frequent confusion between the two artists (Freedberg, _Parmigianino_, 201). Although Fagiolo is at times overly eager to insist on exclusively alchemical readings, he suggests usefully (p. 60) that the high position accorded to Saturn in Parmigianino's _Olympus with Ganymede and Saturn_ (fig. 3.13) may indicate a representation of the Golden Age over which that god was said to preside; this classical image of peace and plenty was adopted by alchemists to symbolize the state of perfection achieved by those who succeeded in making gold, i.e., the philosopher's stone.

56. See Ernst Gombrich, _Norm and Form: Studies in the Art of the Renaissance_ (London, 1965), 95–98; Gombrich, _Art and Illusion_ (Princeton, 1969), 153–54; David Summers, "_Figure come fratelli_: A Transformation of Symmetry in Renaissance Painting," _Art Quarterly_ n.s. 1 (1977–78), 59–88.

57. Dover, 70, 125, and illustrations of numerous vase-paintings, e.g., his nos. R954 (two boys), R1127 (satyrs), R223 (one boy holding another's buttocks), and BB24. For similar examples see also Peter Webb, _The Erotic Arts_ (Boston, 1975), 55, fig. 28; Lucie-Smith, _Eroticism in Western Art_, 20, 279, fig. 17. The most common mode of intercourse between older _erastes_ and adolescent _eromenos_ was intercrural (between the thighs), though in other

social contexts the preference appears to have been for anal penetration (Dover, 99, 140–44). In the Renaissance, Alberti stated that a Ganymede should have beautiful thighs (*De pictura*, bk. 2, ch. 37; ed. Grayson, 66–67).

58. Rhianos 1, Meleagros 90 and 94, in *The Greek Anthology*, ed. A. S. F. Gow and Denys Page, vol. 1 (Cambridge, 1965). The translations of these epigrams in the Paton edition of the *Greek Anthology* otherwise cited in this book (e.g., Meleager, 12:33) are oblique to the point of incomprehensibility; Paton's preface to book 12 (4:280) expresses acute discomfort with and moral condemnation of the subject at hand. Other epigrams referring to boys' beautiful rears or to more graphic evocations of sexual interest include 12:6, 7, which Paton translates only into Latin.

59. E.g., nos. 12:20, 37 (speaking of "honeyed thighs"), 64–70, 133, 175, 194, 230, 254 (ed. Paton).

60. See also admissions of or attacks on anal intercourse by Aristophanes, *Thesmophoriazusae*, 35, 200, 206; *Knights* 877–80, 1242; *Wasps* 1068–70. These and other examples of "comic exploitation" are discussed by Dover, 135–44, who cautions that derogatory terms derived from notions of anal passivity were sometimes used merely as generalized terms of abuse with connotations of weakness or effeminacy.

61. See above, n. 36. Ganymede is also the epitome of the beloved boy in *Epigrams* 11:22, 26, and 104; additional epigrams referring to the anus (*culus*) or to such intercourse include 2:51, 11:88, 12:75.

62. *Libro dei sogni*, "Ragionamento quinto," in *Scritte sulle arti*, ed. Ciardi, 1:104. The same lighthearted attitude is evident in an Italian majolica dish from the early sixteenth century (Paris, Musée de Cluny), which depicts a seated monk pointing at the buttocks of a nude boy and to his own rear. The caption, "Io son fra facio da levere" (I am a monk, I act like a hare), presumably refers to the tradition of medieval bestiaries that associated the hare with anal sexuality; on this see Boswell, 306. The dish is illustrated in Cecile Beurdeley, *L'Amour bleu*, tr. Michael Taylor (New York, 1978), 91. In other works, Lomazzo mentions Ganymede as a more general symbol of beauty and shameful lasciviousness (*Scritte*, ed. Ciardi, 1:75, 290, 2:249 n. 4).

63. Pierre de L'Estoile, *Journal du règne d'Henri III*, ed. Louis-Raymond Lefèvre (Paris, 1943), 181; 200, no. I; 204, no. XIV. Other mignons were similarly accused (191; 201, no. V; 202, no. VII), as was Henri himself (657, no. III). The king's weakness for such sexual practices was also implied by the satirist Agrippa d'Aubigné, in his *Les Tragiques* (ca. 1577–80), bk. 2, lines 1318–19: *Oeuvres*, ed. Henri Weber (Paris, 1969), 85. On homosexuality at the French court see below, chapter 4.

64. Roberto Salvini and Alberto Mario Chiodi, *Mostra di Lelio Orsi* (exh. cat., Reggio Emilia, 1950), 6; Mayo, 113, 140; Kempter, no. 170.

65. Cecil Gould, *National Gallery Catalogues: The Sixteenth Century Venetian Schools* (London, 1959), no. 32; Homan Potterton, *Venetian Seventeenth-Century Painting* (exh. cat., London, National Gallery, 1979), no. 3 (I am grateful to Mr. Potterton for permitting me to observe Mazza's picture while it was undergoing restoration); Kempter, no. 141. For the picture's relation to Rembrandt's *Rape of Ganymede* see fig. 5.8. Other ceiling paintings depicting Ganymede in revealing poses include those by Peruzzi at the Villa Farnesina and by Sodoma: Roseline Bacou, *Italian Renaissance Drawings from the Musée du Louvre 1500–1575* (exh. cat., New York, Metropolitan Museum, 1974), no. 70. A similar wall canvas by Girolamo da Carpi has been related to the influence of both Peruzzi and Parmigianino's *Running Ganymede* by Norman Canedy, "Some Preparatory Drawings by Girolamo da Carpi," *Burlington Magazine* 112 (1970), 92–94. Parmigianino's Ganymedes are also cited in a brief discussion of the prominence of buttocks in sixteenth-century art by Paul Barolsky, *Infinite Jest*, 89–90.

66. Although Ganymede has no wings himself, his conjunction with the abducting eagle implies a similar image; in describing Ganymede's rape, Poliziano says that the Jovian bird

"flies like love [Cupid]" (_Stanze_, bk. I, no. 107; ed. Maier, 68). The confusion of one viewer about Michelangelo's lost _Cupid_ points up the ambiguity inherent in Cupid's attributes. Ulisse Aldovrandi thought the statue represented Apollo on the basis of its being nude and having a quiver and an urn, but all of these could as easily apply to a Ganymede: Condivi, ch. 19; Anton Springer, _Raffael und Michelangelo_, 3d ed. (Leipzig, 1895), 1:22. Numerous illustrations of Ganymede based on Virgil's account show him with bow and sometimes quiver, such as figs. 2.18, 2.23. Cellini, too, invokes Ganymede, Perseus, and Cupid jointly: see below, chapter 4. For formal conflations of Ganymede and Cupid in the seventeenth century, see figs. 5.6, 5.7, 5.13.

67. Apollonius Rhodius, _Argonautica_, 3:110–44; tr. R. C. Seaton (London and New York, 1912), 201–03. Philostratus the Younger, in his _Imagines_ (sec. 402, lines 1–10) offers an ekphrasis of an ancient painting on this theme, a loose reconstruction of which was engraved by Jaspar Isaac to accompany a French translation first published in 1614. See Roger-Armand Weigert, _Inventaire du fonds français_, vol. 5, _Graveurs du XVIIe siècle_ (Paris, 1968), 393–414, nos. 79–96.

68. _Greek Anthology_, tr. Paton, 12:77, 86; see also nos. 12:56, 75, 76, 78, 82, 83.

69. Vasari/Milanesi, 5:227–30; Freedberg, _Parmigianino_, 89, 185; Fagiolo dell'Arco, 58–59, 69, 197, n. 8, discussing alchemical interpretations. The sensuality of Cupid's lesser putti was also understood as partly homoerotic in nature: cf. Giulio's drawing of the _Feast of Venus_, showing clearly the erotic couplings of pairs of little winged boys (Hartt, _Giulio_, 159, no. 217), or Titian's painting of the same subject at Ferrara. Freedberg's contention that the repulsion felt in the presence of Parmigianino's Cupid derives from the picture's implicit homoeroticism—which he labels "perverse" and "immoral"—bespeaks a judgment more characteristic of the historian's own milieu than that of the artist.

70. As has been noted, Correggio's _Ganymede_ was ascribed to Parmigianino when both it and the _Amor_ were in the collection of Antonio Pérez; counterbalancing this slight, Vasari erroneously attributed the original of Girolamo da Carpi's copy after the _Amor_ to Correggio: Vasari/Milanesi, 6:477; Freedberg, _Parmigianino_, 88, 185.

71. Bartsch XV.201.25; Mayo, 128–32, suggests an iconographic source in Lucian, _Dialogues of the Gods_, 10:4. Bartsch was the first to note in this print the influence of Marcantonio Raimondi, who engraved a large number of Raphael's works as well as Giulio's _Modi_. Erkinger Schwarzenberg, "Raphael und die Psyche-Statue Agostino Chigis," _Jahrbuch der kunsthistorischen Sammlungen in Wien_ 73 (1977), 112–14, suggests that the design for this engraving derives from Raphael.

72. A preparatory drawing for the figure of Ganymede (Hartt, _Giulio_, 32, no. 24) has been ascribed variously to Giulio or to Raphael himself, and opinion has been divided over their respective shares in the design and execution of the entire cycle since Vasari (ed. Milanesi, 4:644, 5:523–24); cf. Hartt, _Giulio_, 32–33, n. 7, and Luitpold Dussler, _Raffael: Kritisches Verzeichnis der Germälde, Wandbilder und Bildteppiche_ (Munich, 1966), 106–09. For a later adaptation of this scene by Battista Franco, see fig. 4.13. Ganymede also appears in the villa in Peruzzi's hexagonal ceiling panel in the Sala di Galatea, about 1511, where he represents Aquarius, part of Chigi's horoscope: Christoph L. Frommel, _Baldassare Peruzzi als Maler und Zeichner_ (Vienna, 1968), 61–68, nos. 18a–d.

73. On the prints after this scene and their earlier identification see Henri Delaborde, _Raimondi_, 145–47; Innis H. Shoemaker, _The Engravings of Marcantonio Raimondi_ (exh. cat., Lawrence, Kans., Spencer Museum of Art, and Chapel Hill, N.C., Ackland Art Museum, 1981), no. 44; Bartsch XIV.256.342, XVII.83.100. As with the Farnesina ceiling, Hartt (_Giulio_, 32) assigns at least the execution of this spandrel to Giulio; other scholars stress that the conception is Raphael's, e.g., Dussler, _Raffael_, 108; John Shearman, "Die Loggia der Psyche in der Villa Farnesina und die Probleme der letzten Phase von Raffaels graphischen Stil," _Jahrbuch der kunsthistorischen Sammlungen in Wien_ 60 (1964), 89, fig. 85. On the "chin-chuck motif" see L. Steinberg, "Metaphors of Love and Birth," 280–83.

74. Karl T. Parker, *Catalogue of the Collection of Drawings in the Ashmolean Museum*, 2 vols. (Oxford, 1956), 2:204–05, no. 407. Formerly attributed to Michelangelo; Raffaelle was suggested by Berenson, vol. 2, no. 1720. See also Vasari/Milanesi, 4:542–48.

75. Bartsch XVII.79.79, 80, 86; part of a series of ten mythological illustrations all on loves of the gods or other erotic and satyric subjects. These examples may derive in part from knowledge of the Farnesina motif; Polidoro had worked under Raphael on the Vatican *Loggie* (Vasari/Milanesi, 5:141), and his series was engraved by Cherubino Alberti, who also engraved the Farnesina *Jupiter and Cupid*. While at the Vatican Polidoro formed an intense mutual love for a fellow *raffaelista*, Maturino Fiorentino (d. 1528); Vasari records that their affection grew so great that "they determined like brothers and true companions to live and die together, and . . . set themselves to work in the closest harmony and concord" (ed. Milanesi, 5:143; tr. deVere, 2:1084). Whether this comment is merely a Neoplatonic friendship formula or attests to a more intimate relationship, it suggests one reason for Polidoro's distinctive sensitivity to the theme of two men embracing. A much later picture of *Jupiter Kissing Ganymede* shows the lingering influence of the motif of their face-to-face embrace in the context of a homosexual practical joke. In the 1760s, an artist in the Roman circle around Johann Joachim Winckelmann forged an *all'antica* fresco on this subject and buried it at Pompeii; knowledge of antique style then being relatively meager, the artist seems to have based his conception on elements of the Farnesina group, readily accessible in Rome. Winckelmann's friends were aware that part of the pioneering art historian's motivation for excavating the ruins of Pompeii was the hope of uncovering evidence of homosexuality, which he felt would dignify his own sexual orientation with a classical imprimatur. See Thomas Pelzel, "Winckelmann, Mengs and Casanova: A Re-appraisal of a Famous Eighteenth-Century Forgery," *Art Bulletin* 54 (1972), 300–15.

76. Giulio Bonasone, after Giulio, Bartsch XV.137.96; Hartt, *Giulio*, 211–16. The upper group does not appear in Giulio's surviving sketch for the lost painting (Hartt, *Giulio*, fig. 463), and Jupiter here differs greatly in appearance from his two other episodes in the series. The entire series is characterized by deviations from standard iconography or inconsistencies in its usage. For other works using the chin-chuck embrace, see Hartt, *Giulio*, figs. 406–07, and the figures of St. John and Christ in Parmigianino's *Holy Family with San Zaccaria and Mary Magdalene*: Freedberg, *Parmigianino*, 182–84.

77. For the two paintings including Ganymede and Hebe, see above, n. 42. Two other minor appearances are in the ceilings of the Sala dei Venti and the Sala dei Giganti of the Palazzo del Te: Hartt, *Giulio*, 106, 115–21, figs. 192, 347; Verheyen, *Palazzo*, 19–20, 35–38.

78. Giulio's preliminary drawing for the medallion also survives: Hartt, *Giulio*, no. 224; Kempter, no. 88. The eagle also had personal significance for Federigo; like other rulers we have seen, he adopted it as one of his emblems; see Hartt, *Giulio*, 125–26, 161, 170, no. 8. A possible inspiration for Giulio's medallion is the rape of Ganymede frescoed on the entrance vault of Nero's Domus Aurea in Rome, which was discovered and copied by Raphael's school; see Vasari/Milanesi, 6:551; Nicole Dacos, *La Découverte de la Domus Aurea et la formation des grotesques à la Renaissance* (London, 1969).

79. Hartt, *Giulio*, 107, 161, 179–82; Vasari/Milanesi, 5:544, dated about 1536–37.

Chapter 4. *Benvenuto Cellini: The Libertine and the Counter-Reformation*

1. Vasari/Milanesi, 7:621–23; tr. deVere 3:2087–89. In addition to his autobiography, primary sources for Cellini's life and work include two professional treatises and a number of letters and poems all published by Carlo Milanesi, *I trattati dell'oreficeria e della scultura di Benvenuto Cellini, si aggiungono . . . le lettere e . . . le poesie* (Florence, 1857), hereafter cited as Cellini/Milanesi. A large number of personal *ricordi* regarding the artist's business affairs, legal actions, and family matters were published by Giovanni Palamede Carpani, ed., *Benvenuto Cellini: Opere* (Milan, 1806), vol. 2, hereafter cited as Palamede Carpani. For

later biographical accounts see Symonds, *Cellini*; Benvenuto Cellini, *Autobiography*, tr. and ed. George Bull (Harmondsworth, 1956), Introduction; John Pope-Hennessy, *Italian High Renaissance and Baroque Sculpture* (London, 1970), 369–70; Wittkower and Wittkower, 187–89. Eleven separate criminal accusations against Cellini are documented, ranging in date from 1516 to 1557 and in venue from Rome to Florence, Siena, and Paris, including charges for sodomy, murder, and assault; see Luigi Greci, *Benvenuto Cellini nei delitti e nei processi fiorentini ricostruiti attraverso le leggi del tempo*, Quaderni dell'Archivio di antropologia criminale e medicina legale, fasc. 2 (Turin, 1930).

2. Cellini, *Vita*, bk. 1, chs. 19, 22–30, 34, 40–41, 46, 56, 65, 76–78, 86; and bk. 2, chs. 10, 12, 53, 79–81, 100. See also Greci, 11; Wittkower and Wittkower, 189.

3. Cellini, *Vita*, 2:53, 66–75; tr. Bull, 335.

4. Ettore Camesasca, *Tutta l'opera del Cellini* (Milan, 1955), 41; Plon, 215–16; Pope-Hennessy, *High Renaissance*, 370; Kempter, no. 47. Although some scholars have dated this work as late as 1547, the terminus ante quem for the sculpture is provided by a *ricordo* of 1546 (1545 Florentine style) stating that the restoration was completed in February of that year: Palamede Carpani, 2:497. For the artist's surviving terra cotta bozzetto, see Baron C. A. de Cosson, "Cellini's Model for His Head of the *Ganymede*," *Burlington Magazine* 23 (1913), 353–54.

5. An intimate caress of boy and bird may also be seen in a much later drawing in the Louvre, Paris, Cabinet des Dessins no. 6888, attributed to Guercino (1591–1666). This drawing's erotic suggestiveness is somewhat atypical for its period.

6. For examples see Sichtermann, nos. 270, 286, 299, pl. 14; Gazda, "Ganymede and the Eagle," 56–60.

7. Guido Mansuelli, *Galleria degli Uffizi: Le sculture* (Rome, 1958), 1:142–43, no. 111. For the drawing by Aspertini see Phyllis Pray Bober, *Drawings after the Antique by Amico Aspertini: Sketches in the British Museum* (London, 1957), 47–50. The Naples variant, not documented until 1574, was then in the Palazzo Farnese, Rome (on which see below, figs. 4.9, 4.10): Sichtermann, nos. 289–90; J. R. Martin, *The Farnese Gallery* (Princeton, 1965), fig. 33. Cellini's eagle bears an even closer resemblance to another antique marble *Ganymede and the Eagle* now in the Vatican Museums, no. 587 (photo: Anderson, no. 1832).

8. Dover, no. R758 (Sichtermann, no. 51); for similar scenes on two other red-figure vases see Dover, nos. R348, R833. The cockerel also appears in three other vases and a large terra-cotta figurine at Olympia, showing Jupiter in human form carrying off Ganymede: Sichtermann, nos. 10, 28, 38, 81. A marble version in the Vatican (Museo Pio-Clementino, Inv. no. 2746) shows a childlike standing Ganymede holding a pitcher in one hand and a small bird in the other.

9. Dover, no. R791 (see also nos. B16, B250), 91–93. See also *Greek Anthology*, tr. Paton, 12:44. In contrast, Greek men who courted women customarily gave them money.

10. Dover, 133; Otto J. Brendel, "The Scope and Temperament of Erotic Art in the Greco-Roman World," in Bowie and Christensen, eds., *Studies in Erotic Art*, 4, fig. 1; William Arrowsmith, "Aristophanes' Birds: The Fantasy Politics of Eros," *Arion* n.s. 2 (1974), 119–66. Aretino's pun (*I Ragionamenti* [Venice, 1584], f. 22v) and other examples in Renaissance Italian art and literature are discussed by Jaynie Anderson, "Giorgione, Titian, and the Sleeping Venus," in *Tiziano e Venezia*, 339–40; Boccaccio, in his *Decameron* (fifth day, fourth tale), similarly used the nightingale as a symbol of the penis. The winged penis is illustrated by J. A. Levenson, Konrad Oberhuber, and Jacquelyn Sheehan, *Early Italian Engravings from the National Gallery of Art* (Washington, 1973), 526–27. In his commentary on the plate, A. M. Hind pointed out the similarity to antique representations (cf. Dover, 133, nos. R352, R414) and the modern colloquial use of *uccello*: *Early Italian Engraving: A Critical Catalogue . . .* , 7 vols. (London, 1938–48), 1:260, no. E.III.30. For the sexual significance of birds to Leonardo, see above, chapter 2.

11. Cellini, *Vita*, 2:70–71; tr. Bull, 335–38. The incident is corroborated by Vasari in his

Life of Bandinelli (ed. Milanesi, 6:183–84), who does not quote Bandinelli's exact accusation but does report a second such remark with similar implications.

12. Cellini, *Vita*, 2:57, 61–63; tr. Bull, 318–26. Suspicion about the veracity of the sculptor's denial in the Cencio affair was first voiced by Symonds, *Cellini*, xxxv, n. 3.

13. Cellini/Milanesi, 338, no. 27; Palamede Carpani, 2:451, no. 12. Milanesi, 338, n. 3, comments that "Ganymede" refers to sodomy; Greci (50, n. 1) concurs. Since the act of sodomy for which Cellini was convicted in March 1557 was alleged to have taken place five years earlier, he could be referring in this poem to rumors current before the trial.

14. Camesasca, *L'opera del Cellini*, 41–42; Plon, 216; Friedrich Kriegbaum, "Marmi di Benvenuto Cellini ritrovati," *L'arte* n.s. 11 (1940), 12–14. In accordance with Cellini's last wishes, this sculpture and the *Narcissus* were bequeathed to Grand Duke Francesco I; that Cellini made both works with no patron in mind and kept them until his death suggests that the subjects had an important personal meaning for him.

15. Cellini/Milanesi, 388, no. CII. This entire series is further united by having been designed after the same living figure. In another sonnet (p. 358, no. LXII) Cellini addresses one Guido Guidi, who "was my model for Apollo and Hyacinthus and the beautiful Narcissus, and for Perseus as well."

16. Cellini, *Vita*, 2:72; Camesasca, *L'opera del Cellini*, 42–43, pls. 36–39; Plon, 216 (as unlocated); Kriegbaum, 15–21.

17. *Greek Anthology*, tr. Paton, 12:175, 199, 247 (the name *Meriones* puns on the Greek *meros*, "thigh"). Cf. 12:51, "To the Cupbearer"; 12:180, 236. On "the characteristic Greek conception of sexuality as a relationship between a senior and a junior partner," see Dover, 122. A special case is intimacy between teacher and pupil, where the older partner is technically a "servant" yet clearly retains the position of authority: *Greek Anthology*, 12:34, 222.

18. *Epigrams*, 9:11–13, 16, 36; tr. Ker, 2:81, 97. On Ganymede as a general term for servant, see 2:43; on the broader sexual connotations of Ganymede to Martial see 11:22, 26, and above, chapter 3.

19. Cellini, *Vita*, 1:23, 93; tr. Bull, 45, 173. Cellini's description of clothing Ascanio "as if he were my own son" strikingly parallels the reaction of Michelangelo's father to the favors shown his son by Lorenzo de' Medici.

20. Cellini, *Vita*, 2:81–82; Vasari/Milanesi, 7:240–41; tr. deVere, 3:1904–05. On Michelangelo's relationship to Urbino and the effect of Urbino's impending death on the artist's work, see also Liebert, 393–94, 402–08.

21. Shapley, *Italian Paintings*, 355–57, no. 1159, dates the picture ca. 1555–60 and attributes it to an unknown Parmesan artist.

22. There are some scattered references, among them to the taste for boys at the Mantuan court (see above, chapter 2) and to the rather atrocious pansexuality of Sigismondo Malatesta in fifteenth-century Rimini, for which see Saslow, "Ganymede," app. 2. On the love of Borso d'Este, ruler of Ferrara, for the young Teofilo Calcagnini, see Gundersheimer, 293. In contrast to his readiness to defame Michelangelo's chastity, Aretino, like Cellini, confined his attacks on the nobility's peccadilloes to broad general comments. This relative discretion in regard to the sexual lives of the powerful is hardly surprising; hence, the paucity of evidence cannot be taken as any secure index of the actual frequency of upperclass sodomy. The verdicts of the Florentine *Ufficiali de' notti* sodomy trials are notoriously inconclusive in cases involving influential citizens.

23. Lell, 103, 152–54, 158, with bibliography, documents English travelers' firsthand knowledge of Italy in the Renaissance, specifically their frequent reports on the prevalence of homosexuality there; the English were quick to assert that homosexuality had been imported from Italy. The French too imputed unorthodox sexual practices to the Italians, as witness the lawyer who advised the mother of Cellini's French mistress to accuse Cellini of having performed sodomy on the daughter "al modo italiano" (Cellini, *Vita*, 2:29).

24. L'Estoile, 204, no. XIV. On homosexuality at Henri's court see below, chapter 5.

25. On Bacon's homosexuality see John Aubrey, *Brief Lives*, ed. A. Clark (Oxford, 1898), 71. The British pattern of sex with one's page can also be seen in the case of Capt. Richard Cornish, executed at colonial Jamestown, Virginia, in 1624 for having sodomized his cabin boy: Katz, *Gay American History*, 26–31. Later in the seventeenth century (ca. 1672), John Wilmot wrote: "There's a sweet, soft page of mine / Does the trick worth forty wenches": *The Complete Poems of John Wilmot, Earl of Rochester*, ed. David M. Vieth (New Haven and London, 1968), 51. On the prevalence of homosexuality, particularly between masters and servants (including Bacon and Wilmot), see Bray, esp. 49–55 and 65–74.

26. Thomas Carew, *Poems* (1640; facsimile reprint, Menston, Eng., 1969), 219. For the visual representation of Ganymede in this masque and a fuller description of the text and action, see below, chapter 5, fig. 5.15. Marlowe wrote of two princely love affairs: between Edward II and Piers Gaveston in *Edward II*, and between Henri III and his mignons in *The Massacre at Paris* (*Complete Plays*, ed. Stean, 431–534, 561–84).

27. Charles Kligerman, "Notes on Benvenuto Cellini," *The Annual of Psychoanalysis* 3 (1975), 410–11; Cellini, *Vita*, 1:3; tr. Bull, 19. For the concept of autobiographical myth, see above, chapter 1.

28. Cellini, *Vita*, 1:52; tr. Bull, 101. For his other recorded affairs see 1:29, 2:18, 2:37.

29. Kligerman, 410–19; the fear of castration may be expressed symbolically in Cellini's *Perseus*, who holds the severed head of Medusa; on the parallel significance of Medusa to two other homosexual artists, see Schneider, "Donatello and Caravaggio," 76–91 and "Ms. Medusa," 105–54. Relevant incidents are recounted by Cellini, *Vita*, 1:4; 2:79 (a letter of praise from Michelangelo); 2:63–64, 69, 89 (characterizations of Bandinelli); 2:65 (fears that fellow sculptors did not take him seriously); 2:23, 29, 40 (Etampes); 2:84, 88 (Eleonora).

30. Anthony Blunt, *Artistic Theory in Italy, 1450–1600* (Oxford, 1966), 132 (the decrees concerning visual arts are discussed at length in chapter 8). The classic study of the Council and its effect is Emile Mâle, *L'Art religieux après le Concile de Trente* (Paris, 1931).

31. Rudolf Wittkower, *Art and Architecture in Italy, 1600–1750* (Harmondsworth, 1980), 2, with earlier bibliography; Mâle, 2; Blunt, *Artistic Theory*, 114–23. For Aretino's earlier attack on the indecency of Michelangelo's fresco, see above, chapter 1.

32. Vasari/Milanesi, 7:99, 309, 618, 8:620. In the 1560s, Zucchi assisted Vasari on the decorations of the Palazzo Vecchio in Florence and the wedding of Francesco de' Medici; on these see below. On the Palazzo Firenze see Renzo Montini, *Il Palazzo Firenze* (Rome, 1958), 29–30; Kempter, no. 148. The text of Zucchi's treatise is transcribed by Fritz Saxl, *Antike Götter in der Spätrenaissance: Ein Freskenzyklus und ein Discorso des Jacopo Zucchi* (Berlin, 1927); passages cited are from pp. 21, 40–43, 49.

33. Donald Posner, "Caravaggio's Homo-Erotic Early Works," *Art Quarterly* 34 (1971), 301–24.

34. On the cycle and its conflicting interpretations see Martin, *Farnese Gallery*, 84–85, 112–13; Charles Dempsey, "'Et nos cedamus amori': Observations on the Farnese Gallery," *Art Bulletin* 51 (1969), 363–74; Donald Posner, *Annibale Carracci: A Study in the Reform of Italian Painting around 1590* (London and New York, 1971), 93–208; Mayo, 147; Kempter, no. 43; Bober, 50. The citation from Jean de la Bruyère, *Les Caractères* (Paris, 1692), 574, is translated by Martin, *Farnese Gallery*, 83. A medal struck by Cesati for Paul III Farnese, depicting Ganymede as a purely spiritual allegory, is illustrated and discussed by Bernice Davidson, "Pope Paul III's Additions to Raphael's Logge: His *Imprese* in the Logge," *Art Bulletin* 61 (1979), 385–405.

35. *Catalogo del Reale Museo nazionale di Firenze* (Rome, 1898), 389, no. 23. The work was ascribed to Cellini in the inventory of the Medici household, 1587–91; its presence in the family possessions suggests that it was commissioned by Cosimo. Kriegbaum, 22, proposed the alternative attribution to Tribolo, since accepted by John Pope-Hennessy, in his introduction to *The Life of Benvenuto Cellini*, tr. John Addington Symonds (London, 1949);

Camesasca, *L'opera del Cellini*, 65; H. R. Weihrauch, *Europäische Bronzestatuetten, 15.–18. Jahrhundert* (Brunswick, 1967), 177–79; Kempter, no. 228. On Tribolo's life and career see also Vasari/Milanesi, 6:70–85, 7:203, 236.

36. For numerous examples of the imperial medallion see F. Grecchi, *I medaglioni romani* (Milan, 1912), vol. 2, pls. 43.5, 45.5. A typical example of the early emblem book type is the editio princeps of Alciati's *Emblemata*, printed in 1531: see Henkel and Schöne, cols. 1726–27; Kempter, no. 232. Outside Italy, where the influence of Michelangelo's prototype was less powerful, this same type predominated well into the seventeenth century; see chapter 5.

37. For the biography of Cosimo, see Baccio Baldini, *Vita di Cosimo Medici primo Granduca di Toscana* (Florence, 1578), 65, 75–76. On Cosimo's patronage, see Paul W. Richelson, *Studies in the Personal Imagery of Cosimo I de' Medici, Duke of Florence* (New York, 1978), esp. chs. 4–6 on his increasing involvement in religious imagery and support of the Counter-Reformation.

38. Vasari/Milanesi, 6:575; tr. deVere, 3:1686–87; Baldini, 25–29, 51. For Franco's picture see Arturo Iahn-Rusconi, *La Reale Galleria Pitti in Firenze* (Rome, 1937), 132, no. 144; M. G. Vaccari, in *Firenze e la Toscana nell'Europa del Cinquecento: Committenza e collezionismo* (exh. cat., Florence, Uffizi, 1980), 269–70; Mayo, 113–15; Kempter, no. 73. On Cosimo's mythological personifications in art, see Richelson, 25–35, 64–65, 84–85; on zodiacal imagery, including Aquarius/Ganymede, Claudia Rousseau, "Cosimo I and Astrology: The Symbolism of Prophecy" (Ph.D. diss., Columbia University, 1983). Michelangelo's prototype was clearly prized by Cosimo, who owned a copy of it (Vasari/Milanesi, 7:567; Kempter, no. 54), and it served as model for one further Florentine adaptation, a painted and gilt *grottesca* panel by Alessandro Allori (1535–1607) that is a decorative composite of erotic Michelangelesque motifs (Florence, Museo nazionale del Bargello, no. 2306).

39. Vasari described this cycle in his own *Vita* (ed. Milanesi, 7:700), and the text of his dialogues, entitled *Ragionamenti* and written before 1557, is reprinted by Milanesi, 8:7–228. The chambers of Jupiter and Juno are described in *Giornata prima, ragionamento quinto* (8:62–71) and *ragionamento sesto* (8:71–76); Vasari's details of the rape of Ganymede are clearly taken from the ekphrasis in Virgil, *Aeneid*, 5:250–57. On the commission and its program see further Paola Barocchi, *Vasari pittore* (Milan, 1964), 40–146. During a visit to this room I was unable to discern any panel illustrating Ganymede, nor do I know of any published illustration.

40. Vasari/Milanesi, 10:596–97; *Mostra dei disegni Vasariani* (exh. cat., Florence, Uffizi, 1966), 31, no. 16. The costume drawings for the accompanying marchers form a series with the drawing of the *carro di Giove*, Uffizi, nos. Figura 2731–39. See further A. M. Nagler, *Theatre Festivals of the Medici 1539–1637* (New Haven, 1964), 24–30. Another drawing of the *Rape of Ganymede* by Vasari, recently acquired by the Metropolitan Museum, New York (Inv. no. 1983.31), is rather similar in its overall composition to the cartouche of this subject on Vasari's *carro*, but includes more detail of the group of shepherds seated below the boy; the outline of landscape and the general composition of boy and bird are similar in both. The eagle in this more elaborate drawing is almost identical to that in Michelangelo's version, but Vasari shifts the boy to a position riding atop the bird rather than suspended beneath it.

41. Richelson, 64–65; Baldini, 66–68. From 1564 on, Cellini's petitions to the court are directed as frequently to Francesco as to Cosimo: Palamede Carpani, 2:309–488.

42. On the Palazzo (now the Bibliotheca Hertziana) and Zuccari's career see Werner Körte, *Der Palazzo Zuccari in Rom: Sein Freskenschmuck und seine Geschichte* (Leipzig, 1935), 33–35, 70–79, pls. 20–29; Kristina Hermann-Fiore, "Die Fresken Federico Zuccaris in seinem römischen Künstlerhaus," *Römisches Jahrbuch für Kunstgeschichte* 18 (1979), 35–112; Kempter, no. 247. The quotations from Zuccari's treatises, *Idea de' pittori, scultori ed architettori* (Turin, 1607) and *Origine . . .* (Pavia, 1604), are from the edition of his *Scritti*

d'arte, ed. Detlev Heikamp (Florence, 1961), 32, 267 (cited in full by Hermann-Fiore, 109, who also illustrates his drawing of the rape of Ganymede as recounted in Dante).

43. For *ricordi* detailing these events, see Palamede Carpani, 2:452, no. 13; 457, no. 19; 462, no. 22; 465, no. 25; 467, no. 27; 472, no. 31; 484, no. 38; 488, no. 42. Palamede Carpani (485, n. 1) errs in assigning a date of 1560 to Cellini's marriage; it must have taken place after the *ricordo* of Feb. 19, 1562 declaring his intent to marry, and probably after the birth in 1563 of Liperata, who according to Symonds (*Cellini*, 451, without citing his source) had to be legitimized. Cellini's strong desire for children may reflect the same intrapsychic motivations as some of his earlier swashbuckling escapades; Kligerman, 420, observes that "the establishment of continuity of line is still another means of securing immortality and preserving one's narcissism in perpetuity." On the Escorial crucifix, see Vasari/Milanesi, 7:622–23. Although signed and dated 1562, it was probably begun about 1556: Camesasca, *L'opera del Cellini*, 46; Pope-Hennessy, *High Renaissance*, 371–72; Piero Calamandrei, "Inediti celliniani: Il mio bel Cristo," *Il ponte* 6 (1950), 378, 487.

44. Herbert Keutner, in *Il "Ganimede" di Battista Lorenzi* (exh. cat., Settignano, Misericordia, 1982), 17–24; Bertha Harris Wiles, *The Fountains of the Florentine Sculptors* (Cambridge, Mass., 1933), 90–91; Kempter, no. 69.

45. Vasari/Milanesi, 7:638; Keutner, 18–20.

Chapter 5. The Seventeenth Century and Diffusion to the North

1. Margarita Costa, *Flora fecunda* (Florence, 1640); cited by Malcolm Campbell, *Pietro da Cortona at the Pitti Palace: A Study of the Planetary Rooms and Related Projects* (Princeton, 1977), 32–33. On Ferdinand and Vittoria and the family obsession with dynastic succession see pp. 19–30, 87–88, 155. That the family apparently never considered a female heir worth anticipating provides another instance of the prevailing misogyny discussed above in chapter 3. It is interesting that the early phase of Ferdinand's nuptial decorations was entrusted to Giovanni Mannozzi, whose *Ganymede Replacing Hebe* (fig. 3.19) in a nearby Medici villa dates from the same years.

2. Campbell, 144–47, 153–56. The identity of the constellation is uncertain, though Campbell (129–32) connects the trailing star in Ganymede's hand with "the blazing star of Aquarius." See further the conflicting preparatory sketches for this figure, p. 282, nos. 134a, 140.

3. Campbell, 145–46, reprints the detailed program for Ferri's image. The discovery of the moons and his naming of them in anticipation of forthcoming support from Cosimo II is recorded by Galileo Galilei, *Le opere*, 20 vols. (Florence, 1890–1909), 3:9–10, 75, 96; 10:283–85, 318, 343, 358.

4. Cellini, *Vita*, 2:20, 41; Camesasca, *L'opera del Cellini*, 58. Ganymede was, of course, already familiar in French literature and illustration from the lengthy passage in the fourteenth-century *Ovide moralisé* (see chapter 1).

5. O. M. Dalton, *Catalogue of the Engraved Gems of the Post-Classical Periods . . . in the British Museum* (London, 1915), 11, no. 57, pl. III, with antique sources (cf. also no. 58).

6. Cosimo's cousin, Catherine de' Medici (d. 1589), married Henri II of France and was the mother of Henri III, whose successor Henri IV married first Catherine's daughter Marguerite, then Marie de' Medici, daughter of Cosimo's son and successor, Francesco I. On the northward diffusion of Italian humanist philosophy and symbolism, see Kristeller, *Ficino*, 19; Festugière, *Philosophie de l'amour*. The two cultures' intercourse was sexual as well as philosophical: the French called sodomy "the Italian vice," and the Italians called syphilis "the French disease" (Cellini, *Vita*, 1:32, 2:29); see further Bullough, *Sexual Variance*, 446–50, with additional examples. Sodomy of course remained legally proscribed: see Fernand Fleuret and Louis Percoaux [pseud.: Lodovico Hernandez], *Les Procès de sodomie aux XVIe, XVIIe, et XVIIIe siècles* (Paris, 1920). A basic source for the style and iconography of public

processions, court marriages, and other art is Frances A. Yates, *The French Academies of the Sixteenth Century* (London, 1947).

7. Cellini, *Vita*, 2:31; Vasari/Milanesi, 5:539, 7:405–13, 410, n. 3; Louis Dimier, *Le Primatice* (Paris, 1900), 284–88. On the Salle du Bal see further Anthony Blunt, *Art and Architecture in France, 1500–1700*, 4th ed. (Harmondsworth, 1981), 61, 107–08, noting the strong influence of Parmigianino.

8. The full series, Uffizi nos. 7812–58, are all printed on one large sheet; the Ganymede is signed with the letter S. See A.-P.-F. Robert-Dumesnil, *Le Peintre-graveur français*, 11 vols. (Paris, 1835–71), 9:16–21, 36, and no. 70; LeBlanc, *Manuel*, 2:503–05; on the School of Fontainebleau see Zerner, *Ecole de Fontainebleau*. Kempter, no. 237, catalogues a drawing of Ganymede for a ceiling project, stylistically related to this school.

9. Ganymede appeared in French editions of Alciati published in Lyon in the 1540s and 1550s (see above, chapter 1). In addition to sources cited above, further attacks or insinuations about court homosexuality may be found in L'Estoile, Introduction, pp. 7–28, and pp. 142, 181, 191, 200–05, 444, 544, 569 (comparing the French king's favorites to Piers Gaveston, beloved of England's Edward II: see above, chapter 4), 657; Agrippa d'Aubigné, whose often exaggerated tirades corroborate L'Estoile: *Oeuvres*, 61–82 ("Les Princes"), 575–607 ("La Confession catholique . . ."); Thomas Artus, *Description de l'Isle des Hermaphrodites . . .* , 1605 (Cologne ed., 1724), 30, 32–35, 331–352. A thorough if sometimes naive and overly cautious examination of these reports from a psychoanalytic point of view may be found in Gilbert Robin, *L'Enigme sexuelle d'Henri III* (Paris, 1964), esp. 116–207.

10. Alexandre Baudi de Vesme, *Stefano della Bella*, 2 vols. (Milan, 1906; facsimile reprint, ed. Phyllis Dearborn Massar, New York, 1971), 1:105–07, nos. 489–541 and 2:109, pl. 497; Anna Forlani-Tempesti, *Mostra di incisioni di Stefano della Bella* (exh. cat., Florence, Uffizi, 1973), 62–65, no. 42(h).

11. On these two pictures and the overall history of the decorative campaigns see Jean-Pierre Babelon et al., eds., *Le Cabinet de l'Amour de l'Hôtel Lambert* (exh. cat., Paris, Louvre, 1972); Gabriel Rouchès, *Eustache LeSueur* (Paris, 1923), 22–29; Blunt, *France, 1500–1700*, 226–28, 310–11. LeSueur's works at the Hôtel are all dated 1646–47. For the *Ganymede*, later hung in the Cabinet but originally designed for another room, see Babelon, 22, no. 18; Mayo, 152; Kempter, no. 110. For the *Cupid*, see Babelon, 21, no. 17.

12. Babelon, 9, 44–45, nos. 67, 68. Like his *Ganymede*, this picture was later transferred to a different room in the Hôtel, making explication of its original iconographic intent difficult.

13. I am not aware of any literature on this drawing. Ganymede is included among descriptions of the ceiling subjects that Romanelli painted for Mazarin's palace in 1646–47. I have not been able to visit this building (now the Bibliothèque Nationale), but the description given in Ulrich Thieme and Felix Becker, eds., *Allgemeines Lexikon der bildenden Künstler*, 37 vols. (Leipzig, 1907–50), 28:545, does not fit the present drawing. On Romanelli see further Blunt, *France, 1500–1700*, 227, 251; on his relation to LeSueur, Babelon, 9–10, 29–33, 48–49, no. 51.

14. Kempter lists two minor examples, nos. 11, 200. Two later French sculptures of Ganymede are also known, both variants of the boy standing next to the bird in the manner of Cellini's marble. For these Versailles decorations, one by Laviron from the seventeenth century, the other from the eighteenth, see Marvin C. Ross, "The Statue of Ganymede by Claude-Clair Francin at the Walters Art Gallery, Baltimore, Maryland," *Gazette des Beaux-Arts* 29 (1946), 17–22; Kempter, no. 71.

15. Cornelis Bos(ch) (1506/10–64) engraved three Ganymede scenes: Kempter, nos. 30–32; for the Italianate copy see no. 32. A lost *Rape of Ganymede* painted by Abraham Bloemaert was engraved by Jan Sanraedam (d. 1607): Bartsch III.136.26; Kempter, no. 18. Seventeenth-century works include those by Abraham van Diepenbeeck, Cornelis Schut, and Jan Miel: Kempter, nos. 60, 154, 206–07; Andor Pigler, *Barockthemen*, 3 vols. (Budapest,

1974), 1:98. The *Rape of Ganymede* attributed to Hendrik Goltzius (private collection, The Hague; photograph, RKD no. L57680), actually a copy after Damiano Mazza's ceiling (Fig. 3.23), is included among rejected attributions in the forthcoming dissertation by Lawrence Nichols, "The Paintings of Hendrik Goltzius, 1558–1617" (Columbia University).

16. Margarita Russell, "The Iconography of Rembrandt's *Rape of Ganymede*," *Simiolus* 9 (1977), 5; Mayo, 153–63; Kempter, no. 190. A preparatory sketch for the painting is in Dresden, Kupferstichkabinett: Otto Benesch, *The Drawings of Rembrandt*, 6 vols. (London, 1954–57), 1:92; Kempter, no. 191; Russell, 10, fig. 7. The finished composition served as a model for a painting by Karel van Mander III, now known through an engraving by Haelwegh: LeBlanc, *Manuel*, 2:330, no. 5; Mayo, 164, fig. 67; Kempter, nos. 91, 124; Russell, 18, n. 47, fig. 19. Van Mander's version was then reproduced in a domestic genre scene by Pieter de Hooch, about 1665: Wilhelm R. Valentiner, *Pieter de Hooch*, Klassiker der Kunst, no. 35 (Berlin and Leipzig, 1929), 277, ill. p. 279; Mayo, 164; Kempter, no. 96.

17. Kenneth Clark, *Rembrandt and the Italian Renaissance* (London, 1966), 12–18; cf. Fritz Saxl, "Rembrandt and Classical Antiquity," in his *Lectures*, 2 vols. (London, 1957), 1:302 ("comedy"); Hans Sedlmayr, *Art in Crisis* (London, 1957), 125 ("caricature"); Vitale Bloch, "Rembrandt and the Italian Renaissance," *Burlington Magazine* 109 (1967), 715 ("grotesque parody"); a less judgmental appreciation is given by Jakob Rosenberg, Seymour Slive, and E. H. Ter Kuile, *Dutch Art and Architecture, 1600–1800* (Harmondsworth, 1966), 57. Mayo, 158, calls the picture a refutation of Correggio's glorification of pederasty; Liebert (278, n. 17) sees in it a repudiation of those feelings as expressed by Michelangelo. Nicos Hadjinicolaou, *Art History and Class Struggle*, tr. Louise Asmal (London, 1978), 163–68, attempts unconvincingly to interpret Rembrandt's picture as critical not so much of pagan morality but of the learned mythology of the upper classes, using a Marxist methodology.

18. Russell, 12–14, citing other examples; the urinating putto can be traced back in Italian art to Titian's *Bacchanal of the Andrians*. Emil Kieser, "Über Rembrandts Verhältnis zur Antike," *Zeitschrift für Kunstgeschichte* 10 (1941–42), 133–54, was unable to find evidence that Ganymede and sodomy were associated or cited in Holland at this time. The chronicle of an apparently unprecedented official persecution of homosexual men in Holland in the following century (1730) suggests that prior to that time some degree of toleration was common; see Louis Crompton, "Gay Genocide: From Leviticus to Hitler," in Louie Crew, ed., *The Gay Academic* (Palm Springs, Cal., 1978), 67–91.

19. *Nucleus emblematum selectissimorum*; D. Francken, *L'Oeuvre gravée de van de Passe* (Paris and Amsterdam, 1881), 263, no. 1344; Kempter, no. 177. The version illustrated here is that reused for an English text by George Withers, *A Collection of Emblemes* (London, 1635): Russell, 8, fig. 5. There is some connection between this Dutch tradition and contemporary art in neighboring Germany, where van de Passe's illustrations were also published. The landscape below van de Passe's boy is identical with that in a large circular medal of *Liriope and Ganymede* attributed to a German follower of della Porta, and all share a boy-riding-bird format (cf. fig. 2.12).

20. Bartsch XVIII.151.638–797. The *Ganymede*, no. 94 in the series, is flanked by two further Ovidian homoerotic subjects, Apollo and Cyparissus (93) and Apollo and Hyacinthus (95). Tempesta also designed another *Rape of Ganymede* (Bartsch XII.153.817), apparently primarily a landscape.

21. The sculptural source was suggested by Peter Schatborn, "Over Rembrandt en kinderen," *Kroniek van het Rembrandthuis* 27 (1975), 8–19. On the cherries see I. Bergstrom, "Disguised Symbolism in Madonna Pictures and Still-Life, I," *Burlington Magazine* 97 (1955), 303; Mayo, 160–61; Russell, 9–10.

22. Karel van Mander, "Uytlegghingh op den Metamorphosis Pub. Ovidii Nasonis," in *Het Schilderboeck* (Amsterdam, 1618), f. 77v–78r. Van Mander, like Boccaccio, cites the various classical sources and describes the myth's principal episodes, interpreting Ganymede in Neoplatonic terms as the human soul; see also Russell, 12–13. Francesco Colonna, *Hypner-*

otomachia Poliphili (Venice, 1499; facsimile reprint, Westmead, Hants., 1969), f. e vii. One further Dutch Ganymede, unfortunately now lost, was painted by Pieter de Grebber for a ceiling in one of Prince Frederick Henry of Orange's palaces before 1647; see D. F. Slothouwer, *De Paleizen van Frederik Hendrik* (Leiden, 1945), 306; D. P. Snoep, "Honselaersdijk: Restauraties op papier," *Oud Holland* 84 (1969), 285, n. 28. I am grateful to Frances Preston for bringing this work to my attention.

23. For a partial catalogue of Maes's child portraits, see Rose Wishnevsky, *Studien zum "portrait historié" in den Niederländen* (Munich, 1967), 84–85, 194–95, nos. 83–88; Kempter, nos. 115–23, catalogues nine memorial portraits. The Pushkin portrait (Wishnevsky, no. 85; Kempter, no. 118) is discussed by Shelly Rosenthal, "Two Unpublished Pictures by Maes in Russia," *Burlington Magazine* 54 (1929), 269–71; Mayo, 165. Sometimes Ganymede appears alone in these pictures, at other times with one or more other children; it has been suggested that several pictures depict the same family after succeeding deaths: Russell, 9, n. 18.

24. The thesis that childhood came to be recognized at this period as a distinct and important period of life is explored by Mary Frances Durantini, *The Child in Seventeenth-Century Dutch Painting* (Ann Arbor, 1983). Cf. the cherublike Ganymede in Paulus van Vianen's *Banquet of the Gods*, ca. 1604 (above, chapter 2). A minor point possibly relevant to this process is that two Dutch prints of this period (ca. 1638) after Parmigianino's Ganymede drawings both omit the more specific erotic allusions: Hebe disappears from the copy after *Ganymede and Hebe*, and the abducting eagle from the *Running Ganymede*. See *Parmigianino Catalogue*, nos. O.R. 60, 61.

25. Two of these works are tapestries woven in Brussels (Madrid, Palacio Real); four are vestigial classical pretexts for a Flemish landscape (Kempter, nos. 34, 35, 104, 159). For additional minor examples, see Saslow, "Ganymede," 540–541, figs. 38, 61; Kempter, no. 19.

26. Max Rooses, *L'Oeuvre de Peter Paul Rubens* (Antwerp, 1886), 92, no. 612; Hans G. Evers, *Peter Paul Rubens* (Munich, 1942), 102; Mayo, 149–51; Kempter, nos. 196–97. See also Svetlana Alpers, "Manner and Meaning in Some Rubens Mythologies," *Journal of the Warburg and Courtauld Institutes* 30 (1967), 275–76; Michael Jaffé, *Rubens and Italy* (Ithaca, N.Y., 1977), 22, and similarly in his "Rubens and Jove's Eagle," *Paragone* 245 (1970), 22–24. On the series see further John R. Martin and Claudia Bruno, "Rubens's *Cupid Supplicating Jupiter*," in John R. Martin, ed., *Rubens before 1620* (exh. cat., Princeton University Art Museum, 1972), 3–7, 17–21, nos. 1, 2.

27. Alpers, "Manner and Meaning," 276, n. 18, suggested the memorial function; Russell, 11, proposed the reading of Ganymede giving the cup, but her evidence is arguable. Rubens, who lived for a time in Mantua, probably knew the only other pictures that show Ganymede and Hebe in harmonious cooperation, part of Giulio Romano's series for the Palazzo del Te (see above, chapter 3). Rubens' picture was copied twice: Kempter, nos. 60, 75.

28. Alpers, *Torre*, 210, no. 24; *Museo del Prado, Catalogo de pinturas* (Madrid, 1972), 1:260, no. 1679; Mayo, 149–50; Kempter, no. 198. Rubens was well acquainted with Michelangelo's Cavalieri drawings and himself retouched Giulio Clovio's copy after the *Ganymede*, as well as using several of the others in the series as models. On the iconography of Rubens' *Saturn* and its relation to its *Ganymede* pendant, see above, chapter 1. The series for the Torre included at least two other homoerotic subjects, *The Death of Hyacinth* and *Narcissus*, and possibly a *Cyparissus*: Alpers, *Torre*, 222, 240, 273, nos. 32a, 43, 43a.

29. John Walker, *Bellini and Titian at Ferrara: A Study of Styles and Taste* (London, 1957), 86, figs. 40–43, discusses the putti; Julius Held, "Rubens and Titian," in Rosand, *Titian*, 213–14, pls. 7.23, 7.24, also discusses the archer. Walker's tone suggests that he is revealing his own distaste for homosexual subject matter as much as Rubens' but it was clearly the artist's feeling as well; on Rubens' unusual devotion to Titian, see Held, 283–306. The same process of sexual neutralization may be observed in theatrical literature at this

time: in 1607, when Claudio Monteverdi adapted Poliziano's *Orfeo* for his pioneering opera on the same theme, his librettist replaced the concluding homoerotic and misogynistic incidents of earlier versions by a deus ex machina who restores Orfeo to Euridice in heaven.

30. Thomas Carew, *Poems*, 217–19. The text also outlaws Cupid's nudity at this point, again combining his eroticism with Ganymede's. The drawing of Atlas is catalogued by Stephen Orgel and Roy Strong, *Inigo Jones: The Theatre of the Stuart Court*, 2 vols. (Berkeley and Los Angeles: University of California Press, 1973), 2:566–88, no. 280. For a narrative reconstruction of the stage action, see Roy Strong, *Splendor at Court: Renaissance Spectacle and the Theater of Power* (Boston, 1973), 233–40.

31. At James's accession it was said of him that "We have had King Elizabeth, now we have Queen James." See Caroline Bingham, *James I of England* (London, 1981); Bray discusses James and the more general patterns of homosexuality among the court and aristocracy. James's letters to Buckingham and other favorites have recently been published by G. P. V. Akrigg, ed., *Letters of King James VI and I* (Berkeley and Los Angeles, 1984). Akrigg notes suggestively (no. 176, p. 365) that James appointed Buckingham his "cupbearer." Kieser, "Rembrandts Verhältnis," 133–54, cites an English text by Prynne, the *Historiomatrix* of 1633, that alludes to sodomites using the term *ganymede*.

32. Lucy Hutchinson, *Memoirs of the Life of Colonel Hutchinson*, ed. J. Hutchinson (London, 1906), 84; Bray, 55.

BIBLIOGRAPHY

Achilles Tatius. *Leucippe and Clitophon*. Translated by S. Gaselee. Cambridge, Mass., and London: Loeb Classical Library, 1961.

Alberti, Leon Battista. *De pictura*. Edited by Cecil Grayson. Rome and Bari: Laterza, 1975.

Alciati, Andrea. *Andreae Alciati emblematum flumen abundans*. Edited by Henry Green. The Holbein Society's Fac-simile Reprints. London, 1872.

Alpers, Svetlana. *The Decoration of the Torre de la Parada*. Corpus Rubenianum Ludwig Burchard, vol. 9. London and New York: Phaidon, 1971.

———. "Manner and Meaning in Some Rubens Mythologies." *Journal of the Warburg and Courtauld Institutes* 30 (1967): 272–95.

d'Ancona, Alessandro. *Origini del teatro italiano*. 2 vols. 1891. Reprint. Rome: Bardi, 1966.

d'Ancona, Mirella Levi. "The Doni Madonna by Michelangelo." *Art Bulletin* 50 (1968): 43–50.

Aretino, Pietro. *Lettere sull'arte di Pietro Aretino*. Edited by Ettore Camesasca and Fidenzio Pertile. 3 vols. Milan: Edizioni del milione, 1957–60.

———. *The Letters of Pietro Aretino*. Translated by Thomas Caldecot Chubb. Hamden, Conn.: Archon Books, 1967.

———. *Tutte le opere di Pietro Aretino: Teatro*. Edited by Giorgio Petrocchi. Verona: Mondadori, 1971.

Ariosto, Ludovico. *Orlando furioso*. Edited by Remo Ceserani. 2 vols. Turin: Unione tipografico, 1962–66.

———. *The Satires of Ludovico Ariosto*. Translated and edited by Peter DeSa Wiggins. Athens: University of Ohio Press, 1976.

d'Aubigné, Agrippa. *Oeuvres*. Edited by Henri Weber. Paris: Gallimard, 1969.

Babelon, Jean-Pierre; de Lastic, Georges; Rosenberg, Pierre; and Schnapper, Antoine, eds. *Le Cabinet de l'Amour de l'Hôtel Lambert*. Exhibition catalogue, Paris: Musée du Louvre, 1972.

Bailey, Derrick Sherwin. *Homosexuality and the Western Christian Tradition*. 1951. Reprint. Hamden, Conn.: Archon Books, 1975.

Baldini, Baccio. *Vita di Cosimo Medici primo Granduca di Toscana*. Florence, 1578.

Barocchi, Paola, ed. *La vita di Michelangelo nelle redazioni del 1550 e del 1568*. 4 vols. Milan: Ricciardi, 1962.

Bartsch, Adam. *Le Peintre-graveur*. 21 vols. Vienna, 1803–21.

Beccadelli, Antonio (Il Panormita). *L'ermafrodito*. Edited by J. Tognelli. Rome: Avanzini and Torraca, 1968.

Becker, Marvin S. *Florence in Transition*. 2 vols. Baltimore: Johns Hopkins University Press, 1967.

Beltrami, Luca. *Documenti e memorie riguardanti la vita e le opere di Leonardo da Vinci*. Milan, 1919.

Berchorius, Petrus. *Metamorphosis Ovidiana moraliter a Magistro Thomas Walleys Anglico de professione praedicatorum sub sanctissimo patre Dominico. . . .* Paris, 1509. Transcription. Utrecht: Instituut voor Laat Latijn der Rijksuniversiteit, 1960.

Berenson, Bernard. *The Drawings of the Florentine Painters*. 3 vols. Chicago: University of Chicago Press, 1938.

Bieber, Margarete. *Sculpture of the Hellenistic Age*. New York: Columbia University Press, 1955.

Blunt, Anthony. *Art and Architecture in France, 1500–1700*. 4th ed. Harmondsworth: Penguin, 1981.

———. *Artistic Theory in Italy, 1450–1600*. Oxford: Clarendon, 1966.

Bober, Phyllis Pray. *Drawings after the Antique by Amico Aspertini: Sketchbooks in the British Museum*. London: Warburg Institute, 1957.

Boccaccio, Giovanni. *Genealogia deorum gentilium*. Translated by Giuseppe Betussi, *La geneologia de gli dei de' gentili*. Venice, 1564.

Bocchi, Achille. *Symbolicarum quaestionum de universo genere*. Bologna, 1574. Reprint, ed. Stephen Orgel. New York: Garland, 1979.

de Boer, C., ed. *"Ovide moralisé*: Poème du commencement du quatorzième siècle publié d'après tous les manuscrits connus," vol. 4, bks. 10–13. *Verhandelingen der koninklijke Akademie van Wetenschappen te Amsterdam, Afdeeling Letterkunde* n.s. 37 (1936): 1–109.

Boswell, John. *Christianity, Social Tolerance, and Homosexuality*. Chicago: University of Chicago Press, 1980.

Bowie, Theodore, and Christenson, Cornelia V., eds. *Studies in Erotic Art*. Studies in Sex and Society, vol. 3. New York and London: Basic Books, 1970.

Bray, Alan. *Homosexuality in Renaissance England*. London: Gay Men's Press, 1982.

Brendel, Otto J. "The Scope and Temperament of Erotic Art in the Greco-Roman World." In *Studies in Erotic Art*, edited by Theodore Bowie and Cornelia V. Christenson, pp. 3–108. New York and London: Basic Books, 1970.

Brinckmann, A. E. *Michelangelo Zeichnungen*. Munich: R. Piper, 1925.

Broude, Norma, and Garrard, Mary D., eds. *Feminism and Art History: Questioning the Litany*. New York: Harper and Row, 1982.

Brucker, Gene. *The Society of Renaissance Florence: A Documentary Study*. New York: Harper and Row, 1971.

Bullough, Vern L. *Sexual Variance in Society and History*. Chicago and London: University of Chicago Press, 1976.

Bullough, Vern L., and Bullough, Bonnie. *The Subordinate Sex: A History of Attitudes toward Women*. Urbana: University of Illinois Press, 1973.

Buonarroti, Michelangelo. *Il carteggio di Michelangelo*. Edited by Giovanni Poggi, Paola Barocchi, and Renzo Ristori. 4 vols. Florence: Sansoni, 1965–79.

———. *Complete Poems and Selected Letters of Michelangelo*. Translated by Creighton Gilbert, and edited by Robert N. Linscott. Princeton: Princeton University Press, 1980.

———. *The Letters of Michelangelo*. Translated and edited by E. H. Ramsden. 2 vols. London: Owen, 1963.

————. *Michelangelo Buonarroti: Rime*. Edited by Enzo Noè Girardi. Scrittori d'Italia, no. 217. Bari: Laterza, 1960.

————. *Le rime di Michelangelo Buonarroti.* . . . Edited by Cesare Guasti. Florence, 1863.

Callmann, Ellen. *Apollonio di Giovanni*. Oxford: Clarendon, 1974.

Camesasca, Ettore. *Tutta l'opera del Cellini*. Milan: Rizzoli, 1955.

Campbell, Malcolm. *Pietro da Cortona at the Pitti Palace: A Study of the Planetary Rooms and Related Projects*. Princeton: Princeton University Press, 1977.

Carew, Thomas. *Poems*. 1640. Facsimile reprint. Menston: Scolar Press, 1969.

Castiglione, Baldassare. *The Book of the Courtier*. Translated by George Bull. Harmondsworth: Penguin, 1967.

————. *Il libro del Cortegiano*. Edited by Amadeo Quondam. Milan: Garzanti, 1981.

Catalogo del Reale Museo nazionale di Firenze. Rome, 1898.

Cellini, Benvenuto. *Autobiography*. Translated by George Bull. Harmondsworth: Penguin, 1956.

————. *The Life of Benvenuto Cellini, Written by Himself*. Translated and edited by John Addington Symonds. New York, 1896.

————. *Opere*. Edited by Giovanni Palamede Carpani. 3 vols. Milan, 1806.

————. *I trattati dell'oreficeria e della scultura di Benvenuto Cellini, si aggiungono . . . le lettere e . . . le poesie*. Edited by Carlo Milanesi. Florence, 1857.

————. *Vita*. Edited by Ettore Camesasca. Milan: Rizzoli, 1954.

Chastel, André. *Art et humanisme à Florence au temps de Laurent le Magnifique*. Paris: Presses universitaires de France, 1959.

Ciardi Duprè dal Poggetto, Maria Grazia. "Nuovi ipotesi sul Cellini." In *Essays Presented to Myron P. Gilmore*. 2 vols. Edited by Sergio Bertelli and Gloria Ramakus, 2:95–106. Florence: La nuova Italia, 1978.

Clark, Kenneth. *Leonardo da Vinci*. Harmondsworth: Penguin, 1961.

————. *Rembrandt and the Italian Renaissance*. London: John Murray, 1966.

Clark, Kenneth, and Pedretti, Carlo. *The Drawings of Leonardo da Vinci in the Collection of Her Majesty the Queen at Windsor Castle*. 3 vols. London: Phaidon, 1969.

Condivi, Ascanio. *Life of Michelangelo*. Translated by Alice Sedgwick Wohl, and edited by Hellmut Wohl. Baton Rouge: University of Louisiana Press, 1976.

————. *Vita di Michelangiolo*. 1553. Florence: Rinascimento del libro, 1927.

Copertini, Giovanni. *Il Parmigianino*. Parma: Mario Fresching, 1932.

Cornazzano, Antonio. *Proverbii di Messer Antonio Cornazano*. 1865. Reprint. Catania: F. Gueitolini, 1929.

Cosson, Baron C. A. de. "Cellini's Model for His Head of the *Ganymede*." *Burlington Magazine* 23 (1913): 353–54.

Craven, J. B. *Count Michael Maier: Life and Writings*. 1910. Reprint. London: Dawson, 1968.

Cropper, Elizabeth. "On Beautiful Women, Parmigianino, *Petrarchismo*, and the Vernacular Style." *Art Bulletin* 58 (1976): 374–94.

Cumont, Franz. *Recherches sur le symbolisme funéraire des romains*. Bibliothèque archéologique et historique, vol. 35. Paris: Geuthner, 1942.

Dacos, Nicole. *La Découverte de la Domus Aurea et la formation des grotesques à la Renaissance*. London: Warburg Institute, 1969.

Dalton, O. M. *Catalogue of the Engraved Gems of the Post-Classical Periods . . . in the British Museum*. London, 1915.

Davidson, Bernice F. "Pope Paul III's Additions to Raphael's Logge: His *Imprese* in the Logge." *Art Bulletin* 61 (1979): 385–405.

Davitt-Asmus, Ute. "Zur Deutung von Parmigianinos 'Madonna dal collo lungo.'" *Zeitschrift für Kunstgeschichte* 31 (1968): 305–13.

Degenhart, Bernhard, and Schmitt, Annegrit. "Ein Musterblatt des Jacopo Bellini mit Zeichnungen nach der Antike." In *Festschrift Luitpold Dussler*, edited by J. A. Schmoll, Marcell Restle, and Herbert Weiermann, pp. 139–168. Munich: Deutscher Kunstverlag, 1972.

Delaborde, Henri. *Marc-Antoine Raimondi*. Paris, 1888.

Delcourt, Marie. *Hermaphrodite: Mythes et rites de la bisexualité dans l'antiquité classique*. Paris: Presses universitaires de France, 1958.

Dhanens, Elisabeth. *Jean Boulogne: Giovanni Bologna Fiammingo, Douai 1529–Florence 1608*. Verhandelingen Koninklijke Vlaamse Academie voor Wetenschappen, Letteren en Schone Kunsten van België, no. 11. Brussels: Paleis der Academiën, 1956.

Dickens, A. G., ed. *The Courts of Europe: Politics, Patronage, and Royalty, 1400–1800*. New York: McGraw-Hill, 1977.

Dimier, Louis. *Le Primatice: Peintre, sculpteur et architecte des rois de France*. Paris, 1900.

Dixon, Laurinda. "Bosch's *Garden of Delights* Triptych: Remnants of a Fossil Science." *Art Bulletin* 53 (1981): 97–113.

Dizionario biografico degli italiani. 25 vols. to date. Rome: Istituto della Enciclopedia italiana, 1960–.

Dover, K. J. *Greek Homosexuality*. New York: Random House, 1978.

Dunand, Louis. *Les Compositions de Jules Romain intitulées Les Amours des dieux. . . .* Lausanne: Institut d'iconographie, 1977.

Dussler, Luitpold. *Raffael: Kritisches Verzeichnis der Gemälde, Wandbilder und Bildteppiche*. Munich: Bruckmann, 1966.

———. *Die Zeichnungen des Michelangelo: Kritischer Katalog*. Berlin: Mann, 1959.

Eisler, Robert. "Luca Signorelli's *School of Pan*." *Gazette des Beaux-Arts* 33 (1948): 77–87.

Eissler, Kurt R. *Leonardo da Vinci: Psychoanalytic Notes on the Enigma*. New York: International Universities Press, 1961.

Enciclopedia dell'arte antica: Classica e orientale. 8 vols. Rome: Istituto della Enciclopedia italiana, 1958–73.

Equicola, Mario. *Libro di natura d'amore*. Venice, 1525.

Erlanger, Philippe. *Rodolphe II de Habsbourg, 1552–1612: L'Empéreur insolite*. Paris: Albin Michel, 1971.

Ettlinger, Leopold. "Hercules Florentinus." *Mitteilungen des kunsthistorichen Institutes in Florenz* 16 (1972): 119–42.

Evans, R. J. W. *Rudolf II and His World: A Study in Intellectual History, 1576–1612*. Oxford: Oxford University Press, 1973.

Evers, Hans G. *Peter Paul Rubens*. Munich: Bruckmann, 1942.

Fabricius, Johannes. *Alchemy: The Medieval Alchemists and Their Royal Art*. Copenhagen: Rosenkilde and Bagger, 1976.

Fagiolo dell'Arco, Maurizio. *Il Parmigianino: Un saggio sull'ermetismo nel Cinquecento*. Rome: Bulzoni, 1970.

Fahy, Connor F. "Early Renaissance Treatises on Women." *Italian Studies* 31 (1956): 31–55.

———. "The Intellectual Status of Women in Italy in the Later Sixteenth Century." Ph.D. dissertation, University of Manchester, 1954.

Farrell, Brian. Introduction to *Leonardo da Vinci and a Memory of His Childhood*, by Sigmund Freud, translated by Alan Tyson. Harmondsworth: Penguin, 1963.

Festugière, Jean. *La Philosophie de l'amour de Marsile Ficin et son influence sur la littérature*

française au XVIe siècle. Etudes de la philosophie médiévale, vol. 31. Paris: Vrin, 1941.

Ficino, Marsilio. _Commentarium in Convivio Platonis._ 1474. Translated and edited by Sears R. Jayne. Columbia: University of Missouri Press, 1943.

Fischel, Oskar. _Raphael._ Translated by Bernard Rackham. 2 vols. London: Kegan Paul, 1948.

———. _Raphaels Zeichnungen._ Strasbourg, 1898.

Forlani Tempesti, Anna. _Mostra di incisioni di Stefano della Bella._ Exhibition catalogue, Florence, Uffizi, 1973.

Förster, Richard. "Philoträts Gemälde in der Renaissance." _Jahrbuch der königlich preuszischen Kunstsammlungen_ 25 (1904): 15–48.

———. "Wiederherstellung antiker Gemälde durch Künstler der Renaissance." _Jahrbuch der preussischen Kunstsammlungen_ 43 (1922): 126–36.

Foxon, David. "Libertine Literature in England, 1660–1745: Aretino's _Postures._" _The Book Collector_ 12 (1963): 159–65.

Freedberg, Sydney J. _Painting in Italy, 1500–1600._ Harmondsworth: Penguin, 1975.

———. _Parmigianino: His Works in Painting._ Cambridge, Mass.: Harvard University Press, 1950.

Freud, Sigmund. _Leonardo da Vinci and a Memory of His Childhood._ Translated by Alan Tyson. Harmondsworth: Penguin, 1963.

———. _Leonardo da Vinci: A Study in Psychosexuality._ Introduction and translation by A. A. Brill. New York: Random House, 1947.

Frey, Karl. _Die Handzeichnungen Michelangiolos Buonarroti._ 2 vols. Berlin, 1909–11.

Frommel, Christoph L. _Baldassare Peruzzi als Maler und Zeichner._ Beiheft zum Römisches Jahrbuch für Kunstgeschichte, vol. 11. Vienna: Schroll, 1968.

———. _Die Farnesina und Peruzzis architektonisches Frühwerk._ Berlin: de Gruyter, 1961.

———. _Michelangelo und Tommaso de' Cavalieri._ Amsterdam: Castrum Peregrini, 1979.

Fumagalli, Giuseppina. _Eros di Leonardo._ Milan: Garzanti, 1952.

Il "Ganimede" di Battista Lorenzi. Exhibition catalogue, Settignano, Misericordia, 1982.

Gaye, Giovanni, ed. _Carteggio inedito d'artisti dei secoli XIV–XVI._ 3 vols. Florence, 1839–40.

Ghidiglia Quintavalle, Augusta. _Gli ultimi affreschi del Parmigianino._ Milan: Silvana, 1971.

Ghidiglia Quintavalle, Augusta, ed. _L'opera completa del Correggio._ Milan: Rizzoli, 1970.

Giannotti, Donato. _Dialoghi di Donato Giannotti._ Edited by Dioclecio Redig de Campos. Florence: Sansoni, 1939.

Giglioli, Odoardo H. _Giovanni da San Giovanni (Giovanni Mannozzi: 1592–1636)._ Florence: S.T.E.T., 1949.

Gilbert, Arthur N. "Conceptions of Homosexuality and Sodomy in Western History." _Journal of Homosexuality_ 6:1/2 (1980–81): 57–68.

Gombrich, Ernst H. _Symbolic Images: Studies in the Art of the Renaissance._ London: Phaidon, 1972.

Gould, Cecil. "Correggio and Rome." _Apollo_ 83 (1966): 328–37.

———. _The Paintings of Correggio._ Ithaca, N.Y.: Cornell University Press, 1976.

———. _The "School of Love" and Correggio's Mythologies._ London: National Gallery, n.d.

Graves, Robert. _The Greek Myths._ 2 vols. Harmondsworth: Penguin, 1960.

Grecchi, F. _I medaglioni romani._ 2 vols. Milan, 1912.

Greci, Luigi. _Benvenuto Cellini nei delitti e nei processi fiorentini ricostruiti attraverso le leggi del tempo._ Quaderni dell'Archivio di antropologia criminale e medicina legale, fasc. 2. Turin: Bocca, 1930.

Greene, D. and Lattimore, R., eds. *The Complete Greek Tragedies.* 4 vols. Chicago: University of Chicago Press, 1959.

The Greek Anthology. Translated by W. R. Paton, 5 vols. Cambridge, Mass.: Harvard University Press, Loeb Classical Library, 1959–60.

Gronau, Georg. *Correggio: Des Meisters Gemälde.* Klassiker der Kunst, no. 10. Stuttgart and Leipzig, 1907.

Grote, Andreas. "Cellini in gara." *Il ponte* 19 (1963): 73–94.

Gualandi, Michelangelo, ed. *Nuova raccolta di lettere sulla pittura, scultura, ed architettura.* Bologna, 1845.

Gundersheimer, Werner L. *Ferrara: The Style of a Renaissance Despotism.* Princeton: Princeton University Press, 1973.

Hadjinicolaou, Nicos. *Art History and Class Struggle.* Translated by Louise Asmal. London: Pluto, 1978.

Hartt, Frederick. *The Drawings of Michelangelo.* London: Thames and Hudson, 1971.

———. *Giulio Romano.* 2 vols. New Haven: Yale University Press, 1958.

Hayum, Andrée. *Giovanni Antonio Bazzi, "Il Sodoma."* New York: Garland, 1976.

Hekler, A. "Michelangelo und die Antike." *Wiener Jahrbuch für Kunstgeschichte* 7 (1930): 201–23.

Held, Julius S. *The Oil Sketches of Peter Paul Rubens: A Critical Catalogue.* Princeton: Princeton University Press, 1980.

———. *Rembrandt's "Aristotle" and Other Rembrandt Studies.* Princeton: Princeton University Press, 1969.

Henckel, M. D. "Illustrierte Ausgaben von Ovids Metamorphosen im XV., XVI., und XVII. Jahrhundert." *Vorträge der Bibliothek Warburg 1926–27:* 58–144. Leipzig and Berlin: Teubner, 1930.

Henkel, Arthur, and Schöne, Albrecht, eds. *Emblemata: Handbuch zur Sinnbildkunst des XVI. und XVII. Jahrhunderts.* Stuttgart: Metzler, 1967.

Hermann-Fiore, Kristina. "Die Fresken Federico Zuccaris in seinem römischen Künstlerhaus." *Römisches Jahrbuch für Kunstgeschichte* 18 (1979): 35–112.

Hesiod. *Theogony.* Translated by Hugh G. Evelyn-White. London and New York: Loeb Classical Library, 1926.

Heydenreich, Ludwig. *Leonardo da Vinci.* Authorized translation. New York: Macmillan, 1954.

Hibbard, Howard. *Michelangelo.* New York: Harper and Row, 1974.

Hill, George F. *The Gustave Dreyfus Collection of Renaissance Medals.* Oxford: Oxford University Press, 1931.

Hind, A. M. *Early Italian Engraving; A Critical Catalogue. . . .* 7 vols. London: Quaritch, 1938–48.

Hirschfeld, Magnus. *Homosexualität des Mannes und des Weibes.* 2 vols. Berlin: Institut für sexuelle Wissenschaft, 1920.

Hirst, Michael. "A Drawing of the Rape of Ganymede by Michelangelo." In *Essays Presented to Myron P. Gilmore.* 2 vols. Edited by Sergio Bertelli and Gloria Ramakus, 2: 253–60. Florence: La nuova Italia, 1978.

Hofstede de Groot, Cornelis. *Beschreibendes und kritisches Verzeichnis der Werke der hervorragendsten holländischen Maler des XVII. Jahrhunderts.* 10 vols. Esslingen and Paris, 1907–28.

Howard, Seymour. "The Dresden *Venus* and Its Kin: Mutation and Retrieval of Types." *Art Quarterly* n.s. 2 (1979): 90–111.

Iahn-Rusconi, Arturo. *La Reale Galleria Pitti in Firenze*. Rome: Libreria dello stato, 1937.

The Illustrated Bartsch, edited by Walter L. Strauss. 33 vols. to date. New York: Abaris Books, 1978–.

Jaffé, Michael. *Rubens and Italy*. Ithaca, N.Y.: Cornell University Press, 1977.

———. "Rubens and Jove's Eagle." *Paragone* 245 (1970): 19–26.

de Jong, H. M. E. *Michael Maier's "Atalanta fugiens": Sources of an Alchemical Book of Emblems*. *Janus*, Supplements, vol. 8. Leiden, 1969.

Jung, Carl. *The Collected Works of Carl G. Jung*. Translated by R. F. C. Hull. Princeton: Princeton University Press. Vol. 5, *Symbols of Transformation* (1956); vol. 12, *Psychology and Alchemy* (1968); vol. 13, *Alchemical Studies* (1969); vol. 14, *Mysterium coniunctionis* (1970).

Karlen, Arno. *Sexuality and Homosexuality: A New View*. New York: Norton, 1971.

Katz, Jonathan. *Gay American History: Lesbians and Gay Men in the U.S.A.* New York: Avon Books, 1976.

Kempter, Gerda. *Ganymed: Studien zur Typologie, Ikonographie und Ikonologie*. Dissertationen zur Kunstgeschichte, no. 12. Cologne and Vienna: Böhlau, 1980.

Kirschenbaum, Baruch D. "Reflections on Michelangelo's Drawings for Cavalieri." *Gazette des Beaux-Arts* ser. 6, vol. 38 (1951): 99–110.

Kligerman, Charles. "Notes on Benvenuto Cellini." *Annual of Psychoanalysis* 3 (1975): 409–21.

Knauer, Elfriede R. "Zu Correggios Io und Ganymed." *Zeitschrift für Kunstgeschichte* 33 (1970): 61–67.

Körte, Werner. *Der Palazzo Zuccari in Rom: Sein Freskenschmuck und seine Geschichte*. Leipzig: Keller, 1935.

Kriegbaum, Friedrich. "Marmi di Benvenuto Cellini ritrovati." *L'arte* n.s. 11 (1940): 3–25.

Kris, Ernst. *Psychoanalytic Explorations in Art*. New York: International Universities Press, 1952.

Kristeller, Paul Oscar. *The Philosophy of Marsilio Ficino*. Translated by Virginia Conant. New York: Columbia University Press, 1943.

Ladendorf, Heinz. "Antikenstudium und Antikenkopie." *Abhandlung der Sächsischen Akademie der Wissenschaften zu Leipzig* 46:3 (1953): 1–182.

Larsson, Lars Olof. *Adrian de Vries*. Vienna and Munich: Schroll, 1967.

LeBlanc, Charles. *Manuel de l'amateur des estampes*. 4 vols. 1854–90. Facsimile reprint (4 vols. in 2). Amsterdam: Hissink, 1971.

Lee, R. W. "*Ut pictura poesis*: The Humanistic Theory of Painting." *Art Bulletin* 22 (1940): 197–269.

Lell, Virgil Gordon. "The Rape of Ganymede: Greek-Love Themes in Elizabethan Friendship Literature." Ph.D. dissertation, University of Nebraska, 1970.

Lennep, Jacques van. *Art et alchimie: Etude de l'iconographie hermétique et de ses influences*. Paris and Brussels: Editions Meddens, 1966.

L'Estoile, Pierre de. *Journal du règne d'Henri III, 1574–1589*. Edited by Louis-Raymond Lefèvre. Paris: Gallimard, 1943.

Levenson, Jay A.; Oberhuber, Konrad; and Sheehan, Jacquelyn L. *Early Italian Engravings from the National Gallery of Art*. Washington: National Gallery, 1973.

Lewis, Thomas S. W. "Brothers of Ganymede." *Salmagundi* nos. 58–59 (1982–83): 147–65.

Liebert, Robert S. *Michelangelo; A Psychoanalytic Study of His Life and Images.* New Haven and London: Yale University Press, 1983.

Lomazzo, Giovanni Paolo. *Scritte sulle arti.* Edited by Roberto Paolo Ciardi. 2 vols. Florence: Marchi and Bertolli, 1973–74.

Luzio, Alessandro. *Pietro Aretino nei primi suoi anni a Venezia e la corte dei Gonzaga.* Turin, 1888.

MacCurdy, Edward, ed. and tr. *The Notebooks of Leonardo da Vinci.* New York: Braziller, 1956.

Mâle, Emile. *L'Art religieux après le Concile de Trente.* Paris: Armand Colin, 1931.

Mander, Karel van. *Het Schilderboeck.* Amsterdam, 1618.

Mansuelli, Guido A. *Galleria degli Uffizi: Le sculture.* Vol. 1. Cataloghi dei musei e gallerie d'Italia. Rome: Istituto poligrafico dello stato, 1958.

Marlowe, Christopher. *The Complete Works.* Edited by Fredson Bowers. 2 vols. Cambridge: Cambridge University Press, 1973.

——. *The Complete Plays.* Edited by J. B. Steane. Harmondsworth: Penguin, 1969.

Martial (Marcus Valerius Martialis). *Epigrams.* Translated by Walter C. A. Ker. 2 vols. Cambridge, Mass.: Loeb Classical Library, 1947–50.

Martin, John R. *The Farnese Gallery.* Princeton: Princeton University Press, 1965.

——, ed. *Rubens before 1620.* Exhibition catalogue, Princeton University Art Museum, 1972.

Mayo, Penelope C. "*Amor spiritualis et carnalis*: Aspects of the Myth of Ganymede in Art." Ph.D. dissertation, New York University, 1967.

Meder, Joseph. *Die Handzeichnung.* Vienna: Schroll, 1923.

Mezzetti, Amalia. *Girolamo da Ferrara detto da Carpi: L'opera pittorica.* Milan: Silvana, 1977.

Michaelis, A. "Michelangelos Leda und ihr antike Vorbild." In *Strassburger Festschrift an Anton Springer*, pp. 31–43. Stuttgart, 1885.

Middeldorf, Ulrich and Goetz, Oswald. *Medals and Plaquettes from the Sigmund Morgenroth Collection.* Chicago: The Art Institute of Chicago, 1944.

Milanesi, Gaetano, ed. *Le lettere di Michelangelo Buonarroti ed i contratti artistici.* Florence, 1875.

Moll, Albert. *Berühmte Homosexuelle.* Grenzfragen des Nerven- und Seelenlebens, vol. 11, no. 75. Wiesbaden: Bergmann, 1910.

Monnier, Phillippe. *Le Quattrocento: Essai sur l'histoire littéraire du XVe siècle italien.* 2 vols. Paris: Perrin, 1931.

Montini, Renzo U. *Il Palazzo Firenze.* Quaderni di storia dell'arte 7. Rome: Istituto di studi romani, 1958.

Morlini, Gerolamo. *Hieronymi Morlini Parthenopei: Novellae, fabulae, comoedia.* Paris. 1855.

Museo del Prado: Catalogo de las pinturas. Madrid, 1972.

Mythographi latini.... Edited by Thomas Munckerus. 2 vols. Amsterdam, 1681.

Mutti, Claudio. *Pittura e alchimia: Il linguaggio ermetico del Parmigianino.* Parma: del Veltro, 1978.

National Gallery: Catalogue of the Pictures. London: Her Majesty's Stationery Office, 1921.

Nelson, John Charles. *Renaissance Theory of Love: The Context of Giordano Bruno's "Eroici furori."* New York: Columbia University Press, 1958.

Neusser, Maria. "Die Antikenergänzungen der Florentiner Manieristen." _Wiener Jahrbuch für Kunstgeschichte_ 6 (1929): 27–42.

Oberhuber, Konrad. "Die Fresken der Stanza dell'Incendio im Werk Raffaels." _Jahrbuch der kunsthistorischen Sammlungen in Wien_ 58 (1962): 23–72.

———. _Parmigianino und sein Kreis: Zeichnungen und Druckgraphik aus eigenem Besitz._ Exhibition catalogue, Vienna, Albertina, 1963.

Orgel, Stephen, and Strong, Roy. _Inigo Jones: The Theatre of the Stuart Court._ 2 vols. Berkeley and Los Angeles: University of California Press, 1973.

Ovid (Publius Ovidius Naso). _Metamorphoses._ Translated by Frank Justus Miller. 2 vols. Cambridge, Mass., and London: Loeb Classical Library, 1977.

Panofsky, Erwin. _The Iconography of Correggio's Camera di San Paolo._ London: Warburg Institute, 1961.

———. _Meaning in the Visual Arts._ Garden City, N.Y.: Doubleday, 1955.

———. _Renaissance and Renascences in Western Art._ New York: Harper and Row, 1960.

———. _Studies in Iconology: Humanistic Themes in the Art of the Renaissance._ New York: Oxford University Press, 1939.

Parker, K. T. _Catalogue of the Collection of Drawings in the Ashmolean Museum._ 2 vols. Oxford: Clarendon, 1956.

Pauly, A. F. von and Wissowa, Georg. _Real-Encyclopädie der klassischen Altertumswissenschaft._ 57 vols. to date. Stuttgart, 1895–.

Pedretti, Carlo. _Leonardo da Vinci: A Study in Chronology and Style._ Berkeley and Los Angeles: University of California Press, 1973.

Pelzel, Thomas. "Winckelmann, Mengs and Casanova: A Re-appraisal of the Famous Eighteenth-Century Forgery." _Art Bulletin_ 54 (1972): 300–15.

Perrig, Alexander. "Bemerkungen zur Freundschaft zwischen Michelangelo und Tommaso de' Cavalieri." In _Stil und Uberlieferung in der Kunst des Abendlandes_, 2: 164–71. Acts of the Twenty-first International Congress of the History of Art, Bonn, 1964. Berlin: Mann, 1967.

Perry, Marilyn. "The Statuario Pubblico of the Venetian Republic." _Saggi e memorie di storia dell'arte_ 8 (1972): 75–150.

Phillips, Kyle M., Jr. "Subject and Technique in Hellenistic-Roman Mosaics." _Art Bulletin_ 42 (1960): 243–62.

Philostratus. _Imagines._ Translated by Arthur Fairbanks. Cambridge, Mass., and London: Loeb Classical Library, 1960.

Pico della Mirandola, Giovanni. _De hominis dignitate, Heptaplus, De ente et uno, e scritti vari._ Edited by Eugenio Garin. Florence: Vallecchi, 1942.

Pigler, Andor. _Barockthemen._ 3 vols. Budapest: Akadémiai Kiadó, 1974.

Pirrotta, Nino. _Li due Orfei._ Turin: E.R.I., 1969.

Pittaluga, Mary. "Opere del Tintoretto smarrite o di malsicura identificazione." _L'arte_ 29 (1926): 139–43.

Planiscig, Leo. _Venezianische Bildhauer der Renaissance._ Vienna, 1921.

Plato. _Symposium._ Translated by W. R. M. Lamb. Cambridge, Mass., and London: Loeb Classical Library, 1975.

Pliny. _Natural History._ Translated by H. Rackham. 10 vols. Cambridge, Mass.: Loeb Classical Library, 1969.

Plon, Eugène. _Benvenuto Cellini: Orfèvre, médailleur, sculpteur._ Paris, 1883.

Poliziano, Angelo. *Epigrammi greci*. Translated and edited by Anthos Ardizzoni. Florence: La nuova Italia, 1951.

———. *Stanze per la giostra, Orfeo, Rime*. Edited by Bruno Maier. Novara: Istituto geografico de Agostini, 1968.

Pomeroy, Sarah B. *Goddesses, Whores, Wives, and Slaves: Women in Classical Antiquity*. New York: Schocken, 1975.

Pompeii A.D. 79. Exhibition catalogue, Boston, Museum of Fine Arts, 1978.

Pope-Hennessy, John. *Italian High Renaissance and Baroque Sculpture*. 2d ed. 3 vols. London: Phaidon, 1970.

———. *Italian Renaissance Sculpture*. 2d ed. London: Phaidon, 1971.

———. *Renaissance Bronzes: Catalogue of the Samuel H. Kress Collection*. London: Phaidon, 1965.

———. Introduction to *The Life of Benvenuto Cellini*, translated and edited by John Addington Symonds. London: Phaidon, 1949.

Popham, A. E. "The Baiardo Inventory." In *Studies in Renaissance and Baroque Art Presented to Anthony Blunt*, pp. 22–29. London and New York: Phaidon, 1967.

———. *Catalogue of Drawings by Dutch and Flemish Artists in the British Museum*. London, 1932.

———. *Catalogue of Drawings by Parmigianino*. 3 vols. New Haven and London: Yale University Press, 1971.

———. *Correggio's Drawings*. London: Oxford University Press, 1957.

———. *The Drawings of Leonardo da Vinci*. New York: Reynal and Hitchcock, 1945.

———. *The Drawings of Parmigianino*. New York: Beechhurst, 1953.

Popham, A. E., and Wilde, Johannes. *The Italian Drawings of the Fifteenth and Sixteenth Centuries in the Collection of His Majesty the King at Windsor Castle*. London: Phaidon, 1949.

Posner, Donald. *Annibale Carracci: A Study in the Reform of Italian Painting around 1590*. London and New York: Phaidon, 1971.

———. "Caravaggio's Homo-erotic Early Works." *Art Quarterly* 34 (1971): 301–24.

Potterton, Homan. *Venetian Seventeenth-Century Painting*. Exhibition catalogue, London, National Gallery, 1979.

Pouncy, Philip, and Gere, John A. *Italian Drawings in the British Museum Department of Prints and Drawings: Raphael and His Circle*. London, 1962.

Praz, Mario. *Studies in Seventeenth-Century Imagery*. Studies of the Warburg Institute, no. 3, 1939. Rome: Edizioni di storia e letteratura, 1964.

Procacci, Ugo. "Postille contemporane in un esemplare della vita di Michelangiolo del Condivi." In *Atti del convegno di studi michelangioleschi*, pp. 277–94. Rome: Ateneo, 1966.

Pyle, Cynthia Munro. "Politian's *Orfeo* and Other *Favole mitologiche* in the Context of Late Quattrocentro Northern Italy." Ph.D. dissertation, Columbia University, 1976.

Quintavalle, Armando Ottaviano. *Il Parmigianino*. Milan: Istituto editoriale italiano, n.d. [1948].

Réau, Louis. *Iconographie de l'art chrétien*. 4 vols. Paris: Presses universitaires de France, 1955.

Ricci, Corrado. *Antonio Allegri da Correggio: His Life, His Friends, and His Time*. Translated by Florence Simmonds. New York, 1896.

———. *Antonio Allegri da Correggio: Sein Leben und seine Zeit*. Translated by Hedwig Jahn. Berlin, 1897.

———. *Correggio*. Rome: Valori plastici, 1930.

Richardson, C. M., ed. *Early Christian Fathers.* Library of Christian Classics. Philadelphia: Westminster, 1953.

Richardson, Frances. *Andrea Schiavone.* Oxford: Clarendon Press; New York: Oxford University Press, 1980.

Richelson, Paul W. *Studies in the Personal Imagery of Cosimo I de' Medici, Duke of Florence.* New York: Garland, 1978.

Richlin, Amy. *The Garden of Priapus: Sexuality and Aggression in Roman Humor.* New Haven and London: Yale University Press, 1983.

Richter, Gisela M. *The Sculpture and Sculptors of the Greeks.* New Haven: Yale University Press, 1950.

Richter, Jean Paul, tr. and ed. *The Literary Works of Leonardo da Vinci.* 2 vols. London and New York: Oxford University Press, 1939.

Ridolfi, Carlo. *Le maraviglie d'arte,* 1648. Edited by Detlev von Hadeln. 2 vols. 1914. Reprint. Rome: Multigrafica editrice Somu, 1965.

Robb, Nesca A. *Neoplatonism of the Italian Renaissance.* London: Allen and Unwin, 1935.

Robert, C. *Die antiken Sarkophagreliefs.* 5 vols. Berlin, 1890.

Robert-Dumesnil, A.-P.-F. *Le Peintre-graveur français.* 11 vols. Paris, 1835–71.

Robin, Gilbert. *L'Enigme sexuelle d'Henri III.* Paris: Westmael-Charlier, 1964.

Rochester, John Wilmot, Earl of. *The Complete Poems of John Wilmot, Earl of Rochester.* Edited by David M. Vieth. New Haven and London: Yale University Press, 1968.

Roeder, Helen. "The Borders of Filarete's Bronze Doors to St. Peter's." *Journal of the Warburg and Courtauld Institutes* 10 (1947): 150–53.

Rola, Stanislas Klossowski de. *Alchemy: The Secret Art.* New York: Bounty Books, 1973.

Rosand, David, ed. *Titian: His World and His Legacy.* New York: Columbia University Press, 1982.

Rosenthal, Shelly. "Two Unpublished Pictures by Maes in Russia." *Burlington Magazine* 54 (1929): 269–71.

Ross, Marvin Chauncey. "The Statue of Ganymede by Claude-Clair Francin at the Walters Art Gallery, Baltimore, Maryland." *Gazette des Beaux-Arts* 29 (1946): 17–22.

Rossi, Paola, ed. *L'opera completa del Parmigianino.* Milan: Rizzoli, 1980.

Russell, Margarita. "The Iconography of Rembrandt's *Rape of Ganymede.*" *Simiolus* 9 (1977): 5–18.

Salvini, Roberto, and Chiodi, Alberto Mario. *Mostra di Lelio Orsi.* Exhibition catalogue, Reggio Emilia, 1950.

Saslow, James M. "Ganymede in Renaissance Art: Five Studies in the Development of a Homoerotic Iconology." Ph.D. dissertation, Columbia University, 1983.

Saxl, Fritz. *Antike Götter in der Spätrenaissance: Ein Freskenzyklus und ein Discorso des Jacopo Zucchi.* Studien der Bibliothek Warburg 8. Berlin: Teubner, 1927.

————. *Classical Antiquity in Renaissance Painting.* London: National Gallery, 1938.

————. *La fede astrologica di Agostino Chigi: interpretazioni dei dipinti di Baldassare Peruzzi nella Sala di Galatea della Farnesina.* Rome: Reale Accademia d'Italia, 1934.

Scarabello, Giovanni. "Devianza sessuale ed interventi di giustizia a Venezia nella prima metà del XVI secolo." In *Tiziano e Venezia: Convegno internazionale di studi, Venezia, 1976.* Vicenza: Neri Pozza, 1980.

Schapiro, Meyer. "Leonardo and Freud: An Art-Historical Study." *Journal of the History of Ideas* 17 (1956): 147–78.

Schneider, Laurie. "Donatello and Caravaggio: The Iconography of Decapitation." *American Imago* 33 (1976): 76–91.

———. "Ms. Medusa: Transformations of a Bisexual Image." In *The Psychoanalytic Study of Society*, ed. Werner Muensterberger, L. Bryce Boyer, and Simon A. Grolnick, 9: 105–54. New York: Psychohistory Press, 1981.

Schubring, Paul. *Cassoni: Truhen und Truhenbilder der italienischen Frührenaissance*. Leipzig, 1915.

Schulz, Juergen. *Venetian Painted Ceilings of the Renaissance*. Berkeley and Los Angeles: University of California Press, 1968.

Schwarzenberg, Erkinger. "Raphael und die Psyche-Statue Agostino Chigis." *Jahrbuch der kunsthistorischen Sammlungen in Wien* 73 (1977): 107–136.

Secker, Hans F. *Die Galerie der Neuzeit im Museum Wallraf-Richartz*. Leipzig: Klinkhardt and Biermann, 1927.

Segre, Cesare. *Lingua, stile, e società: Studi sulla storia della prosa italiana*. Milan: Feltrinelli, 1963.

Seymour, Charles, Jr. "Some Reflections on Filarete's Use of Antique Visual Sources." *Arte lombarda* 38–39 (1973): 36–47.

Seznec, Jean. *The Survival of the Pagan Gods: The Mythological Tradition and Its Place in Renaissance Humanism and Art*. Translated by Barbara F. Sessions. New York: Pantheon, 1953.

Shearman, John. "Die Loggia der Psyche in der Villa Farnesina und die Probleme der letzten Phase von Raffaels graphischem Stil." *Jahrbuch der kunsthistorischen Sammlungen in Wien* 60 (1964): 59–100.

Shoemaker, Innis H. *The Engravings of Marcantonio Raimondi*. Exhibition catalogue, Lawrence, Kansas, The Spencer Museum of Art; and Chapel Hill, North Carolina, The Ackland Art Museum, 1981.

Sichtermann, Hellmut. *Ganymed: Mythos und Gestalt in der antiken Kunst*. Berlin: Mann [1953].

Smith, Graham. *The Casino of Pius IV*. Princeton: Princeton University Press, 1977.

Statius, Publius Papinius. *Thebaid*. In *Statius*, translated by J. H. Mozley. 2 vols. Cambridge, Mass., and London: Loeb Classical Library, 1967.

Steinberg, Leo. "The Metaphors of Love and Birth in Michelangelo's *Pietàs*." In *Studies in Erotic Art*, edited by Theodore Bowie and Cornelia V. Christenson, pp. 231–338. New York: Basic Books, 1970.

———. "Michelangelo's 'Last Judgment' as Merciful Heresy." *Art in America* 63 (1975): 48–63.

———. *Michelangelo's Last Paintings: The "Conversion of Saint Paul" and "The Crucifixion of Saint Peter" in the Cappella Paolina, Vatican Palace*. New York: Oxford University Press, 1975.

Steinberg, Ronald M. *Fra Girolamo Savonarola, Florentine Art, and Renaissance Historiography*. Athens: Ohio University Press, 1977.

Stokes, Adrian. *Michelangelo: A Study in the Nature of Art*. London: Tavistock, 1955.

———. *The Quattro Cento, Part I: Florence and Verona*. London: Faber and Faber, 1932.

———. *Stones of Rimini*. New York: Putnam, 1934.

Stoller, Robert J. *Sex and Gender: On the Development of Masculinity and Femininity*. 2 vols. New York: Science House, 1968–74.

Strong, Roy. *Splendor at Court: Renaissance Spectacle and the Theater of Power*. Boston: Houghton Mifflin, 1973.

Summers, David. "*Figure come fratelli*: A Transformation of Symmetry in Renaissance Painting." *Art Quarterly* n.s. 1 (1977–78): 59–88.

———. *Michelangelo and the Language of Art*. Princeton: Princeton University Press, 1981.

Swoboda, Karl M. "Die Io und der Ganymed des Correggio in der Wiener Gemäldegalerie." In his *Neue Aufgaben der Kunstgeschichte*. Brünn: R. M. Röhrer, 1935.

Symonds, John Addington. *The Life of Michelangelo Buonarroti*. 3d ed. 2 vols. London and New York, 1899.

Testa, Judith Anne. "The Iconography of *The Archers*: A Study of Self-concealment and Self-revelation in Michelangelo's Presentation Drawings." *Studies in Iconography* 5 (1979): 45–72.

Thieme, Ulrich, and Becker, Felix, eds. *Allgemeines Lexikon der bildenden Künstler*. 37 vols. Leipzig: Seemann, 1907–50.

Thode, Henry. *Michelangelo: Kritische Untersuchungen über seine Werke*. 3 vols. Berlin, 1908.

Tietze, Hans, and Tietze-Conrat, Erika. *The Drawings of the Venetian Painters*. New York: J. J. Augustin, 1944.

Tiziano e Venezia: Convegno internazionale di studi, Venezia, 1976. Vicenza: Neri Pozza, 1980.

Tolnay, Charles de. *The Art and Thought of Michelangelo*. New York: Pantheon, 1964.

———. *Corpus dei disegni di Michelangelo*. 4 vols. Novara: Istituto geografico de Agostini, 1975–80.

———. "L'Hercule de Michel-Ange à Fontainebleau." *Gazette des Beaux-Arts* 64 (1964): 125–40.

———. *Michelangelo*. 5 vols. Princeton: Princeton University Press, 1943–60. Vol. 3: *The Medici Chapel*, 1948.

Trafton, Dain A. "Politics and the Praise of Women: Political Doctrine in the *Courtier's* Third Book." In *Castiglione: The Ideal and the Real in Renaissance Culture*, edited by Robert W. Hanning and David Rosand. New Haven and London: Yale University Press, 1983.

Tschudi, Hugo von. "Correggio's mythologische Darstellungen." *Die graphischen Künste* 2 (1880): 1–10.

Valentiner, Wilhelm R. *Pieter de Hooch*. Klassiker der Kunst, no. 35. Berlin and Leipzig: Deutsche Verlags Anstalt, 1929.

Varchi, Benedetto. *Due Lezzioni*, Florence, 1590. Translated by John Addington Symonds. In his *The Renaissance in Italy*, vol. 2. New York, 1893.

Vasari, Giorgio. *Lives of the Most Eminent Painters, Sculptors, and Architects. . . .* Translated by Gaston duC. deVere. 2d ed. 3 vols. New York: Abrams, 1979.

———. *Le vite de' più eccellenti pittori scultori ed architettori. . . .* Edited by Gaetano Milanesi. 9 vols. Florence, 1865–79.

Verheyen, Egon. "Correggio's *Amori di Giove*." *Journal of the Warburg and Courtauld Institutes* 29 (1966): 160–92.

———. "Eros et Anteros: 'L'Education de Cupidon' et la prétendue 'Antiope' du Corrège." *Gazette des Beaux-Arts* 65 (1965): 321–40.

———. *The Palazzo del Te in Mantua: Images of Love and Politics*. Baltimore and London: Johns Hopkins University Press, 1977.

Vesme, Alexandre Baudi de. *Stefano della Bella*. 1906. Reprint, edited by Phyllis Dearborn Massar. 2 vols. New York: Collectors Edition, 1971.

Virgil (Publius Vergilius Maro). *Eclogues, Georgics, Aeneid*. Translated by H. Rushton Fairclough. 2 vols. Cambridge, Mass., and London: Loeb Classical Library, 1978.

Voltelini, Hans von. "Urkunden und Regesten aus dem K. u. K. Haus-, Hof-, und Staats-Archiv in Wien." *Jahrbuch der kunsthistorischen Sammlungen des allerhöchsten Kaiserhauses* 13 (1892): xxvi–clxxiv; 15 (1895): xlix–clxxix; 19 (1898): i–cxvi.

Walker, John. *Bellini and Titian at Ferrara: A Study of Styles and Taste.* London: Phaidon, 1957.

Wallace, William. "Studies in Michelangelo's Finished Drawings, 1520–1534." Ph.D. dissertation, Columbia University, 1983.

Warburg, Aby. *Gesammelte Schriften.* 2 vols. Leipzig, 1932. Reprint. Nendeln and Liechtenstein: Kraus, 1969.

Wark, Robert. "A Sheet of Studies by Parmigianino." *Art Quarterly* 22 (1959): 245–48.

Weigert, Roger-Armand. *Inventaire du fonds français: Graveurs du XVIIe siècle.* Vol. 2. Paris: Bibliothèque nationale, 1968.

Weihrauch, Hans R. *Europäische Bronzestatuetten, 15.–18. Jahrhundert.* Brunswick: Klinkhardt and Biermann, 1967.

Weisbach, Werner. *Französische Malerei des XVII. Jahrhunderts.* Berlin: Keller, 1932.

Wesselski, Albert, ed. *Angelo Polizianos Tagebuch (1477–79).* Jena: Diederichs, 1929.

Wilde, Johannes. *Italian Drawings in the Department of Prints and Drawings in the British Museum: Michelangelo and His Studio.* London: British Museum, 1953.

Wiles, Bertha Harris. *The Fountains of the Florentine Sculptors and Their Followers from Donatello to Bernini.* Cambridge, Mass.: Harvard University Press, 1933.

Wind, Edgar. "'Hercules' and 'Orpheus': Two Mock-Heroic Drawings by Dürer." *Journal of the Warburg and Courtauld Institutes* 2 (1938–39): 206–18.

———. *Pagan Mysteries in the Renaissance.* New York: Norton, 1968.

Winner, Matthias. "Zum Apoll vom Belvedere." *Jahrbuch der Berliner Museen* 10 (1968): 181–99.

Wishnevsky, Rose. *Studien zum "portrait historié" in den Niederländen.* Munich: Ludwig-Maximilians-Universität, 1967.

Witt, Robert C. "Notes complémentaires sur la mythologie figurée et l'histoire profane dans la peinture italienne de la Renaissance." *Revue archéologique* ser. 5, vol. 9 (1919): 173–78.

Wittkower, Rudolf. *Art and Architecture in Italy, 1600–1750.* 3d ed. Harmondsworth: Penguin, 1980.

Wittkower, Rudolf, and Wittkower, Margot. *Born under Saturn.* London: Weidenfeld and Nicolson, 1963.

Woodhouse, J. R. *Baldesar Castiglione: A Reassessment of "The Courtier."* Edinburgh: Edinburgh University Press, 1978.

Yates, Frances A. *The Occult Philosophy in the Elizabethan Age.* London and Boston: Routledge and Kegan Paul, 1979.

Zerner, Henri. *Ecole de Fontainebleau, gravures.* Paris: Arts et métiers graphiques, 1969.

———. "L'Estampe érotique au temps de Titien." In *Tiziano e Venezia: Convegno internazionale di studi, Venezia, 1976,* pp. 85–90. Vicenza: Neri Pozza, 1980.

Zucchi, Jacopo. *Discorso sopra li dei de' gentili, e loro imprese. . . .* Rome, 1602.

INDEX

NX 650 .H6 S27 1986
 92 2465
Saslow, James M.

Ganymede in the Renaissance

CABRINI COLLEGE LIBRARY
610 KING OF PRUSSIA RD.
RADNOR, PA 19087-3699

DEMCO